— THE NEW —
PSYCHEDELIC
REVOLUTION

"Compelling, adventurous, and visionary, this book is packed with fascinating and useful information and inspiration. James Oroc is a fine storyteller as he leads us through a twisty tale that is part personal odyssey, part well-researched ramble through the past and present of psychedelic art and culture, and part love letter to humanity and our potential for awakening to the wonder and beauty of life."

STEPHEN GRAY, AUTHOR OF *CANNABIS AND SPIRITUALITY:
AN EXPLORER'S GUIDE TO AN ANCIENT PLANT SPIRIT ALLY*

"James Oroc's book is a timely reminder to translate our psyche-delic visionary insights into action: to make our minds manifest. Oroc proposes that we can create the future we want to live."

CASEY WILLIAM HARDISON, WRITER, FORMER LSD CHEMIST,
AND COGNITIVE LIBERTY ACTIVIST

"An important and fascinating book for anyone interested in the bold psychedelic visionaries whose work and legacies will continue to shape and be felt by our culture for generations to come. Oroc explores the practical application of psychedelics in the modern world and advocates the immense value that they bring."

ALEX SEYMOUR, AUTHOR OF *PSYCHEDELIC MARINE:
A TRANSFORMATIONAL JOURNEY FROM
AFGHANISTAN TO THE AMAZON*

— THE NEW —
PSYCHEDELIC REVOLUTION

The Genesis of the Visionary Age

JAMES OROC

Park Street Press
Rochester, Vermont • Toronto, Canada

Park Street Press
One Park Street
Rochester, Vermont 05767
www.ParkStPress.com

Text stock is SFI certified

Park Street Press is a division of Inner Traditions International

Library of Congress Cataloging-in-Publication Data

Names: Oroc, James, author.
Title: The new psychedelic revolution : the genesis of the visionary age /
 James Oroc.
Description: Rochester, Vermont : Park Street Press, [2018] |
 Includes bibliographical references and index.
Identifiers: LCCN 2017018638 (print) | LCCN 2017026191 (e-book) |
 ISBN 9781620556627 (pbk.) | ISBN 9781620556634 (e-book)
Subjects: LCSH: Hallucinogenic drugs—History. | Hallucinogenic drugs and
 religious experience—History.
Classification: LCC HV5822.H25 O76 2018 (print) | LCC HV5822.H25
 (e-book) | DDC 306/.1—dc23
LC record available at https://lccn.loc.gov/2017018638

Printed and bound in the United States by Lake Book Manufacturing, Inc.
The text stock is SFI certified. The Sustainable Forestry Initiative® program
promotes sustainable forest management.

10 9 8 7 6 5 4 3 2 1

Text design and layout by Virginia Scott Bowman
This book was typeset in Garamond Premier Pro with Gill Sans MT Pro used as
the display typeface

To send correspondence to the author of this book, mail a first-class letter to the
author c/o Inner Traditions • Bear & Company, One Park Street, Rochester, VT
05767, and we will forward the communication, or contact the author directly at
jamesoroc@gmail.com.

Dedicated to the living memory
of the Master alchemists

Albert Hofmann *(January 11, 1906–April 29, 2008)*
Alexander "Sasha" Shulgin *(June 17, 1925–June 2, 2014)*
and **Nicholas Sand** *(May 10, 1941–April 24, 2017)*

CONTENTS

◎

PART THREE

Dreaming of the Light

A Brief History of Visionary Art and Culture

There are many here among us now
Who feel that life is but a joke
But you and I, we've been through that
And this is not our fate
So let us not talk falsely now
For the hour is getting late

<div align="right">

BOB DYLAN,
"ALL ALONG THE WATCHTOWER"

</div>

INTRODUCTION

Experience is not what happens to a man; it is what a man does with what happens to him.

ALDOUS HUXLEY, *TEXTS & PRETEXTS:*
AN ANTHOLOGY WITH COMMENTARIES

Since I was a teenager I have always been fascinated by the art of fiction, and it was never my intention to become either a psychedelic author or a nonfiction writer. Therefore I clearly remember that starry night in December 2003, when, while walking the dirt streets of Pushkar, India, I first considered the possibility of abandoning the novel that I had been writing sporadically for twenty years, to instead begin penning an account of the ongoing personal transformation that I was undergoing thanks to the rare, and barely-known, entheogen* 5-methoxy-DMT (5-MeO-DMT). I also clearly remember my first instinct was that this was a terrible idea, if only because I believed that any book on the subject would be virtually unpublishable.

This personal transformation, which I had encountered almost by accident only a few months earlier, was one of the oldest mysteries known to Mankind; for after smoking 5-MeO-DMT for the

Entheogen: A psychedelic plant or compound capable of inducing the classical mystical experience.

1

first time with virtually no knowledge of its effects, I had received a mystical taste of the Other—an egoless experience of Oneness after I had merged with the conscious totality revealed in the Void—before returning to my body from that singular inner journey transformed from a hardened scientific rationalist and confirmed atheist into a modern mystic. And while I was now fully convinced of the existence of a God far greater than any I could have had imagined, I knew rationally that few books are published these days about psychedelics, and even fewer are published about the mystical experience; hence my skepticism about the value of writing a book that would attempt to combine the two. (See chapter 7, "Where Is God in the Entheogenic Movement?")

Considering my unshakable faith in the universal nature of the mystical experience after this first transpersonal integration, and the fact that this would become a central pillar in the psychedelic philosophy presented in the book that I would eventually write about my 5-methoxy-DMT experiences, it is interesting to realize in retrospect that I had the sudden inspiration to write such a book while in Pushkar. A small oasis town that surrounds a tiny lake in the desert in Rajasthan, Pushkar is a major pilgrimage site that has the reputation of being one of the holiest places in all of India. Temples, mosques, ashrams, and churches of all the major religions line the lake's shore, and I later found out that Pushkar also has the only temple to Brahma—the ultimate Vedic god from which all the other gods manifest—in all of India. It was also probably the stunning variety of spires, arches, and domed ceilings displayed in Pushkar's various houses of worship that inspired the title for of my book—*Tryptamine Palace*.

This unwanted inspiration began what was arguably one of the more remarkable journeys of any book in the modern era. For as doubtful of the project as I was personally, I always say that *Tryptamine Palace* was a book that was determined to be written and published, while I was merely the vehicle that was chosen for the job. It was only a week or so later, on a slow-moving train across the flat and featureless gray desert between Jaisalmer and Jaipur, that I received a steady stream of ideas

about the nature of light and consciousness that were so convincing that I had no choice but to write them down. Over the following five years, these ideas would evolve into the central original theory that I present in *Tryptamine Palace:* that the transpersonal-entheogenic experience is a rare form of quantum coherence (known as a Bose-Einstein condensate) within the quantum-holographic field—known as the zero point, or Akashic Field—which is the Universal Field that connects all things, as well as the place where consciousness actually resides. (And not inside the brain, as our Newtonian sciences propose. See chapter 8, "5-MeO-DMT: Visions of a Quantum God," for a more in-depth and updated description of this theory.)

While suitably inspired to have begun writing *Tryptamine Palace,* I still did not believe that such a book could actually be published for mainstream consumption. Fortunately a surrogate presented itself in the opportunity to participate as a Burning Man artist by writing the book to "gift" at Burning Man, where I had no doubt that it would be read and appreciated. Which is exactly how the first draft of *Tryptamine Palace* was written—as a life raft for some unprepared soul who had just encountered 5-MeO-DMT, and, with their worldview in tatters, was wondering what had just happened to them. In total in its original "playa"* form, I personally gifted five hundred copies of *Tryptamine Palace* in 2006 and 2007. (Which was a first for Burning Man, I believe.)

As crude and incomplete as these early volumes were, they resonated with many of the readers that received them. From these humble playa origins I was convinced by the editor of *The Entheogen Review* that *Tryptamine Palace* was worthy of self-publication to a wider audience, so we labored for another year on that task. Self-publishing offers the freedom to publish virtually anything in the twenty-first century, and while as a writer I was excited for that opportunity, there was still

*The *playa* is what Burning Man regulars ("burners") call the desert environment where Burning Man is annually held. For example, two burners are more likely to ask "Are you going to the playa this year?" rather than "Are you going to Burning Man?"

a part of me that realized that I just hated the idea of getting rejected by actual publishers.

"Better toughen up," I told myself, and so I sent two copies of my printed and bound Burning Man volumes to two different publishers to get used to being turned down. To my astonishment, Inner Traditions (to whom I had sent a copy because they had published the seminal work on the Akashic Field theories of my hero Ervin Laszlo; I did not know that they had published *DMT: The Spirit Molecule*) accepted *Tryptamine Palace* for publication, and in 2009—nearly six years after that fateful decision in Pushkar to change my course as an author and write a nonfiction book about psychedelics and the mystical experience—published the much-revised and expanded "final" version of *Tryptamine Palace* to a global audience, thereby introducing both my ideas and writing to the world.

Since this time *Tryptamine Palace* has been almost universally well received. *High Times* magazine called it "the best book on psychedelics since Terence McKenna," and I often hear it described as a contemporary psychedelic classic. I have come to realize that I was very fortunate to be the right writer with sufficient curiosity and the correct skill set to encounter such an important entheogen at exactly the right time— just as Aldous Huxley had been with mescaline, R. Gordon Wasson with psilocybin mushrooms, Timothy Leary with LSD, and Terence McKenna with DMT and ayahuasca. Although I have been fascinated with psychedelics since my university years, I doubt that I would have ever chosen to write a book about any of the classic psychedelic compounds of the 1960s—mescaline, LSD, psilocybin, and DMT, as listed by Leary, Ralph Metzner, and Richard Alpert in *A Handbook for the Psychedelic Experience* in 1966—since there was little I would have thought I could have added to the volumes that had already been written about these psychedelics.

However when I had my Plus-4* entheo-mystical experience in July

*According to The Shulgin Scale; PLUS FOUR, n. (++++) A rare and precious transcendental state, which has been called a "peak experience," a "religious experience," "divine transformation," a "state of Samadhi" and many other names in other cultures.

of 2003, not only was this by far the singularly most powerful psychedelic experience that I had ever had, but the compound involved (5-MeO-DMT) had been purchased legally off the internet (since it was still unscheduled)! Equally paradoxically there seemed to be virtually no information available about this incredible entheogen at all—a factor that played into my own tremendous surprise at my unexpected mystical conversion, and in the decision to write a book about my research and experiences. 5-methoxy-DMT—which I quickly discovered to my growing confusion was also naturally present in the venom of a certain American desert toad—was clearly not your parents' psychedelic, and the opportunity to write a pioneering book on this practically unknown compound that was capable of so effectively shattering my own personal paradigm proved too great to resist.

> *Psychedelics are illegal not because a loving government is concerned that you may jump out of a third-story window. Psychedelics are illegal because they dissolve opinion structures and culturally laid down models of behavior and information processing. They open you up to the possibility that everything you know is wrong.*
>
> TERENCE MCKENNA

Since around the mid-1990s, contemporary psychedelic culture has undergone a considerable reinvention of itself, with new psychedelic compounds (both synthetic and natural), psychedelic heroes (Terence McKenna, Alexander Shulgin, Alex Grey), psychedelic music (EDM), major gatherings (Burning Man, BOOM!, and the transformational

(*continued from page 4*) It is not connected to the +1, +2, and +3 of the measuring of a drug's intensity. It is a state of bliss, a *participation mystique*, a connectedness with both the interior and exterior universes, which has come about after the ingestion of a psychedelic drug, but which is not necessarily repeatable with a subsequent ingestion of that same drug. If a drug (or technique or process) were ever to be discovered that would consistently produce a plus four experience in all human beings, it is conceivable that it would signal the ultimate evolution, and perhaps the end, of the human experiment. (Alexander Shulgin, *PIHKAL,* 963–965).

festivals they have inspired), and even new psychedelic fashions (tribal versus tie-die). During this same period the proliferation of the borderless and virtually uncensored internet has also had a dramatic effect on the growth and spread of a global psychedelic culture, which distinguishes it from the much smaller and very localized psychedelic first wave of the 1960s.

My own personal second psychedelic revolution on 5-MeO-DMT in 2003 came synchronistically, at the lowest point of both supply and consumption in the history of LSD (because of the dismantling of major LSD-producing facilities in Canada and Kansas; see chapter 1, "The End of Acid?"), and at the beginning of the transformational festival era spawned by the remarkable counterculture events Burning Man (in the United States) and BOOM! (in Europe). (See chapter 24, "New Psychedelic Tribes.") Meanwhile, as a writer, I had long thought that getting a book published was the ultimate goal, but as an author, I quickly realized that I had just made it to the starting line, and was now actually in the game.

This resulted in a symbiotic career as a psychedelic speaker at the transformational festivals and entheogenic conferences that have appeared all over the world over the past decade, both to promote *Tryptamine Palace,* and to personally investigate the far-flung corners of contemporary psychedelic culture. (I am one of a handful of people who get flown around the world to talk about psychedelics, an unintended consequence of writing *Tryptamine Palace* that continues to amaze me!) Along the way I have gotten to meet and converse with many of my personal psychedelic heroes, many of whom I will discuss in these pages: Alexander Shulgin, Nick Sand, Dennis McKenna, Alex and Allyson Grey, Robert Venosa, Martina Hoffmann, Dave Nichols, Carolyn Garcia, David Nutt, and Rick Doblin, to mention just a few. I have also had the opportunity to meet my psychedelic peers, who these days are mostly either electronic music producers (and too numerous to list), or the generation of emerging visionary artists/activists led by Luke Brown, Carey Thompson, Amanda Sage, and Android Jones.

For three years (2011–13), at what was arguably my peak involve-

ment in transformational festival culture, I played a part in the forma-
tion of a remarkable Burning Man visionary art, music, performance,
and information village called FractalNation, which was co-created
by all the younger visionary artists listed above, along with a long list
of international festival producers and artists and engineers in every
imaginable discipline, including Jennifer Ingram, the tireless curator of
Tribe 13. (Alex and Allyson Grey participated with their own art dome
at FractalNation/Area 51 in 2012). With its massive visionary art galler-
ies, live painting, carefully curated music and performance, video map-
ping and projections, and a playa speaker series organized by MAPS*
that was attended by thousands, for many of those who experienced it,
FractalNation was the high point of psychedelic culture on the planet
during its brief and transitory existence, and a shining example (in my
mind at least) of how the world could be if we just let psychedelics do
their job. (See chapter 30, "A FractalNation.")

For a long time after *Tryptamine Palace* was published, I thought
that I would never write another book about psychedelics. But thanks
to my now nearly fifteen-year immersion in contemporary visionary
culture and my newfound status as a psychedelic philosopher, I have
had unique opportunities to give talks and publish articles outside of
my previous 5-MeO boundaries. These experiences eventually made me
realize that I *did* have another book to offer to psychedelic culture—a
book that can, I hope, provide shape and form to this ongoing global
entheogenic awakening, and help usher in the Visionary Age to come.
Initially I envisioned this book as a simple collection of my work
post-*Tryptamine Palace,* but my editors at Inner Traditions in their
quiet persuasion have guided me to a more cohesive version that pres-
ents a clearer picture of this ongoing twenty-first century renaissance in
psychedelic culture. While this has largely removed areas of unnecessary
repetition from this book, in some places you will find varying encoun-
ters with the same central themes in my ideas, and this repetition is

*Multidisciplinary Association of Psychedelic Studies—the legal, above-board face of the
modern psychedelic movement.

deliberate. For as one of my guiding lights, the great mythologist Joseph Campbell, remarked upon viewing the body of his work toward the end of his years, while he had expected to see some progress or greater revelation in his later work, in truth the same themes and explorations had been present in his work from the beginning. While we live in a culture that demands novelty and expects to be fed new and entertaining diversions daily, the great truths that entheogens can reveal are few and ancient, and I believe deserve the respect of the thousands of years of psychedelic philosophy and tradition that have formed them. The central theme you will find me returning to throughout this volume—the role of the ego and psychedelics unique ability to disrupt the ego structure and allow Source to emerge—is thus a modern perspective on an idea with the oldest of roots.

The book you are holding is built of four distinct parts, each of which offers a different facet of twenty-first century visionary culture. The genesis of part 1, "The Second Psychedelic Revolution," came from an invitation to give a presentation at Alex Grey's sixtieth birthday party at CoSM (Chapel of Sacred Mirrors) in upstate New York. This resulted in a six-part series on contemporary psychedelic culture for the webzine Reality Sandwich that provided the underlying inspiration for this book.

Part 2, "What Can Entheogens Teach Us? Psychedelic Culture in the Twenty-first Century," opens with my first-ever article on psychedelics that preceded the publication of *Tryptamine Palace*, the aptly titled, "Where Is God in the Entheogenic Movement? (chapter 7). Part 2 also includes subjects as diverse as ayahuasca and the movie *Avatar* (chapter 9, "The Future of Psychedelics"), and an article written for the MAPS journal on "Psychedelics and Extreme Sports" (chapter 10) that has been seized on by the growing microdose movement and has become my most widely distributed contribution to psychedelic history. (I have since been quoted in the *New York Times* as saying that the best time to eat acid is for breakfast!) A presentation to the Science and Nonduality Conference in California resulted in an article on the Oroc Entheogen Scale, an effort to rank psychedelic compounds by their effects on the ego (see chapter 11, "What Can Entheogens Teach

Us?") that has resonated greatly with my audiences and with numerous scholars, and I believe may prove to be my most-practical contribution to the psychedelic community.

Part 3, "Dreaming of the Light: A History of Visionary Art and Culture," is one of the first major attempts to document and provide a timeline for the emergence of contemporary visionary culture through the long-lens of the contorted history of visionary art; an ongoing process to which I have been a privileged witness over the past fifteen years.

This book concludes with part 4, "Accidental Ingestions, Amazonian Overdoses, and Other Reports from the Front Lines," Gonzo-style accounts of my assorted misadventures for fans of my less scholarly writing.

The New Psychedelic Revolution: The Genesis of the Visionary Age is the ongoing story of the mainstreaming of psychedelic culture. For nearly one hundred years after the first synthesis of a psychedelic (mescaline) in 1918, and despite fifty years of a dehumanizing global prohibition that has tried to both ridicule and eradicate them, our society is increasingly realizing that the lessons present in using sacramental entheogens may yet be our best hope for a sane and sustainable future for humanity.

The next twenty-five years could be quite possibly the most important to mankind since some seventy thousand years ago when our ancestors—as few as a thousand* hominid hunter-gathers scavenging on the Arabian peninsula between Africa and Asia—were poised right on the razor-edge of extinction, their fate seemingly no different to the other 99.5 percent of all the species that had come and gone before them. That moment, when some spark (possibly entheogenic) began *Homo sapiens'* extraordinary adventure in consciousness—the Cognitive Revolution—that then our ancient ancestors to cross into Eurasia bringing complex tools, body ornamentation, and probably language and religion with them. (And beginning our species' unique journey to dominate, and now increasingly destroy, our planet.) For if there is

*According to the science of the remarkable Human Genome Project.

one thing of which contemporary visionary culture has convinced me, it is that psychedelic use promotes critical thinking by making us think about the shape of both our reality and our world—exactly the kind of thinking most needed in this time of global crisis and rapid social change, and yet with the deliberate and institutionalized dumbing-down of the overall population, seemingly the very thing that modern governments all fear. So "Viva!" to this new psychedelic revolution, and the broader, holistic, and more connected perspective that it offers. May its influence quickly spread, take seed, and flower around the globe for never in human history has this kind of tolerant and independent critical thinking been more important or necessary, as the fight for both our minds and our future lives has really just begun.

PART ONE

The Second Psychedelic Revolution

1

THE END OF ACID?

In November 2000, a Drug Enforcement Administration sting dubbed "Operation White Rabbit" arrested William Leonard Pickard and Clyde Apperson while they were moving an alleged LSD production laboratory from a renovated Atlas-E missile silo in Wamego, Kansas, to an undisclosed location. While the DEA now says that no LSD was ever produced at this silo, and while there are still many questions regarding the case and the involvement of the DEA's informant, Gordon Todd Skinner, both statistical analysis and anecdotal street evidence agree with the DEA's claim that after this major "bust" there was a 95 percent drop in the USA's supply of LSD. Because of this event, combined with the earlier arrest of Nick Sand (the co-inventor of Orange Sunshine LSD and the world's most prolific LSD chemist) in Canada in 1997, for the first time since 1968, when LSD was made illegal, it actually seemed possible that there could be An End to Acid.

A year later almost to the day after Operation White Rabbit, Ken Kesey, LSD's original Merry Prankster, died on November 10, 2001. With Timothy Leary's ashes already orbiting in outer space* and the legendary sixties counterculture icons the Grateful Dead—LSD's most successful proselytizers—having been disbanded for more than six years after guitarist Jerry Garcia's death, the casual observer could have eas-

*Some of them, to be accurate. Since I wrote this, Susan Sarandon has also rather publicly taken some of Leary's ashes to Burning Man and undoubtedly left them in The Temple. One well-known psychonaut claims to have snorted some of them.

ily been tempted to believe that the Psychedelic Revolution, which had begun in the mid-1960s with the widespread introduction of LSD into Western society, had finally fizzled to an end. The world changed in many ways thanks to our cultural discovery of psychedelics, but as with most revolutions, its dreams were never really met, and its heroes are now passing into legend.

Ironically however, as antiquated and beaten as the psychedelic movement may have appeared to the uninitiated at that moment, the seeds of what I now call the Second Psychedelic Revolution had already been planted more than a decade before, and were able to bloom in the very desert that the LSD drought then created. In a profound example of how ineffective prohibition can be, the possibility of a world without acid caused a new, younger generation to seek out a plethora of alternative psychedelics—some old, some new—and in the process they have rediscovered and reclaimed the original entheogenic experience: the mystical taste of the Other, the flash outside of space and time, that LSD had provided for the original 1960s pioneers.

Today, some fifteen years after the DEA's "death-blow" to psychedelic culture, we are witness to psychedelic research reentering the universities and research labs, thanks to the vision and persistence of organizations like the Multidisciplinary Association for Psychedelic Studies (MAPS) and The Beckley Foundation. For the first time since psychedelic therapy was driven underground at the end of the sixties, there are professional clinics in Canada, Mexico, Europe, and New Zealand that utilize ayahuasca, ibogaine, and, increasingly, 5-methoxy-DMT to break addictions and help end-of-life patients. We have also seen the global adoption of the virtually uncensorable World Wide Web, and the corresponding birth of hundreds if not thousands of websites (such as Erowid, Nexus, and dmtsite.com) either promoting psychedelics or directly influenced by them. This newfound digital connectivity has also played a part in the dramatic rise in the popularity of electronic dance music (EDM), the first major musical genre to venerate and popularize psychedelics since the 1960s. The success of this global and easily-shared musical form has played a large part

in the rapid growth of the transformational festival meme, and the corresponding visionary art culture that is on display at major events like Burning Man in the USA and BOOM! festival in Europe. There are now even a number of new books on psychedelics on the shelves, along with the greatest array of psychedelics and entheogens—both natural and manmade—that has ever been available to any society in history. All together, these signs indicate that far from having fizzled out as claimed, the psychedelic revolution within Western culture is in fact entering a second renaissance.

So how did this Second Psychedelic Revolution come about? What are its goals and its ideals? Are they any different from the first Psychedelic Revolution of the 1960s, or is this just fashion reinventing itself? As someone who had his own personal (and entirely unintended) second psychedelic revolution in 2003 from a compound purchased legally on the internet, as (subsequently) the author of one of the best-reviewed book on psychedelics in the last twenty years, and as one of the founders of the Burning Man camp FractalNation (along with the digital artist Android Jones), one of the major experiments in visionary culture and community in the twenty-first century, I believe that I have been in as good a position as anyone to examine and help define this latest shift in psychedelic awareness, as well as this movement's hopes, fears, dreams, and aspirations.

In doing so I hope to create a greater awareness of the opportunity that is being presented to us, and of the realization that, as it rises in popularity, this Second Psychedelic Revolution is already under threat. I would also like to put forward the possibility that psychedelics, which seemed like the formula for instant societal change in the 1960s, may in fact be the long-term solution for whatever society manages to emerge from the increasing chaos that the combination of environmental change, population growth, and our global addiction to consumption will wreak upon the second half of this twenty-first century. For I believe that the appearance of psychedelics in Western culture at this critical juncture in human history is not coincidental; for an entheogenic society is a critical piece of the new para-

digm required for humanity to survive its rapidly worsening modern dilemma.

The philosophical birth of this second psychedelic movement began a decade prior to the dismantling of the Kansas missile-silo laboratory and the LSD drought that followed. After a long hiatus in the publication of virtually any relevant information about psychedelics, three* different authors almost simultaneously published major books in the early 1990s that would become the most important contributions to psychedelic culture since the days of Aldous Huxley, Alan Watts, and Timothy Leary: *PIHKAL (Phenethylamines I Have Known and Loved): A Chemical Love Story* (1991) by the chemist Alexander "Sasha" Shulgin published in 1991, and followed by *TIHKAL: The Continuation* in 1997 (both co-authored by his wife Ann); *The Archaic Revival: Speculations on Psychedelic Mushrooms, the Amazon, Virtual Reality, UFOs, Evolution, Shamanism, the Rebirth of the Goddess, and the End of History* (1991) and *Food of the Gods: The Search for the Original Tree of Knowledge—A Radical History of Plants, Drugs, and Human Evolution* (1992) by Terence McKenna, an eccentric underground mycologist; and *Sacred Mirrors: The Visionary Art of Alex Grey* (1990), an art book with essays by the New York–based and psychedelically inspired artist Alex Grey.

These four books were published during the height of what was arguably the most anti-psychedelic era in the United States. The War on Drugs that had been started by Richard Nixon in 1971 had been resurrected by Nancy Reagan and her "Just Say No!" campaign in 1986, and psychedelic use was statistically at its lowest and socially most discredited point ever. (The DEA's infamous flashback conference, which—at the height of the violent cocaine epidemic—vilified LSD as society's most dangerous drug, was held in San Francisco in

*Four authors if you include Ann Shulgin. Since it is the chemical formulas of Alexander Shulgin's from *PIHKAL* and *TIHKAL* that have had such an effect on contemporary psychedelic culture, I have made it three here for the sake of simplicity. In no way, however, do I wish to undervalue Ann Shulgin's contribution, for without her, these books would have been unlikely to have been written.

1991.) The brave publication of these very-different books would provide the philosophical foundation for a new twenty-first-century psychedelic movement by introducing the four main components that distinguish this Second Psychedelic Revolution from the original Acid-and-Rock revolution of the 1960s.

These four new developments were:

1. The introduction of a wide number of new psychedelic compounds and analogues, including synthetic phenethylamines from the 2C family such as 2C-B, 2C-I, and 2C-E.
2. The increased awareness in Western psychedelic culture of sacred, natural plant entheogens (especially ayahuasca, San Pedro, and "magic" mushrooms), and the online publication of simple methods of extracting DMT from plant sources.
3. A new form of nonstop electronic music—psychedelic trance—that had been percolating between the full-moon parties in Goa, India, and primitive electronic music studios in England and Germany. Integrating instruments, rhythms, and the sacred chanting from various cultures with nonstop, repetitive Acid-House beats, by the early 1990s psytrance had begun to spread out to London clubs and remote locations (often deserts) around the world. Once Burning Man—initially an art-and-anarchy event—moved to Nevada's Black Rock Desert in 1993, and BOOM! began in Portugal in 1998, these electronic music tribes, who had already been producing events in isolation, soon found their musical Kumbh Melas. Goa Gil and numerous famous English DJ's played at Burning Man in the mid-1990s, even though there was considerable tension between the Art and Music camps and the Burning Man organization made a point of not encouraging this trend. Perhaps because of this, psychedelic trance never became as popular in the United States as it is in Europe, and this led to a unique West Coast "psychedelic" electronic sound that evolved around the various West Coast based EDM produc-

ers that were part of the Burning Man and emerging West Coast transformational festival culture. Therefore one of the defining features of transformational festivals globally is that they are not necessarily related by music genre,* but by intention and philosophy, with many different styles of music providing the required "soundtrack" for Visionary Culture, where music and dance—which Joseph Campbell describes as two of the oldest vehicles of transcendence—are of the greatest importance.

4. The evolution of visionary art, an often deliberately more sacred form of contemporary psychedelic art, and its two-decade integration into global electronic dance music (EDM), by providing the required visual component for performances by DJ's and EDM producers. This integration resulted in the corresponding birth of an identifiable "visionary culture"; most notably at BOOM! in Portugal, and at Burning Man in the United States, two major events that over the past twenty years have inspired the transformational festival meme that has seen the birth of numerous other similar festivals across the globe.

Anyone who has experienced the worldwide growth of this transformational festival culture over the past decade, stumbled into the Do Lab section of Coachella (one of the last great rock festivals), attended one of the academic MAPS psychedelic sciences conferences in California, or one of the World Psychedelic Forums in Basel, Switzerland, or even merely surfed around on the internet and discovered psychedelic information sites such as Erowid.org and Nexus.org, will easily recognize some, if not all, of these latest developments in psychedelic culture.

But during the waning days of the twentieth century, none of these factors were commonly known. And while it is somewhat irrelevant to rank the importance of the very different contributions of the main

*For example, the European, Australian, and South African festivals mostly feature psytrance with a far higher bpm (beats per minute) than the more dub or house inspired EDM music of the unique West Coast (United States/Canada) festival circuit.

architects of this new psychedelic revolution—Alexander (and Ann) Shulgin, Terence McKenna, and Alex Grey—I think that historians would have to agree that the Shulgins' contribution—*PIHKAL* and later *TIHKAL*—provided both the bravest and the most essential first act.

2

ALEXANDER "SASHA" SHULGIN

The Godfather of Psychedelics

*I first explored mescaline in the late '50s, three-hundred-fifty to
400 milligrams. I learned there was a great deal inside me.*

ALEXANDER SHULGIN,
LOS ANGELES TIMES, SEPTEMBER 5, 1995

If there is ever a Psychedelic Hall of Fame, the section on chemists
will be small, because there have only really been four giants in this
field—the German chemist Arthur Heffter, who first isolated mesca-
line in 1897 (and who, by testing the various extracts upon himself
to see which one was psychoactive, was the first modern psychonaut);
the Austrian chemist Ernst Späth, who first synthesized a psychedelic
(mescaline) in 1918; the Swiss chemist Albert Hofmann, who first
invented LSD-25 in 1938, and later isolated psilocybin in 1958; and
the American chemist Alexander "Sasha" Shulgin, who seems to have
invented nearly everything else since—a remarkable two hundred and
thirty compounds, many of which he and his wife Ann tested upon
themselves.

But when their remarkable book *PIHKAL: A Chemical Love Story*

first appeared in 1991, few people outside of the California psychedelic community knew about Sasha (as his friends called him) or about the quiet existence that he and Ann lived. Those that knew of him outside of California knew of him mostly as the rediscoverer of the drug MDMA, which became one of the most popular illegal recreational drugs in the late twentieth century.

MDMA, first synthesized in 1912, was subsequently used in the CIA's Project MK-ULTRA studies in 1953–54. These reports were declassified in 1973. Shulgin then synthesized the compound and tried it himself for the first time in 1976 after hearing accounts of its effects from his students at the University of California, Berkeley.

Sasha liked to call MDMA his "low-calorie martini," and introduced it to numerous friends and colleagues, including the noted psychotherapist Leo Zeff, who was so impressed with the compound that he came out of retirement to train psychotherapists in its use. The popularity of MDMA as a psychiatric medicine quickly spread in the early 1980s among psychologists and therapists, but then was made illegal in 1985 due to its increasing infamy as a recreational drug. Most commonly known by its street name Ecstasy, by the late 1980s MDMA use had become prevalent in England's rapidly blossoming electronic music or Acid–House scene, where the smiley face logo became identified with both the drug and the new youth culture, and its popularity as a "party drug" soon spread globally. After twenty years of failed prohibition, in 2008 the United Nations estimated that between ten and twenty-five million people use MDMA annually, a number that has continued to grow with the increased popularity of electronic dance music.

An entire article could be written about the similarities and differences between empathogens (also called *entactogens*) and psychedelics (also called *entheogens*), and while this is an important conversation for our community, it is territory I do not have time to cover here. What is important, however, is that both empathogens like MDMA and perhaps the oldest known psychedelic—mescaline—are *phenethylamines*. This means they are all variations of the same basic phenethylamine-ring shape. Thanks to this simple fact, when the Shulgins wrote *PIHKAL*

and released it to the world in 1991, they provided not only the greatest known resource on MDMA and its older cousin MDA (the original sixties love drug), but also revealed a catalog of almost two hundred previously unknown psychedelic and empathogenic compounds that Sasha had invented.

Alexander Shulgin was a giant of a man, both physically and intellectually, reputedly with an IQ that matched Einstein's. Early in his career, he developed the first biodegradable pesticide for the Dow Chemical Company, developing a patent that made his employers millions and garnered him a certain degree of independence, allowing him to relocate his laboratory to his home near Lafayette, California, in 1965. In this remarkable home lab, which looks more like a garden shed, Shulgin would discover, synthesize, and bioassay almost two hundred and sixty psychoactive compounds during the following thirty-five years, often publishing the results in peer-reviewed journals such as *Nature* and the *Journal of Organic Chemistry*.

While clearly a libertarian in his views, Shulgin somewhat paradoxically developed a professional relationship with the DEA, who granted him a special license to synthesize Schedule 1 compounds, and used him as a consultant and legal expert on certain cases. In 1988, he published the definitive volume on illegal drugs for law enforcement, for which he received numerous awards. Then in 1991, in an effort to ensure that his discoveries would never be censored, he and Ann published *PIHKAL,* which is both the story of the Shulgins' remarkable life and love affair, and a detailed manual of how to synthesize almost two hundred phenethylamine compounds—an action consistent with his stated beliefs that psychedelic drugs can be valuable tools for self-exploration.

In the history of literature, there are few braver acts than the Shulgins' publishing of *PIHKAL*. Ironically this could probably only have happened in the United States—the country that has effectively made psychedelics illegal worldwide through influencing United Nations law—thanks to the protection of the First Amendment. (The mere possession of *PIHKAL* in many other countries is a crime.) Nevertheless, when copies of *PIHKAL* somewhat predictably started

turning up in busted underground labs all over the world, the DEA was outraged to discover that one of its own contractors had published what they considered to be a cookbook of illegal drugs (complete with Shulgin's own rating scale). In response, in 1994 the DEA raided the Shulgins' home and lab, fining him $25,000 for the possession of anonymous samples that the DEA themselves had sent him, and revoked his Schedule 1 license. (The Shulgins responded by publishing *TIHKAL: The Continuation* in 1997, which presents Sasha's seminal work on the tryptamine family, which includes psilocybin, LSD, DMT, and numerous other powerful and fascinating psychedelics.)

Raiding Shulgin's lab *after* the publication of *PIHKAL* was something of a case of closing the barn door after the horse has bolted. By the mid-1990s a number of previously rare or unknown—and, most importantly, unscheduled—compounds began to become available on the street, and, in a fresh development for psychedelic culture, online through the websites of "research chemical companies." By the time the LSD drought resulting from the Kansas missile-silo bust in 2000 began to take effect (and during a period of considerable media attention about the low purity of Ecstasy pills), many of these compounds, especially the 2C family, were already becoming established as the psychedelics of choice for a new generation. Many of whom had never had the opportunity to try synthetic mescaline, psilocybin, DMT, or, increasingly, LSD, but who, in a uniquely twenty-first century development, were buying their (99.5 percent pure) psychedelics off the internet.

Although the Federal Analogue Act had been passed in 1986 as a response to these so-called designer drugs, the sheer number of different compounds along with ambiguities in the act itself, made it difficult to contain these new compounds, just as authorities were struggling to deal with the new international factor of the internet. In July 2004, a DEA operation called Web Tryp arrested ten people in the United States associated with five different research chemical companies, effectively closing all remaining companies or driving them further underground (most recently on the Silk Road). In an interesting act of unintended synchronicity, the web info site Erowid.org published (with Shulgin's

permission), all of his formulas contained in *PIHKAL* and *TIHKAL* at around the same time. This act effectively allows access to them to anyone around the world, virtually ensuring that they will never be able to be entirely lost or repressed.

When assessing Alexander Shulgin's legacy to both psychedelic culture and modern society-at-large, it is impossible to calculate the importance of the popularization of MDMA (Ecstasy) to the subsequent global rise of EDM music, other than the fact that for nearly thirty years the two have been virtually synonymous. (As was LSD and the sixties rock-n-roll revolution.) Neither can one ignore the fact that, thanks to his staunch libertarian views and the brave publication of *PIHKAL* a decade earlier, 2C-B became the psychedelic of choice for many in the early 2000s, while a number of other Shulgin creations, such as 2C-E, 2C-I, and DOC, also became prominent.

Breaking open the Pandora's box of psychedelic analogues ensured that the Second Psychedelic Revolution would not be dependent upon the same four compounds that started the first—mescaline, psilocybin, LSD, and DMT. Instead a veritable alphabet soup of new compounds, all based around the organic structure of these original classics, were now available. Today's psychedelic generation is equally familiar with compounds like MDMA, 2C-B, DOC, or 5-MeO-DMT as with LSD or magic mushrooms, and dozens of these analogue compounds are now common at festivals, raves, and on that uniquely twenty-first century marketplace, the Dark Web. While quality LSD has reappeared in psychedelic culture, and plant analogues have greatly increased in popularity, it is hard to imagine the growth and cultural success of either EDM or visionary culture over the past thirty years without the wide-variety of compounds that Alexander Shulgin discovered.

3

TERENCE MCKENNA

The Rise of the Plant Shaman

Metaphorically, DMT is like an intellectual black hole in that once one knows about it, it is very hard for others to understand what one is talking about. One cannot be heard. The more one is able to articulate what it is, the less others are able to understand. This is why I think people who attain enlightenment, if we may for a moment comap these two, are silent. They are silent because we cannot understand them. Why the phenomenon of tryptamine ecstasy has not been looked at by scientists, thrill seekers, or anyone else, I am not sure, but I recommend it to your attention.

TERENCE MCKENNA, *THE ARCHAIC REVIVAL*

Unlike the first Psychedelic Revolution, which was sparked primarily by LSD, and, to a lesser extent, by laboratory-produced mescaline, psilocybin, and DMT, the Second Psychedelic Revolution cannot be defined purely by synthetic drugs alone. The LSD drought of the early 2000s also rekindled interest in the traditional use of natural plant entheogens. This correspondingly accelerated interest in the previously little-known concept of *plant shamanism:* the idea that these plants were not psychedelic drugs, but plant teachers or spiritual medi-

24

cines, ideally administered by mysterious jungle physicians known as shamans.

The Shulgins' first volume, *PIHKAL: A Chemical Love Story,* focused on Alexander Shulgin's discoveries within the phenethylamine family of compounds, and while these include many true psychedelics such as mescaline and the numerous 2C compounds, it was his work with the popular empathogens MDMA and MDA that bought his work to the attention of the burgeoning rave culture of the early 1990s. The Shulgins' second volume *TIHKAL: The Continuation,* however, dealt with his investigations into tryptamines, the class of compounds that include important neurotransmitters such as serotonin and melatonin, powerful natural and synthetic psychedelic/entheogens including psilocybin, 5-OH-DMT, LSD, and ibogaine, and the only endogenous psychedelics, dimethyltrpytamine (DMT) and 5-Methoxy-DMT.

Long regarded as the Holy Grail of psychedelics, DMT was comparatively rare on the illicit drug market even in the 1960s, its scarcity adding to its fearsome reputation—Grace Slick, the singer for the Jefferson Airplane, once famously said that while acid was like being sucked up a straw, DMT was like being shot out of a cannon—and had effectively disappeared from general psychedelic culture long before *TIHKAL* was released in 1997. However, it was the publication of a pair of books earlier in the 1990s by Terence McKenna, a little-known author with no training in either organic chemistry or cultural anthropology, that would ultimately be most responsible for popularizing DMT in contemporary psychedelic culture. And while the methods of the sixties administered DMT either by intramuscular injection or by smoking it in its salt form, McKenna was primarily interested in DMT as the active psychedelic alkaloid in an obscure Amazonian shamanic admixture still commonly known at that time by its Spanish name *yagé,* rather than, as it is now, by the phonetic approximation of one of its many indigenous names: *ayahuasca.*

The Archaic Revival (a collection McKenna's essays and speeches) was published in 1992, followed by *Food of the Gods* (his magnus opus on psychedelic plants) in 1993. It had been nearly two decades since

Terence and his younger brother, Dennis, had written *The Invisible Landscape* (1975), a strange alchemical volume that recounts their 1971 expedition to the Amazon in search of *oo-koo-hé,* a shamanic snuff that contained DMT. (Terence was seeking a natural source for the synthetic DMT experience, with which, as both a linguist and a psychonaut, he had become utterly enthralled.)

While *The Invisible Landscape* did not remain long in print, it became something of a collector's item for psychedelic bibliophiles because of both the extraordinary tale of the expedition and the numerous radical ideas contained within its pages. (These included an early compilation of speculations about time and causality, which Terence would develop into his Novelty Theory, along with his prediction of the arrival of the *eschaton,* a singularity at the end of time, which he later calculated would occur in December 2012.) And although their journey has become perhaps the most famous psychedelic expedition of all time (retold later as *True Hallucinations,* Terence's last book), the McKenna brothers did not actually succeed in finding the DMT snuff that they were searching for. They did, however, find a species of highly psychedelic *Psilocybe cubensis* mushrooms, and, in a less recognized part of the McKenna story, brought the spores of these mushrooms back to the United States. They spent the next few years developing effective methods of indoor cultivation, the results of which they published in 1976 in the popular *Psilocybin: Magic Mushroom Grower's Guide.*

For these acts alone—the introduction of readily available plant entheogens that anyone could cultivate, and the first book on how to do so—the McKenna brothers would deserve a mention in any psychedelic history. But this would only be the beginning of extraordinary careers for both men. Dennis McKenna returned to university and has become a widely respected ethnopharmacologist, while Terence would become the most popular and recognized spokesperson for psychedelics since Timothy Leary.

Thanks to his writings and lectures, it is Terence McKenna who is most responsible for contemporary psychedelic culture evolution into its current state. The publication of *The Archaic Revival* and *Food of*

the Gods coincided synchronistically with the nascent years of both the internet and electronic music, and while Leary was a true early pioneer of the Web—he had one of the first websites, for example—it was McKenna who was enthusiastically embraced by the global rave culture as it continued to grow through the 1990s.

In the last years of his life (he died in 2000), Terence was the most popular speaker and main draw at the various conferences he attended, as well as a headlining attraction at the raves themselves. The self-declared "Mouthpiece for the Mushroom," McKenna had the rare ability to make a packed dance floor sit down between DJs and listen as he waxed eloquently about the wild beauty in the mystery of psychedelics, often for hours and hours on end. His extraordinary capacity for the spoken word and the discovery of a willing and captivated audience coincided with the internet revolution, and many in McKenna's audience were digitally sophisticated. (There is a longstanding relationship between the psychedelic, EDM, and cybercommunities.) Since his death these fans have produced a seemingly infinite number of recordings and podcasts (often accompanied by electronic music and visionary art) that have immortalized his words and philosophy. (After his death, Terence's spoken words also appear on one of the most popular psytrance tracks of all time "A new way to say Hooray" [2001] by the British duo Sphongle.)

Terence's unexpected death at the age of fifty-three also happened to coincide with the LSD drought of the early twenty-first century, and the period when many psychonauts were forced to consider new psychedelic options. Magic mushrooms, popularized by McKenna and his writings, became exponentially more and more important to psychedelic culture, while at the same time DMT, after being incredibly scarce for decades, reappeared with the publication of easy extraction recipes on the internet. Ayahuasca "ceremonies," which had first begun to appear on North American shores in the late 1990s (originally introduced by the Brazilian Santo Daime church, and then later by the first traveling South American shamans), also rapidly increased in popularity. McKenna's role as the main scribe of magic mushrooms, DMT, and

ayahuasca, along with his popularity within both the electronic music and cyber-communities, meant that his influence increased exponentially after he died. This process was also greatly amplified by his bold prediction of the arrival of the eschaton on December 21, 2012—a possibility for change that many in the nascent visionary community then seized upon.

Now, nearly two decades after Terence's death, and some years after the aftermath of the 2012 hope and hysteria that he helped create, there can be no denying McKenna's influence on contemporary psychedelic culture, or even on the fringes of popular culture itself. The hippie veneration of magic mushrooms, and the (often-debated) supposition that natural plant entheogens are inherently superior to synthetic compounds; the current interest in DMT in all its various forms, along with our concepts (and many of our misconceptions) about plant spirits and shamanism, and the corresponding rise of ayahuasca tourism; visionary culture's espousal of an archaic revival in order to reinvigorate spirituality in Western society; the commingling of psychedelics and virtual culture; the fascination with alien abductions and UFOs; and of course the viral spread of the meme of the impending 2012 eschaton—these are all now well-known themes that were either born from, or popularized by, Terence McKenna's ideas and interests, even though ironically he did not live to see either December 21, 2012, or very little of the shift that he had helped to create.

In the years following his death, the focal points of Terence McKenna's life's work have become, for better and for worse, something of a blueprint for the rise of a global neotribal, techno-shamanic culture, annually presented at Burning Man, BOOM!, and countless other transformational festivals around the world. McKenna's ideas have influenced psychedelic fashion, the music we listen to, the psychedelics we take (and the way we take them), the countries we visit, even the way we use the internet. His bold prediction of a singularity at the end of time in 2012 provided a modern coda to an ancient Mayan prediction and helped generate worldwide interest in what would have otherwise been an insignificant archaeological date. But now that we

are on the other side of his much-vaunted 2012 Omega Point and everything is still standing, it is Terence's championing and popularization of ayahuasca that remains most worthy of our attention.

Over the past two decades the rise in interest in ayahuasca has been extraordinary. Not since the original advent of LSD in the 1960s has there been a psychedelic that has so captured the artistic and spiritual imagination of the time. Ayahuasca use, while still nowhere near the levels of LSD use in the 1960s, has become common enough that it has started to penetrate the mainstream consciousness. (*Marie Claire*, a popular women's magazine, is the latest mainstream publication to include a feature article on ayahuasca circles.) Previously only known to psychedelic culture through the slim volume *The Yage Letters* by William S. Burroughs and Allen Ginsberg, published in 1963, it was largely Terence McKenna's popularization of this unlikely Amazonian shamanic brew that would promote the arrival of an international ayahuasca culture.

After the first Santo Daime church members and South American shamans visited Europe and the United States in the late 1990s, ayahuasca use spread rapidly throughout the global psychedelic community in the early twenty-first century—a process, as I have stated, greatly accelerated by the corresponding LSD drought, as psychonauts searched for new pathways to the psychedelic experience. There had also been a renewed interest in San Pedro and peyote, while smokable (salt) forms of DMT appeared in the underground marketplace for the first time in decades, thanks to plant-based extraction recipes that were made commonly available on the internet.

Prohibition, it could be argued, only results in diversification. A noticeable difference between the Second Psychedelic Revolution and the 1960s era is the incredibly wide variety of psychedelics and empathogens, both natural and synthetic, that are now widely available. Ayahuasca culture itself has in various ways begun to develop outside of the traditional psychedelic community. Syncretic Christian ayahuasca churches from Brazil (Santo Daime and União do Vegetal, or UDV, which use *hoasca*, the Brazilian form of ayahuasca, in their ceremonies)

now have branches in many countries, while many practitioners in the Western yoga community have also openly embraced ayahuasca. Independent yoga centers around the world frequently host South American shamans and their ceremonies, attracting many spiritual seekers with little or no connection to the psychedelic community, since they do not view ayahuasca as a psychedelic drug, but as a sacramental medicine.

While ayahuasca contains DMT, a Schedule 1 drug, ayahuasca use itself has (so far) not been prosecuted in the United States. Favorable federal court rulings in favor of the UDV and Santo Daime have been interpreted as a loophole in the law for many, and this has undoubtedly been a factor in ayahuasca's rapid and widespread rise in mainstream popularity. As more and more celebrities endorse their life-changing experiences with the Amazonian brew, and more and more psychiatrists and psychologists speculate on the therapeutic value of the experience, the rhetoric around ayahuasca increasingly resembles the tremendous excitement that LSD inspired before it was made illegal in 1966.

It is virtually impossible to quantify the psychedelic experience. Ayahuasca has gained a special reputation because of the intense colorful visions that it can induce, while the LSD pinnacle is generally represented as dissolution into the mystic's white light. When compared from a strictly phenomenological perspective, both have reputations for being able to induce heaven or hell, and both experiences are long and physically taxing. Both have been described as true entheogens, capable of inducing life-changing spiritual conversions; both originated as medicines (LSD was originally a legal medicine, Delysid), and both have been successfully used to break addictions; many of the extraordinary properties attributed to one—telepathy, an increase in everyday synchronicity, artistic and creative flowering, deeper connections with nature, mystical and transpersonal experiences—have also been attributed to the other, and both have had special communities that have formed around them.

So what is the difference between these two psychedelic revolu-

tions? Have we merely traded high dosages of a potent entheogen once manufactured in a Swiss laboratory for a natural equivalent haphazardly harvested from the Amazonian rain forest?

The difference, I would argue, lies not so much in the phenomenology of the internal psychedelic experience, but in the *external* container: the experience of the shamans and their singing of *icaros* (guide-songs), the ritual provided in the ceremonies themselves. When LSD use exploded in the mid-1960s, the first Psychedelic Revolution ultimately lacked a safe container for the experience. Too many unsuspecting young people slipped through the cracks of both the Prankster model and Leary's rhetoric, and in the aftermath, psychedelics themselves became illegal. What we learned from the first Psychedelic Revolution is that in the West, we lacked the mystery schools needed to successfully and beneficially integrate the use of psychedelics into our society. (This realization in many ways served to open of the door to Western culture's large-scale investigation into the practices of the East; today's yoga classes and meditation retreats come largely from the psychedelic use of fifty years ago.) Much of the evolution of contemporary psychedelic culture has been a process of investigating and integrating ancient wisdom and techniques, alongside the hard-won underground anecdotal psychedelic experience generated over the past sixty-plus years since the publication of Aldous Huxley's seminal work *The Doors of Perception* in 1954.

First looking for knowledge and direction in altered states of consciousness from the gurus and Rinpoches of India and Tibet, then from the shamans of the Amazon jungle, and now from a wide variety of traditional shamanism from numerous cultures, modern psychedelic culture has adapted to the entheogens on hand, moving back and forth between the laboratory and ancient plant traditions in search of the undiluted entheogenic experience. Terence McKenna's enthusiastic advocation of the shaman as a psychedelic spiritual guide (as opposed to a kind of homeopathic healer, which some would argue is closer to the truth) has resulted in tens of thousands of seekers traveling to Peru, Ecuador, and Brazil in search of that guidance, while in a corresponding

wave, South American shamans have arrived on foreign shores. This contemporary psychedelic phenomenon has inevitably spawned a horde of local imitators, which has unfortunately made *shaman* one of the most abused words in the modern vernacular. Sung ayahuasca icaros can now be found melded into electronic music, the woven versions of icaros are found transmuted into festival clothing, and the habit of attending ayahuasca circles has begun to approach a cult status in places as diverse as Asheville, Brooklyn, Los Angeles, Austin, Portland, New Orleans, and Santa Fe.

During this same period, academics studying ancient history and anthropology have had to reconcile with the fact that many of the world's major civilizations and religions—including the Greeks, Hindus, Buddhists, and virtually all of those in the Americas—utilized psychedelic plants. This idea has been extremely unpopular, but is now increasingly obvious to the generations of psychedelically savvy anthropologists and mythologists born since the 1960s, many of whom are familiar with Terence McKenna's writings.

It is increasingly academically recognized that ayahuasca and the tryptamine-heavy snuffs of the indigenous Amazonian tribes can be considered the last remaining sacramental entheogens of a great planetary era marked by at least five known distinctly entheogenic cultures, all of which lasted more than two thousand years. (I will discuss these in chapter 5.) Plant shamanism is now recognized to be the *primary* shamanic model worldwide, not a "vulgar substitute for [the] pure trance" of shamanic methods such as drumming and chanting, as Mircea Eliade originally asserted in his classic 1951 text *Shamanism: Archaic Techniques of Ecstasy*. Eliade himself changed his views at the end of his life, admitting to anthropologist Peter Furst in an interview not long before Eliade's death, that prior to the 1960s anthropologists didn't have enough of an entheogenic perspective to recognize the significance of psychedelics in tribal culture, and so the importance of psychedelics went unnoticed and unreported.

Terence McKenna was one of the first modern writers who really grasped the psychedelic history of humanity, recognizing the links

between magic mushrooms and ayahuasca and our own ancient past. His books have helped bring the beauty, myth, and magic of the Amazonian people and their culture to a far wider audience. Despite his association with the New Age 2012 phenomenon, and the unfortunate co-mingling with his championing of traditional plant entheogens, the introduction of a shamanic perspective to Western culture will ultimately be remembered as McKenna's enduring contribution to the world. Even his Stoned Ape Theory—the idea that spoken language evolved as our primate ancestors developed a diet that included psilocybin mushrooms—may one day be mainstream enough to be given serious consideration. His untimely death at the too-young age of fifty-three robbed the psychedelic movement of its most charismatic spokesperson, while the emerging technology of the internet, which he had enthusiastically embraced and where he will be remembered as one of the internet's earliest podcast stars, has since guaranteed his immortalization. Terence McKenna was a true original, and it is fair to say that despite how hard some may try, there will never be another like him.

4

ALEX GREY

The Mystic-Artist

My art has always been in response to visions. Rather than confine myself to representations of the outer worlds, I include portrayals of multi-dimensional imaginal realms that pull us towards consciousness evolution.

ALEX GREY

From what I can glean from Terence McKenna's writing, he was never that great of a fan of LSD; he certainly never gave it much thought after he discovered DMT, and then the organic tryptamines in psilocybin mushrooms and ayahuasca. Ken Kesey, by contrast, whom I have always considered the best authority on LSD and the sixties psychedelic culture that he helped create, very rarely ever mentions DMT in his writings at all. Close to his deathbed, Timothy Leary was asking for cocaine, but all anybody had was some DMT, which, Leary being Leary, he promptly smoked. When he returned from what was to be his last psychedelic experience, Leary said in some confusion that he had just met up with William S. Burroughs in heaven. (Burroughs was still alive at the time.) Burroughs himself even though his prose has become synonymous with opiates, was the original psychonaut-author, having written a book (*The Yage Letters*) about his travels to Colombia and Peru in 1953 in search

of yagé (ayahuasca) in an effort to break his opiate addiction, as well as being one of the first people to shoot straight DMT recreationally in the early sixties (an experience that terrified him so much that he wrote a letter to Timothy Leary warning him about the dangers of the drug).

By the time LSD came along and kick-started the first Psychedelic Revolution—with the enthusiastic help of Burroughs's close friend (and coauthor of *The Yage Letters*) Allen Ginsberg—Burroughs had apparently already seen enough. Because he was a notable non-participant in the sixties psychedelic revolution, choosing to witness it all from the sidelines with an amused and knowing eye, Burroughs's biographers have erroneously claimed that Burroughs "didn't like" psychedelics. Nevertheless, in an appendix to my book *Tryptamine Palace* (titled "William S. Burroughs: The Godfather of DMT") I argue that the inspiration for *Naked Lunch*, Burroughs's radical 1959 reimagining of the English novel, with its "non-linear narrative without a clear plot" (Wikipedia, "Naked Lunch"), fluid-excreting mugwumps, aliens, transforming typewriters, and other shamanic and psychedelic imagery, came from his yagé (ayahuasca experiences), and not from his opiate addiction, as most commentators assume. Similarly Burroughs use of the "cut-up technique"—an aleatory literary method, first used by the Dadists in the 1920s, in which a text is cut up and rearranged into a new text—was undoubtedly influenced by his decidedly nonlinear experiences while injecting DMT in the early sixties.

My point is that no two psychedelics are alike. One man's medicine can be another's poison; one man's heaven, another man's hell. An individual's biochemistry can be a very tricky thing, and if there is one thing that history has established, it is that there is no universal high or cure. The common ground in psychedelics lies in the actual experience itself—the "ultimate" mystical transpersonal experience being remarkably similar, regardless of the vehicle that takes you there, while the psychoactive compounds involved are merely different fingers that point at the same moon.

The four authors cited above—McKenna, Kesey, Leary, and Burroughs—all deserve special mention because they have been most responsible for translating the psychedelic experience to the outside

world. (Along with the singer-songwriters of the late 1960s who, after Bob Dylan, inherited the custodianship of the Beat Poet tradition.)

In a 1998 interview with Alex Grey published in *The Entheogenic Review,* the interviewer, Jon Hanna, pointed out that describing the psychedelic experience had until that point mostly been the territory of writers, since other than the poster and blotter art of the psychedelic sixties, few visual artists had openly admitted the influence of psychedelics upon their work. With the publication of *Sacred Mirrors: The Visionary Art of Alex Grey* in 1990, however, the psychedelic community soon discovered that the art contained within its pages seemed to many like miraculous snapshots of the psychedelic realm, faithfully rendered vistas brought back with great skill from the far shores of the visionary experience, while the essays that accompanied the paintings openly and rationally admitted the crucial influence of various psychedelics on the artist's inspiration.

When Alex Grey and his wife and fellow-artist, Allyson, first addressed the psychedelic community at the Mind States conference in Berkeley, California, in 1997, they discovered for the first time an enthusiastic audience to whom they didn't have to apologize for their own psychedelic use. Since this fateful encounter, Alex and Allyson Grey's influence on psychedelic culture has been unparalleled. After he was included in Terence McKenna's AllChemical Arts Conference on creativity (alongside the more famous visionary painter Robert Venosa) in 1999, the use of Grey's artwork by the album covers and stage shows of bands like Tool and the Beastie Boys greatly increased his exposure and popularity with youth culture. The tremendous popularity of his prints and art books, and his and his wife Allyson's live-painting appearances, along with the inclusion of his artwork in the actual Burning Man structure in 2006—less than ten years after his first West Coast appearance—has anointed Alex Grey as this generation's most important psychedelic artist.

Over the last two decades, the Greys have inspired and encouraged a whole new generation of classically trained and highly talented visionary artists (including Luke Brown, Carey Thompson, Android Jones, Amanda Sage, Michael Divine, Mars-1, Oliver Vernon, and

Adam Scott Miller), who have taken up the torch and become the new shock troops of the psychedelic experience. Working together in collectives, these younger artists often work alongside stage, lighting, and sound engineers to create psychedelic environments of considerable sophistication at (often remote) transformational festivals and other events around the globe, generally with a visionary art gallery (replete with live-painting) attached. At the same time the internet has provided the ideal vehicle to spread this inspired collective vision around the globe in the form of imagery for thousands of posters, stickers, clothing, CD covers, and websites.

While still painting (often live on stage at major events and festivals), Alex and Allyson Grey themselves have embarked on what is arguably the most ambitious psychedelic art project ever—the long-term construction of a chapel to house the Sacred Mirrors series and other important paintings as a pilgrimage site for visionary art and culture.

The underlying primary psychic reality is so inconceivably complex that it can be grasped only at the farthest reach of intuition, and then but very dimly. That is why it needs symbols.

CARL JUNG

In the earliest body of work that has established Alex Grey's special place in psychedelic history, the Sacred Mirror series manages to blend the physical realms of the human body—a feat in itself only achieved by many years of training in medical drawing—with the psychic energy fields and auras of the mystics and quantum physicists. In a synthesis that has come to the artist from years of meditation, study, and contemplation, human figures are stripped of their covering (what Alan Watts called "the skin encapsulated ego") to reveal a complex multicolored system of organs, bones, veins, and arteries that can be seen to be generating rainbow fields and crackles of pure white energy that penetrate the vacuum in every direction—an effect that could seem ghoulish were it not for the subjects' eyes, which gaze out at the

viewer with an often astonishing humanity, revealing them as the true windows of the soul.

Published in 1990, *Sacred Mirrors: The Visionary Art of Alex Grey* has now sold over 150,000 copies and has been translated into ten languages. The Sacred Mirrors series itself consists of twenty-one paintings that are to be viewed as a single experience. They are intended to serve as a kind of psychic map to reconnect us with the spiritual by stripping away the various layers—the biological, sociopolitical, subtle, and spiritual aspects of the self—to reveal the universal essence. Later Alex Grey paintings show these figures, complete with skeletons, veins, and aura fields, in the acts of prayer, dancing, loving, dying—all powerful visual metaphors that seek to integrate body, mind, and spirit. These paintings evoke the great mythologist Joseph Campbell's assertion that the human body is a "bio-organic field-generator," in which the body's major organs—the Hindu *chakra* system—generate a series of energy fields that combine into one singular field of consciousness that is the ego and essence of each human individual. Both mythology and great art often originate at the juncture of numerous competing and coalescing streams of thought, and Alex Grey's art has appeared at a time where modern scientific understanding is undergoing a radical paradigm shift, as we move away from the old Newtonian ideas about singular points in time and space (a human construct) to the realization that the universe is a series of interpenetrating fields being generated out of the quantum vacuum, and that all forces (including most likely consciousness) originate, and potentially operate, at this unseen quantum level. Grey's art is thus a powerful visual metaphor for a concept that is often difficult to grasp. It skillfully combines and integrates the familiar scientific vision with the ancient knowledge of akashic energies and aura fields, creating a kind of transmission of teaching or "enlightenment," even though the viewer often has no knowledge of the complex entanglement of meditations and philosophies that have resulted in the artist's singular view.

Technically, these paintings reveal great skill and years of training. Viewed from another perspective, they represent the hard-earned understanding of a significant philosophy, a concept so clearly

grasped that the artist is capable of transmitting that knowledge to others through the remarkable clarity of his vision. (Grey himself often describes his art as a "visual philosophy.") A stunning artistic achievement, and politically significant in these days of brutal prohibition because both Alex and Allyson Grey publicly and enthusiastically champion the use of psychedelics (or entheogens as they prefer), openly admitting that many of their artistic visions were delivered (some jointly) through the psychedelic experience. The most obvious example of the influence of the publication of the *Sacred Mirrors* art-book upon contemporary psychedelic culture is the fact that the entire modern genre of what was called "psychedelic art" in the sixties is now called "visionary art" by a growing number of artists, curators, galleries, and collectors.

Having taken the term "visionary art" from the writings of the mystic-artist William Blake, Grey was encouraged by his publisher, Ehud Sperling, to use the term in the subtitle of *Sacred Mirrors*. Exactly what categorizes visionary art, however, can be hard to define, and can mean a number of different things to different artists or groups. By (Alex) Grey's definition, it means any art that has arrived to the artist as a "vision." In addition, it generally implies a respect for the sacred or provides a glimpse into the mystical, and involves the stated or unstated belief that the art has arrived as a transmission from the Absolute or God, rather than being purely an invention of the artist. These visions can be obtained spontaneously, by meditation, or by the use of psychedelics.

While still not recognized or accepted by the traditional art world (Alex Grey has had few museum shows and is not represented by any major gallery), this still-nascent visionary art movement is undoubtedly the most vibrant and youth-driven form of art popular around the world today. It is quite happy to showcase itself at the events and festivals it helps create, notably at BOOM! in Portugal, whose gallery/museum is an important sales portal for emerging visionary artists, and at Burning Man, which is arguably the most significant development in the modern art world, and should itself be recognized

as the last art movement of the twentieth century and the first movement of the twenty-first.

After participating in Terence McKenna's AllChemical Conference on Creativity shortly before Terence's passing, Alex Grey has told me that he (and others) had felt the call to "step up and speak out about psychedelics" in order to occupy the obvious void in psychedelic culture created by Terence's premature departure. And one reason that Grey has become the most popular speaker on psychedelics since Terence McKenna—and perhaps the thing that separates him from other visionary artists—is the fact that there is a serious decades-old philosophy behind his work, and that he himself has been (and continues to be) one of the great students of psychedelic history.

The fact that Alex Grey was more than just a talented painter became obvious in 1998, with the publication of his book *The Mission of Art,* which revealed the extent of his underlying philosophies. (I describe Alex as a philosopher who uses painting as the main medium for explaining his philosophy.) Tracing the development of human consciousness though art and the role of the artist as a kind of lightning rod for the future, the cornerstone in Grey's philosophy comes from the assertion by the universal historian Arnold Toynbee (1889–1975) that the growth and decline of civilizations is a spiritual process, and that new civilizations arise to give birth to "better religions."

Proposing that the artist's creation process is a mystical link with the source of the creation of the universe itself, and that creating visionary art can be the foundation for a new world religion with psychedelics recognized again as sacraments, Grey is the first major psychedelic voice since the early 1960s to return the conversation about psychedelics back onto traditional mystical grounds. With the perspective of a longtime Vajrayana* practitioner, Grey's personal psychedelic philosophy diverges sharply from Timothy Leary's often politically inspired later

*Also known as the "thunderbolt vehicle," Vajrayana is a mystical school of tantric Buddhism, originally from fifth-century India, that became predominant throughout Tibet, Nepal, Bhutan, and Mongolia.

rhetoric, and equally from Terence McKenna's entertaining talk of self-replicating tryptamine elves and the mushroom spore as a spaceship, by rationally arguing that psychedelics are the most effective way for modern man to truly know God.

In the popular slide-show presentation that he and Allyson give to promote the construction of their Chapel of Sacred Mirrors, Grey traces psychedelic history back to the original cave painters, and he explains to his audiences that both psychedelics and art have been an integral part of the religious experience for thousands of years. He is the only speaker in the psychedelic community these days that has the power to hush a packed dance floor and make the audience willingly sit down, and their popularity has become so great that when he and Allyson appear at EDM festivals to live-paint and give their talk and slide show, they are often the headlining attraction (much like Terence McKenna before he died). For while Alex Grey's work is pretty much entirely outside of the mainstream art world, these days he may well be the most popular artist in America.

The ultimate test for that popularity will be the construction of the actual Chapel of Sacred Mirrors (CoSM) on land purchased by the CoSM Foundation in Wappingers Falls, New York, in 2008. (CoSM was granted church status that same year.) It is an ambitious project that will take many years to complete, and while both now in their sixties, the Greys remain undaunted in their task. Their project has already enjoyed some success: the Kickstarter campaign in 2013 for the construction of Entheon Hall, the first stage, was the second best-funded art project on the Kickstarter website ever, reaching 170 percent of its target and raising $210,000. (To learn more about the project, visit www.COSM.org.) Entheon Hall, which will showcase the *Sacred Mirrors* series, is scheduled to open in the spring of 2018.

Alex and Allyson Grey tend to talk of themselves as a team, and very much act as one. They have often shared visions that have become the foundation of their separate works. The inspiration for the Sacred Mirrors series came from Allyson, and the two artists constructed the elaborate frames for the paintings together. The inspiration for

the Chapel of Sacred Mirrors also came from a shared vision. Tireless advocates of both the importance of psychedelics to our society, and the need to have hope for our future, this message combined with the timeless power of their art, has made Alex and Allyson Grey both the psychedelic community's most popular speakers, as well as its most influential voice.

5

A SHORT PSYCHEDELIC HISTORY OF THE WORLD

Over the course of the past four chapters I have proposed that a new, Second Psychedelic Revolution has arisen phoenix-like at the end of the twentieth century out of the ashes of the original 1960s LSD-and-rock 'n' roll revolution, and that the foundations of this second revolution (new psychedelic analogues, organic tryptamines, techno-shamanic tribalism, and visionary art) have emerged from the published work of its three principal author-architects—the chemist Alexander Shulgin, the mycologist and philosopher Terence McKenna, and the mystic-artist Alex Grey.

Of course many other people have also contributed greatly to this process. They include Stanislav Grof, for his sustained examination of the transpersonal realms and its relationship to the human psyche; the ethnobotanist Jonathan Ott, who helped coin the term entheogen; Rick Doblin and his MAPS organization, who have almost single-handedly led the fight to get psychedelic research back into the universities, and Lady Amanda Feilding and the Beckley Foundation in England, and their collaboration of Professor David Nutt; Earth and Fire Erowid, for creating Erowid.org; Rick Strassman, M.D., for conducting the first DEA-approved psychedelic trials in the United States in over thirty years, detailed in his best-seller *DMT: The Spirit*

Molecule; Charles Grob, M.D., for his work with psilocybin and terminally-ill patients at the University of California (with Alicia Danforth); David Nichols, Ph.D., the former Chair of Pharmacology at Perdue University who co-founded the non-profit Heffter Research Institute upon retirement, and was the chemist who synthesized the DMT for Rick Strassman's study; Charles Grob and Dennis McKenna are also on the Heffter Board of Directors in the United States, along with Stephen Szára, the Hungarian-born psychiatrist and chemist who discovered the psychological effect of DMT, and later worked with Nobel-prize winner Julius Axelrod on the metabolism of DMT and related compounds in healthy and schizophrenic volunteers at the (U.S.) National Institute of Drug Abuse; Roland Griffiths, the Professor of Psychiatry and Neurosciences in the John Hopkins University School of Medicine, who has notably repeated Walter Pahkhe's 1962 Marsh Chapel experiment from Harvard (perhaps the most important event in psychedelic academia since Timothy Leary's original tenure), with stricter protocols; Franz Vollenweider, M.D., one of Europe's leading neuroimaging experts, who is the director of the Heffter Research Center Zurich for Consciousness Studies (HRC_ZH); and James Fadiman, Ph.D., the co-founder of the Institute of Transpersonal Psychology, who after nearly fifty years of underground psychedelic therapy has sparked the growing microdose movement with the publication of his book *The Psychedelic Explorer's Guide: Safe, Thereaputic, and Sacred Journeys.* There is also a new psychedelic generation emerging, with visual artists such as Android Jones, Luke Brown, and Amanda Sage creating their own global followings, and authors like Rick Strassman, Jeremy Narby, Daniel Pinchbeck, and myself contributing to the psychedelic conversation.

Other factors greater than any individual have also been involved. As has been previously mentioned, the emergence of the internet has had an unparalleled influence on the emergence of a contemporary global psychedelic culture due to the unfettered sharing of music, imagery, and information. Webzines such as Reality Sandwich have also evolved into viable social platforms, publishing information relevant

to these emerging communities; a large portion of which would not be published anywhere else.

The idea of a Second Psychedelic Revolution is an evocative one, because it hints at the possibility that the first revolution did not entirely fail. But in truth, these psychedelic revolutions were neither the first nor the second. Anthropologists and historians are now realizing that psychedelic revolutions—psychedelic transformations might be a better term—have occurred at numerous other times throughout human history, and may have been essential to the development of our planetary culture.

Humanity has two histories: the short history, produced after written language was developed, and the vast unknown history of the oral traditions that preceded it during an era that many tribes describe as "the Great Forgetting." How language evolved to separate us from all other life by giving us the ability to store and transmit one generation's combined knowledge to the next remains one of the great mysteries of our existence. Time moved much more slowly before written language, and great traditions such as those of the cave painters continued uninterrupted for tens of thousands of years—a process almost inconceivable in this modern age.

What we currently believe, however—thanks in part to the hard science of the Human Genome Project—is that at some point somewhere around 70,000 years ago, the ancestors of our modern humanity were in deep trouble. Forced by sub-Saharan desertification out of their formerly well-forested environment in southeast Africa (the original Lost Garden), these early humans existed as scattered small tribes—with a total population as low as a few thousand—scavenging along the land bridge between Africa and western Asia, precariously perched on the verge of extinction.

Something quite incredible then happened, spurred by some deep unknown catalyst for a new kind of evolution never seen before. One small wavelet of *Homo sapiens,* numbering perhaps as few as a thousand, the direct genetic ancestors of all the non-African races, migrated into western Asia in a revolution of behavior that anthropologists

believe included more sophisticated tools, wider social networks, and the first art and body ornaments, known as the Cognitive Revolution. This is the moment that *Homo sapiens* made its radical break from the other hominids, and began to exhibit the fully modern behavior of complex art and toolmaking. Language and religion also probably began to rapidly evolve at this juncture, as man embarked on his relatively short march to dominate the planet as no other species has ever done before.

The mycologists R. Gordon Wasson and Terence McKenna both proposed that the spark that caused early *Homo sapiens* to first conceive of God and language was the accidental consumption of psychedelic psilocybin mushrooms, which would have been ubiquitous in the dung of primitive cattle. (According to McKenna, the Great Horned Goddess of the oldest Neolithic cults represents that link between cattle, mushrooms, and the first religion.) This theory is practically unprovable (as are most theories about our ancient history) but it is certainly worth noting that many of the strange T-shaped carved pillars at the temple complex of Göbekli Tepe in Anatolia (in modern Turkey)—founded in the tenth millennium BCE and now believed to be the oldest temple in the world—certainly resemble mushrooms, while ancient cave paintings (5000 BCE) of hominoids with mushrooms coming out of their torsos have been found on the Tassili plateau of northern Algeria.

From more than a century of anthropological studies, we now know that the primary spiritual practice employed by primitive hunter-gather societies is a variety of forms of shamanism—the practice of using altered states of consciousness to mediate with the spirit world. While our use of the word comes from the native Siberian (Evenki) word *šaman,* meaning literally "one who knows," the practice of shamanism was widespread throughout the planet, and especially in Africa, Asia, and the Americas. The vast majority of shamanic practices involved the sacramental use of psychotropic plants. (Other techniques, such as fasting, drumming, and chanting are now thought to have developed in areas where such plants were rare or unavailable.)

In the Amazon basin, one of the few areas where traditional

hunter-gatherer societies still exist, these tribes continue to utilize a staggering array of psychotropic plants and plant admixtures, including potent DMT- and 5-MeO-DMT–containing snuffs (*yá-kee, yopo, epéna, paricà*) and the now-legendary jungle brew known by its phonetic approximation, ayahuasca. A burial site in northern Chile that dates back to the eighth century included a bag with snuffing paraphernalia and snuff remnants containing DMT and 5-MeO-DMT, while snuff use in the Amazon Basin is believed to be at least two thousand years old, and almost certainly predates the invention of ayahuasca. (According to ethnobotanist Jonathan Ott, experimenting with the mixtures of the snuffs led to the discovery of the complex relationship between the MAO-inhibitors in the ayahuasca vine and the DMT- and 5-MeO-DMT–containing admixtures that allowed for the later discovery of ayahuasca—a highly plausible theory.)

Six thousand years older than Stonehenge, the uncovering of Göbekli Tepe (in 1996) is considered one of the most important discoveries of modern archaeology. The construction of Göbekli Tepe predates metallurgy, the wheel, or the invention of writing, and is even older than the invention of agriculture or animal husbandry during the so-called Neolithic Revolution. This makes it of particular interest because it is believed to have been built by a hunter-gatherer society that only occupied it sparingly. Thus it was actually more of a temple than a city—upending the belief that the establishment of sedentary farming communities was responsible for the first monumental edifices. Its elaborate construction and carvings—an incredible feat for nomadic peoples utilizing Stone Age technologies—indicates that hunter-gatherer societies had clearly developed significant religious philosophies and practices, so much so that that the first house that humanity built was for the gods. As excavator Klaus Schmidt observed, "First came the temple, then the city" (Schmidt, "Zuerst kam der Tempel, dann die Stadt").

Over the following millennia, as the history of humanity moved out of the wilderness and into the towns and cities, so too apparently did our entheogen use, and at least four major sustained entheogenic cultures are now known to have existed:

- In Mexico, a remarkable number of entheogenic cults existed within the great Meso-American cultures that arose there. The great varieties of psychoactive plants were venerated as gods, and are commonly found in art and carvings in Toltec, Mayan, and Aztec temples. The substances included psilocybin mushrooms, *ololiuqui* (morning glory) seeds containing LSD-like compounds, and even possibly toad venom, containing 5-MeO-DMT. Carbon dating now indicates that the use of mescaline-containing peyote in North America goes back at least 5,700 years.

- In Peru, a significant culture arose around the sacramental use of the mescaline-containing *Trichocereus pachanoi,* now commonly known as San Pedro cactus, after the Spanish tried to suppress its use after their conquest (San Pedro [St. Peter] was believed to hold the keys to heaven, as did anyone who drank from the cactus). This culture peaked with the construction of the Chavín de Huantar temple complex in 1300 BCE. Nestled in a verdant valley just above the Amazon basin on the eastern slope of the Cordillera Blanca, the highest chain of mountain peaks in Peru, the beautifully preserved Chavín de Huantar houses a sophisticated tunnel system (replete with water drains and air shafts for ventilation) that takes one under the main temple complex and through a labyrinth that opens into a chamber with a fifteen-foot-high granite carving of a fanged deity, the chief god of Chavín, the Lanzon.*

 San Pedro cactus grows in large clumps all around the temple complex, while the half-moon-shaped amphitheater at the entrance of the tunnels, with its fire pit, clearly seems to have been built with shamanic intent. The remarkable Chavín civilization conquered other Andean societies without warfare; they simply brought the chiefs and priests of other Andean tribes to

*This floor-to-ceiling carved pillar looks like something the visionary artist Luke Brown might sculpt. Chavín is also the location of a large carving that Erich Von Daniken made famous of what looks like an astronaut in a space capsule—all carved in stone without metal tools.

Chavín de Huantar, filled them up with a brew made from the mescaline-cactus, and then led them into the underground labyrinth. By the time the stunned participants emerged back into the sunshine on the other side of the temple, they were apparently convinced enough of the superiority of Chavín's shamans that they simply joined them. Chavín's influence became widespread across Peru, producing the first recognizable Andean art style. The Chavín civilization, with its incredibly sophisticated stone carvers, is considered to be the origin of the stone construction techniques that the Moche, Inca, and other Andean societies later used in their own temple building. The sacramental use of the San Pedro cactus has remained a continuous tradition in Peru for over three thousand years, and continues today in a much-diluted syncretic-Christian form.

- In the Indus Valley, the mixing of proto-Indo-Iranian people with the Aryan invaders from the north created the Vedanta, the most important of the six philosophical schools (darshans) that are the foundation of what is commonly called Hinduism. These Aryan invaders brought with them the Rigveda (which dates back to at least 2000 BCE), a collection of 1,028 hymns that is considered to be one of the oldest religious texts on the planet. One hundred and twenty of these verses are devoted to the praise of a plant/god called soma, the ritual use of which was an integral part of early Vedic religion. Cognate to the Vedic word *soma* is *haoma,* an Avestan word for a plant sacred to the Zoroastrians. Both words are thought to be derived from the proto-Indo-Iranian word *sauma.*

"We have drunk Soma and become immortal; we have attained the light the Gods discovered" (Rigveda, 8.48.3). Verses such as this indicate that soma was clearly an entheogenic plant, although its identity and method of preparation were eventually lost. Various plants have been suggested, with varying entheogenic potency, including ephedra (Aitchison, 1888), the fly agaric mushroom (Wasson, Hofmann), Psilocybin cubenis mushrooms (McKenna), and white lotus and cannabis preparations, but no definitive

identification has yet been made. Nonetheless, the importance and influence of this mysterious soma on the writing of the Rigveda—the oldest known religious text in the Indo-European languages—and the later development of the Vedanta (which is based on the study of the Vedas) cannot be denied. Alfred North Whitehead described the Vedanta as "the most impressive metaphysics the human mind has conceived," and according to the eminent religious scholar Huston Smith, "the Vedas derive, more than from any other single identifiable source, from Soma."

- The fourth great entheogenic culture, and the one that should be of the greatest interest to us in the West, is increasingly believed to have been ancient Greece, the philosophical bedrock from which, ironically, our own reductionistic scientific (and anti-entheogen) beliefs have grown.

ENTHEOGENS AND THE WEST

For among the many excellent and indeed divine institutions which your Athens has brought forth and contributed to human life, none, in my opinion, is better than those [Eleusinian] mysteries. For by their means we have been brought out of our barbarous and savage mode of life and educated and refined to a state of civilization; and as the rites are called "initiations," so in very truth we have learned from them the beginnings of life, and have gained the power not only to live happily, but also to die with a better hope.

CICERO, *Laws* 2.19.36.

Eleusis, a small town fourteen miles from Athens, was the site of an ancient temple to Demeter, the Greek goddess of nature and agriculture, whose initiation rites became known as the Eleusinian Mysteries. Held annually for over two thousand years, these mysteries were considered the pinnacle of Greek culture: the majority of Greek writers and philosophers—including Socrates, Plato, Plutarch, Aristotle,

and Sophocles—and later Roman emperors and philosophers, such as Hadrian, Marcus Aurelius, and Cicero, were all included among its initiates. An indication of the great importance of Eleusis to Greek society is the fact that when the Romans arrived, the only road in central Greece greater than a goat path was the road from Athens to Eleusis—called "the Sacred Way"—that the initiates walked each year.

Designed "to elevate man above the human sphere into the divine and to assure his redemption by making him a god and so conferring immortality upon him" (Nilson, "The Religion of Eleusis"), the Greater Mysteries were held in late summer each year and lasted for ten days. After candidates purified themselves in the sea at Phaleron, fasted, and then participated in the ritual procession to Eleusis, the great mystical revelation came after the initiates drank a special drink of barley and pennyroyal called *kykeon,* and then entered the great underground hall called the *telesterion,* where the true nature of the Mysteries were revealed.

This much we know; but since revealing the Mysteries themselves to the uninitiated was punishable by death, we do not know a great deal more, other than certain sacred objects were revealed by the hierophants (temple priests and priestesses), and that there was some kind of a grand ritualized performance, often said to involve fire. According to Proclus, who is often described as the last great Greek philosopher, the performance of these Mysteries "cause sympathy of the souls with the ritual in a way that is unintelligible to us, and divine, so that some of the initiates are stricken with panic being filled with divine awe; others assimilate themselves to the holy symbols, leave their own identity, become at home with the Gods and experience divine possession."

The Mysteries retold the ancient myth of Demeter and her virgin daughter, Persephone, who was abducted by Hades, the Lord of the Underworld. As Demeter searched ceaselessly for her missing daughter, she stopped performing her task of maintaining the Sacred Law, the uninterrupted cycle of life and death. The seasons halted, and all life began to wither and die. Faced with the extinction of all living things, Zeus sent his messenger Hermes to the underworld to bring Persephone back. Upon her departure, however, Persephone broke her fast with either

four or six pomegranate seeds. By a rule of the Fates, this act bonded her to Hades and the underworld for four (or six) months a year. Persephone's return to her mother each year coincides with the arrival of spring.

Western scholars have for centuries identified the Eleusinian Mysteries with Demeter's role as the custodian of the seasons and as the goddess of agriculture. In her search for Persephone, Demeter became tired, and rested for a while at the palace of Celeus, the king of Eleusis, where she nursed his sons, Demophon and Triptolemus. It is to Triptolemus that Demeter taught the secrets of agriculture, giving humanity the gift of planting and growing grain.

That gift, however, came at a cost; Demeter's original intent had been to bestow the gift of immortality upon the boy Demophon, but she was interrupted by his mother. Agriculture thus was our consolation prize for losing immortality, for freedom from the cycle of life and death, and any real understanding of the Eleusinian Mysteries must acknowledge that these two themes are irrevocably entwined.

A scholar with a more entheogenic perspective will also notice an obvious mirroring of this myth of Persephone's descent, and then return, from the underworld—her journey mimics the most central shamanic requirement, the psychospiritual death and rebirth of the shaman on their own journey to-and-from the spirit world. This is one of the most common characteristics of shamanism worldwide—the idea that the shaman dies and then is reborn with new knowledge (immortality lost but rewarded).

Judging by the lasting power of the Eleusinian Mysteries, it seems obvious that that some kind of an external mystical-shamanic agent was involved. Commentaries on the Mysteries describe reactions ranging from extreme terror to blissful awe. Pindar, the greatest lyric poet of ancient Greece (here quoted by Clement of Alexandria) said of the Mysteries, "Blessed is he who, having seen these rites, undertakes the way beneath the Earth. He knows the end of life, as well as its divinely granted beginning," while one initiate remarked, in a commentary that would be familiar to any 5-MeO-DMT initiate today: "I came out of the mystery hall feeling like a stranger to myself" (Sopatros *Rhet.Gr.* 8.114).

The knowledge of the preparation of kykeon was lost when the era of the Mysteries finally ended, but numerous candidates have been suggested for as its psychoactive component, including psilocybin and amanita mushrooms, opiates (one of the symbols of Demeter is the poppy, which grew wild in the fields of grain), DMT-containing *Phalaris* grass, or some kind of acacia with Syrian rue. The most compelling theory (forwarded by Albert Hofmann, R. Gordon Wasson, and Carl Ruck) argues that kykeon was made from ergot-parasitized barley grain that contain LSA, an alkaloid that is a precursor to LSD and ergonovine. (Demeter was the goddess of grain.)

The importance of Greek thought to our Western culture is considered irrefutable. The philosopher Alfred North Whitehead once noted: "The safest general characterization of the European philosophical tradition is that it consists of a series of footnotes to Plato" (*Process and Reality,* 39). Clear, unbroken lines of influence lead from the two thousand years of Greek philosophy to early Islamic philosophy, and on to the European Renaissance and the Enlightenment. Greek philosophy made the critical break from understanding the world from a purely mythological perspective to a sustained examination of our environment based on reason. Pre-Socratic philosophers strived to identify the single underlying purpose of the entire cosmos, and their legacy was the initiation of the quest to identify the underlying principles of reality; the origin of our Western scientific rationalism begins there.

Greek philosophy's quest, however, was ultimately mystical, an attempt to reconcile physical laws with the presence of spirit or *pneuma*. For the Greek school known as the Stoics, pneuma is the active, generative principle that organizes both the individual and the cosmos. In its highest form, pneuma constitutes the human soul (*psychê*), which is a fragment of the pneuma that is the soul of God (Zeus). As a force that structures matter, it exists even in inanimate objects. To the Stoics, nothing in the world had an independent existence from this pneuma (also called the *logos*).

Sometimes described as an "ether," the pneuma/logos is similar to the Hindu concept of akasha, and considering the importance of the Eleusinian Mysteries to the Greek philosophers and the importance

of soma to the Vedic philosophers, one has to wonder if some kind of entheogen was not involved in this mystical realization of an etheric and transpersonal nature of reality. As Albert Hofmann puts it: "If the hypothesis that an LSD-like consciousness-altering drug was present in the kykeon is correct—and there are good arguments in its favor—then the Eleusinian Mysteries have a relevance for our time in not only a spiritual-existential sense, but also with respect to the question of the controversial use of consciousness-altering compounds to attain mystical insights into the riddle of life" (from the afterword to *The Road to Eleusis* by R. Gordon Wasson, Albert Hofmann, and Carl P. Ruck).

By the time the Roman emperor Theodosius closed the sanctuaries at Eleusis in 392 CE, the Mysteries had reputedly lost some of their power, with the sacred kykeon having been served at profane parties in Athens (one piece of evidence that kykeon was most likely psychoactive). The last remnants of the Mysteries were wiped out in 396 CE, when Alaric, king of the Goths, invaded accompanied by Christians "in their dark garments," bringing Arian Christianity and "desecrating the old sacred sites" (Kloft, *Mysterienkulte der Antike*). With the end of the Eleusinian Mysteries, for the following fifteen hundred years, unlike most other cultures in the world, the Christianity that evolved in Europe had no obvious entheogenic influences at all, and our spiritual life became dependent on obedience, fasting, and prayer.

THE FIFTH ENTHEOGENIC AGE?

While the European Renaissance was later sparked by a rediscovery of Greek thought, the absence of entheogens in the European worldview continued until the end of the nineteenth century. This situation only changed in 1897, when mescaline was first isolated and identified by German chemist Arthur Heffter, and then radically again in 1918, when mescaline became the first psychedelic synthesized (by the Austrian chemist Ernst Späth).

One theme that continues to fascinate me about contemporary psychedelic culture is the fact that our chemistry, our anthropology, our

interest in psychology, and our spiritual curiosity, all evolved to a point at the beginning of the twentieth century when they became increasingly intertwined. Mescaline, for example, was isolated after Western intellectuals became interested in the phenomenon of the "native peyote inebriation" of the peyote cults of the Indians of the southwestern United States and northern Mexico. In 1887, the pharmaceutical firm Parke-Davis and Company distributed dried peyote (obtained from Mexico) to interested scientists. The first account of "nonnative" peyote inebriation was published in 1897 by the American physician and novelist Weir Mitchell. Mitchell then sent peyote buttons to the British author Havelock Ellis, whose accounts of his own experiments caused considerable scientific interest when they appeared in the *British Journal of Medicine* in 1898.

Mescaline was also first isolated by Arthur Heffter in 1897. Heffter's scientific curiosity was so great that he discovered mescaline by systematically ingesting a number of alkaloid "fractions" isolated from the peyote himself until he identified which one was psychoactive. (Making Heffter the first modern psychonaut.) Once mescaline was successfully synthesized in a laboratory in 1918, scientific interest (rekindled with the end of the First World War) shifted to the pure compound instead of peyote. In 1927, Dr. Kurt Beringer, a friend of Herman Hesse and Carl Jung, published a 315-page study entitled *Der Meskalinrausch* (The mescaline inebriation). There are some reports of mescaline use in the late 1920s and early 1930s among artists and other curious intellectuals (Jean-Paul Sartre, for example, took mescaline in 1935; it is also mentioned in the introduction to Jung's legendary *Red Book*) but these informal experiments were interrupted by the outbreak of World War II in Europe. Investigation into compounds like mescaline was carried out both by the Nazis and the Allies, and, after the war, by the CIA's MK-ULTRA program.

In the early 1950s, the British psychiatrist Humphry Osmond began to examine the properties of mescaline in his research on psychosis and schizophrenia. It was Osmond who administered mescaline to Aldous Huxley in Los Angeles in 1953. Huxley's subsequent ten mescaline experiences would be the basis for his book *The Doors*

of Perception, published in 1954, still considered the most influential book on psychedelics ever written.

Meanwhile, in the great wave of chemical discovery at the beginning of the twentieth century, DMT had been synthesized in 1931 (although its psychoactive effects would not be recognized until 1956 by the Hungarian chemist and psychiatrist Stephen Szára), and in 1938, Albert Hofmann, a Swiss chemist employed by the pharmaceutical company Sandoz, invented lysergic acid diethylamide (LSD-25), the most powerful (by dosage) psychedelic known to man. The psychoactivity of this compound was at first unrealized and might have remained unknown had Hofmann not had a "strange premonition" to reexamine the compound in 1943 (as Hofmann described in many writings and conversations over the years). After accidentally dosing himself when a small amount of LSD landed on his skin, Hofmann repeated the experiment by willfully ingesting 250 micrograms of LSD on April 19, 1943. The drug's psychoactive properties became so overwhelmingly obvious that Hofmann was forced to ride his bicycle home with his lab assistant (due to wartime fuel rationing) convinced that he was about to die. (Each year the psychedelic community commemorates this event on Bicycle Day: April 19.)

The rest, as they say, is history, but Hofmann's discovery was central to modern psychedelic culture. While there have been numerous plant entheogens in history and other powerful synthetic psychedelics have since been invented, there had never been an entheogen of which a competent chemist could make a million hits in an afternoon. When LSD appeared in popular culture in full force in the mid-1960s, it was the perfect psychedelic for the job—laboratory-produced and packaged, first as pressed pills or as a liquid on sugar cubes, and then later on brightly printed sheets of blotter paper, LSD epitomized the space-race-driven scientific frenzy of the sixties in a way that ancient plant-entheogens like peyote, psilocybin mushrooms, or ayahuasca would have never been able to, and its appeal was instantaneous. Its invention introduced an estimated 30 million people to the psychedelic experience between 1960 and 1990, and has changed the cultural and spiritual landscape

in the West more than any other identifiable modern influence (except perhaps television).

The synthesis and invention of psychedelic compounds in our laboratories is the unique contribution of Western culture to the psychedelic history of the world, a development that is now almost a century old. Modern psychedelic history, I would argue, begins in 1897, with Arthur Heffter's extraction of mescaline from the ancient peyote cactus by modern chemistry (and the synchronistic publication of Weir Mitchell's first psychonaut account), and then made the evolutionary leap into pure synthesis in between the two World Wars in 1918. Everything since—from the early curiosity of artists and intellectuals in the 1920s and 1930s; the Nazi experiments during World War II; the American MK-ULTRA programs of the 1950s onward; the interest in mescaline, LSD, and DMT by psychologists and psychiatrists since the mid-1950s; the publication of Huxley's *The Doors of Perception* in 1954; Stephen Szára's discovery of the effects of DMT in 1956, and R. Gordon Wasson's discovery of the Mexican mushroom cults reported in *Life* magazine in 1957; Timothy Leary, and the Merry Pranksters, and the cultural upheaval caused in the mid-sixties by the counterculture's enthusiastic embrace of the psychedelic experience; the anthropological reassessment of human history that began in the 1970s as we have increasingly had to recognize the role of traditional entheogens in our cultural development; the controversial discovery of endogenous entheogens in late 1970s; the rise in popularity of empathogens and the Acid-House culture of the late 1980s; the chemical analogues of the research chemical companies of the 1990s; the worldwide rediscovery of powerful plant entheogens in the early twenty-first century; Burning Man, BOOM!, and this latest twenty-first-century visionary culture that continues to evolve from the work of Alexander Shulgin, Terence McKenna, and Alex Grey—these are all entheogenic milestones in this contemporary societal evolution. Viewed from this perspective, one realizes we may well be a century into the establishment of mankind's fifth great entheogenic age. This statement raises the obvious question at this critical juncture in human history: Why?

6

A NEW EARTH?

The Dawn of the Visionary Age

I share the belief of many of my contemporaries that the spiritual crisis pervading all spheres of Western industrial society can be remedied only by a change in our worldview. We shall have to shift from the materialistic, dualistic belief that people and their environment are separate, toward a new consciousness of an all-encompassing reality, which embraces the experiencing ego, a reality in which people feel their oneness with animate nature and all of creation.

ALBERT HOFMANN, FOREWORD TO
LSD: MY PROBLEM CHILD

Psychedelic history and philosophy are both enormous, virtually neglected, fields of scholarship, and there are days where I feel as if I could write endless volumes about various complex facets of the psychedelic experience, since any attempt to summarize the importance of psychedelics to our contemporary situation within the confines of a single essay is somewhat doomed to generalizations. However, I have managed to come to some definitive conclusions of my own about both the practical use of entheogens and the ultimate purpose of their reappearance in contemporary Western culture.

PSYCHEDELICS AND THE SELF

There are four main beliefs about psychedelics that have become the cornerstones of my own personal entheogenic philosophy and that I now regard as proven facts.

The first of which, at the risk of stating the obvious, is that the most practical application of psychedelics in this day and age is as a tool for examining differentiated states of consciousness and ultimately for investigating the basis of consciousness itself.

This was the promise of psychedelics that first created such tremendous interest within the scientific community before research was effectively banned in the early 1970s. This was also the same aspect of psychedelics that first fascinated experienced spiritual seekers like Aldous Huxley and Alan Watts in the 1950s, who both declared that a single session on psychedelics had taught them more than decades of meditation. (Meditation, which in that period was an avant-garde pastime, was then considered to be ultimate tool for the examination of differentiated states of consciousness.)

The second is that the "ultimate'" psychedelic experience is the still relatively rare transpersonal experience—the blissful realization of the Oneness of all things—and that this transpersonal experience is often identified (by some, not all) as a recognition of the sacred nature of existence, a merging with Source. With the right set, setting, and psychedelic, an untrained individual can experience a very different reality by merging with a state of consciousness remarkably different to the one that we normally occupy. Upon returning to our normal state of consciousness, we generally lack the vocabulary to describe the experience, and often all one can do is meditate in silent, wide-eyed awe and astonishment upon that Mystery of mysteries.

The third belief is that this entheogen-induced transpersonal experience is indistinguishable from the classical mystical experience of union-with-Source and should be regarded as the same experience.

Before the reemergence of the psychedelic experience in Western culture at the end of the nineteenth century, mystical states of

consciousness were considered rare, and were generally accompanied by severe austerities or even obvious psychosis, while the majority of mind-altering compounds available to European society generally offered only a consciousness-numbing inebriation or narcosis. For the traumatized generation emerging from the sophisticated horrors of two consecutive world wars, the search for the white light of the mystical experience became something of an intellectual Holy Grail, a potential escape hatch from the existentialist crisis into which Western civilization had fallen.

Although Huxley's book *The Doors of Perception* has gained considerable notoriety in the decades that have followed its publication in 1954, because of the now-illegal nature of mescaline and the experiences that it promotes, people tend to forget that at the time of the book's publication Huxley himself was regarded as one of the world's great intellectuals and the preeminent Western expert on the mystical experience. His book *The Perennial Philosophy,* published in 1945, is still considered to be the classic work in comparative mysticism. (I cannot recommend this book highly enough. Anybody interested in entheogens should read it, even though it does not mention these substances at all, having been written before Huxley was introduced to mescaline.) It was Huxley's enthusiasm for psychedelics as a genuine tool for spiritual self-examination and personal growth that generated such interest for the generation that experienced the horrors of World War II and for the generation born directly after it.

The most convincing part of my own transpersonal experiences—and I believe that this is the same for all "full-blown" mystical experiences—is the remarkable experience of becoming Consciousness-without-identity. That is to say, a part of me is able to merge and identify with Source/Ultimate Reality, but in doing so "I" have no idea that "I" exist or ever existed. I, James Oroc, human, earthling, that complex amalgamation of cells and particles that seems to contain consciousness, ceases to be anything more than a vague and distant memory of some unimportant shadow of drifting stardust, revealing the unimaginably greater Creator Consciousness that interpenetrates all things.

It was the unexpected experience of this state of consciousness

outside of time and space (sometimes called Universal Mind, or God-consciousness) that shattered not only the bedrock of most of my scientific-rationalist beliefs, but even my rabid atheism. After this experience I could no longer believe that consciousness originated from within the physical body, but was in fact a universal field that our brains and bodies accessed. Since this first experience, I have become convinced that evolution itself is consciousness-driven. (Which is to say that rather than the scientific-rationalist view that consciousness is an accidental epiphenomenon of matter, consciousness is in fact the primary driving force of existence: a possibility recently promoted by Robert Lanza, one of the world's top scientists, in his controversial book *Biocentrism*.) Furthermore, evolution is the history of matter organizing itself into more complex forms so that this Universal Consciousness can evolve into more coherent ways of knowing itself. This philosophy, as I have also come to discover, has been expounded in various forms by mystics since the beginning of human time.

This shattering of my belief system after my unexpected and unwanted mystical experience led to the greatest intellectual adventure of my life—the reconstruction of a worldview that could make sense of my new convictions, a journey that would ultimately be related in my book *Tryptamine Palace*. One of the things I believe that makes *Tryptamine Palace* unique amongst contemporary psychedelic literature is that within its pages I not only offer some complex theories about the very basis of the entheogenic experience but I actually present a model—based on neural Bose Einstein Condensates and the holographic nature of the quantum zero point field—that I believe can explain the mechanism of the transpersonal-entheogenic experience within the far boundaries of current cutting edge science. However, rather than revisiting these ideas in depth I would rather examine in greater detail some of the concepts that have evolved for me since the publication of *Tryptamine Palace*.

The most important of these—and one that came about directly from the recognition of consciousness without identity—was the realization that I had experienced ego death, and that the Ego itself, something

that had only been a philosophical concept to me prior to that experience, had been revealed as a very real state of consciousness and potential entity.

There is a moment at the peak of the transpersonal experience (on 5-methoxy-DMT) when it has all become too much, the moment when even Universal Consciousness feels as if it will shatter in awe from what it is experiencing as it dissolves back into the *mysterium tremendum,*[*] right on the edge of what feels like no coming back. It is at that peak moment that the questions appear that bring *you* back; the moment when a voice asks, "How is this is possible? How long has this been happening?" And then the clincher, "Who am I?"

With this last question, the ego swiftly delivers "you" back to your body, which is usually collapsed in a confused heap upon the bed or floor. From these experiences I have come to believe that this is perhaps the most practical application of personal psychedelic use—to recognize that the ego does exist, by experiencing how its momentary disruption can result in a greater connection with Source.

The Role of the Ego

A human being is a part of the whole called by us "universe,"
a part limited in time and space. He experiences himself, his
thoughts and feeling as something separated from the rest, a kind
of optical illusion of his consciousness. The striving to free oneself
from this delusion is the one issue of true religion. Not to nourish
it but to try to overcome it is the way to reach the attainable
measure of peace of mind.

ALBERT EINSTEIN, IN A LETTER WRITTEN
ON FEB 12, 1950, TO A GRIEVING FATHER
WHO HAD LOST HIS SON TO POLIO

Before I venture further, I should define what I mean by the *ego,* since this word can have numerous definitions. My own understanding of its

[*]A term popularized by Rudolph Otto in his book *Ideas of the Holy* (1917), it is translated as "The Overwhelming Mystery."

effect has been heavily influenced by the assimilation of the collected "great teachings" by the contemporary mystic Eckhart Tolle, and especially as presented by his book *A New Earth: Awakening to Your Life's Purpose.*

By the *ego* I mean the mechanism in consciousness that differentiates between things and labels experiences by creating a thought/memory/ word that becomes attached/associated with that experience. (Or quite simply, the voice in your head.) Over one's lifetime, it is the collection of these thoughts/memories/words (which have now replaced the actual experience itself) that creates a sense of history and self. Babies are born devoid of ego: children often first talk of themselves in the third person before they grasp the concept of "I"—but they are trained to build an ego, and once ego is established, it continues to grow and fortify itself throughout an individual's life.

In the modern West, a sense of self is considered to be the most important thing we have, and we are taught to worship the idea of the rights of the individual above everything else, including family, tribe, or country. ("I have to do what's right for *me!*") The grip of the modern ego on the individual has become so strong and the pace of life so fast that most of us never have a chance to realize that there is anything else. This is the mechanism—which Einstein called "an optical illusion of consciousness"—that has separated humanity from the rest of the web of life on this planet by causing us to believe that we are unique and special (made in God's image, no less) and that the Earth is here for our exploitation rather than our custodianship.

A viewpoint of pragmatic separation became virtual dogma during the late eighteenth and early nineteenth centuries after René Descartes, whose dualistic philosophy posited the complete separation of body and mind, paved the way for the widespread introduction of the scientific method, undeniably Western culture's most dramatic contribution to history. This belief, combined with the absolutist economic philosophies of John Locke and Adam Smith, then became the operating principles of the Industrial Revolution. According to Locke's economic theories (which are one of the foundation stones of our modern capitalist

paradigm) it was mankind's God-given duty to subjugate the Earth and reap the rewards as "wealth." The birth of the Industrial Revolution can be considered the practical starting point of the dualistic (and materialistic) Cartesian-Newtonian paradigm that now dominates our entire culture (Locke famously wrote that "unused property is a waste and an offense against nature").

Therefore my fourth conclusion is that a mystical experience—by any means—destroys the illusion of separation by revealing the singular ground of Reality, the numinous, and this occurs by transcending the dualistic-nature of ego, the pervasive sense of "I," in a timeless reconnection with Source. (Once again, a belief commonly expounded by mystics for centuries.) The Sanskrit word for this paradigm-shattering event, *satcitananda,* is best translated as "being-consciousness-bliss" or "existence-awareness-bliss," or what we in the West might describe as a moment of enlightenment. This very real experience of ego-death is the same mystical experience that Aldous Huxley, Alan Watts, and the Beat Generation were all seeking from their study of Eastern texts and techniques.

This concept of ego-transcendence was mostly abandoned in the West after the cessation of the Eleusinian Mysteries, other than in radical pockets such as the Gnostic or alchemical traditions. Most of Christian mysticism involves identifying with the Godhead through the example of Jesus Christ, as opposed to the mystic's attempts at direct union with Source. Christian mystics have historically risked charges of blasphemy, often with horrific consequences, if they cross this metaphysical line.

It was the Theosophists of the late nineteenth century who generated a wave of interest in the transpersonal teachings and methods of Eastern philosophy that many Western twentieth-century intellectuals later began to investigate. A two-year speaking tour of the United States by the remarkable Swami Vivekanada, a disciple of Ramakrishna, led to the formation of the influential Vedanta Society in the United States in 1894. (Later, Aldous Huxley would be a frequent contributor

to the Vedanta Society journal. These have been reprinted as *Huxley and God: Essays on the Religious Experience*.) It would be this direct line to Indian mysticism that would introduce many Western intellectuals to yoga, meditation, and the philosophy of the Vedanta, in a sober and often studious approach to gaining the mystical experience—Leibniz's *Philosophia perennis,* which Huxley defined as "the metaphysics that recognizes a divine Reality substantial to the world of things and lives and minds"—that still continues in many Vedanta and Buddhist centers today.

This approach would, however, be undermined by the writings of the Beats in the late 1950s, who had realized, in the periods of chaos between their lengthy meditations, that there was another far more accessible form of transcendence available with just the right mix of alcohol, benzedrine, jazz, and marijuana, in the heady setting of smoky mixed-race bars. The surprising commercial success of Ginsberg and Kerouac led to a widespread popularization of Beat philosophies that would prepare youth culture for the spectacular arrival of psychedelics less than decade later.

Allen Ginsberg himself would play a major part in introducing psychedelics to America's underground network of artists, writers, and musicians after he met Timothy Leary, since it was Ginsberg's address book and patronage that attracted many well-known personalities to Leary and to his center in Millbrook, New York. Ginsberg, who had already experienced ayahuasca in Peru (thanks to William S. Burroughs) and LSD (in 1959) before he met Leary, became one of the most enthusiastic proponents of sixties psychedelic culture. Neal Cassady, the hero of Kerouac's *On the Road,* would also become one of the most famous and revered personalities in psychedelic history as the unstoppable driver of *Furthur,* the legendary bus of Ken Kesey and the Merry Pranksters. Kerouac himself, however, never embraced psychedelics, famously stating that "walking on water wasn't made in a day."

So to quickly recap, these are what I see as the most practical personal uses of psychedelics:

1. For examining and experiencing differentiated states of consciousness, and for examining the role of consciousness itself.
2. For realizing the existence of the ego, and experiencing the field of universal consciousness without it.
3. For experiencing the transpersonal nature of reality that is the common ground of all mystical experiences.
4. For realizing our unified connection with Source.

PSYCHEDELICS AND SOCIETY

The task of our generation, I have no doubt, is one of metaphysical reconstruction.

E. F. SCHUMACHER, SMALL IS BEAUTIFUL

The first structure that man ever built was in consciousness, in the inner space that we would eventually call our minds. Man constructed the mental walls of separation and division necessary for the creation of the ego—the "I" that can assign meaning and value and label things. This was the beginning of the intense narrowing of focus of *Homo sapiens* that led to language, tools, the scientific method, and our invention of technology. Numerous commentators throughout history have stated that this false sense of separateness from the universal is the cause of dysfunction in ourselves and our society. By recognizing that the human ego is the mechanism of division and separation that has been responsible for that part of the (unnatural) world that we have created—our emotional worlds included—then it follows that the ways in which psychedelics are practical for singular personal growth might apply also to the collective growth, and in fact survival, of our entire culture.

Although known to be nontoxic and nonaddictive, psychedelics are paradoxically among the most feared *and* the most revered agents of our contemporary society (depending upon whom you ask). Despite an all-out war against their use that has been ongoing for over fifty years, the popularity of psychedelics has in fact steadily increased worldwide, along with the astonishing number of entheogenic compounds and

plants currently available. As we have already seen, there are even signs that psychedelics are already returning to mainstream culture.

There is an aspect of human curiosity that remains fascinated with the psychedelic experience and is willing to face any persecution to continue its influence. In my opinion, this is the part of humanity that recognizes the inherent dysfunction in human thinking, and instinctively wants to break down the prisons of separateness that the modern ego has created—the part of us that longs to reconnect with Source. I also believe that this same Source is desperately trying to get back in touch with us, and that psychedelics or more specifically entheogens, are one of the few known technologies that are capable of penetrating the Western ego's omnipotent view of its own importance, and that could teach us how to reintegrate ourselves holistically back into the web of life. This is why I believe that the reappearance of psychedelics in world culture at this critical juncture in history is more than just a coincidence, because an entheogenic perspective may be the best hope for our species' future survival.

The lasting function of psychedelics must be as a tool for the reintegration of the transpersonal experience into the Western psyche—a very real effect that, as we have seen, is brought about by the temporary disruption (and subsequent recognition of) the ego structure. To my mind, any goal less than this is mere entertainment. While many fascinating things have been written about psychedelics and the psychedelic experience over the past fifty years—from strange tales of transformation and telepathy to ingenious theories ranging from mushroom spores as spaceships, or the soul or spirit occupying a singular molecule—this practical philosophy is ironically ancient ground that has barely been revisited in those five decades, as psychedelic culture has moved further and further away from self-examination and further and further toward hedonism and the fantastic. (The unfortunate entanglement of the psychedelic movement with the 2012 phenomenon is perhaps the most obvious example.)

There are a number of reasons why this has been the case. Aldous Huxley and Alan Watts had the advantage of years of study and

training in Eastern philosophies before they experienced psychedelics, and therefore had fully formed experiential philosophies of their own with which to compare to their psychedelic experiences. Coupled with the fact that their generation experienced psychedelics before there was any stigma attached to their use, this gives their writings and speeches[*] a scholarly authority that few commentators since have been able to equal. Unfortunately, their comparisons of the psychedelic experience with the classical mystical experience would become discredited by association with the hubris of Timothy Leary's cultural excesses less than a decade later.[†] As a result, their fundamental discovery—that the classic mystical experience is achieved by the negation or disruption of the ego, and that this is most easily achieved by the use of psychedelics—has until recently been considered irrelevant.

In the ego-driven decades that have followed Western youth's brief flirtation with the transpersonal in the 1960s, the mystical experience has been of little societal interest, and the illegal compounds of choice have been either potent ego-inflating compounds (cocaine), or vehicles of escapism (MDMA, heroin, prescription opiates)—anything in fact that can help one avoid serious self-examination. This situation has only begun to change again in the last two decades, as the threat of impending ecological disaster and the collapse of the world's economy—two events that are now inextricably entwined with each other—are creating an existential crisis for today's generations similar to the despair for humanity that many intellectuals felt after World War II. In the United States of the twenty-first century, millions of people go to yoga classes, meditate, eat vegetarian diets, and even occasionally take psychedelic drugs, all in the same search for meaning that the beatniks and the hippies once sought. This perennial search for the mystical experience has increased interest in DMT, 5-MeO-DMT, and especially ayahuasca. This interest in many ways mimics the original fascination with LSD

[*]There are a remarkable amount of highly entertaining Alan Watts podcasts on the world wide web.

[†]Excesses that would result in termination of any legal avenues of psychedelic exploration.

before it became illegal (and rare), offering the same hope for a glimmer of meaning in an increasingly meaningless world.

If the function of all revolutions is to bring about radical change, then the so-called Acid Revolution of the sixties remains worthy of that name, because it was a fundamental component in changing Western—and especially American—views on race, sexual politics, religion, and spirituality, and perhaps even more importantly, on our relationship to our planet and our environment. Few social revolutions have succeeded so quickly and then been abandoned with such haste. While the beginnings of the LSD revolution can in fact be dated back to the early 1960s (if not earlier), its main years of influence were remarkably short (1966–73) and coincided with one of the most tumultuous periods in American twentieth-century politics, which also marked the apex of the U.S. middle class in terms of size and influence. (The role of LSD in depoliticizing American universities—the obvious intersection of the middle class and traditional American power—during this time will long be debated.) This era also saw what may prove to be one of the most pivotal moments in human understanding: the first time that human beings saw our planet through another man's view from outer space.

While orbiting satellites had taken grainy images of the Earth from outer space before, it would be two unplanned photographs taken by astronauts on the Apollo missions—"Earthrise," taken by William Anders during the Apollo 8 mission of 1968, and "The Blue Marble," taken during the last manned lunar mission, Apollo 17 in 1972—that would quickly become the most distributed images in human history. Of the two images, it is the latter—showing a fully illuminated Earth—that is perhaps the more remarkable, and has been described by landscape photographer Galen Rowell as "the most influential environmental photograph ever taken." Of the twenty-four human beings who have journeyed far enough into outer space to see that sight (during the nine Apollo missions that went to the moon), only three—the astronauts on the last manned lunar mission—actually had the opportunity to see a fully illuminated Earth (which was otherwise partly obscured

by the moon's shadow). It still unknown which NASA astronaut took the series of four unauthorized snapshots of our planet that have become the most reproduced image in history, since all three of the astronauts on the mission claim to have taken them.*

This stolen image of a fragile blue bubble floating in outer space, broadcast on the borderless medium of television, came in the midst of the LSD revolution that was reintroducing the transpersonal experience—of the connectivity of all things—to a divided American society. Many contemporary commentators now believe that these two seemingly unconnected events were the primary forces behind the birth of the environmental movement, as millions of people around the globe woke up to the great danger that life on this planet faces.

Hard on the heels of the civil-rights movement and the sexual revolution, the environmental movement has, for the first time in the history of our planet, fought for the rights of Gaia, of our Mother Earth. Our society has in many ways become divided between those who believe that the planet is here to serve us, and those who recognize that if we are to survive as a species, we must evolve toward a protective custodianship of the only home we have. This battle is becoming more and more critical every day, as many biologists now believe that the Industrial Revolution and subsequent growth in human population over the last two hundred fifty years have now ignited the sixth great extinction event in history, leading to a new epoch: the Anthropocene, the Age of Man. (For anyone interested in this subject, I recommend the rather terrifying book *The Sixth Extinction: An Unnatural History* by Elizabeth Kolbert.)

The concept of extinction was only realized by science a little over two hundred years ago. Prior to the recognition of extinction in the fossil record by the French naturalist Georges Cuvier in 1796, the prevailing view was that all species existed in a great, unbreakable "chain

*The unauthorized taking of these photographs is in itself a highly unusual event, since every minute of the lunar missions was carefully scheduled and planned, and the military-trained astronauts rarely strayed from their orders.

of being." To realize that extinction is possible—this is an advantage that no other known species presumably has ever had. And yet in the final chapters of *Tryptamine Palace*, after describing the powerful sense of responsibility for the web of life that accompanies a transpersonal-entheogenic experience, I am forced to conclude that our species is suffering from *Extinction Denial*. Our planetary society is on course for the most anticipated crash in history, and yet the peculiar narrowness of our individual focus somehow enables us to ignore it. This narrowing of focus is of course the mechanism of the ego at work: our own personal needs (food, shelter, money, sex, stimulation) keep us distracted from the big picture, especially if that picture is looking grim.

Written language and technology are the things that separate *Homo sapiens* from all other species on Earth. Technology can regarded as the concrete, outward manifestation of the inward ego: the uniquely human concentration and narrowing of focus that was required for the creation of the remarkable tools that have allowed us to become the most dominant species in history. (Tools are now so focused and concentrated that we can expend billions of dollars in search of a single ghostly sub-atomic particle.) But our love of technology is paradoxically the most obvious source of many of the planet's most complex problems. This narrowing of focus, combined with the human fascination with our own ingenuity, has resulted in the development of nuclear, chemical, and biological weapons previously unknown to nature, while the unfettered use of our "good" technology—agriculture, energy, medicine, and transportation—has led to an exponential increase in the human population, which our planet is increasingly struggling to support.

The doubling of the planetary population over the past fifty years has contributed to global warming, because of the enormous amount of greenhouse gases that we have added to the atmosphere as a result of the Industrial Revolution, planetary deforestation, the cultivation of rice paddies, and the ever-increasing burning of fossil fuels. CO_2 levels are at the highest point they have been in at least the last 800,000 years, and by 2050, CO_2 levels will be twice what they were in pre-industrial days. This release of carbon into the atmosphere has also resulted, perhaps

even more terrifyingly since this will affect us more urgently, in a rise in ocean acidification. The evil twin of global warming, this rise in ocean acidification was only discovered at the beginning of the twenty-first century. Roughly one-third of the CO_2 that humans have pumped into the air has been absorbed by the oceans, and by the end of the twenty-first century they will be 150 percent more acidic than they were at the start of the Industrial Revolution. (This increasing acidity of the oceans is believed to be responsible for the extinction of the coral reefs.) What effect this will have on the food chain in the ocean is unknown, but the best-case scenario seems to be "a reduction in bio-diversity." (See Kolbert, *The Sixth Extinction,* page 120; ironically, the chapter is titled "Dropping Acid.")

According to Eckhart Tolle, the ego will constantly try and tell you that it has reformed itself, that it has learned its lesson, and that it no longer needs to be of any concern. This has become very much how I view our relationship with technology. The modern view of technology is almost exclusively celebratory, and the pursuit of technology is viewed as somehow being neutral, no matter how patently evil the use of that technology may be, or how unfortunate the result.

One of the great paradoxes of modern civilization is that we some-how believe that the solution to this looming ecological disaster lies in the very same attitude toward the technology that has caused it. But as Albert Einstein pointed out, "We cannot solve our problems with the same thinking that created them." It seems clear to me that we must recognize that our technology is a manifestation of ego—the mechanism of separation—and requires the same scrutiny and rigorous self-observation as any healthy individual ego. The reappearance of a transpersonal-entheogenic perspective in Western culture after an absence of nearly two thousand years is thus far from coincidental; it is a necessary tool for reassessing both our love of technology and of the indiscriminate ways we use it.

Take for example the one synchronicity that I find both most tell-ing and most frightening, and one that has also been noted by Albert Hofmann, Alexander Shulgin, Stanislav Grof, and other psychedelic

philosophers—the synchronicity between the synthesis of psychedelic compounds and the discovery of nuclear energy.

The isolation of mescaline in 1895 took place the same year that the German physicist Wilhelm Röntgen produced X-rays (or Röntgen rays), the discovery that led to the discovery of radiation and to the birth of the nuclear age. (This won Röntgen one of the first Nobel Prizes, in 1901.) Mescaline became the first entheogen to be synthesized in 1918, less than a year after the cessation of the First World War, and during the period when Ernest Rutherford split the atom. Less than two decades later, in 1938, just before the Second World War, LSD was discovered, although its unique effect on human consciousness was not realized until 1943, after Albert Hofmann had a "strange premonition" to revisit this previously synthesized compound.* During the same period, in 1939, the Einstein-Szilárd letter to President Franklin D. Roosevelt first warned of the potential development of "extremely powerful bombs of a new type"—a warning that led to the creation of the Manhattan Project and the first detonation of a nuclear device in 1945.

The behavior and influence of the unfettered ego apply as much to society as it does to the individual. The atomic bomb is clearly the most egotistical invention in history of man—entailing the belief that one person has the right to order the deaths of millions of other sentient beings because of a perceived political notion of right and wrong. The shadow of the bomb, coupled with the destruction of much of Europe, the deaths of more than 60 million people in the two world wars, and the discovery of the extent of Nazi atrocities, was the primary cause of the existential crisis that Western culture faced in the late 1950s. LSD, on the other hand, has proven to be one of the most effective ego-nullifying compounds ever discovered (especially at higher dosages, as was initially popular).

The fact that the discovery of the effects of both of these morally opposing inventions—LSD and the atomic bomb—came about within two years of each other I find quite remarkable, as if one were the yin to

*This "premonition" to reinvestigate a compound some five years after its synthesis was unique—Dr. Hofmann stated that this had never happened before.

the other's evil yang. Equally remarkable is the way LSD jumped from the postwar laboratory a decade later (with the help of the CIA, wittingly or unwittingly), and then in the following decade introduced a revolutionary taste of the transpersonal into popular Western culture in a way that no other entheogen in history ever could have. Again, I do not consider this a coincidence, since the challenge for human consciousness since World War II has become whether it can survive its own ingenuity. (AI [artificial intelligence] may be the next major challenge.) A sustained study of the role of the human ego may be our only true hope for the future, and entheogens—including LSD—remain the most powerful tools we have.

BUILDING A MODERN ELEUSIS

The answer is never the answer. What's really interesting is the mystery. If you seek the mystery instead of the answer, you'll always be thinking. I've never seen anybody really find the answer, but they think they have. So they stop thinking. But the job is to seek mystery, evoke mystery, plant a garden in which strange plants and mystery bloom. The need for mystery is greater than the need for an answer.

KEN KESEY, *THE ART OF FICTION* INTERVIEW,
PARIS REVIEW, 1994

Late night, at an annual psychedelic gathering during Art Basel in Miami a few years ago, an intelligent dreadlocked young man, who seemed genuinely interested in my work and who, I later found out, is the heir to a considerable fortune, asked me why I spent so much of my time promoting psychedelic culture. As I struggled to connect the dots between my ideas about the ego, technology, and the impending environmental catastrophe, with the absolute necessity of the reintroduction of the transpersonal experience into the Western psyche, he stopped me and told me that he understood, and the way he neatly summarized it was:

"The psychedelic perspective is the perspective required for humanity to adapt and survive."

I couldn't have said it better myself, and along with the birth of the environmental movement, the millions of people worldwide who have adopted healthier lifestyles and attitudes because of their psychedelic use are a testimony to the possibilities of that approach. Perhaps the hallmark of modern psychedelic culture is that if you happen to experience one its many rotating nexuses (such as the annual Alex Grey Bicycle Day event in San Francisco, a transformational festival in North America, a psytrance festival like BOOM! in Europe or Australia, or a major entheogenic conference like MAPS or the World Psychedelic Forum), you cannot help being impressed by the beauty and the complexity of the many-layered vision presented there. A vision that proclaims the possibility of what the world might be like if we simply allowed responsible psychedelic culture to flourish.

Having often been a working part of psychedelic culture over the last decade, and having had long conversations with many psychedelic artist-activists about what it is we are collectively trying to achieve (sometimes despairing that the message is being lost in all the beautiful pictures and the pretty lights), I have concluded that this Second Psychedelic Revolution is instinctively creating modern mystery schools, and that these movable temples of music, dance, and art are the closest things our society has to true portals to transcendence. (Joseph Campbell often stated that two of the oldest and most reliable technologies of transcendence are music and dancing.)

"Visionary art could be the new religion," Alex Grey is fond of saying, "with psychedelics recognized again as sacraments." He and I share the belief that the psychedelic-mystical response to art, music, and dance is one of the few effective methodologies that can cut through the programming of modern existence and help to alleviate our shared existential suffering; a viable technology capable of freeing us from the paralysis of the impending planetary ecocide, through a transformative connection with the universal transpersonal experience.

This is why psychedelic culture often showcases itself these days as rather grandly titled "transformational festivals." These are based on the genuine belief that tremendous personal growth and transformation

can occur from experiencing the transpersonal within the multilayered vision that the neo-tribal community that has evolved around these festivals over the past two decades collectively creates; and that if enough people experience this sense of connection there will be enough of us to make a change, to become, as I wrote in *Tryptamine Palace,* "the sharpened point of the spearhead of humanity."

If there is a substantial difference between the outsider attitude of the psychedelic politics of Timothy Leary's era—immortalized by his unfortunate advice to "Turn on, tune in, and drop out'" in 1966—and the pragmatic politics on display at tech-savvy festivals like BOOM!, Lightning in a Bottle, and Symbiosis, or within a professional psychedelic organization like MAPS or the Heffter Research Institute, it is in the recognition that slow change is more likely to occur within the system than as any kind of overwhelming revolution. While a transpersonal experience with psychedelics can motivate an individual to work toward real personal and social change—a psychedelic form of liberation theology—the mere act of taking the psychedelic itself generally changes nothing.

The psychedelic community is intensely aware of the fragility of this moment in history. Virtually every transformational festival has lecture series and workshops on the environmental crisis, alternative energy, and permaculture, while the entire 2012 phenomenon was, in my opinion, a misguided identification of the stark reality of the global crisis that we will most likely soon face.

One of the things I find most encouraging about the psychedelic community is how many really smart people I meet at these events. They are often the densest concentration of brilliant minds I have experienced outside of a university, and generally the most tolerant and open-minded. A transpersonal experience challenges virtually every foundation stone of our soulless Cartesian-Newtonian paradigm, and can stimulate an aroused intellect to new heights of understanding, while opening up the heart to the tolerance and acceptance that comes from knowing that all things are connected, that we are all part of the One. From more than sixty years of experience, we now know that responsible psychedelic use actually *builds* community. Any community

with a high number of individuals who are familiar with transpersonal spaces—be they from yoga, meditation, prayer, or psychedelics—is likely to be both more conscious and more inviting.

Contemporary psychedelic culture is continuing proof of this, from the original touring family that grew up around the Grateful Dead and is now heading into its fifth decade, to the significant visionary community that has built up around the annual Burning Man gathering—a remarkable experiment in art and group consciousness that is, for that week, the most open and tolerant place on Earth—and the West Coast transformational festivals that it has helped to inspire. In Europe, the bi-annual, openly psychedelic BOOM! festival held in Portugal is the major pilgrimage of the global psytrance tribe, and the two different communities surrounding these two different cultures (Burning Man and BOOM!) are increasingly becoming united (through art and music) into a single global tribe. The Oregon Solar Eclipse Gathering in 2017, which attracted more than fifty thousand people from around the world, was the first major collaborative transformational festival involving major festivals from the United States, Canada, Costa Rica, Australia, and Europe in the United States.

For most people, the more of these festivals you attend, the more this sense of community grows, along with the ability and desire to collaborate with like-minded groups and individuals. The community involved in the production of these festivals worldwide—producers and artists, stage builders and designers, structural engineers, sound engineers, lighting and video engineers, wood and welding wizards, as well as the traveling circus of musicians, DJs, producers and performers, and another whole community of vendors, many of whom now travel with their young children—has grown so large in the past fifteen years that there is now a significant move *away* from the festival model.

Many of the people involved are beginning to feel that these events are becoming too large and wasteful, in view of the amount of time and resources that are spent constructing these elaborate psychedelic environments, only to have to break them down again days later. (Burning Man is the most obvious example of an unsustainable festival, although

to be fair, it has never had any interest in being otherwise.) The natural progression is toward the purchase of permanent sites for these events (such as BOOM! in Portugal) that can develop as prototypes for sustainable villages for a habitually transient community. In an increasingly disenfranchised world, the building of real community offers a powerful draw, and the high concentration of radical freethinkers in the psychedelic community—many who are pioneers in their own fields—may yet have unforeseen advantages in the tumultuous years ahead. The psychedelic community worldwide, for example, includes thousands of sophisticated marijuana growers who are rediscovering traditional permaculture farming techniques that have been lost to big agriculture. No other community that I know of has such a high concentration of skilled farmers. They may yet, out of necessity, find themselves growing more than gourmet cannabis.

Psychedelic philosophy is a neon rabbit hole that fractals in every direction after that first time you dissolve in that tunnel of light. I have spent much of the last decade researching many facets of this rainbow-colored gem, often describing my entheogenic epiphany on 5-methoxy-DMT and the subsequent six-year journey to the publication of *Tryptamine Palace* as the greatest intellectual adventure of my life. It is no wonder that enquiring minds are drawn toward this transpersonal mystery, for psychedelics, and our unlikely relationship with them, is one of the most fascinating subjects for pure thought even without taking them!

The very fact that tryptamine psychedelics even work at all—that there are specialized molecules in trees, plants, and fungi whose shape is similar enough to that of serotonin (a brain hormone) that the sophisticated defense system of the human brain (the blood-brain barrier) is tricked into accepting them, and that these molecules (DMT, 5-MeO-DMT, LSD, and psilocybin) then fit into the same very specialized locks in the brain and dramatically modify human consciousness to a state outside of consensual reality—this is in itself a mystery that defies the human imagination and has kept me awake in wonder many a night.

What possible purpose could this relationship serve in nature

if life and consciousness are nothing but the accidental by-products of a universe full of mindless matter aimlessly bouncing around, as Newtonian scientists would have us believe? Even accepting the possibility that consciousness is merely some highly specialized cosmic accident, how did our ancestors figure out this strange relationship between our inner world and the plant kingdom? What effect did this discovery have on those primitive societies? And this then begs the questions: how long were psychedelics revered before our own culture did its best to extinguish them, and why now, on the verge of planetary destruction, have they so dramatically reappeared in the Western perspective?

This mystery only deepened with the discovery of *endogenous* DMT and 5-MeO-DMT in human blood and cerebrospinal fluid in the early 1970s. This means that the two most powerful entheogens we know of are being produced somewhere naturally within the human body. While this discovery opens up a whole universe of new speculations and possibilities, what I find most fascinating is the phenomenological manner in which these two compounds transform our consciousness.

Dimethyltryptamine, or DMT, opens up the mind's eye to the visionary experience—anything that can be seen or imagined can vividly exist in the DMT realm, which is why it is so revered by visual artists. Nick Sand, the man who invented Orange Sunshine LSD, and also the person who figured out that you could freebase DMT, described it to me as "The Fullness," while in my lectures I correlate DMT to the sixth chakra in the kundalini system. At this level, while you can experience the existence of God in all its infinite myriad forms, there is still a separation between the subject and object, between you and the face of the divine. DMT is thus the endogenous source of the vast and rich realm of our archetypical mythology.

On the other hand, the other known endogenous entheogen, 5-methoxy-DMT, Nick Sand described to me as "The Void," noting that the phenomenological experience of this closely related compound is very different from that of DMT. This singularly powerful compound

I correlate to the seventh chakra of the kundalini system—the crown chakra—the source of that indescribable event where all boundaries dissolve, and you and God become One. The seventh chakra reveals an interconnected dimension beyond vision, thoughts, time, space—the transpersoanal experience defined by Abraham Maslow and Stanislav Grof—which 5-MeO-DMT accesses through an ego death so dramatic and instantaneous that it is impossible to find the vocabulary with which to relate the experience* with the sliver of consciousness that returns, the classical mystic's dilemma. (The Indian sage Ramakrishna would relate the passage of the kundalini through his chakras till the seventh chakra, at which point he would collapse wordlessly into samadhi. Upon his return he explained: "But who should speak? The very distinction between 'I' and 'thou' vanishes.") With its virtually guaranteed experience of ego death,[†] 5-MeO-DMT is the endogenous origin of the singular mystical experience.

Virtually all religions on this planet have been born from a tension between the mystical and the mythological—which is to say that localized mythologies and religious systems have all arisen around the same common ineffable spark known to mystics throughout history. Therefore you would think it might be of great interest to contemporary society that we have recently discovered that the two compounds most likely to induce these experiences are also being produced naturally within our own brains.

The discovery of endorphins—endogenous opiates—and the opiate receptor is now considered one of the major biological discoveries of the last fifty years; its discoverers received a Nobel Prize. So you would imagine that the much more difficult discovery of endogenous psychedelics would be similarly celebrated. But, ironically, shortly before DMT was discovered to be naturally produced within the human body in 1972, it was made illegal (along with LSD and all other known psychedelics) in

*Although I have tried in *Tryptamine Palace!*
[†]There are rare cases when individuals won't or can't let go on 5-MeO-DMT, and their ego refuses to dissolve into the Void. At this point they are invariably dragged through hell instead, and end up having traumatic and potentially damaging experiences.

the United States by the 1971 Convention on Psychotropic Substances, and all research on psychedelics effectively stopped. In 1973, a new federal agency, the Drug Enforcement Administration (DEA), was formed to fight the "rising drug problem," and organizations like the hashish-and-LSD ring known as the Brotherhood of Love—who reputedly kept the price of LSD low for years because they believed it was sacramental and could bring about social change—were dismantled.

The state of California made LSD illegal on October 6, 1966, meaning that our governments have now fought fifty years of a drug war against their own population over a class of nontoxic and nonaddictive drugs that have only grown in popularity—a failed Prohibition that is, thanks to the United Nations, enforced on a global scale. Whether or not the rapid reinvention of global culture results in a sustainable future for humanity or in a forced adaptation for survival among the ruins of the first man-made planetary collapse, I believe that the transpersonal psychedelic experience grants us an invaluable perspective from which to consider our species' relationship with the rest of the web of life—and ultimately, with Source, the Universal Consciousness. The continued investigation into the entheomystical experience is both a basic human right and an inevitable result of our curiosity, and the firsthand experience—the connectivity of all things to Source—remains both the greatest of human mysteries and potentially the greatest gift of all.

I would like to dedicate this chapter to the memory of Alexander "Sasha" Shulgin, who as one of the fathers of this Second Psychedelic Revolution, was a subject of this series, but who died before its final publication. While I cannot claim to have known him well, Sasha was (and will continue to be) one of my greatest inspirations, and I consider the small amount of time I spent with him to be one of the great unexpected privileges of my life. It seems fitting to leave the final words on the lasting value of entheogens—taken from the introduction to *PIHKAL*—to him, as an inspiration to us all.

I have stated some of my reasons for holding the view that psychedelic drugs are treasures. There is, for instance, the effects they have on my perception of colors, which is completely remarkable. Also, there is the deepening of my emotional rapport with another person, which can become an exquisitely beautiful experience, with eroticism of sublime intensity. I enjoy the enhancement of touch, smell, and taste, and the fascinating changes in my perception of the flow of time.

I deem myself blessed, in that I have experienced, however briefly, the existence of God. I have felt a sacred oneness with creation and its Creator, and—most precious of all—I have touched the core of my own soul.

It is for these reasons that I have dedicated my life to this area of inquiry. Someday I may understand how these simple catalysts do what they do. In the meantime, I am forever in their debt. And I will forever be their champion.

ALEXANDER "SASHA" SHULGIN (1925–2014)

PART TWO

What Can Entheogens Teach Us?

Psychedelic Culture in
the Twenty-first Century

7

WHERE IS GOD IN THE ENTHEOGENIC MOVEMENT?

This (edited) article originally appeared in the final edition (December 2008) of *The Entheogen Review: The Journal of Unauthorized Research on Visionary Plants and Drugs* 16, no. 3 (autumnal equinox 2008).

In 1992, former English teacher and entheophile Jim DeKorne started *The Entheogen Review** (TER), a self-described clearinghouse for "hard-to-find empirical data on growing techniques, extraction procedures, dose information and subjective results experienced by readers." The contributors over its sixteen-year run read like a Who's Who? of psychedelic culture, and so when I heard that this legendary underground publication was about to come to an end, I wrote this article in the hope of being included among its prestigious contributors. I was greatly honored when its last editor opened the final issue with my article, which came out some six months before my book *Tryptamine Palace* was published. Alex Grey later told me that this article was one of the main reasons he and his wife Allyson decided to contribute the foreword to *Tryptamine Palace* after our mutual publisher (Inner Traditions) con-

*The entire Entheogen Review library is available on-line at http://entheogenreview .com.

tacted him. The synchronicity of the timing of this article—the first I had ever written about psychedelics, and which I barely got in before the deadline—was thus extremely fortuitous for introducing me to the contemporary psychedelic community.

Ironically, I have discovered that the greatest problem that this investigation presents is what to do with my conclusions, now that this book is nearing its natural end. For I have come to realize that I am writing about the most difficult and controversial subject in the history of humankind: the existence of God, and our ability as humans to be able to know or directly experience God through the use of entheogens.

As I have enthusiastically expounded my ideas over the last few years to those close to me, I have come to realize that the whole concept makes a lot of people very uncomfortable, even hostile. The word "God" creates such immediate emotions, often negative, in this modern age. I can remember back to my pre-5-methoxy-DMT days how skeptical and derisive I would have been, if I had been blindly presented with the bulk of these ideas. "Direct experience is the highest of all ways of gaining knowledge." So said Swami Rama, and I have to agree with him. Experience is the only path to understanding. Explanations just won't do.

JAMES OROC,
TRYPTAMINE PALACE

In the four years that I have been writing about the spiritual epiphany I received the first time I smoked 5-MeO-DMT, I have steadily become more deeply immersed in something I have heard called the entheogenic movement. Since I have discovered this enigmatic movement, I have heard a lot about chemistry, cluster headaches, ayahuasca shamans, neurobiology, aliens, elves, and the impending End of Time—but I have hardly ever heard the word *God*. Which seems rather strange

to me, when you consider that the roots of the word *entheogen* mean *god-generated-within;* and so we have the word *God* used within the definition of the movement—but silence about God from within the movement itself. However, the reason for this seems obvious since—as I have noted in the extract from *Tryptamine Palace*—the word *God* can make some people very uncomfortable, even hostile. It is one of the few words left that still has any power, even though, thanks unfortunately to the politics of centuries of Christianity and the narrow-sightedness of modern science, this power now has mostly a negative connotation among many Western intellectuals. Which I believe presents a big problem for the entheogenic movement—for while the contemporary psychedelic movement hides behind the word *entheogen* (coined in 1979), we apparently aren't even really sure of exactly what it is that the entheogenic movement is trying to achieve.

But I should back up a bit. *Tryptamine Palace* was inspired by my reaction to an overwhelming spiritual epiphany that I received the first time I smoked 5-MeO-DMT (in 2003). On this occasion—despite being a confirmed atheist at the time—I came to believe that I came into contact with a force that I can only describe as the transcendental experience of immersion with God (or G/d, as I denote it in my book). I am not talking about the Christian God, but the God perennial to mysticism—the void that is a plenum that pulsates with a conscious Omniscient Love. This was an encounter that, I can assure you, I most definitely was *not* expecting at the time.

This spiritual epiphany on 5-MeO-DMT in 2003 introduced me to the entheogenic movement from the outside (I had never heard the word entheogen for example) and the publication of *Tryptamine Palace* in 2009 effectively thrust me into its center. The psychedelic movement has always been a paradoxical one; historically fronted by charismatic New Age philosophers validating their beliefs through the lens of psychoactive drugs, while supported by a much smaller backbone of scientists, chemists, and pharmacologists engaged in research that is often counterproductive to their mainstream careers, or (more often) carried on underground. And while there are organizations such as the Council

on Spiritual Practices,* which is dedicated to promoting the idea that God *can* be found with the applied use of entheogens, these are rarities, and are regarded almost as an antiquated throwback within an otherwise modern movement; as are syncretic religions like Brazil's Santo Daime and UDV, or the peyote church. *Mysticism* itself comes off as some kind of dirty word, even though our current use of entheogens is clearly a continuation of this historically ancient philosophy—one that has influenced our own Western culture (since Greek times) far more than the currently fashionable interest in shamanism.

For these days, God is often dismissed as an antiquated idea. Our inherited intellectual resistance to the word is so great that the closest many people will come to admitting it is by calling themselves *agnostic*. The idea is that you can believe in some form of impersonal God who really has little influence over your day-to-day existence—kind of an existentially acceptable view of God I guess. And I am not immune to these inherited prejudices any more than anyone else—for example, at the World Psychedelic Forum in Basel, Switzerland, in 2008, there were a small number of priests and nuns in attendance, and during the course of conference held in honor of Albert Hofmann's 102nd birthday, while I had the opportunity to speak to many of the people there, I could not bring myself to approach this singular group—a fact that I now greatly regret, for I am sure that I would have been interested in their point of view. But the personal intellectual and moral aversion I have for the remnants of the Christian church is so overpowering that it kept me at an arm's length from these individuals—even though we were all clearly there to investigate the same entheogenic phenomena—a mystical human knowledge of the existence of God.

Thus I have come to realize that the mainstream face of this entheogenic community was in fact not that different from that of the conventional scientific community—since the choice lies between conventional science and the cult of materialistic reductionism on the

*This council has produced two of my favorite books on entheogens: *Psychoactive Sacramentals* and *Entheogens and the Future of Religion.*

one hand, or a steep dive into New Age philosophies on the other. For example, we seem to have become more interested in *how many* psychoactive compounds we can create, rather than in any discussion about defining which ones should truly be classified as entheogens. I hear a lot of compounds being classified as entheogens that I personally believe don't warrant that classification—since, by my definition, an entheogen should be able to produce the mystical result of a transcendental union-with-God. And that is not a mere closeness to God, or a heightened appreciation of your humanity or your environment. That is a state of union, of transpersonal *Oneness*. If a compound can't do that, then it's not a true entheogen. And the more often it is able to allow this transcendence, the more powerful of an entheogen it is.

The problem with this point of view is the simple fact that not many compounds *can* produce that result—and none are guaranteed to do so. And few people seem to have experienced that union-with-God that I am talking about—even within the entheogenic movement. But more people than ever seem interested in psychedelic drugs. So perhaps we should admit that the entheogenic movement is in fact only a splinter group of the psychedelic movement—and that the name has been adopted generally so as to throw a cloak of both respectability and obscurity over gatherings of people who are interested in psychedelics—and not necessarily in finding God via the entheogenic experience.

This hasn't always been the case in the psychedelic movement. Aldous Huxley had no fear of talking about the transcendental experience of God even before he discovered mescaline and LSD, because that's what he was interested in, and it was his reputation as a scholar of mystical experience that garnered such attention for his views on psychedelics. Huxley's last book, the novel *Island,* embraces the idea of the spiritual use of entheogens, while Albert Hofmann talks about his relationship with God quite frequently in *LSD: My Problem Child.*

The next generation of psychedelic authors that followed these two elder statesmen have for the most part scrupulously avoided any direct conversation about the transcendental nature of God. Self-replicating

mechanical elves, alien abductions, plant teachers, the Mayan calendar, even the absurd idea that smoking DMT is somehow going to bring about a fundamental change in the nature of reality—these concepts are fine. But let's not talk about God, because you end up sounding odd and old-fashioned and generally weirding people out.

Such a situation results in the paradox of one of the foremost champions of the word *entheogen*—Jonathan Ott—stating in interviews that he doesn't have any belief in God, while Alexander Shulgin described himself in interviews as both an atheist and an agnostic—despite his statement in the introduction to *PIHKAL* that "I have experienced, however briefly, the existence of God. I have felt a sacred oneness with creation and its Creator." This contradiction points up the slippery slope of language and the dangers of using the word *God,* if nothing else.

You see the same thing among conventional scientists as well. Einstein, Sir Arthur Eddington, Niels Bohr, and Werner Heisenberg all had their mystical sides—but the discussion about the existence of God virtually stopped after World War II. Maybe it was due to the unholy slaughter of those two "Great Wars" less than twenty years apart, and the sustained attempts at genocide by the Nazis and Stalin. Or maybe it was because science unleashed the full forces of hell into the world at Hiroshima and Nagasaki—an act of terrifying aggression that our society has never really processed. For there can be no doubt that those tragedies severely affected our confidence in God—if there was a God, why would it allow such a thing? And for that next generation, which grew up knowing that they were just one itchy human trigger finger away from Armageddon, science had triumphed as the dominant concept. In post–World War II society, the twin towers of science and industry were wholeheartedly accepted as a modern substitute for religion.

However, this very same science would ironically also be responsible for reintroducing experiential spirituality into Western culture with the invention of LSD-25, the first mass-producible entheogen. Then only two decades later—and at the height of the LSD revolution—we

viewed the first photographs of the Earth floating in space, and the first inklings of a transpersonal reality began to emerge, the transcendental image of a fragile bubble floating in space, a stark reminder that our fate on this planet is indeed as One.

But our own spirituality was too damaged and fraught with propaganda to be of any use to us, and no modernized substitute has arrived. After the Beatles went to India to sit at the Maharishi's feet, the Aquarian Age invested itself in a thousand different philosophies, mostly turning its back on both Western religion and science—bringing in a New Age where the channeled missives from Pleiades are somehow equally credible to many today as the results of the Hubble telescope.

Indeed mainstream science and the entheogenic movement both suffer from the same predicament: any discussion of the potential nature of God is considered ignorant and old-fashioned. Existentialism has come to reign so supreme that our own entheogenic movement will try to explain away those experiences as "by-products of consciousness." Which, science tells us, is just a by-product of matter, so we break the sacred compounds down to molecules and atoms in search of an answer. (Mistaking the finger that points at the Moon for the Moon.) In the "scientific" belief that it is the physical nature of the compounds that "causes" the entheogenic effect, there is little examination of the possibility that they actually allow us access to a broader band of consciousness, let alone transcendental access to God.

It's no wonder that kids are more interested in MDMA than they are 5-MeO-DMT or even good old acid—people just want to get high so they can escape their pointless existence, and they don't believe much in God anyway. (I certainly didn't.) And there seem to be very few people willing to go out on a limb within the entheogenic movement and tell them that they can. Stanislav Grof's work would be the main exception, though here the revelation is often cloaked in heavy psychiatric-speak. Alex Grey is the champion of the idea that entheogens can lead to genuine mystical experiences, but he avoids any criticism of his views because he is an artist, and materialistic reductionists can explain his views as "artistic metaphor." (While buying his prints of *St. Albert* at MAPS auctions!)

I belong to a group of scientists who do not subscribe to a conventional religion but nevertheless deny that the universe is a purposeless accident. Through my scientific work I have come to believe more and more strongly that the physical universe is put together with an ingenuity so astonishing that I cannot accept it merely as a brute fact. There must be, it seems to me, a deeper explanation. Furthermore, I have come to the point of view that mind—i.e. conscious awareness of the world—is not a meaningless and incidental quirk of nature, but an absolutely fundamental facet of reality.

PAUL DAVIES, *THE MIND OF GOD*

This position is beginning to change in the mainstream sciences, because we are undergoing a massive paradigm shift in our knowledge of the universe and our reality. And the cause of this paradigm shift is exactly where mainstream science and the entheogenic community meet. It is changing, because the new scientific paradigm that will come to dominate our knowledge in the twenty-first century is one that no longer recognizes the primacy of matter as the stuff of our reality, but increasingly recognizes consciousness and information as the precursors of existence. As the cosmologist Sir James Jeans wrote in *The Mysterious Universe,* "The universe begins to look more like a great thought than a great machine" (Jeans, *The Mysterious Universe,* 44).

This revelation is no news to the mystics, for this has been a perennial intuition in mysticism since the beginning of language. But there is no doubt that this is a revolutionary transformation of scientific belief, for it opens up some obvious spiritual possibilities: if consciousness *is* primary, then it cannot solely be the human form of consciousness alone. Some form of consciousness must have been around since the beginning of time, long before we arrived on the scene. And perhaps our consciousness is simply a limited form of that consciousness after all.

There are a host of other factors in this scientific reappraisal of the possibility of God (or some other form of higher consciousness). The identification of the quantum vacuum or zero-point field, the realization

that we occupy a flat universe, the increasing awareness of universal constants and how finely tuned for the creation of life our universe really is—discoveries like these (and there are too many for me to list here) are challenging materialistic reductionism.* Science is in fact increasingly at war with itself, as the old guard of the old paradigm bitterly dig in and try to shield themselves from the avalanche of data that is proving them wrong—just as those who believed in a sun that revolved around the earth came up with more and more complicated attempts at explaining away all the data that confirmed Copernicus's hypothesis.

This fact is neatly demonstrated by the publication of two books by two respected Western scientists in the same year that offer two radically different spiritual points of view. In 2006 Richard Dawkins, the noted Darwinist and atheist, released *The God Delusion,* while Bernard Haisch, an astrophysicist who works with NASA, published the polar opposite concept in his book, *The God Theory: Universes, the Zero-Point Field, and What's Behind It All.* Dawkins's book has been by far more popular, having been reviewed around the world and sold over a million copies, while Haisch's book was released in comparative obscurity. But in comparing the two books, I felt that Dawkins's was full of tepid ideas, with surprisingly little hard science other than extrapolated Darwinism, and an overtone that is brimming with a righteous anger that borders on fundamentalism, while Haisch's book quietly and soberly takes the mind on a journey through some amazing new scientific discoveries that can be successfully integrated with important philosophical concepts as well. People want a return of experiential spirituality to their lives; but it's helpful if they can also believe in the validity of it. While science is our dominant belief system, the fact is that a number of people—both within and outside of the entheogenic community—have had faith-based transformations of their lives due to their experiences with entheogenic compounds and admixtures like 5-MeO-DMT, DMT, and ayahausca.

*Random material-reductionism; the belief that matter is the basis of reality; that things can be broken down into smaller and smaller parts to explain how they operate; and that all forces in the universe operate randomly.

These experiences are so powerful and self-validating that these individuals are no longer afraid of the social stigma of talking about their personal relationship with a transpersonal God. I know, because I am one of them, and I have been meeting more and more of us as I travel around.

The basis for this transformation can be expressed in the (originally radical Christian) concept of "liberation theology"—the idea that a true faith-based spiritual epiphany effectively creates a social and political transformation in an individual that cannot be ignored. This mystical transformation creates "contemplative activists"—Gandhi, Martin Luther King Jr., Mother Teresa, Thich Nhat Hanh, and the Dalai Lama are all modern examples. Contemplative activists have in fact been "some of the most effective agents for encouraging the liberation of individuals and systems in all of human history" (Cairns, *The Theology of Human Liberation and Entheogens*), since in liberation-theology, "there is not first the mystical and then the political. . . . The political is of the substance of the mystical" (Lee and Cowan, *Dangerous Memories*). Such individuals, realizing the full reality of God, have then found the inner strength to set about changing the world.

So perhaps there is still hope for our society to rediscover God. For as science turns toward the realization of the importance and perhaps even primacy of consciousness, I think there is one area where both the entheogenic movement and our modern science can agree: that the applied use of entheogens is the most effective tool we have both for exploring consciousness, and for reappraising the mystical states. A mystical realization of God, based on a scientific understanding of how this might be possible, would radically transform our own understanding, and could produce enough effective contemplative activists to bring about the massive shift in awareness that our society will need to survive the twenty-first century. But to do this, we must confront our own prejudices about the word *God,* and we must rescue it from the tyrannies of its distinctly human history. And if there is one group in our modern society that *should* be able to embrace a new concept of God, it is this entheogenic movement. It is time for us to open up our hearts and minds, and to let God back in.

8

5-MEO-DMT

Visions of a Quantum God

What are you here for? You, and you, and you. What are you here for?

<div align="right">WILLIAM S. BURROUGHS, INTRODUCTION
TO "WILLIAM'S WELCOME"</div>

This an edited transcript of a talk I prepared for the now legendary 2009 Symbiosis Festival outside Yosemite in California. This was my first festival appearance and marked the beginning of my alternate career as a public speaker at transformational festivals.

What are you here for? Why have you come here, what do you hope to gain? That was the challenge that William S. Burroughs liked to throw at his audiences at the start of his immortal spoken-word performances, and so in honor of both his role as both the Godfather of DMT, and as one of the great agitators of reality in the twentieth century, I would like to echo "William's Welcome" to my audience tonight. What are you here for? What do you hope to gain from this talk? Are you bored? Vaguely curious? Lost? Trying to figure out where the Dub-Step stage is? Or are you just really high and are trying to find a quiet place to chill out?

You may even know that I have recently published a book on the rare entheogen 5-methoxy-DMT titled *Tryptamine Palace*. If so, and you are a fan of DMT and have come here to hear talk of self-replicating machine elves, aliens, insect entities, or dog-headed Egyptian gods, then let me warn you that you are in the wrong place, but that there will be other popular authors around this weekend with their trippy tales of the Amazon to tell. For let's face it, tales of the fantastic will always be popular; we all seek escape from reality, transport to the bizarre, to that bright and shiny realm that John Perry Barlow once described to me as "God's video game."

My interest, however, lies in what would be described as the transcendental—that realm beyond imagery, words, and even thoughts—so much of what I will present to you tonight will challenge your imagination, your intellect, and my own credibility, as I will attempt a wholesale reevaluation of our consciousness, our consensual reality, and ultimately, of the existence of God—a word to which many of us have become allergic at the beginning of the twenty-first century.

"Achieving genuine happiness," the Dalai Lama warns us in *The Art of Happiness,* "may require bringing about a transformation of your outlook, your way of thinking, and this is no simple matter."

No simple matter indeed, but that is what we shall attempt tonight: a transformation of our understanding of reality, and with that, the seeds of a transformation of that very reality itself. This transformation was, in my case, from the profane to the sacred, from a fervent disbeliever to self-proclaimed Disciple of Source. In 1933, in an essay titled "The Spiritual Problem of Modern Man," Carl Jung wrote that "a higher level of consciousness is like a burden of guilt." So be warned that if what you hear tonight takes hold of you, lights a fire in you, then it is almost inevitable that your life will change, for with the awakening of a real understanding, there comes an equally important realization of responsibility, of the need for positive action, and of creating a future that you can call your own, rather than being a helpless passenger on this sinking oil tanker that is our industrial civilization.

"Visions of a Quantum God" is the title I have given to this

presentation tonight, and I stand before you as a modern mystic, with a tale of both a spiritual and an intellectual realization to tell. Prior to smoking 5-methoxy-DMT in 2003, I was a happy and hardened scientific-rationalist atheist who had no interest or need in God. By presenting these ideas here to you tonight about my personal experience of a Quantum God that I accessed through the use of psychedelics, I know I am opening myself up to ridicule and attack, for in the short period since the widespread publication of my book, I have already experienced a few of these stings and barbs from the inevitable critics that any attempt at a fresh examination of spirituality will inspire. Tonight, however all that I ask is that you listen with an open mind, and remember that once I was as cynical and disbelieving of the very things that I will now attempt to describe as any person here tonight.

Let me start by reading an excerpt from the beginning of *Tryptamine Palace,* which describes how this strange journey of mine first began.

In July of 2003, shortly before my thirty-sixth birthday, I smoked 5-methoxy-DMT for the first time. Attaching no particular importance to the event, and approaching it with the same characteristic lack of caution that has accompanied many of my various adventures in life, I sat down on a mattress in a nondescript suburban house in Portland, Oregon, and drew the strange-tasting smoke down into my lungs. I remember looking at my friend whose house we were in and wondering when something would happen, before he reminded me to breathe out. When I did that my old world—and indeed my old life—magically evaporated.

Having read Terence McKenna's descriptions of smoking N,N-DMT, and not knowing at the time that there was any difference between 5-MeO-DMT and its less potent cousin, I was expecting the effect of the drug to be something of a cross between taking LSD and a bong hit, and thus I cannot describe the paradigm-shifting amazement that I experienced when I suddenly came out of this "trip" some thirty minutes later, now somehow standing in a corner of the room and waving my arms in perfect yoga sun saluta-

tions as I watched dragons and griffins flying in waves of red and gold along the wall.

This sense of unabated amazement continued to grow as I turned around and found my friend and his brother with their eyes wide and their jaws agape after having been stunned witnesses to the whole affair. And when I learned that at one point I had gotten to my feet and declared ecstatically that, "It exists! It exists!" and then later, "I am there!" I could only wonder what had actually just happened to me, and what it was that I had just experienced. For in the half-hour after I had exhaled from that pipe, I had come in contact with a force far greater than I had ever known possible—or even imagined—and I now felt as if I had blindly stuck my wet finger firmly into the cosmic socket and come away with my senses totally fried. Suddenly smoking 5-MeO-DMT had become one of the most important events of my life.

Incidentally, I was recently back in Portland with my friend at whose house I smoked 5-MeO-DMT for the first time, and he told me that in *Tryptamine Palace* I have heavily downplayed just how crazy things got. He described it to me as being very scary, since he and his brother had no idea how long the trip would last, and after half an hour of me behaving like a rampaging warrior in the small suburban office that the three of us were contained in, they were beginning to wonder if they needed to call 911. His brother's impression of my Maori war dance is very convincing!

There are a lot of bizarre occurrences described within this book, and I have tried diligently to simply report them as they naturally occurred, for they had no need of any embellishment. But since the subject of this book is the universe of infinite astonishment that smoking 5-MeO-DMT can open up to an unsuspecting consciousness such as my own, it's obviously a pretty hard thing to be objective about. And as I have been speaking about my book around the country this summer, I have realized that the make-up of my audience makes a big difference to the kind of interaction I can expect with you all. Terence McKenna

once described smoking DMT as "an intellectual black hole . . . you are either one side of the experience or the other," (McKenna, *The Archaic Revival*) and the more you try to explain your experience to the uninitiated, the harder it is to find the correct language. So for the uninitiated, let me quickly explain some of the terminology that will keep coming up, as well as giving a brief description of what 5-MeO-DMT is, where it comes from, and what happens to me when I smoke it.

Let's start with the word *entheogen,* which means "generating God within," and is defined as "an ethnographic term used to describe a plant or drug that invokes a sense of the numinous, or a mystical experience."

Many different so-called psychedelic plants and compounds, such as psilocybin mushrooms, peyote, San Pedro, LSD, and even MDMA, have been described as being entheogens, but it is fair to say that the most entheogenic group of compounds are the tryptamines—the best-known of these being LSD and psilocybin, but which also include DMT and 5-methoxy-DMT. These have been traditionally administered in the Amazon area for thousands of years, in the form of ayahuasca, which is generally mostly DMT and beta-carbolines, or in snuffs such as ebene, which is mostly 5-MeO-DMT. Both DMT and 5-MeO-DMT can be found in a variety of plants. In addition, 5-MeO-DMT can be found in a single species of bufo toad, the *Bufo alvarius,* or Sonoran Desert toad. A splendid animal, this toad can contain up to a staggering 15 percent pure 5-MeO-DMT in its venom, and is the only known entheogenic venom–producing animal on earth. Obviously psychedelic drugs affect our consciousness, and our consciousness has traditionally been intuited as having something to do with our brain. Well, one of the fascinating things about the tryptamine family—and from a scientific viewpoint the most important—is that it also includes neurotransmitters like serotonin. It is the similarity in the molecular structure of DMT and 5-MeO-DMT to serotonin that allows these compounds to cross the incredibly sophisticated defense system of the blood-brain barrier, and fit into the specialized "locks" in the brain designed for serotonin.

The blood-brain barrier (BBB) is the most sophisticated defense system in the human body—considerably more sophisticated than any

of the other major organs—and it only allows what it wants to cross over, mostly simple sugars, like glucose for fuel, and sophisticated brain hormones that it needs to operate, like serotonin. Special "carrier molecules" willingly transport across the BBB, and the brain gobbles them up—You can almost go as far as calling DMT and 5-MeO-DMT "brain food."

Which is pretty weird in itself. But just about everything about DMT and 5-MeO-DMT is weird. Consider the fact that humans first synthesized DMT in the laboratory in the 1930s, more than two decades before we would discover them in nature through an examination of the tribal use of indigenous entheogenic plants during the late fifties and early sixties. Then, in the mid-sixties, 5-MeO-DMT was discovered in toad venom just as interest in psychedelic compounds was at a peak. More recently, and more incredibly, in the early 1970s doctors and scientists discovered DMT in human blood, urine, and cerebrospinal fluid, while 5-MeO-DMT was also found in cerebrospinal fluid. Which means that these compounds are endogenous, which is a fancy way of saying that they are produced somewhere within the human body itself. This is why Dr. Rick Strassman, in his book *DMT: The Spirit Molecule* goes as far as classifying DMT as a "brain hormone."

So these are the closely related compounds DMT and 5-MeO-DMT. Two of the most powerful known entheogens, they were (in the West at any rate) first created in a lab, then found in nature, and finally discovered intrinsically within ourselves—naturally and uniquely active in our bodies and brains. Very mysterious, very recently discovered, and very little understood, because few studies have been carried out, thanks to the draconian laws since 1971, which can somehow categorize compounds that are contained naturally within the human body as illegal drugs! Yes, my friends, every single one of you is a walking drug factory, so don't let the DEA catch you!

Because of this bizarre fact, the only DEA-approved study of the effects of DMT on human consciousness was performed by Dr. Rick Strassman and his team at the University of New Mexico in 1990. He describes these trials, and his theories about them, in *DMT: The Spirit*

Molecule. I feel it is important to point out that while Strassman proposes that the pineal gland in the brain is the source of the DMT found endogenously within the human body, and that this idea has been widely circulated with some popularity, this is only a theory and to date has yet to be proven.* In fact, DMT is being found in other places in the human body. One recent study reports that it is present on the ends of nerve cells all over the body. Whether or not the pineal is the source of the endogenous tryptamines found within the human body, it is a fact that DMT and 5-MeO-DMT—arguably the most powerful entheogenic compounds known to man—are both naturally present and presumably active within our own bodies.

So now while I have described *externally* my first 5-MeO-DMT experience, and the chemistry of how tryptamines act, what I have not described is what happens within the experience itself. Indeed this has proven to be the most difficult aspect of the tryptamine phenomenon for many people: it is so weird and confusing that they can find no words for it at all. I have never been the kind of person who really takes anybody else's word for anything. I have worked as a journalist, so I know the media can usually only tell a part of the whole story, and I tend to believe only things I have seen or experienced myself. So as a way of understanding what I had myself been through, I decided to take on the challenge of trying to describe *phenomenologically* what happens to me during my 5-MeO-DMT experiences. Although every person is different, and thus every person can have a totally different experience, I will say that my model seems to be holding up and that many other people seem to resonate with it. In my own experience it has repeated itself many times, the biggest difference now being how quickly I pass through the various phases toward the core of the experience. This is kind of a contradiction in itself, since at its peak this is a transcendental experience, and everything seems to happen at once,

*In 2015, the Cottonwood Institute, which Strassman founded after leaving the University of New Mexico, reported it had located DMT in the pineal glands of rats—the first solid evidence that he may be correct in his theory.

like a quantum nonlocal event, where things like time and space no longer apply.

So at this point let me quickly describe the sequence of events that generally occur when I smoke 5-MeO-DMT.

1. Dissolution into fractals of light upon exhalation of the 5-MeO-DMT.
2. Transportation via rapid acceleration into the coherent white light.
3. The subsequent recognition of the unity of All, and that Love is the principle that organizes the universe.
4. Complete dissolution from ego/identity and any concept of time, as I dissolve into resonance with the One, with God—what William James called "cosmic consciousness."
5. Fear arising from disorientation caused by transitioning back into a restricted consciousness, caused by the return of "my" ego.
6. An abrupt repossession of my physical body as the last effects of the 5-MeO-DMT fade away.
7. A period of fading resonance between physical consciousness and God consciousness ("Mind" with a capital "M"), as I return completely to my normal baseline state.

So that's where I go when I smoke 5-methoxy-DMT. Definitely not your garden-variety trip. For me, it is the only true entheogen, since it was the one that provided the classical mystical experience, and connected me with God.

Not long after I first gave out the early versions of *Tryptamine Palace* at Burning Man, I started to get emails from various people thanking me for writing the book. They said that their own tryptamine experiences had been so weird and so powerful that they had simply not talked about them. They had locked them way, and were forced to ignore them because they could not express them without fear that people would think they were insane, but after reading my book, they had found a vocabulary with which to discuss their own experiences.

I met a lovely Ukrainian woman at Burning Man who had found

a copy of *Tryptamine Palace* lying around in my camp, and immediately read five chapters of it before finding out that its author was asleep on his art car about 25 yards away—so she waited six hours for me to wake up so she could thank me. The woman had previously had two experiences on 5-MeO-DMT and experienced the same transpersonal zones that I encounter, and she too had returned convinced she had encountered the divine realms of the Infinite. But her friends had not had experiences like hers, and when she started telling people that she had no fear of dying and that she had experienced heaven—a liberating feeling I know only too well—her friends wanted her to get psychiatric help, because they were convinced she was going insane and was potentially suicidal. So she just stopped talking about her experiences altogether, and now she was going back home to beat her friends over the head with my book!

I also have received emails such as this following one:

I returned to the US recently after spending 2 months in the Peruvian Amazon dieting with plant medicines and drinking ayahuasca. Upon my return, I found myself virtually unable to relate to any of my friends, and sensitive to people's thoughts and energies to the point where I would answer questions before they were asked . . . I was barely able to ride in a car or walk down a busy street without feeling sick and panicking . . . conversely, for the first time in my restless existence, I find sitting in a quiet place in nature takes me into a state of rapturous bliss, much like the 5MDEs you describe in your book.

The reason I'm writing you this e-mail is to thank you for your profoundly helpful and provocative book. Much as *The Archaic Revival* was sent to you at a time when you desperately needed it, your book was spontaneously given to me a few weeks ago . . .

My time in the jungle has allowed me to untangle and release a massive amount of emotional turbulence, and had left me in a state where my intellect felt insecure because of the constant ego upsets and truths it was confronted with on ayahuasca. Your book has been

helping me bridge a gap between my spiritual understanding of the evolutionary process I am undergoing and the intellectual understanding that had really been neglected.

As I am sure you can imagine, when I get an email like that, or meet someone who really understands what I'm talking about like the woman at camp, I feel really blessed, and grateful that the Numinous has allowed me to be a vehicle to let positive helpful information flow through, and that *Tryptamine Palace* is out there doing some good. For just as Terence McKenna liked to say that he was a mouthpiece for the mushroom—he legendarily spoke for over twenty-one hours straight at one rave—I have to say that I didn't really write *Tryptamine Palace,* at least not in the conventional manner, for it wrote itself once it could get me to sit down. It was a steady flow of information that actually freaked me out at times—information and connections so seamless that I wondered if I was just making up these connections as I went along.

But the thing that separates *Tryptamine Palace* from most of the other books in this genre, at least in my opinion, and the reason I believe it has been some help to people who have experienced the same mystical zones that I have is the fact that, while my book is full of wild tales of my personal 5-MeO-DMT experiences, it also contains a proposed bio-quantum model for the entheogenic experience. It also suggests why this model can help us understand why certain individuals throughout history believe they have experienced a mystical insight into the nature of God, reality, and most importantly, themselves.

I believe that the 5-MeO-DMT experience is without a doubt a modern continuation of the original mystical experience that is at the roots of all religion and all spirituality that have appeared on this planet. I describe myself as a modern mystic—and not a shaman, as some people would like to label me—because mysticism is a continuation of a spiritual tradition that has been an important part of our own Western spirituality for thousands of years, and which, like it or not, is the system we have been hereditarily born into. I do not believe that rejecting our own spiritual history for those of some other cultures

is necessarily the answer to the dilemma that virtually all spirituality faces on Earth today. The descriptions given of the nature of God by virtually all mystics throughout history, irrespective of their culture, are in themselves remarkably similar—a void that is actually a plenum, an essential emptiness that is contradictorily a mystical fullness, a conscious cosmic Oneness of energy, information, and potential. It is a transcendental vision of reality, which is exactly how I would describe the field of infinite potential that smoking 5-MeO-DMT consistently allows me to experience. A field of energy that I myself had no choice but to name "God," even though I had not believed in God before I encountered this transpersonal Void.

During the course of writing *Tryptamine Palace,* my investigations and imaginations ranged far and wide, and within its pages I cover a number of topics other than quantum physics, including the parallels between both Eastern spirituality and the entheogenic experience, the near death experience (NDE), and smoking 5-methoxy-DMT; the relationship between the 5-MeO-DMT toads and the Mayan and Aztec Indians; my relationship with Burning Man; my experiences in India; and why William S. Burroughs should be known as the Godfather of DMT.

Perhaps not surprisingly, many of my fans seem to prefer the chapters dedicated to subjects other than quantum physics, and for a lot of people the more scientific chapters are harder to get through, even intimidating for some. But as my father would say, these chapters are where the real meat and potatoes lie, and this is where I believe that I may have made some original contributions to understanding the entheogenic experience, rather than simply regurgitating my own personal mythology. So instead of amusing you all with my wild tales of strange trips in strange places, I am going to concentrate now on the physics of my proposed bio-quantum model of the entheogenic experience, in the belief that understanding this will lead to the greatest elucidation. Once we get through this, I promise I will return to less technical fare.

To understand this model of a bio-quantum mechanism for the

mystical entheogenic experience, we will need to examine the following things:

1. The nature of consciousness.
2. The nature of light. We will examine what exactly light is, and is relationship, if any, to both our physical reality and our consciousness.
3. A quantum nature for consciousness. We will examine a recent model for consciousness based on quantum fluctuations within the neurons of our brain, proposed by Danah Zohar in her pioneering book *The Quantum Self.*
4. Resonance and the Bose-Einstein condensate. Danah Zohar's model is based on the existence of two rather bizarre conditions described by modern quantum physics: the phenomenon of resonance; and the unique and spooky energy state that is created through a special kind of ultimate resonance, which is called a Bose-Einstein condensate.
5. The zero-point/Akashic field. Hopefully I won't have either emptied out or put the whole dome to sleep by then, and we will examine a recently proven universe of energy that lies beneath our universe of matter at the lowest possible energy state, the state that energy occupies when it lies in a vacuum at absolute zero, known scientifically as the zero-point field, and more popularly, thanks to Ervin Laszlo, as the *Akashic field.*

This universal field of energy has been long suspected, rejected, abandoned, and rediscovered, and has now been scientifically proven; and while it is the energy of the vacuum, the ether that fills all empty spaces, it contains far more energy than our world of matter can even imagine. The physicist Richard Feynman calculated that one square foot of the cosmic vacuum contains enough energy to boil all the oceans of the world. While the knowledge and study of the zero-point field is less than twenty-five years old, this will prove to be the most paradigm-shifting discovery made by our science since Copernicus realized the Earth was not the center of the universe.

Back to my own search for understanding, which began with a series of questions that were generated by the 5-MeO-DMT experience itself. The first was phenomenologically the most obvious: what was the source of this tremendous inner light that I experienced when I smoked 5-methoxy-DMT, this tunnel of light that so uncannily resembles the descriptions of the NDE?

I reasoned that light is energy, and that this energy must have been produced from somewhere apparently within my brain or my consciousness itself. So I figured that I might as well start at the beginning of the mystery and examine the brain and consciousness itself. How do we form the visions that appear in our mind? What makes us dream? How can a light brighter than I have ever know appear in a room that is totally dark, with my eyes closed?

Since I didn't know much about the subject, I figured that modern neuroscience would be able to provide many of the answers, naively believing that the brain had long since been mapped and that the mechanism for consciousness was now well understood. But when I started reading up on the current state of consciousness studies, I was surprised to find out how little we really knew, and I soon realized that I had stumbled into the battleground for our definition of reality. For it is our belief about what consciousness is and how it works that dictates our basic structure and understanding of reality, and shapes the nature of the world we live in.

To further elucidate, to date in human history two major models of reality have been proposed. Each of these represents a diametrically opposing view of the role of consciousness. These same two models also best represent the polar views of Eastern and Western philosophy.

In the West, we subscribe to a view of reality known as *materialistic realism*. This view proclaims that there is nothing but matter and force, that all real things in the universe are solid, have mass, and exist in a very tangible way. This philosophy regards consciousness as a sort of annoying epiphenomenon—an accidental arrangement of neurons in organic matter that has led to our current human sophistication, and that has little if anything to do with the real nature of the universe

(despite the fact that the human brain is the most complex known structure in this universe).

This view of the universe has become particularly strong over the past four hundred years. It has been reinforced by the Industrial Revolution, which was itself the spectacular result of the discovery of a powerful logical tool we call scientific rationalization, or the scientific method. In the West we are born into a reality system where we have been taught that only physical things are real, and that the mental side of our existence belongs to some mythical realm we call "the imagination" that doesn't really have much effect on reality at all. If it's not physical, if it can't be weighed, measured, detected, then it's not real—that is the worldview that most of us in the West have inherited, even though the vast reshaping of our planet, which has taken place through these same sciences that seek to devalue the nature of consciousness, has clearly originated within our consciousness and our imagination.

Meanwhile in the East (and especially India), they have always had the diametrically opposite view of reality, believing that consciousness is in fact the primary force in the Universe. This viewpoint is called *monistic idealism.*

> *In this philosophy, consciousness, not matter is fundamental. Both the world of matter, and the world of mental phenomena, such as thought, are determined by consciousness. In addition to the material and mental spheres (which together form the immanent reality, or world of manifestation), idealism posits a transcendental, archetypal realm of ideas as the source of material and mental phenomena. It is important to recognize that monistic idealism is, as the name implies, a unitary philosophy: any subdivisions, such as the immanent and the transcendent, are within consciousness. Thus consciousness is the only reality.*
>
> INDIAN-BORN PHYSICIST AMIT GOSWAMI
> IN *THE SELF-AWARE UNIVERSE*

"Consciousness is the only reality." This is the kind of talk that tryptamine smokers can really get their metaphysical teeth into. Or as the Tibetan teacher Kalu Rinpoche puts it in another way, when asked to describe the essence of Buddhism in as few of words as possible: "You do not really exist."

So using the nature of consciousness as the starting point for my inquiry, my first question was, how could my consciousness, in a dark room, with my eyes closed, experience the tremendous field of light that 5-MeO-DMT propels it into? I gained a few insights from a fine book called *The Cosmic Serpent,* which is the story of a Swiss-Canadian anthropologist named Jeremy Narby's search for answers after he had his scientific, rationalistic world view turned upside down by ayahuasca. Narby began his investigation as I began mine, by looking into the nature of consciousness itself.

From Narby I learned that when I hold a book up and look at it, I'm not really seeing the book at all. What I am seeing is an internal 3-D reproduction that is constructed by my brain. I can never actually see the book; I can only see the photons of light that are bouncing off the book itself before striking my retinas. These photons are then broken down into electrochemical information that is sent on to the brain, where the nerve cells separate the information into categories such as form, color, depth, and movement. The brain then somehow puts it all back together, virtually instantly, into a coherent 3-D image—the vision that I actually "see" inside my mind. This forms the neurological basis for our consciousness, but everything beyond that remains a complete mystery to modern science.

From what I could gather, this seemed to be the limit of our current scientific knowledge about the brain and consciousness—that information, generally in the form of light (though obviously the brain can process sound and smell as well), is passed on by the sensory organs to the brain, which then goes about effortlessly, instantly, and seamlessly internally creating our sense of physical reality. Past that, we don't really know much at all.

So this is where I encountered the first bona fide mystery about

the smokable tryptamines: this current scientific model for consciousness is entirely dependent on sensory input: we need light to see, odors to smell, sounds to hear. Take away the sensory input, and we have *no* explanation for consciousness whatsoever. But we all dream, and many of us can close our eyes and either imagine or remember a scene or imagery. Universes of imagery are available to DMT smokers in rooms devoid of light, and these same DMT smokers often hear sounds and signals that are not heard by observers in the room, while 5-MeO-DMT smokers report dissolution into the brightest light that they have ever known, even if they are in a room as dark as the blackest night.

How is this possible? Modern physics states that energy cannot be destroyed, it can only be transformed, so according to science itself, the light that I experience from somewhere within my consciousness *must* be real and it *must* contain energy. But where is it coming from, and why does no one else in the room experience it? The more I researched this question, the more the scientific-rationalist approach to consciousness felt increasingly hollow to me, because consciousness is clearly far more than the mere processing of input.

Some six months after I smoked 5-MeO-DMT for the first time, I happened to be in India paragliding, and I ended up being either sick or injured for much of the time that I was there. I spent a lot of my time reading books about quantum physics and Eastern metaphysics, until the two of them began to read one and the same, with both the descriptions of the quantum realm from the cutting-edge of our Western sciences and the descriptions of consciousness from ancient Eastern philosophy resonating with my own 5-MeO-DMT experiences. At the end of my trip, while on a long, slow train ride back from the border of Pakistan, I then experienced a spontaneous flow of intuitions moving through my mind about the nature of consciousness and its relationship to light, until I finally came to the belief that light and consciousness are essentially the same, and that our human consciousness was the result of some matter-bound transformation of the universal light that was within all things. By smoking 5-MeO-DMT, I realized, my consciousness was somehow freed of this matter-bound constraint, and was

able to return to the infinite sea of light that all things originate from, thus recognizing its own infinite nature.

All of this came from thinking about a quote that I saw in a spirituality column in the the *Times of India,* attributed to Krishna, where he tells Hanuman that "nothing is faster than mind." I got to thinking about this, and I thought, what if that was literally true? What if mind—or should we say consciousness—could move faster than light, despite what Einstein's Special Theory of Relativity suggests? What would happen then?

Consider this quote about light from the book by physicist Peter Russell, *From Science to God.*

> Since light travels at the speed of light, let's imagine a disembodied observer (pure mind with no mass) traveling at the speed of light. Einstein's equations would predict that, from light's own point of view, it travels no distance and takes zero time to do so. This points to something very strange indeed about light. Whatever light is, it seems to exist in a realm where there is no before and no after. There is only now.

Bingo! I thought when I first read this. That's exactly where my consciousness goes—to a place with no sense of time, no divisions, only an omnipotent all-encompassing NOW! So I began studying more and more about this strange and wonderful thing called light that, much like consciousness, we take so for granted and actually know so little about. And before long I started to find explanations within quantum physics that basically propose that our entire universe of matter is simply light moving at speeds slower than light, and that the source of this light is no longer assumed to originate from within our universe of matter at all. Rather, our universe of physical things materializes in and out of another energetic universe that is entirely made of light, and surrounds us—inside and out—at all times.

One of the prime architects of this radical new view of reality was the British physicist David Bohm, who wrote an increasingly influen-

tial book in 1980 titled *Wholeness and the Implicate Order*. According to Bohm, the universe of matter that we occupy is only one part of an "integrated whole" that includes other universes of energy and information. We are only capable of sensing one of these universes, or dimensions of reality, if you like—the one accessed by our five basic senses. But according to Dr. Bohm, matter and mind exist in different dimensions and "enfold" and "unfold" into each other, creating an unbroken wholeness of both fields and particles. True reality is thus an infinitely multilayered, multidimensional wholeness, while what we consider "reality" is only a fragment of that Whole, like the froth of a wave.

This description of reality, when I first read it, seemed like the best description of the transcendent state of a 5-MeO-DMT experience that I had been able to find. Bohm also states that matter is "condensed, or frozen light"—which is to say light moving slower than the speed of light (Nichol, *The Essential David Bohm,* 152). Just as Eastern metaphysics and my own intuition were telling me that light and consciousness are the same thing, and that if my consciousness could be freed of the physical restraints of its mass—i.e., of my body—then it would instantaneously return to the ocean of light that it originates from. Cutting-edge quantum physics now informed me that *everything* is basically an ocean of light that somehow gets condensed or slowed down to form the essential particles that make up the universe of matter.

All matter originates from light. All organic matter originated as particles of light, and is sustained by the light of our sun. Life on this planet is a continuing process of light evolving into more and more complex forms, evolving toward our current consciousness itself—which is where it can begin to stare its own origins right in the face.

So what if the light that I am encountering during my 5-MeO-DMT experiences actually originates from this infinite ocean of light that this entire universe of both matter and mind is proposed to originate from? This idea doesn't make any sense if we use the old Western model of consciousness as an accidental by-product of the chemicals in our brains bouncing around—the idea that the physical matter of our brain actually *generates* consciousness like some kind of a biochemical machine.

The entheogenic experience promotes a different possibility (suggested by Aldous Huxley), the idea that the brain actually *receives* consciousness, just as a TV or a radio or your laptop receive a signal. According to the model of reality proposed by David Bohm, this primary consciousness exists as an infinite holographic field that interpenetrates everything in the Universe.

Then as I searched for other models of consciousness that made more sense in relationship to my 5-MeO-DMT experiences, I came across a very convincing quantum theory about the nature of consciousness, proposed by an American writer, Danah Zohar, in collaboration with her psychologist husband I. N. Marshall.

In his introduction to *The Cosmic Game,* the psychiatrist Stanislav Grof states that no one has ever proposed a working mechanism for human consciousness. However, in her pioneering work *The Quantum Self,* Danah Zohar does in fact offer us a convincing mechanism for how human consciousness may operate, based on quantum fluctuations within the neurons in our brain. According to this theory, human consciousness is due to an intense field of coherence that is caused by resonance amongst these estimated 100 billion neurons; this extreme form of coherence is called a Bose-Einstein condensate (BEC), which was first proposed in a series of letters between Einstein and the only Indian physicist who is considered one of the fathers of quantum physics, Satyendra Nath Bose.

Zohar began her enquiry into consciousness in *The Quantum Self* by considering the fact that although our consciousness receives numerous streams of information and outputs untold signals and orders to make our bodies work, we do not perceive these inputs and outputs as being individual, but instead we perceive them all as an unbroken whole, much like a mini version of how the universe operates as proposed by David Bohm. Which is to say, if you see a fire in front of you, and your hand feels the pain of burning, and you hear a shout of warning from a friend, you do not process these as three separate inputs and then order your hand to pull back. Instead your consciousness perceives these events as an unbroken reality, and your hand pulls back even before your mind has registered what is going on. The same is true of

breathing, sweating, smelling, and the hundreds of thousands of other commands that are circulating instantaneously throughout your body at any given moment.

Zohar went looking for a mechanism that could explain the unbroken wholeness of our consciousness, and she came across this supreme state of resonance, the BEC, which is the highest known form of coherence in the universe. Bose-Einstein condensates were originally discovered within the field of superconductors, which occur when elements like helium have their energy state lowered all the way down to absolute zero—which is that zero-point energy state I keep talking about. In this lowest possible energy state, all the helium atoms begin to resonate together into a BEC. When this happens, something very, very, strange also happens: the distinguishing feature of a BEC is that the many parts that go to make up an ordered system not only *behave* as a whole, they actually *become* whole. Their identities merge or overlap in such a way that they lose their individuality entirely, and in the most physical of senses, many-becomes-One.

Which is fascinating if you're talking about superconductors operating at absolute zero, but what does that have to do with the hot, messy biology of human consciousness? Well, this is where things get even stranger again, for it turns out that Bose-Einstein condensates are proposed to exist within living tissue, within something called a "pumped system" first described by Professor Herbert Fröhlich in the 1970s.

Fröhlich's pumped system is simply a system of vibrating, electrically charged molecules—these are called dipoles, positive at one end, negative at the other—into which energy is pumped. As they jiggle, the vibrating dipoles, which are molecules in the cell walls of living tissue, emit electromagnetic vibrations—virtual photons—just like so many miniature radio transmitters. Fröhlich demonstrated that beyond a certain threshold, any additional energy pumped into the system cause its molecules to vibrate in unison. They do so until they pull themselves into the most ordered form of condensed phase possible—a Bose-Einstein Condensate. (In Zohar, *The Quantum Self*)

So these Bose-Einstein condensates, which exist within supercon-
ductors at absolute zero, can somehow also exist within the living biol-
ogy of our own tissue. Now we can imagine helium ions, or the neurons
in our brains, in essentially the same way: as vessels of charge, with a
positive on one end and a negative on the other, all floating around like
tiny compasses, all pointing in different directions.

Ervin Laszlo, a Hungarian systems theorist who is one of the great
"Renaissance" thinkers of the twentieth century, tells us this about the
human brain in his book *Third Millennium:*

> The evidence that surfaces, surprising as it may be, indicates that
> our brain is not limited to the neural processes that go on within
> our cranium—it is a wide-band receiver and high-powered proces-
> sor of information. This information it receives originates not only
> in our own body, but comes from all over the world. The brain's
> ten billion neurons, with 10,000 connections each, constitute the
> most complex system of electronic organization in the known uni-
> verse. This system, which operates at the edge of chaos, receives and
> transforms information from our own body, as well as the electro-
> magnetic, acoustic, and other wave fields in our environment. It also
> receives and decodes information from more subtle fields, including
> the vacuum's zero-point holofield. Potentially, our brain connects us
> with the wide reaches of the cosmos.
>
> As mystics, prophets, and people of insight and sensitivity intu-
> ited through the ages, our brain is an integral part of the universe,
> and our mind is a potentially open window on it. It is up to us to
> throw open that window, to the full extent of our remarkable, but
> hitherto largely unexploited, physical and mental capacities.

There are as many neurons in our brain as there are stars in the
Milky Way—over ten billion. It's an evolved processor of unimaginable
complexity, nothing like it exists in the universe that we know of, and
its role appears to be to lift us above mute survival, so we can gaze out
in wonder at the mystery of the universe. My entheogenic intuition

about the nature of reality resonates with Danah Zohar's view that consciousness is a quantum process, and that the brain is a highly tuned antenna designed to receive a universal signal that each of us then interprets in our own unique way, through the lens of our physical existence. Coherence occurs when these ions or neurons pull into resonance. This is analogous to a situation where you put a magnet close to a number of compasses, and they suddenly all start pointing in the same direction. Danah Zohar proposes that our consciousness is formed by a certain amount of coherent resonance between a large number of these neurons, for example, let's say 70 billion of these internal "compasses" deciding to point the same direction, with a few billion "offline" as activity moves around in the brain.

Now here is where my theory starts to appear. If you could get all the neurons in your brain to click into coherent resonance, they will produce a Bose-Einstein condensate. Every single atom, or every single neuron, actually ceases to retain an individual identity. In this state of supreme resonance they actually become One, a seamless unified Whole. Such a physical event is identical to the psychological union that occurs when the lens of our ego is destroyed by 5-MeO-DMT and you experience a transpersonal integration with the entirety of the universe—and remember it is not that you simply experience the entirety of the rest of the universe, you *are* the entirety of the universe. You have ceased to exist separately, you only exist as part of the whole—and in fact, you no longer exist individually at all. One of my favorite metaphors of the 5-MeO experience is that you are a drop, and then you return to the ocean. Just as a drop of water can no longer distinguish itself from the rest of the sea, so too my consciousness can longer distinguish itself from the whole of the cosmic ocean.

Over the past decade I have become increasingly fascinated by the possibility that it is coherence within the highly-polarized microtubule system (that creates the cytoskeleton within the cells and neurons of the body) that creates a BEC during an entheogenic experience. Consisting of tiny protein tubules on the edge of the quantum scale, the cytoskeleton formed by these microtubules is essential to the morphogenetic

process of an organism's development, and to the formation of the nervous system in higher vertebrates. While there are as many neurons in the brain as there are stars in the Milky Way, there are as many microtubules in the human body as there are stars in the entire Universe, making this internal "scaffolding" the most complex known system in the Universe. The Penrose-Hameroff model* (orchestrated objective reduction: "Orch OR") proposes that quantum superposition and a form of quantum computation occur in microtubules, with the microtubule scaffolding acting like "the internet of the body," allowing for non-local communication within the cells. But instead of a rigid scaffolding, I envision this microtubule structure more as a very fine net being buffeted in waves by the quantum sea . . . the "micro-movement" caused by this buffeting is what then converts the quantum signal into biochemical information in the body at the Planck-scale.

A quick recap: I propose that consciousness is a universal field that our brain receives from the underlying universe of zero-point energy from which we now believe all reality originates. David Bohm predicted that this field of energy had to exist, and Danah Zohar proposes that our individual consciousness is created by the billions of neurons (or the even more complex microtubule system within the cells and neurons, as suggested by Roger Penrose and Stuart Hameroff) in our brains, forming a powerful state of coherence known as a Bose-Einstein condensate (BEC).

It is my belief that the greater the coherence of one's own consciousness, the more this zero-point light can flow into our minds. Within

*In the Penrose-Hameroff Orch OR model (proposed by physicist Roger Penrose and anesthesiologist Stuart Hameroff) reduction of microtubule quantum superposition to classical output states occurs by an objective factor: Roger Penrose's quantum gravity threshold stemming from instability in Planck-scale separations (superpositions) in spacetime geometry. Output states following Penrose's objective reduction are neither totally deterministic nor random, but influenced by a non-computable factor ingrained in fundamental spacetime. Taking a modern pan-psychist view in which protoconscious experience and Platonic values are embedded in Planck-scale spin networks, the Orch OR model portrays consciousness as brain activities linked to fundamental ripples in spacetime geometry.

superconductors, a Bose-Einstein condensate has been proven to force other, weaker (less coherent) condensates into higher states of coherence. So if any of you have experienced being tongue-tied around a high Rinpoche or spiritual teacher whom you thought you had a bunch of questions to ask, you are experiencing your own field of energy spontaneously attempting to become more coherent, generally at the expense of the weaker ego structure. I believe that this is how the master-pupil relationship in the East works, and I also believe that this is the foundation upon which shamanic healing can be performed: the shaman's energy field enters into resonance with the patient's, aided by doses of ayahuasca, peyote, San Pedro, and so on. Disease itself, by contrast, will ultimately prove to be a low level of coherence within the organism.

Therefore the light that I experience during a 5-MeO-DMT experience is always there. It's just that when I smoke 5-MeO-DMT, the neurons in my brain create a Bose-Einstein condensate, allowing an experience of total coherence with Source. At this point I am stripped of the shell of my ego and my identity, and the universal nature of mind and the universe is spontaneously revealed as consciousness (light) without form or identity. This is what the Tibetans would call the spontaneous eruption of *rigpa,* or the nature of Mind (which is also believed to appear as a field of light).

The more coherent your consciousness is, the more the light comes in. This idea has been proposed by countless mystics and spiritual teachers for centuries, and it is a model with which quantum sciences are beginning to agree. These concepts of coherence and the Bose-Einstein condensate provided me with a very important part of my model for understanding the 5-MeO-DMT experience, for they predict a connected reality that is identical to the one that I experience on 5-methoxy-DMT, and they can be applied over and over again to explain various facets of the transpersonal entheogenic experience.

But there were still a lot of unanswered questions. For starters, while I was now sure that light and consciousness were linked entities, I wasn't really sure I understood where this light was supposed to be originating from. And none of these explanations really pointed toward

any reason why I was so sure I had realized the true nature of God, or even why I now so firmly believed that God exists. So my search now moved from the nature of consciousness to the nature of physical reality. Following the path that David Bohm predicted in the eighties with his theories of Wholeness and the Implicate Order, I soon found myself investigating an aspect of our universe that had previously been completely unknown to me—the existence of what was initially known as the quantum vacuum, or scalar fields, and which physicists now refer to as the zero-point field.

The zero-point field in many ways resembles both the ancient Hindu concept of *akasha,* and the Greek idea of the ether field revived by the English physicists in the nineteenth century; the idea that the so-called empty spaces of the universe were actually occupied by an invisible energetic element. Early twentieth-century science mostly abandoned the ether hypothesis after the Michelson-Morley experiment of 1887 failed to detect the motion of the Earth through the ether. Ether theory was subsequently considered dead after the publication of Einstein's special relativity theory in 1905, the mathematics of which seemed to eliminate any need for the existence of such an ether, even though Einstein himself said it was still possible that an energetic ether field exists. During the first half of the twentieth century, Nikola Tesla was the last great proponent of ether theory; the "dynamic theory of gravity," which he was working on at the time of his death in 1943, presumed the existence of a luminiferous ether that filled all space, and that at speeds approaching light is thrown into infinitesimal whirls or micro-helices, and becomes ponderable matter. He died without finishing his unified field theory, and this would be the last serious consideration of the possibility of an ether field for more than thirty years. (All Tesla's papers were confiscated by the FBI at the time of his death and have never been released.)

Then very recently, science has proven is that there is no such thing as a vacuum, no such thing as empty space at all: for what we previously thought was the empty space between things as big as galaxies and as small as electrons, is in fact occupied by an infinite sea of light. This

infinite field of light—which we can't see with the human eye because the wavelength is so short and because it surrounds us and emanates from us in every direction—was once known as the "quantum vacuum" or "scalar fields," but is now mostly called the zero-point field. The existence of this counter-universe of light has been experimentally proven, and is universally accepted as a fact by today's physicists. Here is NASA astrophysicist Bernard Haisch's explanation, from his book *The God Theory*, of this radical redefinition of physical reality.

Esoteric traditions attribute primacy to light rather than to matter, which is intimately connected with time and space. Arguably matter cannot exist apart from time and space, and is dependent upon them. Einstein's relativity theory also suggests that space and time are defined by the propagation of light. So the key to creation does seem to lead back to light, in the context of both the ancient traditions and modern physics. From the point of view of a beam of light, all distance reduces to zero and all time comes to a halt. While you can argue that no true observer can ever "ride" a light beam or a photon to make such an observation, the point here is that the inference of no time and no space for the reference frame of a light beam is a legitimate limit of the transformation equations of special relativity. That much is scientific inference, not fuzzy speculation.

A beam of light, or the smallest quantum bundle of light called a photon, moves through space and time at a fixed pace of 186,000 miles per second—at least from your material perspective. From its own perspective, however, there is no space or time. Herein lies what I suspect is a profound connection between the basis of space and time, and light in the form of the zero-point radiation of the quantum vacuum. I propose that light may be the progenitor of an apparent universe of matter. In some sense, "slowing down" ever so minutely from that privileged, timeless, spaceless reference frame of light manifest[s] a realm of space and time. In other words, space and time are created when you leave the reference frame of light.

Einstein's special relativity theory tells us that light propagation

defines the properties of space and time. I argue that light propagation may actually create space and time. The zero-point field inertia hypothesis implies that the fundamental property of matter, namely mass, is also created by light.

This passage confirms one of my basic intuitions from my time in India: our universe of matter is light slowed down. To my astonishment, I also found that within the countless fields that make up the zero-point field, there is assumed to be a field that is identical in its mathematics to the coherent field that Danah Zohar proposes as the basis for our consciousness. Holographic in nature, crystalline in structure, this field is believed to operate on the same proposed principles of human quantum consciousness, and is capable of carrying the infinite amount of information generated by the material world.

Which is to say that the Bose-Einstein condensate that is created by coherence within the 10 billion neurons* in your brain, and is hypothesized to produce the "wholeness" of consciousness, is believed to be a microcosmic replica of the universal field of infinite proportions—a proposition which immediately brings to mind the Hermetic statement "As above, so below," and provides us with the first scientific model for the Mind of God.

Let us briefly look closer at some of the potential properties of the zero-point field in this quote from Michael J. Coyle, found in Ervin Laszlo's *The Connectivity Hypothesis.*

The quantum vacuum is a kind of neo-ether through which all matter and energy evolves in continuous nonhertzian communication. The neo-ether model posits that the vacuum state has the same properties as a dynamic holography crystal: it infinitely stores the diffraction patterns of matter-energy systems in a nontemporal and nonlocal fashion analogous to holographic information storage throughout the recording material. Due to quasi-infinite superposi-

*Or the millions of billions of microtubules.

tion possibilities, the quantum vacuum is the source of all possible matter-energy states and parallel universes. Individual states can be selected using a fundamental form of holographic, self-referencing, phase-conjugate mirror-like process. This process accounts for the non-locality observed in biological organisms as well as in consciousness. (Laszlo, *Connectivity Hypothesis,* 64)

What is being proposed here is that the zero-point field contains within it an imprint of all temporal existence. So while it is the underlying universe of potentiality, it also contains a record of every wave of existence of every matter-energy form that has ever existed. In a sense, our existence is in-forming the universe, or as William S. Burroughs liked to put it, We are all writing our report.

So it is my proposition, as an entheogen user, that 5-MeO-DMT briefly increases the coherence of the brain into the supreme act of coherence—a Bose-Einstein condensate in resonance with the "absolute" BEC of the zero-point field. When this happens, the two BECs would actually cease to be separate—they would truly become One—and consciousness, freed of the anchors of matter and the focused blinders of the ego structure, would experience unity with both the Source, and the record of the entire universe—which is the cosmic God-consciousness that we all share. Our human consciousness is basically a filtering mechanism—it filters (and slows) the divine white light down to create our material existence—time and space—just in the same way that white light shined through a film creates filtered images on a screen. But if you smoke 5-MeO-DMT and resonate with that white light, you leave the world of the material behind, and your consciousness virtually instantaneously returns back to the transpersonal realm from which all things—both material and mental—emerge.

Does this sound far-fetched to you? Consider this passage from Ervin Laszlo, the father of systems theory, and one of the most remarkable renaissance men of our times. (A former concert pianist who didn't start studying physics until he was in his forties, Laszlo has also been nominated for the Nobel Peace Prize—twice—among his numerous

achievements.) Laszlo has written several books about the zero-point field, which he has renamed the *Akashic field* in recognition of the ancient Hindu intuition of its existence. In these books, Laszlo turns his attention to both mystical insight and the entheogenic experience.

> To begin with, even if we cannot directly observe consciousness in the vacuum, we could attempt an experiment. We could enter an altered state of consciousness and identify ourselves with the vacuum, the deepest and most fundamental level of reality. Assuming that we succeed (and psychotherapists tell us that in altered states people can identify with almost any part or aspects of the universe), would we experience a physical field of fluctuating energies? Or would we experience something like a cosmic field of consciousness? The latter is much more likely. We have already noted that when we experience somebody else's brain "from the outside," we do not experience his or her consciousness—at the most we experience gray matter consisting of complex sets of neurons firing in complex sequences. But we know when we experience our brain "from the inside," we experience not neurons, but the qualitative features that make up our stream of conscious thoughts, images, volitions, colors shapes, and sounds. Would not the same hold true when we project ourselves into a mystical union with the vacuum?

Cosmic consciousness. God-consciousness. The revelation that there exists an infinite in-formed holographic field that permeates all things, that was there long before your ego-mind was born, and will be there long after your material body dies. This is the mystic's plenum, the Void that is an absolute fullness, a transcendental Oneness beyond the boundaries of language, understanding, even thought . . . the Mystery of mysteries from which I believe our human consciousness has evolved, along with the very structure of the multiverse itself.

A conscious holographic realm of infinite energy and transcendental information that I could find only one word with which to describe it when I returned from my first encounter, and the same name—in

different localized forms—that virtually all mystics have given it throughout time: *God*. I now believe that God must have been the first word, the first sound attached to an idea after a monkey-mind swam in the infinite ocean of the transcendental for the very first time. After this radical experience (probably thanks to psilocybin mushrooms, as R. Gordon Wasson first proposed) the proto-man returned equipped with the Promethean gift of language, with the ability to link meaning with sounds and sacred symbols and imagery. Awe-struck, *God* was the surely first word that this now more-than-a-monkey shouted out at the startled world, and the tens of thousands of culturally bound permutations of the word that our species has created to express that singular experience, make up the tower of Babel we have built on our path toward the ultimate realization of the transcendent nature of the Word.

"Existence!" the Dalai Lama says, "It is this wonderful thing . . . a bridge between the finite and the infinite," and that is where we stand, one foot rooted in our mortality, while the other, like a dancing Shiva, searches for a footing in our transcendental immortality Now that we have made it through the physics part of this lecture, I would like to consider the nature of transpersonal experience, and what effect the recognition of a holographic nature of God might have on future human society. For as Fritjof Capra stated in *The Tao of Physics* more than forty years ago, "Science does not need mysticism, and mysticism does not need science, but men and women need both" (297).

Since I have now explained how I believe it is scientifically possible to have a genuine mystical experience from smoking 5-MeO-DMT, I would like to state that I believe it is imperative that the so-called entheogenic movement, if such a thing even exists, embrace unequivocally the belief that entheogens are truly windows to the sacred, and not merely curiosities that somehow trick and confuse our mechanical consciousness.

In 2011, a few years after my own (legal) introduction to the compound, the DEA classified 5-methoxy-DMT as a Schedule 1 drug along with its close cousins DMT and LSD, making our most effective entheogens amongst the most illegal things on the planet.

I believe that the only way we can combat this, and eventually see all psychedelics legalized, is by fighting for the rights of Cognitive Liberty, and for the ancient human right to use entheogens for the purpose of our own spirituality. The persecution of psychedelic users in this country and others around the world may be the last great battle for religious freedom—for we should be free to find God in any manner or form, and your American Constitution is supposed to guarantee you that right.

In 1965, Walter Panhke performed an experiment in which he gave thirty divinity students either a placebo or psilocybin at the Marsh Chapel at Harvard University on Good Friday. Over 60 percent of those students who got the psilocybin reported having a primary (mystical) religious experience, and in a follow-up some thirty years later, the majority of these students—many who went on to become clergy—rated it the most significant spiritual experience of their lives. Almost forty years later, a follow-up experiment at Johns Hopkins by Roland Griffiths and his team demonstrated a 65 percent success rate with stricter protocols. These are solid experimental results from highly respected American academic institutions—and this is the kind of evidence that we will need to fight the battle for legalization at the level of the Supreme Court. But to do that, the entheogenic movement, and many of us, will have to get over our aversion to using the word *God*.

We have undoubtedly developed this aversion because of the many excesses that the organized religions of the world—especially the Western ones—have perpetrated in the names of their various gods and goddesses. As the British existentialist writer Colin Wilson once wrote, "All religions begin like a mountain stream, and slowly turn into a rather muddy river" (Wilson, *The Occult*). But having experienced what I believe to be the transcendental reality of what I recognize as God, and realizing both that my belief is identical to that of all mystics throughout all times, and that an explanation for this belief can be supported by the cutting-edge discoveries and theories of numerous thinkers in multiple scientific disciplines around the globe, I can no longer see any reason to abhor the word *God*.

In fact, I believe that our battle as entheogen users should be to reclaim that word, and to create a worthy modern metaphor for God. All descriptions of the transcendental infinite can only be metaphors, and we urgently need to create a metaphor that is worthy of the miraculous mystical discoveries of our time. For we are the sharpened spearhead of humanity, we are the ones who have had what the psychologist Abraham Maslow describes as the "absolute peak experience," which he believed was the ultimate achievement of being human, and something that occurs only for a tiny fraction of the human population. We are the 5 percent who have to help humanity move into its next phase, the recognition of our own divine origins, and the ensuing realization that we must be the caretakers of our planet, not its consumers. And the way we can do that is by promoting the belief that the real nature of God is both quantum and transcendental, beyond words, imagery, even thought, and that, miraculously, with the sacred use of entheogens—in plants from all around us, even in the venom from a toad!—we can experientially enter into a mystical resonance, even a dialogue of sorts, with that same infinite transcendental Source. For as they say in the East, *Thou art that!*

One of the great teachers I appreciate the most these days is the master mythologist Joseph Campbell. Close to the end of his remarkable life, Campbell delivered a lecture based on the theme that humanity's future mythology would have to incorporate the new scale of the universe that it is discovering. Campbell asserted that our society has totally lost the ability to understand metaphor in myth or religion, and that it is the dogged insistence of the Western religions on regarding universal spiritual metaphors, such as Moses parting the Red Sea, the Virgin Birth, or the physical ascension of Jesus to heaven, as if they were actual factual events—even though these metaphors run contrary to the established science of our times—that has caused many in the West to lose their religion.

According to Campbell in his book *The Inner Reaches of Outer Space,* the use of universal metaphors can be timeless and transcendental, and these are vehicles to greater truths.

"Have you not heard," asked Nietzsche, already in the introduction to his "Thus Spake Zarathustra" (1883–84): "Have you not heard that God is dead?"—the god in point, of course, being the named and defined creator-god of the historically limited Bible. For the conditions, not only of life, but of thought also, have considerably changed since the centuries of the composition of that guide to truth and virtue, which by its deliberately restricted and restricting ethnocentric horizon and tribal "jealous God" (Exodus 20:5) is culture specific to such a degree that its "folk ideas" and "elementary ideas"* are inseparably fused.

The first step to mystical realization is the leaving of such a defined god for an experience of transcendence, disengaging the ethnic from the elementary idea, *for any god who is not transparent to transcendence is an idol, and its worship is idolatry.* Also, the first step to participation in the destiny of humanity today, which is neither of this folk or of that, but of the whole population of the globe, is to recognize every such local image of a god as but one of many thousands, millions, even perhaps billions, of locally useful symbolizations of that same mystery beyond sight or thought which our teachers have taught us to seek in their god alone. Black Elk's phrase, "The center is everywhere" is matched by a statement from a hermetic, early medieval text, *The Book of Twenty-four Philosophers* (*Liber XXIV philosophorum*): "God is an infinite sphere, whose center is everywhere and circumference nowhere." (Campbell, *Inner Reaches of Outer Space,* 17–18)

I am proposing that the entheogenic movement needs to unite round the all-encompassing concept of a transcendental God that is the

*Campbell is referring here to terminology coined by Adolf Bastian (1826–1905), the German ethnologist of the nineteenth century, to define certain reoccurring mythic motifs common to all the religious traditions of the world. Bastian identified "folk ideas," *Volkergedanken,* as localized representations and applications of the universal or "elementary ideas," *Elementargedanken.* Carl Jung (1875–1961) would later redefine these mythical motifs as "archetypes of the collective unconscious."

origin of all religion, and that this transcendental reality can be experienced through the sacramental use of entheogens. If you have heard the call, if 5-MeO-DMT or any other potent entheogen has upended your world as it has upended mine, and you have experienced the same transcendental reality that I have, then you have been called, just as I believe I have. Now it is time for us to try to change the world, or at least to set a course for the humanity that survives the next fifty years— which I think everyone can agree, no matter what happens, will be a half-century like humanity has never known before.

What happens when you have a genuine entheogenic epiphany is exactly the same as when you have any genuine spiritual epiphany. You are changed from the very core of your being, because your reality is transformed. The person you were no longer exists; you see the world with totally fresh eyes; you are like a baby, but somehow you possess more energy, strength, resolve—and you feel a deep sense of thankfulness and responsibility for the gift of understanding that you have received. You feel the need for action. My first action was the writing of *Tryptamine Palace,* and my second is standing here before you and telling the story of my spiritual conversion despite the fear of ridicule. These actions are my first steps in becoming what the school of radical Christianity known as liberation theology would call a *contemplative activist.*

Liberation theology, which began in Latin America, focuses on the twin actions of mystical insight and pragmatic activism. It is being practiced in more than a million small communities worldwide, where its effectiveness amongst some of the most repressed and most neglected peoples in the world has made it both feared by the authorities and suppressed by the Catholic Church* from which it came, as it is regarded as the "only theology of radical, and even revolutionary, social and political action" (Cairns, "The Theology of Human Liberation and Entheogens").

*Liberation theology, which had effectively been squashed during the late 1970s by the Catholic Church for its allegedly socialist roots, is now being reassessed and reinvigorated thanks to the more liberated views of Pope Francis.

Obviously liberation theology is being practiced by a new wave of radical Christian activists who are trying to get back to the roots of Jesus's original teachings. But the idea can be applied to any kind of spiritual epiphany. What I find interesting about it is the fact that there is thought to be a double action to a genuine spiritual epiphany—one that can be both mystical *and* political. There is not first the mystical and then the political: the political is of the substance of the mystical, since the contemplative experience leads one to understand how the inner work and the outer work are irrevocably entwined:

> In fact, contemplative activists are some of the most effective agents for encouraging the liberation of individuals and systems in all of human history. They are the persons whose inner practice overflows into the public sphere in exceedingly effective and powerful ways. They heal the split and expose the great fallacy through their prayers and actions. Consider this short list of action in the 20th Century who have had contemplative awareness: Gandhi, Martin Luther King Jr., Thomas Merton, Mother Teresa, Thich Nhat Hanh, and the Dalai Lama are but a few. These people embody the contemplative potentialities of what it is to be human and to act effectively on these understandings. (Cairns, "The Theology of Human Liberation and Entheogens")

The realization that accompanies a spiritual awareness of the interconnectivity of all things is, first and foremost, experiential. This experience has been reported by individuals throughout history and has never been successfully explained—and if it happens to you, the experience is so paradigm-shattering that you have no choice but to believe in it. You know it is "true enough" to paraphrase Alfred North Whitehead, a knowledge that comes from an inner "faith"—a word that used to make my skin crawl. This is *gnosis* at its purest form, and if you accept the full implications of that gnosis, then you are no longer a creature of chance alone in the universe—you are an informed being, carrying a heavy responsibility for a newfound purpose.

In *The God Theory,* published in 2008, Bernard Haisch, a NASA astrophysicist and one of the key investigators into the zero-point field, proposes the following:

> I propose a theory in this book that does provide a purpose for our lives while at the same time being completely consistent with everything we have discovered about the universe and about life on earth, in particular, the Big Bang, a 14.6 billion-year-old earth, and of course, evolution. The single difference between the theory I propose and the ideas current in modern physics is that I assume that an infinite conscious intelligence preexists. You cannot get away from the preexistence of something, and whether it is an ensemble of physical laws generating infinite random universes or an infinite conscious intelligence, is something present day science cannot resolve, and indeed one view is no more rational than the other.
>
> One might argue that one view is supported by evidence and the other is not. I would agree one hundred percent. The evidence for the existence of an infinite conscious intelligence is abundant in the accounts of mystics and the meditative, prayerful, and sometimes spontaneous exceptional experiences of human beings throughout history. The evidence for random universes is precisely zero. Most scientists reject the former type of evidence as merely subjective, but that simply reduces the contest to a draw, zero on both sides. (Haisch, *The God Theory,* xi)

As we stand on the precipice of a previously unimaginable ecocide completely of our own making, if there has ever been a time in history for us to break that draw, the time is now. And we entheogen users are on the front lines, so to speak, for we are rediscovering one of the most powerful conduits to the Divine ever known to man. The use of entheogens has gone hand in hand with humanity's quest for spirituality until comparatively recently, and in our own times there can be no doubt that the invention of synthesized psychedelics, and now the reintroduction of traditional plant entheogens have led to the

most radical reappraisal of Western spirituality since the Reformation.

The concept of Gaia—the idea that the planet is a singular linked organism or entity—and the environmental movement that was born from this realization—largely came from the experimentation with LSD by the Western youth and intelligentsia, and the resulting rediscovery of the transpersonal experience. The fact that Röntgen discovered radiation the same year that mescaline was first isolated in 1897, or that the discovery of the psychological effects of LSD in 1943 occurred within months of the completion of the Manhattan Project, does not seem coincidental to me either; rather I believe we were delivered an instrument of light at the same time we invented weapons of terrifying darkness. So it is my hope that as LSD helped us to come to a greater understanding of our relationship to our planet, then 5-MeO-DMT can help us to come to a better understanding of our relationship with our universal God, the transcendental God that all of humanity shares, and that is the root of all human spirituality.

In a remarkable book published in 1973 called *Small Is Beautiful: Economics as if People Mattered,* the economist E.F. Schumacher wrote, "The task of our generation, I have no doubt, is one of metaphysical reconstruction." Schumacher's book was very influential at the time (California's own Jerry Brown took time off from his gubernatorial campaign to attend Schumacher's funeral in 1977) but the book's central message—that we need to return to human-scale, village economics as quickly as possible if we don't wish to consume all the planets resources in one five-hundred-year flash—remains mostly ignored.

I wrote this section from *Tryptamine Palace,* titled "A World in Crisis," all before the economic crash of 2008, so things have slowed down a bit as the economy slipped into recession, but the system that is in place needs to get the industrial-military complex firing on all cylinders again.

Not long after I first smoked 5-MeO-DMT, I was looking in a mirror in a bathroom one day, and an idea jumped into my brain as loud as a shout or a command: *Find the tribe!* After some reflection,

I took this as a sign to search for the enlightened society of 5-MeO-DMT-smokers that I believed existed (probably on the West Coast) who, for some unknown reason, had been keeping this revolutionary compound under wraps. Which led to my toading adventures with Yaron, and to my return to Burning Man. But I eventually realized that this tribe probably didn't actually exist. At which point, the message seemed to change (or maybe I had got it wrong the whole time). The message now was: *Find* your *tribe. Build* your *tribe. And quit pissing around and get started.*

Find your tribe? Build your tribe? Noah, go into the hills, and make an Ark! Sounds like "crazy people talk," right? The only problem is, if you take a long cold look at the state of the world, it might actually be the only sensible advice.

As we near the end of the petro-chemical paradigm, we are beginning to witness the enormous pains that will accompany our civilization running out of oil. Two hundred years of burning up the planet's non-renewable resources have created an unprecedented explosion in the human population and its domestic species. We are within half a century of that massive energy-bank, which took 3.8 billion years to create, running out. History, if our species continues to have such a thing, will undoubtedly consider this period of our civilization completely insane . . . (for as I have said before, our species is suffering from "Extinction Denial." The blindness of contemporary society is without precedent, particularly since there are so many educated voices who are now shouting at the top of their lungs that Rome is about to fall. But if you are logical and you have been paying attention, using "all the available facts to form the best hypotheses," then you don't need to be a genius to see that there is no way out of this blind alley that the Industrial Revolution has led us down. If you have crunched any of the wide variety of astonishing numbers that are readily available to demonstrate the exponential rate of increase of our expanding-population's consumption of the planet's resources (with no discernible *decrease* in consumption, let alone the actual *conservation* of our rapidly extinguishing resources

on any major scale) then you may have come to similar conclusions to mine. That in the not too distant future, the resources of the planet will begin to see such significant shortages (oil, water, top soil, wood, etc.) that we will not be able to sustain society at its required energy levels, entropy will finally set in, and our civilization will completely unwind. A process that I believe has clearly already begun.

A lot of this I knew before I first smoked 5-MeO-DMT, and like most modern intellectuals over-burdened with information, I felt powerless and unable to do anything to make a change. The 5MDE has changed that for me, since as a modern mystic, I have considered these same conclusions, and now found the strength and inspiration to try to make a stand. For as I see it, our cancerous modern civilization *must* collapse—for if it does not, it will take down the entire ecosphere. As the majority of the non-renewable resources on the planet run out—in about 30 years or so by my estimate, in concert with the radical environmental crisis that our technology has created there will be an upheaval of human society that will be without parallel in human history—and out of the rubble of that society, over the centuries to come, survivors will emerge. If you have found strength from the transcendental G/d within, than you must start taking steps to build your tribe and build your future, to be part of the pro-active five-percent that will lead by surviving, and not part of the ninety-five percent who are likely to be left behind. The future is clear to the enlightened. Now the task is to see if we can live up to that responsibility. (Edited from *Tryptamine Palace*, pages 246–251)

A pretty dark view of the future huh? I have a lot of really smart friends who think I'm way off on this point, but they are the same ones who believe that the very science and technology that created this dilemma will somehow save us. And while I concede that our current exponential growth of knowledge and technology is astonishing and entirely unpredictable, unless they know something that I don't know,

some secret up their sleeve, for me the numbers just don't add up. For unless it is addressed, our expanding population alone will destroy us, the sheer rate of our consumption exponentially increasing as our now global consumer culture intensifies, coupled with the simple fact that those resources have already begun to run out.

We are living in exponential times, and the only reason it doesn't seem completely insane to us is that we are the first generations who have ever been born into it, and we have inherited a culture of extinction denial necessary for our cancerous modern consumer society to survive—bread, circuses, and reality TV, while the planet smothers, chokes, and dies. But the Tibetans believe that you have chosen the era of your incarnation, and that the lessons you need are in this lifetime. As terrifying as the future may be, I for one am excited, for the next thirty years are going to be one hell of a ride, and I intend to experience it head-on and with all my eyes wide open. For my God is Great, and I don't feel that I have anything to fear about the future, for we are all part of the great experiment, all part of this improbable thing called Life, and no more miraculous thing has ever occurred in our known universe. My transpersonal experiences with 5-methoxy-DMT have convinced me that existence itself is the most divine thing, both the mystery and the miracle, while the Vedic philosophy describes enlightenment with the most incredible word: *saccichanada,* which means "existence-awareness-bliss"—and this is the truth that I believe the whole world needs to learn.

9

THE FUTURE OF PSYCHEDELICS

The term psychedelic is derived from the Greek words ψυχή (psyche, "soul") and δηλουν (dêloun, "to manifest"), translating to "mind-manifesting." A psychedelic experience is characterized by the perception of aspects of one's mind previously unknown, or by the creative exuberance of the mind liberated from its ostensibly ordinary fetters.

"PSYCHEDELIC," WIKIPEDIA

This term *psychodelic* was coined by the Canadian psychiatrist Humphry Osmond in 1957 in an attempt to create a more specific terminology for compounds traditionally characterized as *hallucinogens* or *psychotomimetics*—Aldous Huxley later changed the spelling and popularized the term as *psychedelic*. Today's new wave of psychedelic authors tend to prefer the term *entheogen* over *psychedelic* for many of the same reasons that Osmond and Huxley preferred their new term: the old terminology had become tainted with negative associations of the word. Which is to say, Osmond and Huxley didn't like the word *hallucinogen* because it implied that the effects of mescaline and LSD were mere hallucinations and of little lasting value. These days, in turn, if we are trying to provoke a serious conversation about the positive

effects that powerful compounds like DMT or 5-MeO-DMT can have on human consciousness and spirituality, we try to avoid words like *psychedelic,* since that tends to evoke images of the Grateful Dead, light shows, and tie-dyed shirts (connotations that I am sure Huxley and Osmond never envisioned!).

At the very end of the twentieth century, and during these first two decades of the twenty-first century, a new American subculture has emerged that is loosely known as "Visionary" or "West Coast tribal" culture. A bastard child of the original Californian psychedelic tribes originally inspired by the Acid Tests held by Ken Kesey and The Merry Pranksters, this modern variant counts the Burning Man festival in Nevada as its annual spiritual pilgrimage, and the numerous spin-off festivals like Lightning in a Bottle and Symbiosis that Burning Man has inspired as its main nexuses. While centered in California, this subculture runs right up the West Coast to Canada, and through its links with the European psytrance/Goa tribe that centers around the bi-annual, openly psychedelic BOOM! festival in Portugal, the meme has now spread around the world, with events and representatives in places as far-flung as Australia, Russia, and South Africa, spawning its own fashion, its own music, and its own powerful art. Within this contemporary tribal culture, cannabis is more accepted than alcohol, traditional psychedelics like peyote, San Pedro, and psilocybin mushrooms are universally revered, while the previously much rarer plant entheogens, like ayahuasca or ibogaine, are considered to be the highest forms of sacrament.

So what does *psychedelic* mean today? Words like *psychedelic* and *trippy* have entered the common vernacular, and now often can be used by people who have never tried any psychedelic drugs at all. Modern technology can also recreate many of the visual and aural effects of psychedelics without the use of those drugs themselves. Today's video-game generation is seemingly well prepared for the effects of smoking DMT from the thousands of hours they have logged on their PCs, while modern video artists like Jonathan Singer and Android Jones can digitally mimic the psychedelic experience with an eerie precision. So perhaps

in one vision of the future, psychedelics may not even be the chemical compounds we currently use, but will in fact be virtual reality software programs. Take for example the 3-D movie *Avatar,* which thanks to the revolutionary new technology that it employs, is undoubtedly one of the most psychedelic movies ever made.

However it is more than just the technology that makes *Avatar* so psychedelic, for it is loaded with imagery, and even a plot line, ripped straight out of the imagination of this new West Coast subculture, and I would be very surprised if numerous people involved in this project have *not* experienced ayahuasca or smoked DMT. The film's director, James Cameron, himself claims that he has not done psychedelics in years, but it's no secret that there are ayahuasca circles in very expensive houses all over Los Angeles, and there are numerous famous people— Sting leaps to mind—who make no secret about their ayahuasca use. I am asked all the time, "How do we get Oprah to smoke 5-MeO-DMT?" and my reply is, "What makes you think she hasn't already tried ayahuasca?" For if Oprah herself hasn't, then I have no doubt that someone in her inner circle has already made the trip to Peru, snorted the tobacco juice, the whole deal; ayahuasca is just that *hip* these days.

Now you may think me presumptuous in saying that various individuals involved in making *Avatar* have tried ayahusca or smoked DMT, but here is my reasoning. The vast majority of this new subculture is very Web-savvy, and paradoxically, its members often maintain high-tech jobs in Silicon Valley or movie jobs in LA. The other real center for this culture is in fact the Web, and it realized itself early with one of the first social networks called Tribe.net before anyone knew what social media was. Just about everyone interested in visuals, lights, holograms, video-mapping, lasers, and so on, these days, and especially on the West Coast, has heard about DMT and ayahuasca, exactly because of their reputation for producing intense visions. So if you live in LA, you're into visuals, you're into 3-D, and you're under forty, then you know about DMT, you know about Burning Man, you know about visionary artists like Alex Grey, Luke Brown, and Android Jones, and you know about tribal culture, since they are throwing all the best parties.

Thus it's easy to see that this new subculture has stamped its imprint all over *Avatar;* the only thing missing was an actual ayahuasca ceremony around the Tree of Souls in the movie—since one of the popular translations of the word *ayahuasca* is in fact "vine of the souls."

So in this mega-budget Hollywood movie, you have this one vision of the future, which is pretty damned psychedelic, even without any psychedelics. This is in part because of the 3-D technology, which will undoubtedly change the way we view things for years to come. You put on the glasses, accept the technology, and in you go—a really immersive experience. But interestingly, there is another modern technology at our disposal that can make this experience even more immersive, so much so that at times you don't even realize it's not real. That technology is LSD. If you think the 3-D experience is intense, try it on 100 micrograms of liquid acid or a handful of shrooms.

You probably think that I am joking, but I am actually serious, for the fundamental difference in our relationship between these two technologies, 3-D versus LSD, is mostly based on the fact that psychedelics are now illegal. But let's take a look, say, twenty-five years into the technological future, if we still have one, and consider our society's obsession with new experiences and new wonders. If someone created a new compound similar to LSD—which happens quite often these days—and they could somehow get it passed by the FDA as nontoxic, nonaddictive, and safe within the prescribed doses, and that could be guaranteed to last only for the length of a feature movie, then what would stop ticket-buying adults from using that technology in the same way we use 3-D glasses? Americans take a pill for everything else, why not for a five-star movie experience? For the fact is, as amazing as 3-D technology may be, it will be more amazing on a compound like LSD. (Which incidentally is why I find it hard to believe that James Cameron has abstained from psychedelics. You know someone in his crew must have come to him and said, Boss, honestly, you got to watch it again on a couple of grams of mushrooms if you really want to see the jungle light up . . .)

So that's one future for psychedelics that I can see: we remain a

disposable, consumption-driven society doped up on Prozac and dumbed down on television, in which case I can see commercial FDA-approved "visionary aids" being a part of that future. If you think that is a negative view of our current society, consider George Orwell's famous book *1984*, which predicted that the future society would be forced to take drugs and be indoctrinated in front of a TV screen. In reality this future society has turned out to be far more insidious, one in which the vast majority pay for their own drugs, voluntarily watch more TV than they sleep, and then believe that they live in a free democracy even though it only has two political parties that are very close to identical. We are a nation of drug users, and as old habits start to change and attitudes (in some circles) are beginning to turn against alcohol and cigarettes and look more favorably on marijuana, then Americans' attitudes about other recreational drugs will soften, especially if they are new and FDA-approved. And as capitalism is proving over and over again, it will look down any alleyway, any avenue, for new markets and new goods. It was Karl Marx who first pointed out the fact that capitalism needs ever-increasing markets and populations to survive, a reality into which our species is currently running head-on.

There are countless possible compounds out there. One interesting side-effect of banning the handful of psychedelics we knew about in the 1960s—LSD, mescaline, DMT, and MDA mostly—was that it created the situation for the discovery and invention of dozens and dozens of new consciousness-altering compounds, mostly by one man, Alexander Shulgin, who made the recipes for these so-called "designer drugs" available in his books *PIHKAL* and *TIHKAL*.

One of the great things about the First Amendment is that books like these can be published in the United States: they are illegal in a number of other countries. Furthermore, these days the recipes are readily available on the internet. In the beginning of the twenty-first century, when LSD was scarce and MDMA had begun to get a bad rap due to the impurity of the drug being sold on the street, then the new analogues flooded in to fill the gap. Meaning that many of today's younger rave generation are probably more familiar with 2C-B or 2C-I

than they ever will be with LSD. Eventually the DEA wakes up to the new drug that's hitting the scene, finds out what it is, and then they make it illegal. But then something else comes along, like 2C-T-7, or Bromo-Dragonfly, compounds that you have probably never heard of, but before long could be the next drug of choice.

My point is, when you make a drug illegal, it either fuels interest in that drug, as it did with Ecstasy in the eighties, or it causes other compounds to be investigated. The use of psychedelics has a long history: we have records of psychedelic-using cultures that go back six thousand years, while our own Western tradition had the Eleusinian Mysteries of Greece, which ran for two thousand years. The modern use of LSD and other synthetic compounds is due to that same basic human curiosity. Outlawing the use of psychedelics is like outlawing the use of fire: it is doomed to fail because their use is a part of who we are and what made us human.

This opens up the second possibility for psychedelics: a lifting of the self-defeating ban on these compounds, and an era of serious scientific research into their unique properties. And thankfully there are some signs that this is happening, because there are now a handful of studies going on at major U.S. universities that involve psilocybin—and for the first time since the 1960s, LSD—as part of their research. This is a very positive step, since psychedelic compounds may prove to be one of the most useful research tools we have into the exploration of consciousness, which is something we know precious little about. I believe that we are at the most important point in our intellectual and spiritual development as a species since Galileo proved that the sun did not revolve around the Earth. We have inherited a Newtonian paradigm of solid, predictable forces and particles that can occupy a position in space and time, and that have no place for components that cannot be measured. This is a philosophy of distinct separation, which dictates that consciousness is an accidental side-product of matter, and makes every man a lonely, pointless particle in a universe grander than he can imagine. But now that paradigm is rapidly falling, almost a full century after the emergence of the quantum paradigm, which states that

nothing is solid, nothing ever exists as a moment in space in time. Consciousness itself, far from an accidental by-product of matter, now increasingly resembles a unique bio-energetic field capable of recognizing that it occupies a universe consisting of energetic fields, both vast and microscopic, all of which originate from a Field that exists outside of both space and time, and that connects us all as One.

There is little argument that psychedelics are among the most powerful tools we have for the exploration of consciousness, which remains perhaps our greatest scientific mystery. Keeping psychedelics illegal will shackle our ability to explore this realm of existence as surely as making rockets illegal would hamper our ability to get to the moon. At the same time, the emerging quantum paradigm will increasingly reveal that understanding consciousness is a vital key to understanding reality. I personally can attest that while I had read a lot about quantum physics, I could not intellectually grasp it until I experienced that energetic dimension outside of time and space on 5-MeO-DMT. From that point on, the quantum paradigm was the only one that still made sense in my radically altered worldview. Many scientists are now disclosing that they have had powerful intellectual realizations while using psychedelics: persistent rumors, for example, have had Sir Francis Crick conceiving of the double-helix shape of DNA while under the influence of LSD—a vision that would earn him a Nobel Prize. As Aldous Huxley proposed more than fifty years ago, the applied use of psychedelics by our intellectual community could produce both profound breakthroughs and new visions of our reality, or at the very least, it could be a powerful tool for the exploration of the antipodes of the mind. So this is another possibility for the future of psychedelics, that thanks to organizations like MAPS getting psychedelic research back into the universities, the possibility remains that psychedelics could again be recognized and revered for their unique ability to help us probe the mysteries of human consciousness.

Meanwhile on a more visceral level, probably the easiest way to realize the interconnectivity among life on this planet is to experience it through the use of psychedelics. Countless people over the past fifty

years have experienced the feeling of closeness with nature that comes from taking mushrooms, LSD, San Pedro, and similar substances in the outdoors. As I have argued, the modern environmental movement, and the whole idea of Gaia, of the Earth seen as a single living organism, came from the millions of people who experienced with LSD and mushrooms in the 1960s and 1970s. They came to feel, as the American Indians and countless other indigenous races around the world would have it, that we are all custodians of the land. Ayahuasca has a reputation for endowing its users with this sense of spiritual ecology.

You can also experience thinking and feeling as one as a group while on entheogens. Many people have experienced this phenomenon at music concerts, where the music itself opens one to the experience of transcendence. Indeed the original name given to the MAO-inhibitor harmine (one of the active alkaloids in the *Banisteriopsis caapi* vine) was telepathine, because of ayahuasca's reputation to enhance telepathy. Entheogens can also give users access to out-of-body consciousness, where, it could be argued, they are exploring the far reaches of the collective consciousness, the liberating experience of existing as consciousness without a sense of time or space or identity, or even the phenomenon of God-consciousness.

Let us return to my metaphor of Pandora, the teeming planet of sublime interconnectivity in *Avatar*. The concepts that are being presented in such a stunning visual feast in this movie clearly represent the battle between this emerging paradigm of interconnectivity, and the current dominant paradigm that treats our environment like disposable capital. Many of the movie's themes are related to psychedelic states of consciousness. For example, the Tree of Souls, which is like the antenna that connects all things, provides a very ayahuascalike experience of transpersonal interconnectivity, while human consciousness is seen as something that can be transferred into another, physically superior, bioenergetic body, its avatar in a new reality.

Indeed the very use of the word *avatar* is revealing. For while it is presently used as a name for one's surrogate in the virtual world, its origins come from the Sanskrit, and mean the manifestation of a deity on

Earth in human form. Viewed from this perspective, the movie *Avatar* expresses the gnostic desire within our species to evolve past a race of violent territorial monkeys seemingly hell-bent on destroying our own Garden of Eden, and to become the Godlike creatures in balance with our environment that we feel that we can become. But we are still being driven by our Newtonian technological paradigm, so that transformation is seen as a rejection of the human form for one that is partly digital. We envisage this transformation as physical, since we come from the physical age. But the quantum paradigm tells us that the only way we can change anything is by changing ourselves. These bio-energetic bodies that we could occupy could well be reality generators, and that this life-covered planet that we now seem to want to depart could indeed be the very center of existence, although not in the physical way that we first imagined. The human race is currently undergoing a traumatic revision of its understanding of reality and its role in the universe, although it's mostly too worried about eating, working, terrorism, and *American Idol* to actually realize it.

Which brings me to the third and final possibility for the future of psychedelics, or rather for entheogens. The ones I find the most interesting are those in the tryptamine family, especially DMT and 5-MeO-DMT, not only because of the powerful and transformative experiences that they can provide, but because they are uniquely endogenous to the human body. They are a part of the human experience, so by understanding them better we have a better chance of understanding both our consciousness and our relationship with the sacred and the Divine.

In his book *The Art of Happiness: A Handbook for Living*, the Dalai Lama writes, "Achieving genuine happiness may require about bringing about a transformation in your outlook, your way of thinking, and this is not a simple matter."

No simple matter indeed, and if we think how difficult the transformation of an individual is, then think how exponentially more difficult such a change in vision must be for an entire society. Just as when the Japanese witnessed their emperor reduced from being a god to a mere man at the end of World War II, a whole belief system must be

ripped out by the roots for a new one to take hold. As the Dalai Lama points out, drastic changes in point of view do not come willingly. And yet some dramatic new influence in human thinking is clearly required. Authors like Aldous Huxley, Terence McKenna, and myself have argued that this influence has already arrived, and has in fact been here all along, whether you want to call them entheogens, psychedelics, or plant teachers.

And so this is the third and final possibility that I see for the future of psychedelics: that as a culture we realize their role in both our history and our survival, and that by using them in a sacred manner we regain balance with our environment, and recognize our role as custodians of this magnificent planet. For if we can come to realize that existence is indeed differentiated states of consciousness, and that we are all linked on multiple levels with each other and with the universe, then we will realize that, as the Gnostics said, we are unrealized gods, spiritual beings blessed with a human existence. If we do not make this recognition—if human society continues to cling to its Newtonian and ego-driven sense of individual importance—then we will probably destroy this planet within another hundred years and leave the planet stripped of life, just as we are told the Earth has become in *Avatar*.

At the end of *Avatar,* the bows and arrows of the natives defeat the superior technology of the humans and send us home. It is an idealistic ending, but it ignores the fact that that same technology would probably then just nuke the rebellious planet to ashes. Our technology and our vision of reality will not go easily. It will take more than bows and arrows, and psychedelics and entheogens may well be the most effective weapon we have to employ.

10

PSYCHEDELICS AND EXTREME SPORTS

This article originally appeared in *MAPS Bulletin* 22:1 (2011). According to its website, "The Multidisciplinary Association for Psychedelic Studies (MAPS) is a 501(c)(3) non-profit research and educational organization that develops medical, legal, and cultural contexts for people to benefit from the careful uses of psychedelics and marijuana." Since its inception in 1986 by MAPS president Rick Doblin, this organization has been virtually the sole voice advocating a return to psychedelic research and has certainly been the most effective. Hence when MAPS guest editor David Jay Brown contacted me and asked if I would like to write an article about psychedelic use in extreme sports, I was overjoyed, and told him that it was an article I had been waiting to write for more than twenty years!

Rick Doblin has frequently told me that the resulting article was one of the most controversial that the *MAPS Bulletin* ever published, and one of his favorites. With the current interest in microdosing, this has also become the most quoted and reproduced article that I have written. It has been quoted multiple times in the *New York Times*. It is also the only piece of my writing that I know of that has been translated into Russian.

For those unfamiliar with the effects of psychedelics (or more specifically of LSD and psilocybin mushrooms) at a wide range of dosages,

the title of this article may seem like an obvious contradiction—for what connection could there possibly be between these infamous "hallucinatory" compounds and the obviously highly coordinated physical pursuit of the unfortunately named "extreme sports"? Based on the tangled reputation that LSD has had since the mid-1960s, it would seem impossible to believe that various experienced individuals have climbed some of the hardest big walls in Yosemite, heli-skied first descents off Alaskan peaks, competed in world-class snowboarding competitions, raced moto-cross bikes, surfed enormous Hawaiian waves, flown hang gliders above 18,000 feet, or climbed remote peaks in the Rockies, the Alps, the Andes, and even above 8000 meters in the Himalayas—all while under the influence of LSD.

However, in the often outlaw underground culture of extreme sports, the use of LSD or psilocybin mushrooms while skiing, snowboarding, mountain biking, surfing, skateboarding, and so on is in fact common throughout North American ski-and-sports towns, where they enjoy an almost sacred reputation. According to the legends of this tightly knit underground, many incredible feats have been accomplished by modern extreme athletes while under the influence of psychedelics— a fact, which for obvious reasons, generally never gets recorded in the record books. The reason for this radical disparity between the popular perception about the disabling effects of psychedelics and their common use among the fringes of the extreme-sports community is mostly a matter of dosage and historical familiarity. LSD is extraordinarily potent, effective on the human physiology in the millionths of grams (micrograms), and very small differences in dosage can lead to dramatically different effects. In the first decade of LSD research it was commonly known and accepted that there was a wide range of types of "LSD intoxication" that occurred across the range of dosage (20 micrograms–1500 micrograms+), with only the mid- to higher dosages producing what became known as "psychedelic" effects. At the lower dosages, a state known as "psycholytic" was also recognized, where in many cases cognitive functioning, emotional balance, and physical stamina were actually found to be improved.

This recognition of the varying effects of LSD was lost after the popular media demonized LSD with the help of the various myths and excesses of the 1960s Love Generation. When LSD made the jump from the clinic to the underground, its early explorers were universally fascinated with the higher-dosage entheogenic experience, while the more subtle effects at lower dosages were largely forgotten or ignored. The first "street" LSD in the 1960s was thus generally between 250 and 500 micrograms, a potency powerful enough to guarantee the casual user a truly psychedelic experience. LSD is somewhat unusual, however, in that a user can build a fast tolerance to the compound after regular (daily) use, and while one's initial experiences on even a single dose can be dramatic, before long veteran acidheads may be increasing their own dosage tenfold—thus requiring much stronger hits than the average user. It was the high dosage of this early street acid that, in combination with the complete ignorance of its early users, that would be responsible for the high number of "acid casualties" that gave LSD its fearsome reputation. However, by the 1980s, both Deadheads and the Acid House generation had realized that they should drop the dosage of street acid to between 100 and 125 micrograms, while these days a hit may be as low as 50 micrograms, or as little as 10 percent as powerful as a hit of 1960s acid. This dosage is well below the true psychedelic threshold for most people, and for an experienced user suitably inclined, can certainly be calculated to fall within the forgotten "psycholytic" category.

There was always a strong contingent of experienced psychedelic users among the extreme sports community due to the little-realized fact that the seeds of the extreme sports revolution were actually planted with the dismantling and dispersal of psychedelic culture in the late 1960s and early 1970s. As countless numbers of counterculture refugees left the major cities and moved out to small towns in the country in the "Back to the Land" movement, most were looking for new paths to fulfillment after the spectacular promises of the brief Psychedelic Age had failed and a new age of uppers and downers was emerging. Faced with an obviously dangerous downturn in what was now being universally called "drug culture," as first heroin and then cocaine dramatically

increased in popularity—the beginning of our urban society's more than thirty-year-old epidemic of cocaine and amphetamine abuse—a few turned to the traditions of Christianity, Islam, Eastern, or New Age religions, while many others, perhaps less institutionally inclined, went to small coastal towns in California, Oregon, or even Hawaii to surf; or landed in the numerous small towns in the Rockies from Montana to New Mexico that were being developed as ski areas at that time.

These hippies brought with them a newly found cultural respect for the land that had come directly from the use of psychedelics, since the use of psychedelics in nature inevitably increases the spiritual appreciation of one's role in nature, and of nature itself. (There are many commentators today who believe that the modern environmental movement was born out of the fact that 25 million people took LSD in the late 1960s.) They also had an adventurous attitude to the land, derived from a general fascination with the Plains Indians and the Wild West era, and from the naturalist vision of the American wilderness that Walt Whitman, Thoreau, and especially Jack Kerouac espoused, the perennial philosophy that one could somehow find oneself out among the wilds of America.

At the same time as this sudden influx of these "freaks" to the beaches, deserts, and mountains of the world, technological advances in what were considered minor, cultlike sports were suddenly allowing ordinary individuals unprecedented access to the wildernesses of the world—in the mountains, the ocean, and even the air—as a new kind of athlete took the concept of finding oneself in the wilds to a whole new definition. The invention of these highly individualistic sports (surfing, skateboarding, snowboarding, BASE jumping, tow-in surfing, etc.), which sought to use existing terrain in new and inventive ways, generally raised the ire of the status quo. As a result, most extreme sports began life as outlaw sports, with their participants regarded as rebels. The attraction of these sports for the newly arrived Psychedelic Era refugees is obvious, and most of the early pioneers of surfing, rock climbing, backcountry skiing, hang gliding, and so on were clearly cultural rebels living well outside of the norms of society. For this particular

branch of the psychedelic tree, the oceans, deserts, and great mountains of the world were now being recognized as the ultimate set and setting—a realization common to mystics and *sadhus* since the beginning of recorded time.

Thanks to the exponential growth of the worldwide leisure industry toward the end of the 1970s, becoming a climbing, skiing, or surfing "bum" (the modern evolution of Kerouac's backpacking Dharma Bums) became the easiest way of dropping out of contemporary society, a socially healthier alternative to the free-love communes of the previous decade that still allowed one to smoke pot, take psychedelics, and mostly fly under the cultural radar. By the 1980s a good portion of the transient population in any American ski town (especially the leather-booted telemark skiers) were Deadheads—faithful followers of the Grateful Dead, the most effective LSD network in the country—while many other less obvious skiers and climbers still kept alive the traditions of using cannabis (a remarkable natural analgesic), acid, and mushrooms in the mountains, while the mountains themselves acted as natural shields from prying eyes.

After the invention of snowboarding, mountain biking, and to a lesser extent paragliding in the eighties, virtually all of the newly named extreme sports experienced a rapid growth of popularity in the mid-nineties that resulted in a corresponding growth in the populations of these same small ski-and-sports towns. Between 1992 and 1997 *MTV Sports* was one of the most popular shows on cable television as it glorified the emerging extreme sports to its youthful audience and established the grunge and hip-hop music it was promoting as the "in" sound of the exploding snowboarder population. The emerging electronic (rave) music of the same period also appealed to the naturally rebellious nature of extreme athletes and introduced that culture to Burning Man from its very inception, further reinforcing the knowledge of modern psychedelic culture in what are often remote mountain towns. (Burning Man's Black Rock City got its name the same summer as the first X Games: 1995.) Many Western ski towns now have a resident Burner population much in the same way they had a hippie or freak popula-

tion in the early seventies, and these small towns generally remain more liberal-minded than other towns of similar size in America.

This entwined relationship between the cultures of psychedelics and extreme sports has in fact been there since the beginning with what is perhaps the original extreme sport, the much-mythologized sport of surfing. After the fallout of 1967–68, when San Francisco and the Haight-Ashbury became overrun and its original hipster founders abandoned it, the Southern Californian surfing town of Laguna Beach became the de facto center of the psychedelic world when a group of diehard surfers—known as the Brotherhood of Love—became the world's first LSD cartel. Along with the smuggling of tons of hashish from Afghanistan to fund their operation (often in hollowed-out surfboards), they would ultimately be responsible for the distribution of tens of millions of hits of Orange Sunshine LSD, for paying for the radical Weatherman group to help Timothy Leary escape jail, and ultimately the creation of the DEA (to combat them). In explaining the connection between LSD and surfing, early Brotherhood of Love member Eddie Padilla remarks on the practical side of a culture based on pot and psychedelic use, and not on our culturally acceptable drug, alcohol:

> The effect of the LSD we were taking was starting to demand a higher-quality lifestyle, food-wise and in every way. All these surfer people [that Padilla and Brotherhood of Love founder John Griggs knew] had that lifestyle already in place. To surf, you had to remain sober and be more in tune with nature. Don't get too screwed up, because the surf may be good tomorrow. (Schou, *Orange Sunshine*)

In this explanation, Eddie Padilla hits on half of the real *physical* reason why psychedelics have always been a part of extreme sports culture: psychedelic use is not only more inspiring in the wilderness, but it is also eminently more practical. LSD can easily be a ten- to fourteen-hour experience, which is too long of a trip for most people, especially if it is taken at night. If it is taken in the morning, however, and one has the voluminous expanses of the ocean, the deserts, or mountains of the

world to roam and contemplate, then the length of an acid trip is rarely a problem, since it will also start to fade with the end of the light of the day. If one keeps hydrated, and the acid trip is kept within regular hours to allow normal sleep, then this trip can in truth be one of the *least* physically debilitating altered-states experiences available, with little or no discernible hangover—ridiculously so when compared to the effects of cocaine and/or alcohol (for example) and the extreme hangover they bring. The nonaddictive and nondebilitating qualities of psychedelics are rarely touted by the popular media, but are well known among communities that are familiar with them, and the nontoxic qualities of psychedelics are half of the physical reason for their enduring appeal among extreme athletes.

The other half of this *physical* reason that psychedelic drugs are so popular with extreme athletes is their previously noted psycholytic effects at the correct dosages. Virtually all athletes who learn to use LSD at psycholytic dosages believe that the use of these compounds *improves* both their stamina and their abilities. According to the combined reports of forty years of use by the extreme-sports underground, LSD can increase your reflex time to lightning speed, improve your balance to the point of perfection, increase your concentration till you experience tunnel vision, and make you impervious to weakness or pain. LSD's effects in these regards among the extreme-sport community are in fact legendary, universal, and without dispute.

It is interesting to note the similarities between the recollection of these athletic feats while in this psycholytic LSD state and descriptions that professional athletes give of "being in the zone," a heightened state of neo-perfection where athletes report very psychedelic effects such as time slowing down and extraordinary feats of instantaneous nonthinking coordination. Athletes and normal individuals also claim the same effects in moments of heightened adrenaline—the classic fight or flight response. As LSD research returns to the mainstream in the United States, further investigation into the claims of athletes such as the extreme sports underground could result in a radically different perception for the variety of uses of psychedelics.

As an athlete, journalist, and advocate of extreme sports since the late eighties, and a former resident of the Rockies for over a decade, I have witnessed numerous incredible feats on psychedelics in the mountains—none of which unfortunately I have permission to tell of here. However, after MAPS asked me to write this article earlier this year, I started asking around for other people's stories. If you start asking about sporting feats accomplished on psychedelics in pretty much any bar in a ski town, you will hear some fine tales. I have heard of a hang glider flown tandem off of a mountaintop under a full moon with both the pilot and passenger on magic mushrooms; of helicopter skiing in Alaska on acid, when the guide got avalanched off a cliff right in front of the tripping skier; of radical solo rock or ice climbs of the highest intensity performed on equally radically head-fulls of psychedelics; I have even heard of someone taking a hit of DMT before they jumped out of an airplane skydiving. (Now *that's* crazy!) I also have no doubt that someone rides Slickrock in Moab on mushrooms or acid probably every single day, and that you couldn't calculate the number of people who are tripping on a powder day in the central Rockies. Psychedelic use among extreme sports enthusiasts is simply that prevalent, and has been (or was probably higher!) since the start.

Psychedelics and sports, incredibly, can go together like cheese and bread. An enhanced spiritual appreciation of the natural environment, along with increased stamina and an almost unnatural improvement in balance, are too powerful a combination not to become sacred among mountain athletes. (And, I suspect, among our hunter-gathered ancestors.) When I asked a well-known high-altitude climber in Colorado about climbing in the Himalayas on acid, he just laughed and stated that at high altitude LSD was like "cheating" because it did such a good job of overcoming fatigue and altitude sickness. He also had no doubt that at least one climber had summited Mt. Everest while tripping. But since I can see this could all seem very circumstantial and uncorroborated to the skeptical, I can offer the single documented example of LSD being used in a remarkable sporting achievement, and not one that comes from the outlaw

fringes of extreme sports, but from baseball, America's game itself.

On June 12, 1970, the Pittsburgh Pirates' starting pitcher, Dock Ellis, threw a no-hitter against the San Diego Padres in a regular major-league baseball game, which he admits occurred while he was on LSD. Ellis had thought he was off the pitching roster for that day and so had taken acid with friends in Los Angeles, only to find out while high (from his friend's girlfriend) that he had to pitch a game against the Padres that night.

As Ellis recounted it:

> I can only remember bits and pieces of the game. I was psyched. I had a feeling of euphoria. I was zeroed in on the (catcher's) glove, but I didn't hit the glove too much. I remember hitting a couple of batters and the bases were loaded two or three times. The ball was small sometimes, the ball was large sometimes, sometimes I saw the catcher, sometimes I didn't. Sometimes I tried to stare the hitter down and throw while I was looking at him. I chewed my gum until it turned to powder. I started having a crazy idea in the fourth inning that Richard Nixon was the home plate umpire, and once I thought I was pitching a baseball to Jimi Hendrix, who to me was holding a guitar and swinging it over the plate. (Tayler, "Today Is the 47th Anniversary of Dock Ellis' Acid-Fueled No-Hitter.")

So for those of you who find it hard to believe that someone can ski, mountain bike, or even fly a hang glider while on psychedelics, I submit to you the well-documented case of Dock Ellis, who would go on to win a World Series with the Pirates, and to be the starting pitcher for the National League in the All-Star Game, but whose now-legendary acid-fueled day was his only no-hitter. While there have been over 175,000 professional baseball games played since 1900, only 269 no-hitters were pitched between 1879 and 2010. Pitching a no-hitter in baseball is therefore considered to be one of the hardest achievements in professional sports.

11

WHAT CAN ENTHEOGENS TEACH US?

Introducing the Oroc Entheogen Scale

In 2010 I was fortunate to be invited to be a presenter on the subject of entheogens at a fascinating conference in San Rafael, California, titled "Beyond the I: The End of the Seeker." The conference organizers had recruited a remarkable collection of physicists, neuroscientists, consciousness researchers, and spiritual teachers, all with a common interest in what turned out to be the rather hazy subject of science and nonduality. The entheogen section of the conference—titled "Entheogens as a Portal"—was a panel composed of Rick Doblin (MAPS), James Fadiman, myself, and a couple of other speakers (whose names I must confess I don't remember). Each of us received twenty minutes to speak about entheogens and (I presumed) nonduality.

My normal presentation (on the unique properties of 5-methoxy-DMT) takes at least an hour, and since I was considering nonduality to be another way of describing the classical mystical experience of transpersonal Oneness that occurs with the complete dissolution of ego and identity ("the loss of all opposites"), I decided to talk about a subject that I had been giving a great deal of thought; namely the correlation between the effect a compound has on the ego (i.e., one's personal

sense of "I") and its relative toxicity. I would take the broad spectrum of different consciousness-altering compounds available, and rather than considering how each particular drug affects our physical or mental well-being, as most scientific studies would, I would instead rank each drug on how it affected our sense of ego.

Since the total loss of ego is the core of the transpersonal mystical experience (and I am an experiential mystic at heart), I decided that I would assign each drug its own "entheogenic value," with the drugs that can induce the transpersonal state of total loss of ego and identity having the highest value (that is, they are of most value to an experiential mystic), while the drugs that reinforced or inflated the sense of the ego would have the lowest.

After having ranked the various compounds (according to experiential reports in literature, Erowid, and other sources), I realized that the scale naturally descended by the chemical class of the compound—tryptamine, phenethylamine, opiates, amphetamines, alcohol—and that this corresponded to a noticeable increase in toxicity.

Here is how I ranked the various compounds, along with my personal commentary on the effects of the compound, its toxicity, and its related human history.

The Oroc Entheogen Scale
THE ENDOGENOUS TRYPTAMINES

1. 5-methoxy-DMT. Regularly capable of inducing a classical mystical experience of transpersonal Oneness with complete dissolution of ego and identity, even at dosages as low as 5 micrograms.

 Endogenous, which means that it is naturally produced within our own bodies. Also present in nature in the leaf, bark, and roots of trees, and in the venom of the Bufo alvarius *toad. In the forms of snuffs, 5-MeO-DMT has been used in South America for an estimated three thousand years. The modern use of 5-MeO-DMT, in the form of smoking toad venom began as a little-known phenomenon in the southwest states of the United States in the 1970s, until the synthesized version*

of the drug became one of the most popular compounds available from the online research chemical companies of the early twenty-first century. After coming to the attention of the DEA, 5-methoxy-DMT was then made a Schedule 1 drug (the same as DMT and LSD) in 2011.

2. DMT (dimethyltryptamine). Capable of inducing a classical mystical experience of transpersonal Oneness, with complete dissolution of ego and identity, mostly at high dosages, and in certain individuals.

 Endogenous. Found in the leaf, seeds, bark, and roots of plants, DMT has been used in South America as snuffs, and as the active alkaloid in ayahuasca, for more than fifteen hundred years. These plant admixtures are regarded as sacred among the Amazonian cultures from which they originate.

 First synthesized in 1931, DMT was then discovered to be psychologically active by the Hungarian psychologist Stephan Szara in 1957. After being sporadically used by intramuscular injection throughout the early 1960s (most notably by William S. Burroughs and Timothy Leary), DMT then experienced a brief burst of popularity in the late 1960s after the underground chemist Nick Sand discovered that the fumurate was smokable, before disappearing almost completely by the end of the 1970s. The writings of Terence McKenna in the early 1990s subsequently rekindled interest in the compound in both its smokable (salt) form, and in ayahuasca, an Amazonian plant that contains DMT. The resulting rise of interest in plant entheogens, and especially ayahuasca, combined with the publication of Rick Strassman's controversial book DMT: The Spirit Molecule *in 2000, has resulted in a significant modern mythology around this compound in contemporary psychedelic counterculture, while easy-to-find online extraction recipes have seen DMT now return to the underground market place.*

COMPLEX TRYPTAMINES

3. LSD-25 (lysergic acid). Also a tryptamine, LSD is capable of inducing a classical mystical experience of transpersonal Oneness, with

complete dissolution of ego and identity, in high dosages, and in certain individuals.

A synthetic tryptamine created by Albert Hofmann in 1938, LSD-like compounds (LSAs) have been isolated from the Aztec ololiuqui (morning glory) seeds. The Greek Eleusinian Mysteries used an entheogen called kykeon, *which was most likely an LSD analogue produced from an ergot (grain) fungus (the temple at Eleusis was dedicated to Demeter, the goddess of grain). Modernly packaged and mass-producible, LSD reintroduced the entheogenic experience to Western culture during the late 1960s and early '70s when an estimated 75 million people tried the compound.*

While the very high dosages (600+ micrograms) recommended by Leary, Metzner, and Alpert in The Psychedelic Experience *to induce a transpersonal-mystical experience ultimately proved to be more than most people liked to handle psychologically, LSD is physiologically one of the safest known compounds, since it requires the smallest known amount (1/10,000th of a gram) to be psychologically active, and thus has an incredibly low toxicity. (LSD is an estimated 3000 times more powerful than mescaline.) You can ingest the same amount of cyanide, or even plutonium, and it will pass through your body without affecting you.*

4. Psilocybin (4-OP-DMT). Can induce transpersonal-mystical experience in high dosages.

Naturally occurring in some two hundred mushroom species, psychedelic mushrooms were used in a sacred manner by the Amerindians of Mexico, and are the proposed natural entheogen in the theories of R. Gordon Wasson and Terence McKenna's. First isolated by Albert Hofmann in 1958, psilocybin was the first psychedelic investigated by Timothy Leary at Harvard in 1960–61. The least powerful of the tryptamines, psilocybin is of low toxicity. Overdoses have been reported on synthetic psilocybin, such as in the death of John Griggs (the leader of the notorious LSD-and-hashish cartel the Brotherhood of Eternal Love), although none are reported on Erowid.

PCP/KETAMINE

5. PCP/ketamine: Neither tryptamines or phenethylamine, these unique dissociative compounds are the most difficult to classify. Capable of inducing a classical mystical experience of transpersonal Oneness, with complete dissolution of ego and identity, mostly at high dosages, and in certain individuals.

While PCP was first synthesized in 1926, its illegal street use peaked in the mid-1970s. Ketamine is a legal PCP analogue (with an estimated 5–10 percent of the strength of PCP), which acts as a stimulant on the central nervous system. It requires inclusion because of its impressive record for inducing mystical experiences in individuals (mostly by intramuscular injection). It could be argued that the drug deserves a higher ranking than some of the complex tryptamines. Since it is used as a medical anesthetic, it is considered physically very safe, and overdoses are rare. Ketamine's use as an entheogen (and increasingly as a party drug in small doses) is a relatively recent development.

PSYCHEDELIC PHENETHYLAMINES

6. Mescaline. Can induce transpersonal-mystical experience in high dosages.

Naturally occurring in various cactus species, mescaline is one of the oldest psychedelics known to man. There is evidence of peyote use in Mexico and North America dating back 5700 years, while the Huachuma (San Pedro) cactus cults of northern Peru are the longest known continuous shamanic tradition, having existed for at least three thousand years. These include the Chavín culture—the first great Andean civilization, some 1500 years before the Inca—which peaked with the construction of Chavín de Huantar, an underground temple complex deep in the Andes that was the South American equivalent to Eleusis in Greece.

The first psychedelic isolated (1897) and then synthesized (1918), synthetic mescaline was the subject of Aldous Huxley's pioneering book The Doors of Perception *in 1954. Mescaline (along with psilocybin, LSD, and DMT) was listed in the introduction to Leary, Metzner,*

and Alpert's book The Psychedelic Experience *in 1964, but other than in its natural forms, is very rare today. Like most psychedelics, mescaline is of low toxicity and is nonaddictive.*

7. 2C-B, 2C-I. Structurally related to mescaline, both 2C-B and 2C-I can induce transpersonal-mystical experience in high dosages.

Synthetic phenethylamines, these are notoriously dose-sensitive, and little is known about their toxicity, but they can be assumed to be relatively nontoxic and nonaddictive, with the lethal dosage being far greater than the required psychoactive amount. Both compounds were created Alexander Shulgin; 2C-B was first sold commercially as an aphrodisiac under the trade name "Erox," and was briefly popular with the psychiatric community as an aid to therapy, thanks to its mild nature, relatively short duration, and absence of side-effects. Both 2C-B and 2C-I became widely available on the underground market during the LSD drought of the early twenty-first century, proving once again that prohibition simply results in diversity.

CANNABIS

8. THC (Cannabis or marijuana). Decreases the effect of the ego by shifting perspective away from the self, making one more likely to see another's point of view, or the humorous side of a situation.

Relatively low toxicity, with no possibility of physical overdose. Although cannabis-related crimes are the number one reason for incarceration in the United States, with over a million people in jail for its sale, distribution, production, or possession, there has never been a single death related to THC consumption itself. Since 1996, twenty-four states have introduced medical-marijuana laws, and four states and the District of Columbia have passed recreational-marijuana laws, but there were 8.2 million cannabis-related arrests between 2001 and 2010, and 60 percent of the U.S. Prison population are in jail for non-violent victimless crimes. The inhuman and untenable War on Drugs declared by the Reagan Administration in the 1980s has been*

*50 percent for drug offenses, 10 percent for immigration.

responsible for the creation of an institutionalized Prison Culture, with the United States now having the highest per-head-of-population incarceration percentage in history—worse than in the Stalinist era in the Soviet Union, or the era of Apartheid in South Africa.

FATAL OVERDOSE LINE
PHENETHYLAMINE EMPATHOGENS

9. MDA. Empathogen (also known as an *entactogen*). The original 1960s "love drug," now sometimes known as "sassafras." As with all the compounds in this class, empathogens can decrease the effect of ego by inducing love and compassion toward others and weakening the sense of "I" and its perceived importance.

Empathogens also differ from psychedelics/entheogens in their acute toxicity, with deaths caused by cardiac arrest or brain hemorrhaging at a fatality rate of approximately 2 in 100,000 users, approximately the same as the more popular MDMA.

10. MDMA, also known as Ecstasy (see MDA).

First synthesized in 1912 by Merck chemist Anton Kollisch, MDMA held great promise for psychiatry after it was rediscovered by Alexander Shulgin in 1976, and subsequently popularized by the noted therapist Leo Zeff, who was so impressed by its potential he came out of semiretirement to promote it.

Between the 1970s and 1980s a loosely knit network of therapists, psychiatrists, and the occasional knowledgable psychonaut consumed an estimated half-million legally produced hits of MDMA. Most of this MDMA was produced by a group of therapy-minded chemists in the Boston area. When shortages in supply began to occur, Michael Clegg, the southwest distributor for the "Boston Group" recognized a business opportunity and started his own "Texas Group," renaming the drug "Ecstasy" in 1981. Aggressive marketing tactics by the Texas Group resulted in Ecstasy tablets being widely available in bars in the Dallas–Fort Worth area. They were also available at toll-free numbers for purchase by credit card as sales spread nationally, with

taxes being paid on all sales. By 1984 the Texas Group had produced 10 million doses of Ecstasy in the months leading up to its scheduling, with 500,000 doses a month being consumed in the Dallas–Fort Worth area alone. By 1985 MDMA use was listed in twenty-eight states, and the DEA announced an emergency scheduling in a wave of federal paranoia. At these hearings the DEA claimed to be unaware of any therapeutic use of the compound.

Ecstasy then rose to worldwide prominence in the late 1980s with the birth of the Acid House electronic-music culture in Ibiza, and later in the United Kingdom and Europe, where its use and the music were inextricably entwined. An estimated 19 million people a year now use MDMA illegally worldwide. MDMA is also on the brink of making a comeback in therapy; it is currently being used in clinical trials in Israel, and in the United States for soldiers with severe post-traumatic stress syndrome (PTSD). The MAPS organization is on track to see MDMA reclassified as a FDA-approved medicine by 2021.

OPIATES

11. Opiates: Heroin and Oxycontin. Nullifies the ego by negating all desire, although not necessarily the sense of "I."

 Highly physically addictive with regular fatal overdoses, the United States has experienced a sharp increase in opiate abuse since 2010 after the spectacular commercial success of the prescription drug OxyContin (OxyContin sales generated 35 billion in sales over two decades). Along with heroin, and other prescription opiates such as Percocet, Vicodin, and fentanyl, 62,000 drug-overdoses fatalities were reported in the United States, a 19 percent increase from the previous year that made an overdose the most common cause of death for men under fifty. According to the DEA, overdose deaths are reaching epidemic levels.

COCAINE AND METHAMPHETAMINE

12. Cocaine: The ultimate "me" drug. Physically and psychologically addictive, highly toxic, and a nervous-system stimulant. Cocaine

dependence (addiction) can result in cardiovascular and brain damage, while overdoses can result in death.

The Greed Culture of the 1980s that came only a decade after the Psychedelic Revolution can be epitomized by its reverence for cocaine, the most expensive drug that does the least to your consciousness for the shortest amount of time.

In 2009 cocaine and crack cocaine overdoses were responsible for over 400,000 ED visits in U.S. hospitals. While the first cocaine epidemic in the United States was in the 1880s, cocaine has greatly grown in popularity since the 1970s, with the estimated U.S. cocaine market exceeding $70 billion in street value in 2005—a greater revenue than that of a corporation such as Starbucks. A multibillion-dollar "war against cocaine" has been waged at the military level in South American countries since the 1980s, with no noticeable effect on supply. After destabilizing the country of Colombia for more than two decades, and causing considerable social harm in coca-producing countries such as Peru and Bolivia, the drug cartels shifted the cocaine production to Mexico (where the precursors required to make cocaine from the coca leaf are easy to obtain and difficult to trace), and now violence along the border of Mexico related to the cocaine and methamphetamine trade is killing more than five thousand people a year.

13. Methamphetamine. Physically and psychologically addictive. Highly toxic. Legally prescribed under the brand name Desoxyn, for treatment of ADHD.

Illegal methamphetamine abuse is reaching epidemic proportions at many levels of American society, with over 93,000 ED visits in 2009. Crack cocaine and methamphetamine addiction have long been associated with both forced and voluntary prostitution in every country they appear in, while the violence associated with Mexican drug cartels (fighting for control of a cocaine and methamphetamine market valued in excess of $50 billion a year) is currently responsible for over 15,000 fatalities annually.

ALCOHOL

14. Alcohol. Clinically defined as a psychoactive depressant. Highly toxic and physically addictive. Western civilization's most dangerous and most costly drug, as well as one of its most efficient weapons against indigenous races.

While the last three compounds on this chart—cocaine, methamphetamine, and alcohol—are the only three compounds most likely to reinforce the ego to the point of physical violence, alcohol is the one that is most likely to make you do yourself physical harm as a result of self-loathing. Alcohol is the most common extenuating factor for homicides, rapes, beatings, and suicides, not to mention vehicular fatalities, although these statistics (other than drunk driving deaths) are rarely reported. The least sophisticated drug on this chart in terms of both its production and its crude inebriating effects, the first alcoholic beverages can be traced back nine thousand years to Neolithic times, which is why I call it "the Neanderthal drug." Perhaps because of its ancient origins, alcohol is the only completely legal drug on this list in the vast majority of countries around the world. The Centers for Disease Control estimate that medium to high consumption of alcohol leads to the death of approximately 75,000 people a year in the United States.

My conclusion from ranking these various compounds by their unique entheogenic value in comparison to their toxicity can thus be expressed quite simply as:

Oroc's Law of Entheogens. The more a compound disrupts the ego, the physically safer (less toxic) that compound will be, while the more a drug reinforces and inflates the sense of ego, the more physically harmful (toxic) that compound will be.

After my presentation, a number of people in the enthusiastic audience asked me if I had ever written anything about this Entheogen Scale, and I had to confess that I had not, but that some time in the future I would try to. But in all truth, I probably would have stored it away in the back drawers of my very messy mind had not the former chief advisor on drugs to the British government, David Nutt, published a very

interesting report in the respected medical journal the *Lancet* that was released just a month later (November 2010) and made worldwide news.

In this report by the government-sponsored Independent Scientific Committee on Drugs, every common drug in British society was scored by a panel of social health experts on the harm it created, including mental and physical damage, addiction, crime, and costs to the economy and the community, effectively ranking the public health effect of the various drugs. The maximum harm score was 100 and the minimum zero. When the results were tabulated, the most harmful drug was alcohol (72), then heroin (55), crack cocaine (54), methamphetamine (33), cocaine (27), cannabis (20), and ketamine (15), with MDMA (9), LSD (7), and magic mushrooms (5) being ranked as the least harmful substances to British society! (Neither DMT or 5-MeO-DMT was on the list.) The authors also wrote, "Our findings lend support to the previous work in the UK and the Netherlands, confirming that the present drug classification systems have little relation to the evidence of harm" (Nutt, King, and Phillips, "Drug Harms in the UK: A Multicriteria Decision Analysis," *Lancet* 376, no. 9752: 1558–1565).

Based on this highly scientific report, my own observations about the related toxicity of my Entheogenic Value scale would appear to have been mostly validated: those drugs that most eradicate the effect of the ego have been deemed to be the safest by public health experts. Psychedelics are nonaddictive and of low, if any, toxicity. Therefore educated use of psychedelic drugs offer no threat to physical health, and yet they are legislated by our society to be among the most illegal substances on the planet. This contradiction, many now believe, restricts a basic human right.

The word *drug,* incidentally—which means (in this context, according to Webster's dictionary) "a chemical substance which enhances physical or mental well-being"—is a ridiculously loaded term, as well as misleading and virtually meaningless, since nearly everything we eat and drink could be considered a drug. Nitrous oxide, a gas, is a drug. Coffee, tea, sugar, and chocolate are all drugs. Even McDonald's french fries, under this broad definition, could be considered a (highly addictive)

drug. Now as much as I love chocolate, coffee, and even—I hate to admit it—the occasional McDonald's french fry, I see little purpose in comparing them in any way, shape, or form, to LSD, DMT, or 5-MeO-DMT, which are far more likely to completely change your view of consensual reality than they are to "enhance your physical or mental well-being." But the very use of a term as broad as *drugs* (drug law, drug war, illegal drugs, dangerous drugs, etc.) to describe and regulate such a ridiculously broad range of compounds is in itself a verbal smokescreen designed in part to limit the socially transformative possibilities of psychedelics.

If I may digress for a moment, it is my personal opinion that the first Psychedelic Revolution in the United States (1963–71) failed ultimately because of the mass influx of a variety of distinctly nonpsychedelic drugs into the chaotic and highly exploratory youth culture of that period. Psychedelics in high dosages have proven to be safest when used in a thoughtful and controlled set and setting, but as the Youth Revolution took hold, many teenagers were exposed to LSD in a cavalier and Dionysian manner.

Considering the fact that an average hit of LSD in 1968 (300–400 micrograms) was around four times stronger than a hit of street acid (80–100 micrograms) today, and that first-time LSD users were frequently encouraged to take two hits if they wanted to see the "white light" that Timothy Leary promised, often with little thought to their set and setting, it is easy to see how a large number of young hippies feared acid as much as others revered it. (You still witness this same phenomenon today. Many of the millennials that I talk to at festivals seem to love DMT but are terrified of LSD, often having already experienced a trip too long and arduous for them—even though they probably ate a quarter of what their parents did for their first time in the sixties.) This tendency to push all experiences to the limit ("the Prankster ethic") opened the door for the more seductive and much easier mental rides of first heroin, and then cocaine. (Which being the ultimate ego drug, is the antithesis of LSD.)

The alternative culture that was inspired by psychedelics failed to respect that psychedelics are best used carefully, in a sacred man-

ner, with trusted guides, and not wildly in recreation among crowds of strangers (unless you are greatly experienced). This, along with the CIA's well-documented role in introducing psychedelics and other illegal drugs into the American ghettos and universities, ultimately allowed for a wide variety of very different compounds being lumped together into a singular "drug culture" that failed to distinguish between the wide variety of experiences available, and ultimately settled for uppers and downers and ego-reinforcing drugs that actually reinforce the status quo. By the early 1980s, cannabis and psychedelic use were at their lowest statistically recorded rates, while heroin, cocaine, and amphetamines became the most popular illegal drugs of the last thirty years of the twentieth century, along with the skyrocketing use and abuse of legal prescription drugs.

It is interesting now—with fifty years perspective—to recognize the fact that our society's so-called drug culture rapidly turned away from the original sixties psychedelic ethos, with its the mystical destruction of the ego (and the social structures that the ego creates) toward a range of compounds that actually reinforce the ego (and thus the existing social structures that the ego has built), for it could also be argued that the last thirty years of the twentieth century, which came after the failed Psychedelic Revolution of the 1960s, were the most egocentric years in human history.

The repopularization of psychedelic culture in the twenty-first century coincides with the increased awareness of the danger of our environmental situation, and the possibility of the collapse of the world economy and local government, largely created by the greed-driven governmental deregulation that began in the 1980s. The future of humanity may depend on whether or not we learn that our collective fate and our planet are connected, or if a corrupt one-percent will doom us to an ego-blinded destruction. The tools for both futures are on-hand, and the choices we collectively make will shape our future society.

12

LIVING IN DANGEROUS TIMES

What Orwell feared were those who would ban books. What Huxley feared was that there would be no reason to ban a book, for there would be no one who wanted to read one. Orwell feared those who would deprive us of information. Huxley feared those who would give us so much that we would be reduced to passivity and egotism. Orwell feared that the truth would be concealed from us. Huxley feared the truth would be drowned in a sea of irrelevance. Orwell feared we would become a captive culture. Huxley feared we would become a trivial culture, preoccupied with some equivalent of the feelies, the orgy porgy, and the centrifugal bumple-puppy. As Huxley remarked in Brave New World Revisited, *the civil libertarians and rationalists who are ever on the alert to oppose tyranny "failed to take into account man's almost infinite appetite for distractions." In 1984, Orwell added, people are controlled by inflicting pain. In* Brave New World, *they are controlled by inflicting pleasure. In short, Orwell feared that our fear will ruin us. Huxley feared that our desire will ruin us.*

<div align="right">

Neil Postman, foreword to *Amusing Ourselves to Death* (1985)

</div>

While this may seem like a divergence from the subject matter of this book, let me state that I consider that television, and most recently the development of social media, have proven with their effectiveness at influencing and controlling docile (and often legally sedated) populations to be the most powerful mind-control drugs yet developed, and are having an effect that is unparalleled in human history. In their diverging views of future society, Aldous Huxley (*Brave New World*) and George Orwell (*1984*) both got one thing right: the pen has truly turned out to be mightier than the sword, and exponentially more so now that the official narrative is delivered by a virtual world of colorful moving images.

The full effect of this development upon human culture and consciousness is still unknown. Most children watch more television than they sleep (and far more than they are schooled) and are more comfortable on computers than they are on bicycles, while virtually all adults these days are semipermanently attached to a savvy media device disguised as a telephone, and increasingly feel lost and disconnected without it. We are the children of the Great Experiment, and we march off increasingly synchronized toward a new kind of future for humanity; the end result still dark and obscure.

Perhaps it is because I grew up in the late twentieth century in a small country that for a long time only had independent newspapers and two television channels that (as children) we were largely not allowed to watch ("Go outside and play!"), but it seems clear that the use of the world media as an instrument of social control took on a new and more dominant form in the early twenty-first century, and has increased greatly over the past decade with the innovation of the internet, and especially social media. The use of the media to influence and control society—something that Nazi Germany pioneered some eighty years ago with the then-recent inventions of the radio and moving pictures, and a future that both Huxley and Orwell famously anticipated—has now flowered into something quite new and unprecedented thanks to the innovation of social media, the Frankenstein monster that has delivered us at least four years of

a brutish, narcissistic, and ill-educated Trump presidency that even Orwell would have had a hard time believing.

How did such a thing happen? How have the people of the most informed society in history become so ignorant, fearful, and superstitious, and perhaps more importantly, so easily steered that democracy now appears to have run off its rails? In the twenty-first century, the current state of American power and prestige (at least in its own people's eyes) has largely been dictated by two media blitzes of unprecedented proportions. The first of these was September 11, 2001, which was really the first day of the twenty-first century, since this was the day when the modern world changed forever. Most of us remember exactly where we were when we first heard the news reports that morning of 9/11—I was driving to the local hardware store in New Orleans to buy materials to work on the home that I had purchased just a week before when the radio in my truck broadcast the news of the first plane hitting the first tower. By the time I was at the paint store, the footage of the second plane hitting the tower was being broadcast, which I mistakenly believed must have been the first.

I didn't own a television, but almost immediately it was easy to see that this was the beginnings of a twenty-four-hour-a-day media blitz of previously unknown proportions. In response, I kept my own (foreign) head down, offered no opinions, read the few newspapers I trusted, and just worked away on my old wooden house the best I could. I didn't yet have internet at my new house, and while I had an AOL account and an email address, I was unaware of the primitive social media of that era. Some months later I was in a bar that had a TV on late at night and upon seeing a different clip of the second plane hitting the Twin Towers, I instinctively let out a loud "Wow!" Everybody else in the bar looked at me as if I had just climbed out of a cave, since no one could believe that I had not seen the footage before, while they had seen it so many times, they had become immune to it.

What I did observe in those weeks after 9/11 was how many seemingly intelligent and educated people really seemed to believe that the United States was in imminent danger of being invaded by fun-

damentalist terrorists, and that it was now engaged in an actual war. Which before too long it was, with Saddam Hussein, who had nothing to do with 9/11 (although Dick Cheney and company used the media to convince Americans that he was), and in Afghanistan, fighting the Taliban for not giving up Osama Bin Laden. Fifteen years later, nearly eight thousand American soldiers have died, and a million have come home wounded, along with an estimated 210,000 civilian fatalities. The United States is still in Afghanistan, Iraq is a living hell, as is its formerly moderate neighbor, Syria, while the entire region has been massively destabilized, which emboldens Iran and Saudi Arabia, and more nebulous entities like ISIS. George Bush and his cronies managed to use up the entire empathy of the planet in a few short weeks, and along with this never-ending "War on Terror," we got the Patriot Act, fictitious weapons of mass destruction, wire-tapping, Abu Ghraib, and daily debates about the moral validity of torture, kidnapping, and death by drones. Somewhere along the way, with the embedding of reporters with the troops in the Second Gulf War that followed 9/11, and the media largely accepting without question the Bush administration's obvious lies and propaganda, real journalism in America died.

The second great media blitz that has shaped modern American consciousness was when Hurricane Katrina glanced off my adopted home town of New Orleans some five years later. In the aftermath, the poorly constructed canals designed to take pressure off the levee system failed, and the Crescent City—the town that care forgot—was subsequently flooded and abandoned in the costliest natural disaster in U.S. history.

By an extreme stroke of luck, I was at Burning Man in the Nevada desert at the time, which at that point was probably the United States' only true media blackout zone. (Sadly, no more.) Katrina had been off the coast of Florida and not even on Louisiana's mind when I drove out of New Orleans on my way to help build Black Rock City in 2005, but by the time we drove into the desert the Thursday night before the gates opened to the public, the massive hurricane had found its way into the Gulf of Mexico, and it seemed unlikely that New Orleans would avoid

it. My fiancee at that time was very nearly trapped in New Orleans. A native-born New Orleanian, she caught the next-to-last flight out of the city on a ticket we had purchased months earlier. She arrived at Burning Man on Sunday night, and then early on Tuesday morning, August 29, 2005, Katrina hit. Later in the day, after everyone thought that New Orleans had dodged the bullet and while we were having our annual Fat Tuesday Mardi Gras party at our Burning Man camp, the levees failed, and the city quickly fell into chaos.

It is interesting to note, a little more than a decade later, how a handful of newspapers, for perhaps the last time in history, played a major role in my memory of the events. As I was driving into Burning Man, the uninvited memory came into my mind of the front page headline of a British tabloid newspaper—"Jazz City to Be Destroyed!"— from another hurricane that had eventually missed New Orleans a couple of years earlier. A late arrival brought a *New York Times* to our camp two days after the levees failed, with a photo of the top of a crossroads signpost sticking out of eight feet of water just a few blocks from my fiancee's house. (Which meant we didn't need to worry about that anymore.) After we left Burning Man a horrific article in the *San Francisco Chronicle* about the alleged abuses in the Convention Center and Superdome—complete with graphic descriptions of rape and violence that turned out to be entirely fictitious—spooked me so badly that I hid it from my fiancee and seriously questioned exactly what had been going on back in New Orleans (mostly lies, as it turned out). Or the front-page photo, again in the *San Francisco Chronicle,* of the cops and military kicking in someone's front door in New Orleans that convinced me to return to the city while everybody else was being evacuated out.

I remember virtually nothing about the television coverage, because I quickly returned to New Orleans after Burning Man, and ignored the mandatory evacuation, choosing instead to gut the now-rotting basement apartment in my two-story house (my home is in one of the oldest—and highest—neighborhoods in New Orleans and only took about a foot of water). By doing so, I once again avoided the vast major-

ity of the constant media barrage that seemed to paralyze almost everybody else. In the weeks that followed, when no one else was allowed to come home, and the city was off-limits to civilians after the largest forced migration of Americans since the Civil War, I got to meet a few of the American media elite in the field at the various bars still open in corners of the city (notably the Maple Leaf, when we reopened it), and found out first-hand that virtually all of them shared my disenchantment with the state of modern journalism. Many of them in fact had quit entirely after 9/11 and the Gulf War, but had come out of retirement for Katrina. With its relentless coverage, Hurricane Katrina became the instrument of civil revenge for the remnants of left-wing mainstream journalism against George Bush and his legacy, the last gasp of people's journalism after the terrible damage to the media's credibility created by the propagandistic coverage of the Second Gulf War. (The fact that many media-savvy people now check Al-Jazeera for unfiltered news says a lot about the state of American journalism in 2017.) The events of 9/11 and Katrina were thus the two greatest blows to the post–World War II myth of American invulnerability since the war in Vietnam, as well as to the belief that the U.S. government was capable of aiding and protecting its own citizens, or even interested in doing so.

It would not have been possible for us to take power or to use it the way we have, without the radio.

JOSEPH GOEBBELS,
NAZI MINISTER OF PROPAGANDA

It is also interesting—and perhaps even important—to realize that both of these pivotal events were (at least for most of us) pre–social media. (MySpace launched in 2003; YouTube in 2005.) Thus the official narrative of these two events were the last major ones to have been created entirely by the major media—newspapers and television—something that is almost hard to imagine now only a decade later. Of the two, the first—9/11—has become the most challenged narrative since John F. Kennedy's assassination, and thanks largely to the rapid

ascension of social media, the most widely distributed conspiracy theory in history: 50 percent of Americans have doubts about the official story, according to a poll taken on the twelfth anniversary of 9/11. The second narrative—the gross mismanagement of the aftermath of Katrina, and the failure of engineering that had been forecast for decades—has largely been forgotten, even though the U.S. Supreme Court ruled that the Army Corps of Engineers was liable for the disaster, a first in the United States history.

It has become increasingly apparent to me over the past year that we have been experiencing the third great media blitz of the twenty-first century, one that has led to the mystifying election of Donald Trump and this radical new (further) swing to the right for the United States and its policies. This constant barrage of fear-based rhetoric and propaganda far eclipses those of 9/11 and Hurricane Katrina in sheer volume, since this latest onslaught has mostly been transmitted by the new hydra-headed form of social media, with its seemingly infinite number of questionable outlets.

The frightening thing that we are witnessing at this critical juncture in U.S. history is that since many people no longer trust the mainstream media or the elected government (after 9/11 and Hurricane Katrina and a host of other increasingly obvious government lies), they now take their news—or their worldview—from this same social media that gives voice to their frustrations, even though it is a quagmire of opinion, where facts no longer appear to matter. The official narrative has now been replaced with the competing narrative, and at this point the individual is constantly bombarded with any number of extreme and dangerous views with no veracity filter attached. On social media the most important thing seems simply to be heard—a fact that the president-elect and his savvy media advisor Steve Bannon, a modern Goebbels who has compared himself to Dick Cheney and Darth Vader—accurately recognized and have ridden into power.

This often angry and xenophobic rhetoric is most prevalent and most easily spread on social media, where deliberately generated fake

news—now infiltrating institutions as once renowned as the *Washington Post*—and equally deliberate disinformation, is proving to be as dangerous as any state-fed propaganda, and far more insidious. For while a new Cold War is brewing over Russia's involvement in hacking and fake-news dissemination—and I for one have no doubt that Vladimir Putin, a former KGB intelligence officer, would use every opportunity to influence popular opinion in the West—the deeper and more difficult truth is that fake news is an inevitable result of the new digital-information economy.

In an opinion piece in the online version of the British newspaper *The Guardian* (January 7, 2017) that mirrors many of my own uneasy thoughts on the subject, Evgeny Morozov, the author of *The Net Delusion: The Dark Side of Internet Freedom*, writes:

The big threat facing western societies today is not so much the emergence of illiberal democracy abroad as the persistence of immature democracy at home. This immaturity, exhibited almost daily by the elites, manifests itself in two types of denial: the denial of the economic origins of most of today's problems; and the denial of the profound corruption of professional expertise [. . .] The problem is not fake news but the speed and ease of its dissemination, and it exists primarily because today's digital capitalism makes it extremely profitable—look at Google and Facebook—to produce and circulate false but click-worthy narratives. [. . .] When think tanks gladly accept funds from foreign governments; when energy firms fund dubious research on climate change; when even the Queen—what a populist, she—questions the entire economics profession; when the media regularly take marching orders from PR agencies and political spin doctors; when financial regulators and European commissioners leave their jobs to work on Wall Street—could anyone really blame the citizens for being skeptical of "experts"?

Morozov—a contributing editor to *The New Republic* and a visiting scholar at Stanford—then goes on to say, "Apparently, an economy

ruled by online advertising has produced its own theory of truth: truth is whatever produces the most eyeballs."

The result? I would argue that the average semi-intelligent human mind, when confronted by a digital cosmos of debatable information of previously unimaginable and potentially infinite proportions, simply shuts down. Information overload. (As foreseen by Aldous Huxley.) If you try too hard to really grasp the Big Picture from your own little corner of the world, and start disappearing down the infinite number of rabbit holes available on the World Wide Web, you risk becoming at the very least enraged or obsessed, and at the very worst, quite mad. I don't know anyone who claims to have become enlightened because of the internet, but I know plenty who seem to have become more radical or more confused. And then along with this information overload comes information fatigue, for when the stream of news is so depressing, why bother even reading it, let alone fact-checking it?

So what do we do? We practice how we have been taught to survive in the modern age: we insulate ourselves by specialization, and pour the greatest amount of our concentration and energy into some tolerable facet of our lives, some noble curiosity or distraction. Baseball, aliens, organic gardening, marijuana legalization, Burning Man. (Or psychedelic philosophy, photography, and paragliding, in my own case.) Often we become indignant at some obvious injustice in the world, or enthralled by some ancient art or modern miracle. And thanks to the click-and-bait culture of social media, people now have an active forum in which to argue passionately about Trade Tower Seven, the existence of the Illuminati, 2012, or a flat earth, or to deny things as seemingly obvious as climate change. Few subjects or opinions are taboo or considered "too out there" to be expressed. And while we can try and keep an open mind to others, another kind of fatigue sets in with every new Pizzagate: the fatigue of credibility, even the fatigue of just not wanting to know.

I have also witnessed how, although everybody on social media is supposed to be your "friend," this loud outpouring of radical positions on just about everything has largely turned our own communities

against ourselves. Along with the distrust of the media and government that many people are expressing and this apparent overwhelming desire "for their turn to be heard," I have witnessed an accompanying mean-ness of spirit and a complete lack of any empathy or interest in listen-ing to any viewpoint other than their own. As the celebrity food critic Anthony Bourdain said in his first interview after the recent election:

> The threshold of acceptable rhetoric right now, the threshold of hate and animus that's being shown at this point—this really naked hatred of every flavor, racists, sexists, pure misogyny, class hatred, hatred of the educated—this is something I've never seen before. And it's now acceptable! (Rosner, "Anthony Bourdain: The Post-Election Interview")

The last great war against fascism—World War II—was in many ways a war of production, with the workers of Britain and the Soviet Union, and then finally of the United States, proving to be the differ-ence against the mighty Nazi war machine. After the war, for a period of about twenty-five years, and largely thanks to their role in winning of World War II, the workers and the middle-class in the West were (sta-tistically) the strongest they have ever been in human history. In Britain, the much-maligned Labor government took power after the war with clearly socialist policies, while in both Britain and the United States, trade unions were powerful political forces until they were largely bro-ken in the 1980s by Margaret Thatcher and Ronald Reagan.

Thanks to the GI Bill and the postwar increase in production, by the mid-sixties the U.S. middle-class was, by percentage, the largest it had ever been, even though it was the era of the greatest internal dissent since the Civil War, and the last time that American univer-sities were remotely political. The fascist element in the West—and let's not forget that the United States, the home of the robber barons and Henry Ford, has always had a distinctly fascist streak—realized throughout the course of the twentieth century that the way to nullify dissent was to simply eradicate the middle class. They have managed

to do this remarkably successfully with the shifting of the onus of taxation from the corporations to the work force under Reagan, and the policies of deregulation that Clinton and all other presidents have continued since.

According to Noam Chomsky, the true role of government has traditionally been to protect the people from power—originally from the crown and then from the nobles, and later, in the twentieth century, from the new threat of corporations. In this respect our governments have failed us miserably. By financing politicians who have steadily deregulated the controls on financial institutions over the past thirty years, and by increasingly avoiding paying taxes, the top 5 percent have made themselves exponentially wealthier, while the middle class has been gutted by financial instability. According to Wikipedia, from the years 1945 to 1980, the income of the American middle class increased at around the same rate as that of the wealthy, while since 1980 the major increase in income has flowed almost exclusively to the top 1 percent of Americans. In 2014, in the aftermath of the housing crisis, the top 5 percent in the United Sates increased their overall wealth an incredible 20 percent, a virtually unnoticed increase that surely would have caused a revolution in any other era. Today the top 1 percent own 35 percent of the wealth in America.

This dramatic increase in the wealth of the American elite has resulted in a corresponding increase in power. Close to 11,000 registered lobbyists (the total number of Washington lobbyists is estimated to be up to seven times higher) spent $2.36 billion in 2016 on influencing the 100 members of the Senate and 435 members of the House of Representatives. That's nearly $4.5 million per elected official, down from a peak of $6.5 million dollars in 2010 (figures from Center for Responsible Politics). By comparison, trade unions are powerless to confront or counter this kind of centralized wealth, nor do the media have a credible voice, since there are no independent news outlets anymore; everything has been bought and homogenized or disbanded.

In 2010, the Supreme Court—the last bastion of American democracy—ruled (in the case of *Citizens United* in a 5–4 vote) that

corporations had the same rights as citizens, and for the first time extended these same corporations the full right to spend money as they wish in candidate elections—federal, state, and local. An estimated $1.5 billion was spent trying to influence the last election by the Super PACs and other dark money that the Supreme Court's decision now allows—a 43 percent increase from the previous presidential election. Super PACs now appear to prefer directly financing candidates they favor rather than lobbying elected officials. The number of both licensed Washington lobbyists and the annual amount they spend has dropped by one-third since the *Citizens United* decision— over a billion dollars.

The political landscape we now occupy comes largely from the tyranny of that Supreme Court decision that has green-lighted the complete fascist takeover of the United States. (David Bossie, president and chairman of the group Citizens United at the time the case was argued, was Donald Trump's deputy campaign manager.) While that may sound like a strong statement to many Americans, modern fascism, according to Noam Chomsky's definition, is quite simply "when business interests control government." (When Rex Tillerson, the CEO of Exxon, is made Secretary of State, for example.) These lunatics seriously believe in this idea of "the invisible hand," the idea that the only thing that is stopping world industry from running like a perfect well-oiled machine, is government and regulations, and pesky things like unions and people. These ideologues hold that, left alone, industry and the economy would operate on some perfect harmonic wave, and the future of humanity would be secured, guided by the invisible hand. The subprime mortgage crash, which took out most of the middle class's savings, was the latest example of how well that theory works. For the unfortunate truth about the invisible hand is it that operates on a singular requirement— increasing profits. But as Karl Marx pointed out, the flaw in capitalism is that it requires continuous growth and an unlimited market, and unlike the invisible hand, we all live in a very finite and bounded world. A world that is getting more crowded and more polluted, and less habitable and less tolerant, every coming year.

Contrasting this is the disturbing smugness of the Silicon Valley elite and the rudderless Democratic Party that it largely supports—the same all-knowing smugness that has made San Francisco the most unaffordable city in the world, forced its artists across the bay into death traps like Oakland's Ghost Ship, and turned Burning Man from an anarchistic-underground-artistic expression into the new Ibiza—and their naive and childish belief that the world could be changed simply by breaking the old paradigm down. (The same mistake Timothy Leary made.) The same tech elite now has to watch in horror as Steve Bannon and the new social media–savvy altright has skillfully used American ignorance and a dinosaur-demagogue like Donald Trump (most likely with the help of the twentieth century's last great dinosaur, Vladimir Putin) to turn Silicon Valley's own perceived information power against itself. The looks on the faces of Elon Musk, Larry Page, Tim Cook, et al. when they were summoned to Trump Tower just days after the election said it all: The employees of the ten largest Fortune 500 tech companies had contributed just $179,400, from 982 campaign donors, to the Trump campaign, while Hillary Clinton raised $4.4 million from the employees of the same companies, with more than 20,400 donations, according to a Reuters review of contributions. The Donald was clearly crowing while serving up some serious humble pie.

Powerless in the face of the overwhelmingly obvious, Facebook has become our equivalent of church meetings and trade-union halls, while Twitter marks the full extent of our social dissent. (The Occupy movement, incapable of coming up with even the most basic of demands—such as a ban or limit of lobbyists, or equally matched federal funding for elections, for example—quickly became the ultimate media storm in a teacup.) Twitter—arguably the most condensed of the social media forms, since it consists almost entirely of sound bites—is also apparently how the new president intends to run the Free World—the greatest reality TV show in history. (The ratings will be off the charts.) For the next four years, the entire planet will be addicted to this media circus and to a bombardment of unimaginable proportions from both traditional and

social media, twenty-four hours a day, seven days a week, twelve months a year, perhaps never to end.

Crazy shit, huh? You can't make this stuff up. One thing that the social events of the past twelve months has clarified for me—and a perspective that has very much come from the philosophical consideration of my psychedelic experiences—is the elementary truth in the Buddhist perspective that we occupy two universes: the inner universe, which we can to some extent learn to control, and the outer universe, which we cannot and which the philosophers of ancient India called the world of *maya,* or illusion. This new, all-pervading element of the social media is very much the outer world, and yet if we let it, it will quickly occupy our inner world as well, where its views can infect us and your personal philosophy, arousing such powerful emotions that it can turn you against your own family and friends. Which is really a very sophisticated form of indoctrination and mind control, if you think about it.

Interestingly, one of the recently reported effects of microdosing on LSD, or using a nootropic (cognitive enhancer) like modafinil, is that people stop checking their social media on their smartphones. The increase in focus and discernment that microdosing or nootropics can provide recognizes that social media is actually a waste of our time; *maya,* or illusion. This is part of the reason I have decided to start 2017 with a personal social-media embargo, by going digital cold turkey for a while, if you like. I'm not going to stop using the internet or email of course—that would be like going back to riding a horse—and as a photographer I will continue to post on Instagram so people can see my work, but I am going to take a break from my personal Facebook account, and from the hubris of all its opposing views, if only for the sake of my own sanity. I am fortunate to be friends with a number of the most productive artists of my generation, and I have noticed that other than Instagram, they are rarely on social media (or they have assistants in charge of their social-media accounts, if they are successful enough) since they are too busy making art, so in 2017 I am going to try and follow their lead, while ducking out the best I can on this

supersaturated twenty-first century media blitzkrieg, just as I did after 9/11 and Katrina.

In doing so I hope to focus on what's really going on in my immediate world, and inside myself, and try and ignore the constant temptation in a moment of boredom to be a voyeur of other people's lives on social media, out there among the trolls and the digital phantoms. I'm going to do more yoga, I'm going to spend more time outside, I'm going to read more books, and most importantly, I'm going to try to write a couple more, all from the extra time I will undoubtedly save. I also believe that I will smile more, because I won't be thinking about some obvious crap I read on Facebook, nor will I have been suckered into some pointless argument about global warming. I'm going to make art, and I'm going to take the time to observe the beauty around me in the world while I still can. Thinking not about George Orwell and his dark mechanical vision, but of Aldous Huxley's, and his much-quoted statement that "it is a little embarrassing that after forty-five years of research and study, the best advice I can give people is to be a little kinder to each other." For as allies turn on allies, and friends turn on friends in the easily offended social-media arena, as the fascists and their sophisticated forms of mind control increasingly turn ourselves against one another, few truer words have ever been said.

I encourage you all to try some digital cold turkey too. Break free for a little while from your social-media accounts, boycott Facebook and Twitter for a week, or a month, or a year, and—who knows?—we might actually learn to like it. Shield yourself and your children from its insidious grip as much as you can, for the reality is, it is increasingly difficult to function socially these days without it. I am sure I will be forced back on social media eventually; any kind of commercial success in the twenty-first century virtually demands it. But when I do, I intend to carefully structure my time on it, allowing myself only limited access each day, while ultimately creating a personal platform of my own outside of Facebook (i.e., my own blog, gallery, and newsletter) for those who are interested in my work, while hopefully not becoming addicted again to social media's seductive beck and call. In the meantime, hope-

fully there is some young unsung genius among us who is developing a more truly community-based structure for social media, one that disempowers sophisticated platforms like Facebook and Google (that are designed to make a few people exorbitantly rich, and are increasingly being used as sophisticated agents of control), while empowering us, the very people that social media claims to represent. Proponents of blockchain technology claim that this latest technological innovation could one day allow for the direct and fair elections of officials in which we could all easily participate; something like that would be truly revolutionary. For in a Trump presidency, when the whole world often seems as if it's falling into the grip of a crazy dark dream, it's time to take the red pill and wake back up in the real world while we still can.

This article first appeared on the webzine *Reality Sandwich*.

PART THREE

Dreaming of the Light

A Brief History of Visionary Art and Culture

INTRODUCTION:
WHAT IS VISIONARY ART?

One makes oneself a visionary by a long, immense, and reasoned disordering of the senses.

ARTHUR RIMBAUD

The most obvious and significant development of the Second Psychedelic Revolution that I have mapped in this volume is the rise—and indeed domination—of the latest incarnation of psychedelic art, now known as visionary art, within contemporary psychedelic culture. For unlike the first Psychedelic Revolution of the 1960s, which was most influenced by writers such as Aldous Huxley, Alan Watts, Timothy Leary, and Ken Kesey, this latest psychedelic wave has been headed primarily by visual artists (led by the visionary painter Alex Grey), while the developing genre itself has played a major part in the success of the electronic music–driven "transformational festivals" of the early twenty-first century. Visionary art, by providing vital contemporary psychedelic imagery for the worldwide electronic music scene that supports it, and thanks to the invention of the internet and digital format, which have embraced it, has quickly become the most recognizable feature of twenty-first century psychedelic culture, and arguably the most influential—so much so in fact that today psychedelic culture is often referred to as visionary culture. I believe this fact makes it timely to contribute a history of the genre's historic influences and genesis as I understand them, as

well as contemporary visionary art's main architects and contributors.

As a caveat, let me state that I am far from an art historian, nor do I make any claim to be a expert in Visionary Art. I have, however, thanks to the synchronicity of the publication of *Tryptamine Palace* in 2009 and my co-career as a public speaker through the first decade-and-a-half of transformational festivals, been a central witness to the rise of visionary culture, as well as a friend and fan of many of the contemporary visionary artists mentioned. Thanks to this synchronicity, I have had plenty of firsthand opportunity to discuss what visionary art means to many of the artists who have been involved in the growth and current success of this culture, and I have had an equal opportunity to form an educated opinion of my own.

This "Brief Guide to Visionary Art and Culture" should therefore be considered a very personal and far from complete one. There will be many fine artists and pivotal events that I will undoubtedly leave out because of either the timing of the narrative or just plain ignorance of my own, while some of my historical inclusions are bound to be challenged by art critics far more knowledgeable than myself. I will readily admit that in the writing of this history, I have both learned a great deal and considerably clarified my limited knowledge about this genre, while discovering the existence of many fine artists in the process. Academically, I have come to understand both the technical differences between the terms *visionary art* and *psychedelic art,* while practically, I have come to recognize how these differences may not even effectively matter anymore, since in the twenty-first century the two terms have now merged as One.

And while it is my hope to keep this history relatively brief, to be thorough we need to start back with the sixty-thousand-year-old tradition of the Paleolithic cave painters, right at the very birth of Art itself.

13

PRIMITIVE AND ANCIENT VISIONARY ART

On his return from this blissful though terrible experience, the shaman is able to report on the psychological experience in the symbolic language of the visions. Assuming that the cave painters were depicted by shamans following such ecstatic experiences, the cave paintings may be seen to reflect the visionaries' mystical experience. Moreover, since the psychological experience springs from the deep layers of the unconscious concerned not with the personal but with the universal, collective problems of humankind, the paintings are of an archetypal nature. The remarkable thing is not that the shaman of the Paleolithic had the visions that they did but that they accepted them as divinely or externally inspired, and that accepting them they translated them into mortal form, the art of their rock paintings. The visions captured in the form of paintings seem to point to a higher, archetypal truth. Rather than giving individual stories, they tell of man's intimate relationship with nature, of his understanding of the coming and going of the seasons and the animal herds, and of man's role as hunter that he has played since time immemorial. Perhaps one of the reasons why the paintings communicate such a sense of wholeness is that they are not manmade but divinely given masterpieces—Man was not their creator; he was the emissary of the creation.

DR. ILSE VICKERS, *THE DESCENT INTO THE CAVE*

It is impossible to say where the intersection of art and psychedelics first began, because that comingling most definitely occurred in prehistoric times. Cognitive archaeologist David Lewis-Williams theorizes that the earliest cave art emerged when early *Homo sapiens* attempted to "fix" their visions experienced during altered states (Lewis-Williams, 2002: 193–96). It is also possible that art—along with other developments such as language, body ornamentation, and even religion—was catalyzed by the accidental consumption of psychedelic plants or mushrooms* during the period when a few hardy bands of hominids, numbering in the thousands, were driven out of the African continent and into Eurasia by desertification, bringing with them the radical modifications in animal behavior that would allow them to develop over the subsequent 60,000-year period into *Homo sapiens,* the most dominant and destructive species that nature has ever known.

Supporting the theory that plant entheogens were involved in the development of the first human culture, the earliest known human art†—the first fertility symbols, or the cave painters of the Upper Paleolithic era some 40,000 years ago—appears to contain a significant shamanic component and was undoubtedly of spiritual significance to the peoples of that time. *Shamanism,* while taking its name from a Siberian variant, has been proven to be a universal human phenomenon that has been practiced by different peoples in various forms all over the planet. It generally utilizes a staggering variety of psychedelic and other mind-altering plants to give the shaman access to other dimensions of consciousness.

The artists that produced the first human masterpieces of art in places later named Willendorf and Chauvet and Lascaux (around 16,000 years ago) were clearly shamans, since the making of shamanic objects, which contained great power, could only be done by a shaman of power. Therefore it can be theorized that psychedelics and art first intersect there, that these ancient shamans were the first artists, and

*As both Gordon and Valentina Wasson, and Terence McKenna have proposed.
†While there is evidence emerging of human art that dates back much earlier than these examples—perhaps as long as 70,000 years ago—the art of the Upper Paleolithic represents the most obvious leap in cultural and spiritual development.

that the inspiration to make art came from the shamanic—potentially psychedelic—states that preceded it.

Until recently it was believed that human civilization needed to develop agriculture and settled communities before it was able to build significant cities and temples for worship. But the discovery of Göbekli Tepe in Turkey—a series of massive carved megaliths around 11,000 years old—has upended that theory, since they were produced in the Neolithic era well before the agricultural revolution, and are clearly the work of a hunter-gatherer society of significant cultural and spiritual development. (To put the age of Göbekli Tepe in perspective, it predates Stonehenge by six thousand years, and the development of agriculture by at least a thousand years.) These T-shaped pillars—the highest 16 feet tall, and weighing between 7 and 10 tons—are elaborately carved with foxes, lions, scorpions, and vultures, while a number of the pillars themselves have an uncanny resemblance to mushrooms. Klaus Schmidt, the archaeologist who discovered the significance of Göbekli Tepe, believes that before humankind ever built a town or a city, hunter-gatherer tribes in this area at the northern tip of the Fertile Crescent first built a temple used for Neolithic shamanism. (The numerous carvings of vultures suggest that the site was used for "sky burials" such as are still practiced in Tibet today.)

Scholars have long assumed that only after people learned to farm and live in settled communities did they have the time, organization, and resources to construct temples and support complicated social structures. Schmidt suggests, however, that it was the other way around, and that the extensive, coordinated effort required to build the monoliths literally laid the groundwork for the development of both agriculture and complex towns and societies. Human spirituality, freed from the deep and imposing natural caves that had nourished the mystery for the previous 50,000 years,* now sought to build suitably inspiring

*The incredible recent discovery of a 176,500-year-old Neanderthal "chapel" in the Bruniquel cave in France—where 400 stalactites, each weighing 2.2 metric tons, were broken and arranged in circles, and are now believed to be the oldest known manmade structures—now potentially places the origins of cave temples far further back in time.

containers of its own, and the ancient tradition of temple building began.

As civilization developed, there is clear evidence that psychedelic plant admixtures were used as sacraments, a factor that clearly must have influenced the artists of these times enormously. Art itself lost none of its sacred nature and for thousands of years was used mostly for the symbolic adornment of temples and shrines.

Four major psychedelic cultures, all of which produced significant artistic and philosophical output and lasted for hundreds if not thousands of years, are now known to have existed, as discussed in chapter 5, "A Short Psychedelic History of the World": in the East, the spiritual traditions of ancient India and Zoroastrian Persia, which employed the sacramental mixtures *soma* and *haoma* respectively; in the Americas, the remarkable pre-Incan Chavín culture, which used mescaline-containing cactus admixtures as a sacrament; the Olmec, Toltec, Mayan, and Aztec civilizations of Mesoamerica, which all utilized the widest variety of psychedelic plants on the planet; and finally, in the West, the ancient Greek cult at Eleusis, which used kykeon, an entheogenic potion (most likely of ergotized wheat) in its initiations for close to two thousand years.

An interesting study could undoubtedly be made of the connection between psychedelic cultures and the invention of rock carving and sculpture, since the psychedelic cultures listed above invented the majority of the techniques used in this art form, and produced the majority of masterpieces of their time. The often-repeated adage that the sculptor frees the form hidden with the rock—Michelangelo is famously quoted for saying, "I saw the angel in the block of stone and I set it free"—brings to mind the transformation that many commentators have witnessed of natural forms transmuting into other beings or entities while on psychedelics.

DMT is most famous for this effect, and I can offer the following anecdotal evidence. A few years ago I smoked DMT on the shores of Lake Churup in the Andes in Peru at around 14,500 feet (4300 meters). It is a small, pristine, high-alpine lake with a nominal shoreline that is accessed by a steep, five-hour-plus climb. There were towering

black rock cliffs just a short distance across the very cold, pristine water from where I sat and smoked the DMT, and I saw a variety of jaguar and birdlike gods and goddesses emerge from their dark walls. As synchronicity would have it, I traveled to Chavín de Huantar on just the other side of the Andes later that week, and I was astonished to realize that the intricate rock carvings in this temple (which I had never seen before) closely resembled those shapes and figures I had just seen in the black cliffs of Lake Churup just a few days earlier! When I looked on a map, I realized that even though it had taken many hours to drive there, the temple complex at Chavín and Lake Churup, higher up in the Andes, were probably only a dozen miles apart as the crow flies.

14

VISIONARY ART IN MEDIEVAL CHRISTIANITY AND THE RENAISSANCE

These visions which I saw were not in sleep nor in dreams, nor in my imagination nor by bodily eyes or outward ears nor in a hidden place; but in watching, aware with the pure eyes of the mind and the inner ear of the heart.

HILDEGARD OF BINGEN

By the time of the decline of the Roman Empire (which had incorporated many of the Greek artistic traditions into its own), Europe had lost the sanctified use of any known entheogens, and a thousand years of the dominance of the Christian church in Byzantine and Gothic art—which insisted on the expression of biblical truths as opposed to the material reality of the world—ensued.

The tradition of constructing transcendental cathedrals to God, however, continued unabated, notably in the mystical theology of the Eastern Orthodox church, which was behind the construction of the Hagia Sophia (573 CE) in Constantinople, which drew its inspiration from the Greek wisdom traditions with roots in Eleusis. (Sophia was also the Gnostic goddess of wisdom.) Hagia Sophia was the largest

Christian church in the world for a thousand years (today it is one of the world's most famous mosques). The tradition also produced the sublime Gothic Chartres Cathedral in France (1194–1250), which Joseph Campbell, waxing with a mystic's passion about the transcendental function built into the design of Chartres, once described as "the womb of the world." Both of these cathedrals were built on pilgrimage sites whose origins stretch back into antiquity.

In 1141, at the age of forty-three, the German Benedictine abbess Hildegard of Bingen (1098–1179) received a vision (bathed in an inner light) that she believed to be an instruction from God to "write down that which you see and hear." Still hesitant to record the visions she had been receiving since she was three years old, Hildegard became physically ill before she was convinced to produce three beautifully illustrated volumes of visionary theology—*Scivias* (Know the ways), *Liber vitae meritorum* (The book of the rewards of life), and *Liber divinorum operum* (The book of divine works)—which could be considered the first masterpieces of Western mystical or visionary art. She also wrote the *Ordo virtutum* (The order of virtues), an early example of liturgical drama and arguably the oldest surviving morality play, two volumes on natural medicine and cures, and more than four hundred letters. Considered one of the great women of her times, the remarkable abbess also invented a constructed language, the *lingua ignota* or "unknown language."

While Hildegard was later canonized for her mystical contributions to Christianity, the Middle Ages were generally marked by the brutality of the Inquisition. The use of mind-altering plants or consciousness-altering techniques would have been considered witchcraft—an accusation punishable by a myriad of painful deaths—and few painters of this period are consequently considered related to the development of visionary art.

The singular exception to this is the Early Netherlandish painter Hieronymus Bosch (1450–1516). His paintings—which contain fantastic imagery, detailed hallucinatory landscapes, and illustrations of religious concepts and narratives, including macabre depictions of

hell—create, in the words of the art historian Walter Gibson, "a world of dreams (and nightmares) in which forms seem to flicker and change before our eyes" and which presaged Surrealism by some four hundred years.

The true work of art is but a shadow of the Divine perfection.
<div align="right">MICHELANGELO</div>

The arrival of the Renaissance in Europe between the fourteenth and seventeenth centuries brought about a plethora of intellectual and social changes as medieval society was transformed by the Western rediscovery of classical Greek philosophy following the fall of Constantinople to the Ottoman empire in 1453. After this event, many Byzantine scholars and émigrés arrived in Western Europe, bringing with them volumes of Greek and Roman science and philosophy, which were subsequently translated into Latin and thus rediscovered in the West.

Few roles in European society were transformed more dramatically than that of the artist, where the monumental discovery of perspective in oil painting was accompanied by the rise of two opposing stereotypes of the artist himself—one as the suffering and tortured mystic, the other as the Neoplatonic ideal of the perfect Renaissance man, the *uomo universale* or "universal man," an ancient Greco-Roman ideal now seen as the highest form of humanity.

These stereotypes evolved from the extraordinary lives of the Renaissance's two most gifted artists and polymaths: Michelangelo (who was known in his time as "The Divine One") and Leonardo da Vinci (considered the epitome of genius), and they have survived intact into modern times. This was also the period during which individual artists first achieved widespread and lasting fame—Michelangelo was the first person for whom a biography was written while he was still alive, while Da Vinci was considered by many to be the greatest man of his age. *Genius,* which previously had been considered a grace that touched upon the individual from the heavens, was now personified in

the actual artist—often a heavy burden for those rare mortals who were so afflicted.

All levels of European society would be further changed during this dramatic period after the discovery of the New World in 1492, the sustained Renaissance investigation into the natural sciences, and the Protestant Reformation. The invention of the printing press around 1450 heralded a new era of mass communication and a democratization of knowledge. By 1500, more than 20 million volumes had been printed; by the end of the sixteenth century, an estimated 150–200 million volumes had been produced.

Like the internet today, the printing press created a shift in both technology and information. It allowed for the widespread distribution of dissenting religious views such as Martin Luther's Ninety-Five Theses (1517) and his revolutionary translation of the Bible into German (1522–34), as well as tracts containing radical scientific knowledge such as *De revolutionibus* (On the revolutions [of the planets]) by Copernicus in 1543, which advocated the heliocentric model of the solar system and in many ways introduced the modern age. From the sixteenth century onward, European man was no longer intellectually yoked to his village or town. For those who learned to read in this era, centuries if not millennia of accumulated knowledge became widely available for the first time in history.

Inspired by the rediscovery of Greek philosophy, the Italian artists of the Renaissance broke from the morbidity of the medieval period in their desire to portray the beauty inherent in nature, and in doing so unraveled the axioms of aesthetics. Similar advances in architecture (inspired by Filippo Brunelleschi's study of ancient buildings and the flourishing discipline of mathematics) resulted in the majestic dome of Florence Cathedral, and the rebuilding of St. Peter's Basilica (by Bramante, Michelangelo, Raphael, Sangallo, and Maderno), which are considered the pinnacle of late Renaissance architecture.

Around the same time in the Netherlands, the important innovation of painting on canvas began, and the artists there explored the beginnings of naturalism. But while the Renaissance is considered the

bridge between the medieval and the modern eras, it was marked by its nostalgia for classicism. It would take the Romantic period at the end of the eighteenth century, with its emphasis on emotion and individualism, to produce the first artist who would use the term *visionary* to describe his art and inspiration—the English mystic, poet, painter, and printmaker William Blake.

15

THE GENESIS OF VISIONARY ART

◈

William Blake and the Romantics

Shall painting be confined to the solid drudgery of facsimile representations of merely mortal and perishing substances, and not be as poetry and music are, elevated into its own proper sphere of invention and visionary conception? No, it shall not be so! Painting, as well as poetry and music, exists and exults in immortal thoughts.

<div align="right">

FROM THE DESCRIPTIVE CATALOGUE OF
WILLIAM BLAKE'S EXHIBITION OF 1809

</div>

Barely recognized during his own lifetime, William Blake (1757–1827) is now considered a seminal figure in the history of the poetry and visual arts of the Romantic Age, as well as one of the greatest artists that England has ever produced. A man with a deeply mystical nature, Blake was "afflicted" by visions of heaven, angels, and other entities from the age of four, and these visions continued to be the lifelong source of his poetry and artistic endeavors. Eschewing conventional religious dogma, Blake's first "illuminated book" was entitled

All Religions Are One, while Blake himself was highly sympathetic to the populist revolutions of the time—he was tried (and acquitted) of high treason (allegedly for cursing the king), and many interpret the words of his famous short poem from the preface to his epic *Milton: A Poem*—"those dark Satanic mills"—as a warning of the dehumanization of the Industrial Revolution.

Blake was considered insane, or at least visited by periods of madness, by most of his contemporaries, and his work was forgotten for a generation after his death, until the publication of his biography *Life of William Blake* in 1863. It wasn't until the twentieth century that Blake's work was fully appreciated and began to have a wider influence. Today, while it is the water-colored "illuminated" volumes of his poetry*—often dictated to him by "Archangels," who, Blake claimed, actively read and enjoyed his work—and his unfinished illustrations for Dante's *Divine Comedy* that have cemented his artistic reputation, it has been the modern interest in his writings and poetry—from William Butler Yeats to Aldous Huxley, and then Allen Ginsberg, Bob Dylan, Van Morrison, and Jim Morrison—that makes Blake "the Romantic writer who has exerted the most powerful influence on the twentieth century" (Larrissy, *Blake and Modern Literature*).

The lasting influence of William Blake upon psychedelic culture leads us to the main conundrum of contemporary visionary art—the question of whether or not an artist needs to take psychedelics to be considered a visionary artist.

*Blake's illuminated manuscripts combined his poetry text with relief etchings of his own invention that involved coloring the plates in colored inks before pressing them, or tinting them with watercolors after pressing. Blake was not averse to changing text or colorations between each printing, making every one of the surviving Blake volumes unique. As his biographer Peter Ackroyd points out, Blake's "newly invented style now changed the nature of his expression. It had enlarged his range; with relief etching, the words inscribed like those of God upon the tablets of Law, Blake could acquire a new role" (Ackroyd, *Blake,* 115–16).

VISIONARY VERSUS PSYCHEDELIC ART

If the doors of perception were cleansed, everything would appear to man as it is, infinite. For man has closed himself up, till he sees all things thro' narrow chinks in his cavern.

WILLIAM BLAKE,
THE MARRIAGE OF HEAVEN AND HELL

While it is nearly impossible to say when the modern Psychedelic Era first began, most commentators agree that psychedelics first gained widespread attention with the publication in 1954 of Aldous Huxley's *The Doors of Perception,* in which Huxley wrote about his experiences on the little known psychedelic *mescaline.* Since Huxley, a former atheist—his grandfather Thomas Huxley coined the term *agnostic*—was considered the preeminent authority on mystical states in the West (after the publication of his classic *The Perennial Philosophy* in 1945), as well as one of the world's most talented writers (he was nominated for the Nobel Prize for Literature seven times), *The Doors of Perception* was an instant classic and received considerable international attention.

By choosing the title for this book from a line from Blake's poem *The Marriage of Heaven and Hell,* Huxley unwittingly yoked Blake's visionary philosophies to the soon-emerging psychedelic culture—a connection that would be further immortalized in sixties counterculture when Jim Morrison named his seminal rock group The Doors after reading Huxley's book. Even later, almost forty years after the publication of *The Doors of Perception,* Blake would be invoked by psychedelic culture once again, this time by Ehud Sperling, Alex Grey's publisher at Inner Traditions, by proposing the title *Sacred Mirrors: The Visionary Art of Alex Grey* for Grey's first art book.

Although many contemporary artists considered it to be an awkward and clumsy term, classifying Grey's art as "visionary" focused attention on the mystical tradition of his art, as opposed to advertising the psychedelic inspiration to which both Alex and his wife, Allyson, readily laid claim. For Grey himself, the term is linguistically accurate:

he paints the things he "sees," often in psychedelic visions, and as a longtime practitioner of the Tibetan Buddhist Vajrayana tradition, he is able to clearly differentiate these mindscapes from the products of the ordinary imagination. Meanwhile at the time that *Sacred Mirrors* was compiled—at the height of Nancy Reagan's Just Say No! campaign and the reinvigorated War on Drugs—the word *psychedelic* was mostly either ridiculed or deprecated, and both marijuana and psychedelic use were statistically at the lowest point they had been since the 1960s. To use the word *psychedelic* in the title of nearly any book of that time might have been considered professional suicide, and Alex Grey was little known to psychedelic culture outside of New York at that time.

Just as the word *entheogen* (which had been coined in 1979) emerged as a coded reference to psychedelics in the 1990s (it was much safer to have an entheogenic conference or journal than a psychedelic one), so too the word *visionary* was used here as a sophisticated substitute for *psychedelic* in reference to Grey's art. Furthermore, by invoking Blake's lineage, Grey was attempting to place his own, psychedelically inspired art within the larger context of the historical visionary tradition; for not all visionary art is psychedelic, nor is all psychedelic art necessarily visionary. Ironically it would be the tremendous success of Alex Grey's art in the early twenty-first century that has led to the commingling of these two terms.

William Blake clearly had no need for drugs of any kind, nor is he known to have used any, but his visions came from the deepest and most fragile part of the psyche, which the first modern psychedelic explorers recognized as the same mystical territory that they can enter. Blake's ideas are sometimes presented as a precursor to Carl Jung's identification of the collective unconsciousness, and as with many great artists, Blake's writings seems to foreshadow the great revolution in the human psyche now evident in the societal transformations of the late nineteenth, twentieth, and now twenty-first centuries. For it would be art that would lead this intellectual revolution, during a period when virtually all the great old world empires would fall, and the artist and the revolutionary became close to indistinguishable.

THE ROMANTICS:
J. M. W. TURNER AND EUGÈNE DELACROIX

To say the word Romanticism is to say modern art—that is, intimacy, spirituality, color aspiration towards the infinite, expressed by every mean available to the arts.

CHARLES BAUDELAIRE

While Blake labored away in obscurity throughout his lifetime, another British artist was inventing some of the techniques that would soon impel the centuries-old Western tradition of radical realism to fall, and the realm of the psyche to emerge as the artistic inspiration of the modern era.

The British Romantic painter J. M. W. Turner (1775–1851) is considered one of the greatest landscape painters, and enjoyed considerable commercial success while alive. Turner found mystical inspiration in the sublime, awe-inspiring, and often savage grandeur of the natural world unmastered by men, which (to the Romantic artist) was seen as the evidence of the power of God. To Turner, light was the emanation of God's spirit, and this was why in his later paintings he left out the distractions of solid objects and detail, representing instead the play of light on water, or the radiance of the sky or fire, evocations of almost pure light by the use of fields of shimmering colors.

In France, Turner's equivalent was the painter Eugène Delacroix (1798–1863), who portrayed subjects (often historical) fraught with extreme emotion, dramatic conflicts, and violence, and whose work was marked by bold colors and expressive brushstrokes. Turner and Delacroix would be two of the main influences on the French school of Impressionism, which would break from centuries of Western artistic tradition at the end of the nineteenth century and boldly lead the way to the birth of modern art. While neither of these two are generally characterized as visionary artists, I believe Turner's work deserves mention because it is so clearly mystically inspired (as well as awesome to behold—the light literally pours out of a Turner painting); while little

has been made of the fact that Delacroix is listed as a member of one of the first known sustained modern European investigations into altered states of consciousness—the infamous Parisian Club des Hachichins.

THE CLUB DES HACHICHINS

Taste this greenish paste, and the boundaries of possibility disappear, the fields of infinite space open to you, you advance free in heart, free in mind, into the boundless realms of unfettered reverie.

ALEXANDRE DUMAS,
THE COUNT OF MONTE CRISTO (1844)

During his travels in Egypt, Syria, and Asia Minor between 1837 and 1840, the French sociologist Dr. Jacques-Joseph Moreau became fascinated with the idea of using the hashish experience as a model for psychosis. Upon returning to Paris, he realized that to do this kind of research he had to observe the effects of hashish objectively, by invoking the help of volunteers so that he could observe the drug's effects on others while he himself abstained.

In 1844, Moreau was involved in the founding of the Club des Hachichins where members met once a month at the Hôtel Pimodan in Paris, dedicated to the exploration of drug-induced experiences, in particular with hashish, and occasionally opium. (Hashish had become common in France after Napoleon's soldiers were introduced to the drug in Egypt.) In 1845 Moreau published a book entitled *Hashish and Mental Illness,* in which he establishes an equivalence between dream, hallucination, and hashish delirium. This book is the first written by a scientist about a drug.

"There are two modes of existence—two modes of life—given to man," Moreau mused. "The first one results from our communication with the external world, with the universe. The second one is but the reflection of the self and is fed from its own distinct internal sources. The dream is an in-between land where the external life ends and the

internal life begins." With the aid of hashish, he felt that anyone could enter this in-between land at will.

The Club des Hachichins operated between 1844 and 1849 and its influence on Romantic writers is well-known. Among its members were a number of Paris's leading artists, poets, and writers, including Victor Hugo, Alexandre Dumas, Charles Baudelaire, Honoré de Balzac, and Théophile Gautier. Baudelaire and Gautier already lived in the hotel, and Gautier is often credited as the founder of the club, while Baudelaire used the gatherings as research for his own book, *Les paradis artificiels* (Artificial paradises).

What is less well understood is the fact that at these gatherings the attendees were not *smoking* hashish; they were *eating* it, in the form of *dawamesk*—a mixture of hashish, cinnamon, cloves, nutmeg, pistachio, sugar, orange juice, butter, and cantharides. Most people don't know that eating hashish—as compared to smoking it—is a much more powerful experience that can be highly psychedelic,* while Dr. Moreau was known to administer dosages—on himself and patients, as well as on the Hachichins—that have been described as "unethical by today's research standards" and reputedly as high as 16 grams.

In Gautier's description of the experience—*Le Club des Hachichins,* published in 1846 to considerable attention—the faces of the people at the table with him change shape and color, and "madness, like a wave foaming against a rock, which withdraws to hurl itself once more, entered and departed my brain, at length altogether invading it." Eventually totally absorbed in his thoughts, Gautier knows that others are with him in the room, but he sees no one. He is completely wrapped up in himself, his mind filled with grotesque characters whose faces and bodies are monstrously contorted.

The accounts of the Club des Hachichins are well known to have influenced Arthur Rimbaud (1854–1891), whose poetry presaged the arrival of Surrealism, and the symbolist poet Paul Verlaine

*The rise of the accidental consumption of highly potent marijuana "edibles" is changing this perception.

(1844–1896), who were enthusiastic proponents of hashish (and absinthe as well). Rimbaud in particular in turn would have a profound influence upon both Dylan Thomas and the Beat Generation poets and writers (such as Ginsberg, Kerouac, and Corso), and then later upon the singer-songwriters of the 1960s (including Bob Dylan, Jim Morrison, and Van Morrison). But the fact that the romantic painter Eugène Delacroix was a member of this hallucinatory hashish-eating society has been mostly overlooked.

Nevertheless, in the context of the history of visionary art this is highly significant, because Delacroix's hashish "dreaming" undoubtedly influenced his paintings—which were often imagined scenes from mythology or literature that were in themselves early experiments in color over form. Delacroix's known membership in the Club des Hachichins makes him the first major Western painter whose art was undeniably influenced by visionary compounds. This discovery is all the more important because of his influence on the Impressionists, the most controversial and most influential artistic movement of the nineteenth century.

16

STUDIES IN LIGHT

Impressionism, Van Gogh, and the Birth of Modern Art

Monet is only an eye—but what an eye!

PAUL CÉZANNE

While Turner was striving for an expression of spirituality in the world, and Delacroix was struggling to paint "the forces of the sublime," their experimentation with color, expressive brushstrokes, and deconstruction of form would profoundly inspire the French impressionists (Claude Monet for one carefully studied Turner's techniques), who continued the rebellion against painting historical or mythological scenes in favor of landscapes or scenes from their natural surroundings, and preferably painted under natural light and in a lighter and brighter style than was used by the established realism of the day.

This group of French artists, led by Monet, Pierre-Auguste Renoir, Alfred Sisley, and Frédéric Bazille (and later joined by Paul Cézanne), were considered radicals who violated the rules of academic painting. They infuriated the Académie des Beaux-Arts, whose annual juried Salon de Paris—which valued historical subjects and religious themes painted as realistically as possible—was the preserver of traditional French painting. Monet's and his friends' paintings were routinely

rejected during the 1860s by the Salon jury, as was Edouard Manet's *Luncheon on the Grass* (whom the younger Impressionists greatly admired) in 1863, primarily because it contained a realistic nude in a contemporary setting.

After Emperor Napoleon III saw the rejected works in that same year, he ordered a show of the paintings for the public to decide, the Salon des Réfusés. While many came to mock the work, the new Salon drew more visitors than the original, and the influence of the new school—satirically named Impressionists (after the title of one of Monet's paintings) by an influential art critic—quickly spread. Significantly, although the established French art critics continued to attack the group, the public ultimately embraced the Impressionists and their independent shows, setting the stage for the emergence of modern art at the end of the nineteenth century. Today a number of the paintings of that era are considered among the most valuable art* works in history.

By the middle of the nineteenth century, thanks to the dramatic changes in European society brought about by the Protestant Reformation, and later the French Revolution, along with the creation of a new class with wealth that accompanied the expanding Industrial Revolution and created a new form of patronage, art and the artist were able to make the monumental leap into what is now known as modern art, by turning away from the ever-increasing realism of over a thousand years of European art, and discovering the hitherto unexplored territory of the unfettered mind. Artists such as Turner and Delacroix had started this exploration by beginning to paint what was seen not by the eye, but

*When *Dance at Le Moulin de la Galette* (1876) by Renoir sold at auction for 78.1 million dollars in 1990, this was briefly the most expensive painting of all time. The *Portrait of Dr. Gachet* (1890) by Vincent Van Gogh sold for $82.5 million later at the same auction. (And to the same Japanese industrialist.) As incredible as these prices might seem, they appear like bargains now a little over twenty-five years later; Paul Cézanne's *The Card Player* (1882/3) sold for somewhere between $259 million and $300 million in 2011, while Paul Gaughin's *When Will You Marry Me?* sold for $300 million in 2015, making it one of the most valuable paintings of all time. (Both paintings went to private sales in Qatar.)

by the mind's eye, and the Impressionists continued that investigation almost to the point of abstraction (as in Monet's late waterlilies).

However it would be a Postimpressionist painter who would later most fully explore the line between what is real and what is unreal, and what is seen and what is unseen. It was a vision that required pushing his mind's eye to the brink of madness and beyond, an artist who died convinced he was a failure but who has become one of the most famous artists in history and recognized as one of the fathers of modern art, one of those seers who made the vital break from the prison of realism. Although I have never seen Vincent Van Gogh mentioned in commentaries on visionary art, I feel compelled to include him in this one, if only for the fact that I still think that *The Starry Night* ranks as one of the most psychedelic paintings I have ever seen with my own eyes.*

THE VISIONARY WORLD OF VINCENT VAN GOGH (1853–90)

Real painters do not paint things as they are . . . they paint them as they themselves feel them to be.

LETTER FROM VINCENT VAN GOGH
TO HIS BROTHER THEO

Although the most romanticized artist since Michelangelo and the modern stereotype of the tortured mystic artist, the Dutch Postimpressionist painter Vincent Van Gogh has rarely been mentioned as a visionary artist, simply because he painted the objects he saw in front of him, as opposed to visions that he received. But Van Gogh's art itself is visionary in that it reveals a world very different to what most ordinary people see. The objects in Van Gogh's paintings take on a very psychedelic character, with bright layers of startling color that writhe

*I'm not alone in these kinds of thoughts; when I asked the visionary artist Luke Brown what he considered to be the most psychedelic painting ever, he answered Marcel Duchamps, *Nude Descending a Staircase*.

with strange and unexpected shifts in perspective. Considering the artist's known addiction to absinthe—a highly alcoholic beverage with a hallucinogenic reputation—and perhaps to opium, one can wonder how much his physical addictions (coupled with a lack of food and sleep and general poor health) influenced his artistic vision.

What is equally interesting to consider is Van Gogh's famous history of mental illness and psychotic episodes—most dramatically the cutting off of his own ear after a fight with Paul Gauguin—which have been posthumously diagnosed as schizophrenia, bipolar disorder, syphilis, and lead poisoning from licking his paintbrushes to name a few. A link has also been suggested between schizophrenia and endogenous DMT production. One study found higher levels of DMT in the cerebrospinal fluid of severely schizophrenic patients, and it has been suggested that fluctuating levels of entheogenic DMT and 5-MeO-DMT could induce schizophrenic episodes.

According to art-critic Dale Cotton, "nature is the catalyst that Van Gogh used to lose himself in the act of creation. It was not trees, stars, and landscapes that interested him, but their effect on his nervous system. Painting was an almost religious devotion. 'I have a terrible lucidity at moments, these days when nature is so beautiful,' he wrote to his brother Theo. 'I am not conscious of myself any more, and the picture comes to me as in a dream'" (Cotton, "On the Road to Tarascon: Francis Bacon Meets Van Gogh"). Van Gogh was also known to suffer from hallucinations and delusions, and his mental health became so tenuous that in early 1889 he wrote that his life was "sometimes moods of indescribable anguish, sometimes moments when the veil of time and fatality of circumstance seemed to be torn apart in an instant" (Hughes, *Nothing if Not Critical*, 145).

At this time he voluntarily committed himself to an asylum in Saint-Rémy-de-Provence in France, and was during his stay at this sanatorium that he painted and one of the most famous and most reproduced paintings of all time, *The Starry Night,* which now hangs as one of the major exhibits in the Museum of Modern Art in New York. One of my all-time favorite works of art, this painting is characterized by

Van Gogh's use of swirls to represent the galaxies in the night skies above Saint-Rémy, which in turn look remarkably like the night skies when I gaze upon them after smoking DMT or drinking ayahuasca. While this cannot be offered as any evidence in itself, if the link between endogenous DMT production and schizophrenia is ever proven to be correct, then that is probably exactly what was happening to Vincent Van Gogh's consciousness as he struggled to retain his grip on reality, and documented in those final paintings.

Van Gogh produced a number of the most famous of his paintings over the last two years of his life as his mental health rapidly declined (including *The Portrait of Dr. Gachet*), a period of "fits of despair and hallucination during which he could not work, between long clear months in which he could and did, punctuated by extreme visionary ecstasy" (Hughes, *Portable Van Gogh*). Finally on July 27, 1890, overcome by the weight of his pronounced slide into madness—which painter Francis Bacon later advocated was actually an "extreme lucidity"—Van Gogh shot himself in the chest with a revolver, and later died from the complications. He was only thirty-seven.

17

SURREALISM, SALVADOR DALÍ, AND THE ROOTS OF MODERN PSYCHEDELIC CULTURE

Art is the path to the spiritual.
PIET MONDRIAN (1872—1944)

By the end of the nineteenth century, the widespread wealth created by the Industrial Revolution and the personal freedoms inspired by the French Revolution gave artists the independence to explore new themes outside of the narrow commissions traditionally offered by wealthy patrons or the church. With the publication of Sigmund Freud's *The Interpretation of Dreams* in 1899* and the popularization of the idea of a subconscious mind, many artists began to explore dreams, symbolism, and personal iconography as inspiration for their art, and the era of what has become known as modern art was fully actualized as a number of schools emerged at the

*Joseph Conrad's *The Heart of Darkness,* which has been called "the first modern novel" because of the author's use of an inner monologue for the narrator and is one of the most analyzed books in history, was published the same year.

beginning of the twentieth century inspired by the Postimpressionist experimentation of Van Gogh, Paul Cézanne (1839–1906), Paul Gauguin (1848–1903), Henri de Toulouse-Lautrec (1864–1901), and the pointillism of Georges Seurat* (1859–1891).

Some artists (such as Henri Matisse) explored the new universe through a new revelation of color, seeking to free color from the restraints of nature; others (like Pablo Picasso) sought inspiration from primitive art, as the Cubists engaged in a revolution against form. The schools of Fauvism, Cubism, Expressionism, and Futurism all emerged in the early twentieth century as humanity entered the most bloody and transformative century of its existence, and the revolution of modern art, with its complete break from the traditional narrative and its rejection of the two thousand years of previous history as it explored the boundaries of color, perspective, subject, and abstractionism, presaged the radical social upheavals that would dominate our global culture to this day.

But alongside the emerging paradigm of the artist as a revolutionary—epitomized by Picasso's cubist antiwar masterpiece *Guernica* (1937)—the enduring archetype of the artist as a visionary seer, the mystic who peers through the veil, remained and was implicit in the explorations of many early twentieth-century artists, especially the pioneers of abstraction, such as Wassily Kandinsky, Piet Mondrian, Kazimir Malevich, and Paul Klee. According to philosopher Ken Wilber's essay in *Sacred Mirrors:*

> [The Abstractionists] felt that a new spirituality in art would have to be Spirit approached directly and immediately, but through direct intuition and contemplative realization. They felt they that they had in fact pushed beyond the individual mind and body and discovered, through their art, a genuine and powerful approach to Spirit itself. (Wilber, "The Eye of the Artist," 10)

*Many of my personal DMT experiences remind me greatly of Seurat's pointillism.

Art, freed from both the temples that had spawned it and the religions that had long controlled its subject matter and development, now sought again for a more direct connection with Source, a purer kind of mysticism, as observed in minimalist works such as Malevich's *White on White* (1918). For the pioneering Dutch abstractionist artist Piet Mondrian (1872–1944), painting was a spiritual pursuit, and his great break from representational painting fused his mystical beliefs with his art.

Mondrian became interested in the mystical ideas of the Theosophical Society, formed by Helena Petrovna Blavatsky (1831–1891) in the late nineteenth century, and joined the Dutch branch in 1909. The Theosophists believed that it was possible to attain a more profound knowledge of nature than that provided by empirical means, and much of Mondrian's work for the rest of his life was inspired by his search for that inner spiritual knowledge, with the teachings of Blavatsky and a parallel spiritual movement, Rudolf Steiner's Anthroposophy, significantly affecting the further development of his aesthetic. Mondrian wrote—eerily presaging the great carnage that would descend upon Europe shortly after—that "Life is becoming more and more abstract. The truly modern artist *consciously* perceives the abstractness of the emotion of beauty . . . In the vital reality of the abstract, the new man has transcended the feelings of nostalgia . . . There is no escaping the tragic, so long as our vision of nature is naturalistic. That is why a deeper vision is essential" (Lipsey, *An Art of Our Own*).

Still other painters sought to reconnect with the archetypical and mythological dimensions of life derived from deep within the human subconscious. The mysterious and compelling metaphysical paintings of the Italian painter Giorgio de Chirico attracted the attention of numerous other artists when he moved to Paris in 1911, and would lay the foundations for a new school of art in the early 1920s that sought to combine both the psychological and the political: Surrealism.

THE MIXED CORRIDORS OF THE MIND:
SURREALISM AND PSYCHEDELICS

Take me, I am the drug. Take me, I am hallucinogenic.

SALVADOR DALÍ

Though now best known for its visual artists (such as Salvador Dalí, Max Ernst, Marcel Duchamp, René Magritte, Joan Miró, and Man Ray), Surrealism (as envisioned by the poet Guillaume Apollinaire) was considered from its inception a political movement, and formed around the writer/psychiatrist André Breton (1896–1966), who initially conceived of it as a literary group—Breton's *Surrealist Manifesto* of 1924 was signed by only a single painter. According to Wikipedia, "The group aimed to revolutionize the human experience, in its personal, cultural, social, and political aspects. They wanted to free people from false rationality, and restrictive customs and structures. Breton proclaimed that the true aim of Surrealism was 'long live the social revolution, and it alone!'" (Wikipedia, "Surrealism").

Born during the period between Europe's two crippling world wars and in reaction to the insanity of the trench warfare of World War I—Europe having just sacrificed many of their best and brightest in a brutal and essentially senseless war—Surrealism was heavily influenced by Freud's ideas about the unconscious. Free association and dream analysis were of utmost importance to the surrealists in developing methods for liberating the imagination. Embracing idiosyncrasy, the surrealists rejected the idea of an underlying madness. In his *Surrealist Manifesto,* Breton declared that the ideal art form was produced by the unconscious mind. Breton originally advocated automatic writing, but eventually, after a number of established painters (notably Ernst) belonging to another postwar anti-art movement known as Dada moved to Paris and became aligned with Breton's ideas (which were similar to the dadaists in ridiculing conventional artistic tradition and the Western belief in reason and order), Surrealism emerged as a visual art movement also, encompassing not only paint-

ing, but groundbreaking experiments in photography (Man Ray) and film (Luis Buñuel) as well.

It was during this era—in 1918—that mescaline was first synthesized by the Austrian chemist Ernst Späth, signaling a new era in the exploration of consciousness. Therefore it is with Surrealism, whose stated interest was the investigation of the unconscious (primarily through dreams) that we can place the birth of the first modern psychedelic art, for there is no doubt that the surrealist writers and artists of that time were aware of this new class of "psychotomimetic" drugs: the surrealist playwright Antonin Artaud wrote an account of his peyote experimentations in *Voyage to the Land of the Tarahumara* (1937), and the Belgian writer and painter Henri Michaux wrote about his mescaline experiences in *Miserable Miracle* (1956).

Evidence of peyote or mescaline use amongst the original surrealist painters, however, is harder to find; André Masson (1896–1987) is known to have experimented with mescaline in his automatic drawing experiments,* and was part of a group experimenting with altered states of consciousness that included Artaud, Joan Miró, and Jean Dubuffet, who were all neighbors of his studio; while Henri Michaux (1899–1984) exhibited his mescaline-inspired ink drawings (some of which are now in collections at the MoMA, the Tate Gallery, and other major museums).

The Wikipedia entry "Psychedelic Art" also lists the Spanish-Mexican painter Remedios Varo (1908–1963) as an example of surrealist psychedelic art. A major influence of the contemporary visionary artist Martina Hoffmann, Varo had a lifelong interest in mysticism

*Masson's experiments with automatic drawing have a fascinating parallel in contemporary visionary art. In a frank presentation on the psychedelic influences of his art at BOOM! in 2010, the digital artist Android Jones showed images that he had produced with his digital tablet whilst in an altered-state on the drug ketamine. Since Jones is a much more skilled artist than Masson with a remarkable dexterity for digital art, the images that he produced were fully formed and very beautiful, even though when he returned to consciousness he had no memory of where the image had come from, or of ever creating them.

and the occult, and was "influenced by her belief in magic and animistic faiths. She was very connected to nature and believed that there was a strong relation between the plant, human, animal, and mechanical world (Wikipedia, "Remedios Varo"). Forced into exile in Mexico in 1941 from Paris during World War II (Varo had fled Spain during the Spanish Civil War) her interest in mysticism and the plant worlds may have led her to peyote or the magic mushroom cults. Most of her work resides in Mexico in the Museum of Modern Art in Mexico City. What can be stated for certain is that, with her fascination with the paintings of Hieronymus Bosch, and her equal interest in the ideas of Jung, the mysticism of G. I. Gurdjieff and P. D. Ouspensky (she underwent a sustained two-year investigation into "the fourth dimension," one of Ouspensky's central themes), Madame Blavatsky, Meister Eckhart, and the Sufis, as well as her fascination with the legend of the Holy Grail, sacred geometry, alchemy, the I Ching, and "the plant worlds," Remedios Varo clearly deserves a mention as an early twentieth-century example of a visionary artist.

Salvador Dalí (1904–1989), however—the most famous of the surrealist painters, and one of a handful of artists who most captured the imagination of the twentieth century—publicly derided the use of drugs. When asked if he used them, Dalí stated "I don't do drug; I am drugs." But Dalí also said, "Everyone should eat hashish. At least once," and as we have seen, eating hashish can produce a psychedelic effect just as strong as that of LSD. He also once made a fake documentary about hunting for giant hallucinogenic mushrooms in Mongolia, was friends with some of the greatest psychedelic painters of the sixties and seventies, and named one of his most famous paintings The Hallucinogenic Toreador; so it's fair to say that we will probably never really know how much—if at all—psychedelic drugs influenced him.

Surrealism itself remained true to its core belief that the unconscious was the source of art, with dreams and Freudian analysis being seen as the most useful inspirations; the idea of using psychedelic

drugs as a tool for examining differentiated states of consciousness was still largely yet to come.

PSYCHEDELICS AND "CLINICAL ART"

Ironically the first known psychedelic art was created not in the set and setting of a surrealist's studio, but under clinical supervision during the same era in Germany.

Kurt Beringer's 1927 book *Der Meskalinrausch* (The mescaline inebriation) presented his study of the effects of injected mescaline hydrochloride on thirty-two human subjects. Some of them illustrated their written descriptions of their mescaline experiences, and while they did not have any artistic training (the one fine-art painter in the group drew nothing) and their sketches were "aesthetically unimpressive," this was the first publication of visual imagery made under the influence of mescaline (Stuart, "Modern Psychedelic Art's Origins").

Another early figure was Stanisław Ignacy Witkiewicz (a.k.a. Witkacy),

a Polish philosopher, playwright, and artist. He obtained peyote from Warszawskim Towarzystwie Psycho-Fizycznym (the Warsaw Metaphysical Society), and later from the scientists Alexandre Rouhier and Kurt Beringer. He also got mescaline directly from Merck pharmaceuticals. An expurgated version of his description of a peyote experience was published in his 1932 essay, *Narcotics.* The censored text originally included surreal sexual imagery such as, "violet sperm-jet straight in the face, from a hydrant of mountain-genitals." Author Marcus Boon commented: "Profane and misanthropic, Witkiewicz's prose reads somewhat like a modernist version of Hunter S. Thompson's" (Boon, 2002). Boon speculates that Witkacy's novel *Insatiability* may have been influenced by his peyote experiences. Apparently, Witkacy was the first modern artist to work under the influence of a classical hallucinogen. In 1928, Witkacy took "peyotl" under the supervision of

Drs. Teodora Bialynickiego-Birula and Stefan Szuman. Dr. Szuman published illustrations of Witkacy's peyote and mescaline visions in 1930. In 1990, Irena Jakimowicz published a 1928 drawing and ten pastel portraits created from 1929 to 1930 that Witkacy made under the influence of peyote, as well as three drawings and five pastel portraits he made under the influence of mescaline. (Stuart, "Modern Psychedelic Art's Origins")

18

POST–WORLD WAR II

Ernst Fuchs and the Vienna School of Fantastic Realism

One could see the works of the Fantastic Realists as a blueprint to a poetic worldview. This worldview is not sharply bordered, neither logically or only after aesthetic categories structured, but a free floating organism, open on all sides. As such it is the attempt of a synthesis, which combines within the mythos of fantasy the Micro and Macro Cosmos, the Outer and Inner, Light and Dark, Day and Night, Sun and Moon, Heaven and Hell, Religion and Magic. All the Viennese Fantasists are in a special and personal way builders of myth, and as such in our modern world picture representatives of a type of artists, which since the Renaissance bring to light the numine afflatur, the poetic in its original meaning pertaining to poetry and creation.

OTTO RAPP, "THE VIENNA
SCHOOL OF FANTASTIC REALISM"

THE VIENNA SCHOOL OF FANTASTIC REALISM

The rise of the Nazi party in Germany shattered the peace in Europe in 1939, starting a global war that caused an estimated 50–85 million fatalities and marginalized Western Europe's influence in the postwar

217

world for more than fifty years. The dropping of the atomic bombs on Hiroshima and Nagasaki in Japan in 1945 signaled the rise of a new world power—the United States—and a new, far different world, where along with the revelations of the horrors of the attempted Nazi genocide and the rumors of Stalin's pogroms, all of humanity was now faced with the potential of instantaneous destruction, and even planetary extinction.

During the excitement of the Jazz Age, those golden years between the two world wars, art was seen as the cutting edge of a vast social revolution against the madness of modern life and the artist was reimagined as a revolutionary. This period was probably only matched in the twentieth century by an even shorter period in San Francisco in the late 1960s, when another idealistic social revolution (with the rock musician now as the revolutionary) would quickly flower, bloom, and die. But despite its current association with psychedelic culture, the genesis of contemporary visionary art occurred not in San Francisco in the 1960s, but in Vienna, Austria, in 1946, barely a year after the war in Europe ended, when a group of students of Professor Albert Paris Gütersloh from the Vienna Academy of Fine Arts founded the Vienna School of Fantastic Realism.

At the beginning of the twentieth century, Vienna had been one of the great cultural capitals of Europe: at one time in 1913, Freud, Adolf Hitler, Joseph Stalin, Leon Trotsky, and Josip Tito all lived within a few miles of each other in central Vienna, and often frequented the same coffeeshops. But with the collapse of the Austro-Hungarian Empire after World War I, Vienna fell from this status, and the visual arts there stagnated after the death of Gustav Klimt and Egon Schiele in 1918, and later with the Nazi occupation and its campaign against "degenerate art." Thus, even though Sigmund Freud had lived in Vienna, Surrealism did not find its way there until after World War II, when the Vienna Academy of Painting reopened its doors in 1945.

At that time, Vienna was an occupied (and divided) city complete with foreign troops, war machinery, barricades, ID checkpoints, food

stamps, and black-market prices. The city had been badly bombed during the war, many great buildings and monuments to its glorious past lay in ruins, and most known artists and musicians (including Oskar Kokoschka) emigrated during this time, often to the United States. Despite the difficulty of day-to-day living, the end of the war signaled an opportunity for new beginnings. The young Austrian artists that first cleared the Fine Art academy's hallways of debris before the classes could started included a fifteen-year-old Ernst Fuchs, and a sixteen-year-old Erich (later Arik) Brauer.

As Fuchs remembered it:

> It was 1945. A glimmer of hope, a longing for freedom awakened in the people, still surrounded by the smoke and darkness of the ending war. Now that the war has ended in Europe, a small group of painters came together at the bomb-devastated Academy on the Schillerplatz to start a new direction in art. They were only vaguely oriented: there was nothing to see of this new, modern art, only tales one could hear from the Mecca of Painting, Paris. (Muschik, *Die Wiener Schule des Phantastischen Realismus,* 12)

Those tales from Paris were of Surrealism. During and after the war, the Saarlandish painter Edgar Jené, who had been a member of André Breton's surrealist group and who reestablished links with Breton after the war, lived in Vienna and would be the young group's link to Paris. But it would be the lessons of Professor Albert Paris Gütersloh that would provide the group with the means to create their own form of Surrealism that was distinctly different from Parisian surrealists, for he would be their link to the past, the brief moment of glory of Viennese art shortly after the turn of the century.

Gütersloh, who had been a student of Gustav Klimt, and was an associate of Schiele's, gave the group of young artists an appreciation for the art of painting, and a basis in realism—breaking from the trend toward abstractionism in modern art that had begun in the late nineteenth century with Cézanne. As much a poet as a painter, Gütersloh's

own flair for the fantastic found a receptive audience in his students; as a poet he *painted,* as a painter he *spoke,* eloquently of the *language* of the "inner universe" (*Innerer Erdteil*), a language not separated by barriers between poetry and painting, but both existing as an inseparable whole; and from him his young students inherited an interest in religious and esoteric symbolism.

Of the early days at Gütersloh's class, five leading artists emerged from the initial seven. These five remain as the nucleus of a movement known today as the Vienna School of Fantastic Realism: Fuchs, Brauer, Rudolf Hausner, Wolfgang Hutter, and Anton Lehmden. By the 1970s, they had in turn influenced a following of well over ninety exhibiting artists in Vienna. That influence continues unabated today, with museums and institutes now attesting to the school's continuing importance.

From this original group, the artist who most deserves the title "Father of Visionary Art" is Ernst Fuchs (1930–2015). For not only was Fuchs one of the indisputable founders of Fantastic Realism, and arguably its most irrepressible spirit, he would also be responsible for teaching his Old Masters techniques to (at least) three generations of visionary (and psychedelic) artists. Commentators virtually unanimously agree that Fuchs's own body of work has had the profoundest influence upon what is now considered visionary art—both in Europe and in the United States, where the term is used quite differently.

For unknown to Fuchs and his friends at that time, in 1947, the year after the formation of the Vienna School of Fantastic Realism and a mere 500 miles away in Basel, Switzerland, the Swiss pharmaceutical company Sandoz Laboratories released a psychiatric medicine with the trade name *Delsid.* While originally invented in 1938, the psychological effects of this new drug—lysergic acid, or LSD—had gone unrecognized until Albert Hofmann, the Sandoz chemist who had first invented it, reinvestigated the compound in 1943 after an unusual premonition. In less than twenty years these two seemingly unconnected social currents would meet with spectacular effect, and although nobody knew it at the time, the era of psychedelic art was about to be born.

ERNST FUCHS:
THE GODFATHER OF VISIONARY ART

In the winter 1945/46 I realised for the first time, how a media-compulsive creative urge seized me. My hand created, led in trance, obscure things. As if under force, standing, I produced a great number of linear drawings in a few days. Through those drawings I detached myself from my first role models and immersed into unknown grounds of my fantasy. It did not take long for me to realise that I was a surrealist. [. . .] Not seldom I get into trance while painting, my state of consciousness fades giving way to a feeling of being afloat (like a medium) and being led and moved by a safe hand, doing things I do not know much about consciously. This condition lasts for hours. Afterwards, everything I did in this time seems to me, as someone else would have done it.

ERNST FUCHS, *THE GRAPHIC WORK* (1980)

Listed by Wikipedia ("Ernst Fuchs") as "an Austrian painter, draftsman, printmaker, sculptor, architect, stage designer, composer, poet, singer, and one of the founders of the Vienna School of Fantastic Realism," Fuchs, with his prolific output—much like his friend and mentor Salvador Dalí*—is in many ways the epitome of the contemporary twentieth-century artist. Fuchs's website—whose banner headline proclaims "Painter—Architect—Visionary"—lists, along with the various frescoes and large-scale building projects that Fuchs completed (including his own museum in a restored chateau), the fact that he designed furniture, tiles, porcelain, jewelry, medallions, tapestry, carpets, fabrics, and costumes and stage decorations. Fuchs also composed operas and produced a number of records and CDs, as well as writing poems, children's books, and fairy tales, along with his more scholarly work.

*One of Fuchs statutes is in the entry of the Dalí Museum in Figueres, Spain, atop the famous Cadillac.

However, it is the high technical quality of Fuchs's painting—increasingly considered among some of the finest of the twentieth century*—for which he has become known. Fuchs's greatest contribution to Fantastic Realism, and to much of what we now call visionary art, was in reviving and invigorating the Old Masters' *mischtechnik* (mix technique), a tedious technique of layering paint that gives numerous visionary art paintings their remarkable luminescence and an almost jewel-like effect. Fuchs (and his assistants, including his son Michael) then taught the technique to a number of important visionary artists, including Abdul Mati Klarwein, Robert Venosa, and most recently, Fuchs's last painting assistant, Amanda Sage. These artists in turn continued the tradition of passing the techniques on to other artists, ensuring that these so-called New Masters' techniques have not been lost (though they are often modified). Noted for their brighter colors and internal light, these have become the most recognizable features of contemporary visionary art.

Equally important to contemporary visionary art is the source of Fuchs's inspiration. According to his own words, "Things that you could not see in the normal world always pursued me. I always occupied myself with a kind of painting that renders pictures other people see in dreams or hallucinations. I could pass the barrier of this world of inner pictures even in awakeness and normal condition. The change from the world of dreams or phantasy into the world of reality in visible pictures for me was constantly possible" (www.ernstfuchs-zentrum.com/starteng5.html).

By stating that he sought to "get into trance while painting," and that his best work came from there, Fuchs revealed a mystical nature to his process, while his interest in Meister Echart, the transpersonal psychology of Jung, and esoteric symbolism and mythology only reinforced that mysticism, placing his art within the same lineage as Blake's. Thus the themes of Fuchs's paintings, his techniques, and his mystical lineage all make him as the Godfather of Visionary Art.

This is also where the confusion between visionary and psychedelic

*In 1993 there was a retrospective of Fuchs's work at the State Russian Museum in St. Petersburg. He was one of the first Western artists to be given that honor.

art begins, for in Europe "Visionary Art" is another name that is applied to Vienna School of Fantastic Realism and the various fine-art painters that they have inspired (including Fuchs, H. R. Giger, and Robert Venosa), while in the United States, visionary art has become the twenty-first-century code name for the broader, and often less-sophisticated, genre of Psychedelic Art. Thus not all psychedelic art should necessarily be considered visionary, nor is all visionary art necessarily psychedelic.

This confusion only grows greater when you consider the fact that Fuchs is also the first major European painter who can be positively identified to have used psychedelics. Fuchs admitted to taking both peyote and mescaline, is known to have taken magic mushrooms, and he was also a keen hashish smoker. Also, as something of a rock 'n' roll artist in the late 1960s and 1970s, he would have had plenty of opportunities to try LSD. It was also Fuchs who taught his mischtechnik to a young Abdul Mati Klarwein (1932–2002) in Paris in the late 1940s, the German-Jewish painter who (after he moved to New York) would later become regarded as the quintessential Sixties psychedelic artist.

The problem with assigning such pioneering status to either Fuchs or Klarwein (who both maintained reputations in the classical art world) is that neither was comfortable with being called a psychedelic artist, or even with admitting that psychedelics were an inspiration in their art. (Fuchs tantalizingly penned a drawing titled Doors of Perception, showing an eye peeking through a cubist-looking hole in a door.) When the first major book on psychedelic art was being compiled in the early 1970s, Klarwein was warned that he would have to admit to taking psychedelics to be included—something he wouldn't do—and after his interview he called Fuchs and warned him likewise. Hence neither Fuchs nor Klarwein was included. For unlike dreams or mythology or any other of the inspirations of the art movements of the twentieth century that sought to mine the deep territory of the subconscious, by this time psychedelics, while arguably the strongest tools available for such explorations, had quickly become illegal and stigmatized after their widespread influence in the late 1960s. This fact makes tracing the roots of psychedelic art uniquely difficult for any would-be historian.

19

PSYCHIATRY'S DARLING

The (Brief) Science
of Psychedelics and Creativity

I suddenly became strangely inebriated. The external world became changed as in a dream. Objects appeared to gain in relief; they assumed unusual dimensions; and colors became more glowing. Even self-perception and the sense of time were changed. When the eyes were closed, colored pictures flashed past in a quickly changing kaleidoscope. After a few hours, the not unpleasant inebriation, which had been experienced whilst I was fully conscious, disappeared. What had caused this condition?
DR. ALBERT HOFMANN, *LABORATORY NOTES*, 1943

As shown by the earlier chapter on the clinical art produced under supervision on mescaline in Germany in the 1930s, since the very beginning of psychedelic research there has been considerable interest in the links between psychedelics and artistic creativity.

Max Rinkle, M.D., who initiated the United States' first LSD research in 1949, reported (in 1955) that he and Clemens C. Benda, M.D., "gave mescaline and, on another occasion, LSD to a nationally known contemporary painter who showed a progressive disintegration in his drawings though each line showed the superior craftsman in

his art." In 1955, the American psychologist Louis Berlin investigated the effects of mescaline and LSD upon four graphic artists of national prominence. There was an impairment of finger-tapping efficiency and muscular steadiness among the four artists, but all were able to complete paintings. A panel of art critics judged the paintings as having "greater aesthetic value" than the artists' usual work, noting that the lines were bolder and that the use of color was more vivid. However, the technical execution was somewhat impaired. The artists themselves spoke of an increased richness of imagery and of pleasurable sensory experiences. One said, "I looked out of the window into the infinitely splendid universe of a tiny mauve leaf performing a cosmic ballet." Another spoke of "light falling on light" (Stuart, "Modern Psychedelic Art's Origins").

According to the doctor's analysis,

This improvement in their [the artists'] esthetic creativity may be explained by the following observations. The subjects became aware of "dead areas and dull colors" in their paintings and were able to modify them. There was a new feeling of unconcern about drawing in a "loose free way," and this loosening of restraint was evident in the size, freedom of line and brilliance of colors employed in their paintings. One artist who described her approach to painting as "indirect and tentative with many changes" felt "relaxed about the mistakes in drawing" and "'could cope with them in due time,'" while under the influence of mescaline. (quoted in Stuart, "Modern Psychedelic Art's Origins")

After the publication of *The Doors of Perception* in 1954, interest in psychedelics among writers, artists, and musicians only grew; the Beat poet Allen Ginsberg (1926–1997) first tried LSD in 1959 and cowrote the book *The Yage Letters* in 1962 (with William S. Burroughs) after traveling to Peru to experience ayahuasca. After Timothy Leary and Ginsberg met in the early sixties, the pair set about introducing America's intelligentsia, including numerous artists, to LSD. In the period between the publication of *The Doors of Perception* in 1954 and

1970, when most psychedelics were made illegal under the Controlled Substances Act and research stopped, numerous studies were made on the various effects of LSD, and to a lesser extent, mescaline and psilocybin.

The pioneering Los Angeles–based LSD psychotherapist Oscar Janiger (1918–2001) was particularly interested in the relationship between creativity and psychedelics. (Janiger is best known for providing LSD therapy to Cary Grant.) Janiger was fascinated by the similarities between paintings made under the influence of LSD, and the work done by schizophrenics. Janiger maintained that trained artists could "maintain a certain balance, riding the edge" of the LSD-induced psychosis; the artist could then "ride his creative Pegasus." Janiger coined the term "'dry schizophrenia," where a person was able to control the surroundings and yet be "crazy" at the same time (Wikipedia, "LSD art").

Between 1955 and 1962, Janiger had seventy prominent artists paint a picture of a standard object (an American Indian kachina doll) before ingesting LSD. During their psychedelic sessions, they painted the doll again. The artists produced some two hundred fifty paintings and drawings after ingesting LSD. Historian Carl Hertel analyzed the art in 1971 and compared it to the artists' non-LSD work. Hertel found that while the LSD art was neither superior nor inferior to the artists' other work, it was brighter, more abstract and nonrepresentational, and tended to fill the entire canvas.

The most notable study of psychedelics and artistic creativity was an extensive study of ninety-one American artists made by the psychologist Stanley Krippner of the Dream Research Laboratory in Brooklyn, New York. They included an award winning filmmaker, a Guggenheim Fellow in poetry, and a recipient of Ford, Fulbright, and Rockefeller study grants in painting.

A remarkably large number of the artists surveyed (93 percent) agreed with a broad definition of the "psychedelic artist," and 81 percent felt that the term could be applied to them personally. It was concluded that the "psychedelic artist" is one whose work shows the effects of psy-

chedelic experience—usually, but not necessarily, chemically induced. The work may have been produced as a result of psychedelic experience, during psychedelic experience, or in attempt to induce a psychedelic experience. In addition, the work may remind someone of a previous psychedelic experience, or it may be used to facilitate psychedelic experience brought about by something other than the work of art.

Of the ninety-one artists in the survey, 100 percent reported having had at least one psychedelic experience. When asked if they had ever taken a psychedelic substance, 96 percent answered "yes," while 4 percent answered "no." Seventy percent of the group stated that psychedelic experience had affected the content of their work, 54 percent of the artists surveyed said there had been a noticeable improvement in their artistic technique resulting from their psychedelic sessions (a greater ability to use color was the example mentioned most frequently), and 52 percent of the artists attributed a change in their creative approach to the psychedelics.

Many artists also claimed that psychedelic experience had eliminated superficiality from their work and had given them greater depth, both as creators and as people. Some referred to their first psychedelic experience as a "peak experience," as a turning point in their lives. "My dormant interest in music became an active one," said a musician, "after a few sessions with peyote and DMT." Another said that a psilocybin experience "caused me to enjoy the art of drawing for the first time in my life."

20

THE FIRST PSYCHEDELIC REVOLUTION

Art in the 1960s and 1970s

[The] psychedelic experience has deeply influenced all aspects of my life. It was an experience of self recognition, under LSD, which opened my eyes to drawing and painting as the means of self expression for which I had always been seeking. During subsequent experiences, many difficulties, personal and artistic, were resolved. When the personal difficulties were solved, energy was released for the benefit of my art.

ISAAC ABRAMS (1939–)

One of the subjects of Krippner's 1967 study was a self-taught American artist called Isaac Abrams, who is arguably the first true psychedelic artist, and most likely the artist who coined the term *psychedelic art*.

Abrams first tried psilocybin and mescaline in 1962, and he found that both were pleasant and positive in nature. Early in 1965, he took LSD for the first time, and during his session, he began to draw.

"As I worked," Abrams recalled, "I experienced a process of self-

realization concerning the drawing. When the drug wore off, I kept on drawing. I did at least one ink drawing every few weeks."

Abrams attended art classes to learn about technique and materials. His wife went to different classes, took notes, and passed on the information to her husband, and his skills developed quickly, so he began to paint.

"For me," Abrams said,

The psychedelic experience basically has been one of turning on to the life process, to the dance of life with all of its motion and change. Before 1962, my behavior was based on logical, rational, and linear experience. Due to the psychedelics, I also became influenced by experiences that were illogical, irrational, and non-linear. But this, too, is a part of life. This aspect is needed if life is to become interrelated and harmonious.

Psychedelic drugs give me a sense of harmony and beauty. For the first time in my life, I can take pleasure in the beauty of a leaf; I can find meaning in the processes of nature. For me to paint an ugly picture would be a lie. It would be a violation of what I have learned through psychedelic experience.

I have found that I can flow through my pen and brush; everything I do becomes a part of myself—an exchange of energy. The canvas becomes a part of my brain. With the psychedelics, you learn to think outside of your head. My art attempts to express or reproduce my inner state.

Concluding, Abrams states, "Psychedelic experience emphasizes the unity of things, the infinite dance. You are the wave, but you are also the ocean." Later in that same year (1965), after having met Timothy Leary, Abrams opened the Coda Gallery on New York's East Tenth Street, which (for the first time) featured painting, sculpture, and multimedia light shows under the banner of Psychedelic Art. Abrams was also one of the first artists to exhibit paintings that were specifically influenced by experiences with LSD. In 1966 Abrams stated:

Psychedelics have, in my experience, opened doors to other universes. Universes that under certain conditions, are as tangible as our own. Within these universes I have encountered spirits who identified themselves by name. Only later in my readings, did I come across those names. I have had inner body experiences, flowing through my own bloodstream, nervous systems and gender identities, and out of body experiences, flying, animal forms and above all conscious formlessness leading to an identification with the singularity of creation and the total inner-connectedness of nature. (Quoted in Rubin, *Stimuli for a New Millenium*)

As a defining statement for psychedelic art, this early one by Abrams certainly covers all the bases—the inner, the outer, the transpersonal; and yet if you took away the references to psychedelics, the words could have come straight from William Blake. From the very beginning it was obvious to those who were engaged in psychedelic exploration that the psychedelic experience, the visionary experience, and indeed the mystical experience were all inextricably entwined, branches from the same great tree.

Now in his eighties, Isaac Abrams continues to paint and exhibit to this day; from his roots as a self-taught artist inspired by LSD, his work has been exhibited in galleries and exhibitions around the globe, including the "Summer of Love" show at the Tate in London, and at the Whitney Museum of American Art in New York. Abrams has never lost his commitment to psychedelics, nor has he lost his commitment to art: he took up sculpture in the 1970s, was an early innovator in video art. Ever-determined to improve as a painter, Abrams studied for six months in Austria with none other than Ernst Fuchs.

RECORD COVER AND POSTER ART IN THE 1960S

Turn off your mind, relax and float down stream.
It is not dying. It is not dying.
Lay down all thought, surrender to the void.
It is shining. It is shining.

THE BEATLES, "TOMORROW NEVER KNOWS,"
FROM *REVOLVER* (1966)

On August 29, 1966, the Beatles played their last live concert, ironically in San Francisco. The same month—less than two months before LSD would be made illegal in California—the band also released the *Revolver* album, whose last track, the John Lennon–penned classic "Tomorrow Never Knows," announced that a never-before-seen wave of psychedelia was about to crash on Western shores.

Ranked the number three rock album of all time by *Rolling Stone* magazine, *Revolver* was revolutionary in presenting this new psychedelic rock: the lyrics for "Tomorrow Never Knows" are clearly about LSD to those who can decipher them, and British bands like the Beatles, the Rolling Stones, and Pink Floyd, and San Francisco bands like Buffalo Springfield, the Jefferson Airplane, and the Grateful Dead, would soon be making them world famous. *Revolver* was revolutionary in another way: it had the first major rock-pop LP cover that rebelled against the long-held record-company tradition of featuring a photograph of the band or artist on the cover.

Klaus Voormann (1938–),* an artist friend of the Beatles since their Hamburg days, designed the black-and-white photo montage cover for *Revolver,* which led the way for the full-color psychedelic extravaganza of the *Sergeant Pepper's Lonely Hearts Club Band* album a year later. (The cover for *Sergeant Pepper* is considered the most famous album cover in history; *Rolling Stone* also ranks *Sergeant Pepper* as the number

*Voormann is also a talented musician and producer; he is best known for producing the world-wide hit "Da-Da-Da" for the German band Trio in 1980.

one rock album of all time.) Ever the cultural bellwether, pop artist Andy Warhol (1928–1987) also produced the revolutionary *Nico and the Velvet Underground* LP in 1967, with its famous Banana cover, and later designed the iconic 1971 cover for the Rolling Stones' *Sticky Fingers.*

The commercial success of the full-length 33⅓ long-playing (LP) album in the mid-1960s allowed emerging psychedelic rock bands like the Beatles to break away from the existing model of 45s, which played only two songs—one of which was hoped to be a hit—toward the creation of concept albums like *Sergeant Pepper,* which often offered listeners a cohesive theme or message. The success of these concept albums, and of the larger-sized 33⅓-inch LP in general, also created a new medium for artists, to whom the 12 x 12–inch record sleeves offered a perfect-sized canvas. Who better to design the covers for these emerging psychedelic rock bands than the emerging psychedelic artists?

During 1965 and 1966, author Ken Kesey and the Merry Pranksters held a series of events introducing LSD to the Californian underground. These events—which were initially sponsored by the acid chemist Augustus Owsley Stanley III, and featured early light shows, strobe lights, black lights, fluorescent paint, and a rock band called the Warlocks, who would later become known as the Grateful Dead—were known as The Acid Tests. The Merry Pranksters had a very loose, dadaist concept of art, which was evident in their fluorescent hand-painted bus Furthurr, and created elaborate hand-drawn and intricately illustrated flyers and psychedelically inspired posters to promote these Acid Tests. The Trips Festival in January 1966 (co-produced by Ken Kesey and The Merry Pranksters, with Owsley providing the sound system) was promoted with an Op-Art style psychedelic poster, and then in July of 1966, Bill Graham, the Trips Festival promoter, had local San Francisco artist Wes Wilson (1937–) create the "first" psychedelic-rock poster for a show at The Fillmore. Other savvy promoters and San Francisco bands soon followed suit.

Inspired by the Art Nouveau movement as well as by symbolism, Victorian art, dada, and pop art, a group of San Francisco artists that

included Wilson, Rick Griffin (1944–1991), Victor Moscoso (1936–), Bonnie MacLean (1939–), Stanley Mouse (1940–), and Alton Kelley (1940–2008), would be responsible, through their rock-concert posters, LP album covers, and underground comics (such as Zap Comix), for creating a recognizable San Francisco style. From 1966 onward, it would become synonymous with psychedelic art and would be exported around the world. At the same time in Europe, the Beatles continued to explore new cultural boundaries by working with artists such as the Czech-German illustrator Heinz Edelmann on the film *Yellow Submarine,* while English-based artists like Martin Sharp (1942–2013) took up the San Francisco model by designing iconic posters and LP covers for British rock groups, such as Sharp's classic paint-and-photo collage cover for Cream's *Disraeli Gears.*

By Sharp's definition;

"Psychedelic" was the style of the day amongst the youth in America and England, like "Cubism" in its day, or "Pop Art." I did some "psychedelic" painting for my first gallery exhibition in Sydney in 1965 [. . .] I hadn't even heard of the word, nor had a trip, nor smoked a joint. The style was in the air. It preceded the experiences that were to follow in Bangkok and London. I had a few trips in London [. . .] the first when I saw [Pink] Floyd at U.F.O. Of course it was an eye-opener: another dimension of reality was revealed. I attempted to express that within my art, I didn't draw under its influence. I don't believe one can. Worthwhile art takes a lot of discipline. (Hathaway and Nadel, *Electric Banana*)

ABDUL MATI KLARWEIN (1932–2003): THE FATHER OF PSYCHEDELIC ART

Some visual artworks are made to be talked about more than to be seen, others are made to be seen more than to be talked about. I think I belong in the latter category.

ABDUL MATI KLARWEIN

While San Francisco is generally considered the birthplace of psychedelic art, New York can equally lay claim to that title. Isaac Abrams, as we have already noted, is credited with opening the world's first psychedelic gallery in the East Village in 1965, and psychedelic art in various forms (including early light shows) had been percolating in New York since the late 1950s.

New York was after all, the post–World War II center of the art world, with many of the world's most influential artists and art dealers living there. The war drained Europe's capitals of their artists, many of whom fled to New York. The list of artists and collectors who arrived in New York during the war included Max Ernst, Marcel Duchamp, André Masson, Roberto Matta, Marc Chagall, Fernand Léger, and Piet Mondrian. (And a returning Peggy Guggenheim.) After the war, while a broken Europe was rebuilding, it was America that was flush with cash, and by the late 1950s, New York was soon established as the world's premier art market.

Meanwhile, by the early 1960s, New York was also one of the early centers of psychedelic culture, thanks to the activities of Dr. Timothy Leary (1920–1966), one of the most colorful and controversial characters in counterculture history. Before the summer of 1967 granted San Francisco its psychedelic immortality, it was Leary's presence on the East Coast that made the New York area the major psychedelic node on the planet.

After getting kicked out of Harvard in 1963, Leary had established his International Federation for Internal Freedom in an old mansion in Millbrook, New York, provided by heirs of the Hitchcock Mellon family. With the enthusiastic help of Allen Ginsberg and his famous little black book, a long list of artists, musicians, and celebrities journeyed in and out of Millbrook's gates, including the jazz musicians Maynard Ferguson and Charles Mingus. (Mingus apparently liked to prune the roses at Millbrook each weekend, and would spend long hours outside alone.)

At such a major intersection of both psychedelics and culture, it would seem inevitable that the first great psychedelic art would emerge;

and such was the fertile ground in 1961, when a German-born Jew who had named himself Abdul Mati Klarwein first visited and exhibited in New York, where he met and became friends with both Leary and a then little-known guitarist by the name of Jimi Hendrix.

Like Fuchs and Dalí, Klarwein is one of those larger-than-life characters of the twentieth century that both define and defy the stereotype of the modern artist. Born to a Jewish father in Nazi Germany, Klarwein's family emigrated to the British mandate in Palestine when he was two years old, and then moved to Paris when Palestine became Israel in 1948. In Paris the young Klarwein studied under Fernand Léger (1881–1955), and met Ernst Fuchs, who taught him the *mischtechnik*. Klarwein would later say that Fuchs "insisted in teaching me his *mischtechnik* in Paris, and I have sold every painting since."

A period of travel began in the mid-1950s that took Klarwein to numerous countries including Tibet, India, Bali, Turkey, Morocco, Jamaica, and Brazil. In the early 1960s he located in Paris, where his studio was often the site of all-night jams with musicians like Ornette Coleman and Ravi Shankar, and spent a summer with Fuchs and Arik Brauer in Mallorca, and still later in Israel, where Klarwein's father had won the commission to design the Israeli Parliament building.

After his first visit to New York in 1961, Klarwein painted his magnificent *Annunciation*. The electricity of New York had clearly affected him, as had meeting Hendrix, Leary, and, synchronistically, Dalí, who from then on took an interest in Klarwein's work. Settling in New York in 1964, Klarwein's New York studio-loft on 17th Street quickly became a smaller psychedelic equivalent of Andy Warhol's heroin-and-amphetamine driven Factory. (Warhol himself said that Mati Klarwein was his favorite painter.)

At a time when Abstract Expressionism and Pop Art were the two dominant schools in the commerce-driven New York art market, Klarwein's art, with its roots in Surrealism and Fantastic Realism, was a total anomaly to the contemporary art world. Meanwhile, the colorful European-born Klarwein, with his great knowledge and love of jazz, highly charismatic manner of "hip" speaking, and often enlightened

personality, was far more Beat than many of the Beats themselves, with his seven years of travel to exotic locales (no small feat in the 1950s), making him something of a forerunner of the international hippie trail of the sixites.

In 1965, New York was arguably the premier psychedelic city in the world. Isaac Abrams opened the Coda Gallery, underground New York psychedelic artists were creating the first projection and light shows that would soon inspire Andy Warhol and the Velvet Underground (and later Timothy Leary). At the same time Leary, along with Ralph Metzner and Richard Alpert, were about to release their book *The Psychedelic Experience* on an unsuspecting world, one of the tipping points that would see the psychedelic culture explode in the national consciousness. Many young artists, uninspired by either the shallowness of pop art or the extreme erudition of abstract expressionism, were naturally attracted to the subversive and underground nature of psychedelic art. By 1964 the New York artist Allen Atwell had already converted his apartment into a psychedelic temple by painting all the ceilings and walls, and there were numerous other similarly inspired artists at work in New York City. Considering Klarwein's existing friendships with Leary, Jimi Hendrix, and a long list of legendary jazz musicians, it was not surprising that Klarwein's studio quickly became a psychedelic hotspot for the New York in-scene. And then of course there was Klarwein's glorious visionary art itself.

Brightly colored, often packed full of dense, intricate imagery, psychedelically juxtaposed like facets on a jewel, Klarwein's paintings have "a blissful and rapturous quality" (Brown and Novick, *Mavericks of the Mind*). In 1958 Klarwein had taken the name Abdul (which means "servant" in Arabic), espousing the belief that all Jewish people should take on Palestinian names, and all Palestinians Jewish names so as to understand each other better, and his often universal paintings of black and white people entwined together, combining symbols and imagery from the numerous cultures that Klarwein had himself experienced, expressed that same belief in the brotherhood of man.

In 1971, Klarwein conceived the idea of the Aleph Sanctuary, an

enclosed space 10 × 10 × 10 feet (3 × 3 × 3 meters), with seventy-eight of his paintings to form the interior. From the time of its construction, *The Aleph Sanctuary* was on nearly permanent display in his New York studio-loft, and consisted of many of Klarwein's greatest works, including his Angel series, *Annunciation, Grain of Sand,* and a highly sexual Tree of Life painting titled *Crucifixion.* (This painting generated the greatest controversy whenever the portable Chapel was exhibited elsewhere, sometimes requiring armed guards and even police intervention.)

A young psychedelically inclined art director by the name of Robert Venosa who worked for the legendary jazz label Blue Note had discovered Fuchs's and Klarwein's work from an early 1960s book on Fantastic Art while searching for material for classical record covers. Venosa later discovered that Klarwein was living in New York, and after a period began apprenticing with Klarwein as a painter. Here he recalls the scene around Klarwein's studio:

> What a time (Autumn, 1970) that turned out to be! Not only did I get started in proper technique, but at various times I had Jimi Hendrix, Miles Davis, Jackie Kennedy and the good doctor Tim Leary himself peering over my shoulder to see what I was up to. That loft was the energy center in New York, and I reveled in it. And somehow, miraculously, in the midst of all the nonstop pandemonium taking place every day I learned to lay the paint down properly. Even though it was never put to the test, discipline was one of the more important necessities that Mati emphasized and—through his own adherence—strongly impressed on me: I could only join in the festivities after my work was done and all brushes were washed. Mati taught well the techniques of painting and, even more relevant, of quality living. I'm honored to have been one of the fortunate few to have studied with him.

It would be through Venosa that Klarwein's greatest fame would arrive, since it was he who introduced Carlos Santana to Klarwein's art, which resulted in Klarwein's 1961 masterpiece *Annunciation*

being used as the cover* of Santana's hit 1971 album *Abraxas*. The success of Santana's album introduced Klarwein's work to an audience far beyond the art world (which didn't know what to do with him anyway), and led to a lucrative side career designing some of the most iconic rock and jazz album covers of all time—so much so that the influential art and culture magazine *Juxtapoz* called him "the man literally responsible for every great, legendary record cover you've ever seen—if he didn't do it, he inspired it."

Along with Santana's *Abraxas*, Klarwein then became best known for the paintings that Miles Davis commissioned for the jazz-fusion albums, *Bitches Brew* and *Live-Evil*. Described now as "'ground breaking" and "paradigm shifting," *Bitches Brew* was highly controversial and a huge hit for Columbia Records, selling over a million copies as one of the best-selling jazz albums of all time. Along with making Miles Davis in 1970, once again, the hippest cat in America, this also brought Klarwein's stellar artwork to the attention of an even greater audience. (*Bitches Brew* is considered by many to be the greatest LP cover of all time.)

Here Klarwein explains in his own descriptive language how he and Miles Davis came to be friends:

> I hooked up with Miles the way I hooked up with everything else in life: through the women I've known. Be they friends or lovers, they are all mothers with excellent taste. Without them I'd be a dead spermatozoid in a dry puddle, and Miles saw that in my paintings. The only time he discussed subject matter was for Live-Evil. He asked me to paint a toad for the Evil side. So I painted J. Edgar Hoover as a toad in drag—which turned out to be another one of my prophetic insights.

Salvador Dalí was another frequent visitor at Klarwein's loft. After he and Klarwein had met in New York in 1961, Klarwein had called

*In 1963, Klarwein had created the cover art for an Eric Dolphy jazz album called *Iron Man,* but the use of one of his paintings on the *Abraxas* album was a first.

him a "spiritual teacher." The two became fast friends, much as Dalí continued to be interested in Fuchs's career.

Here at this point we find the intersection of arguably the three greatest psychedelic painters of the twentieth century—Dalí, Fuchs, and Klarwein—and face once again the conundrum that none of the three would publicly admit that psychedelics had an effect upon their art.

Dalí is one of the handful of true giants in twentieth-century art exactly because Surrealism possesses an archetypical popularity that has seen it survive for nearly a century despite the fickle winds of modern art where new schools have been exponentially required, and Dalí's interest in psychedelics—if any—probably would have come after he had already made his major artistic breakthroughs (*The Persistence of Memory* was painted in 1931), although mescaline could have contributed to the development of his early surrealist views. Dalí believed the world was being held together by a mysterious order, a ubiquitous symmetry, and the discovery of the DNA double helix by Francis Crick and James Watson in 1953 confirmed his intuition of a hidden order, encouraging his belief in the transformational power of "nuclear mysticism"—that is, in what he called the vision of matter constantly in the process of dematerialization, of disintegration, thus showing the spirituality of all substance. What Surrealism called for, in art as in life, was new, cohesive interaction between the phenomena of the objective, external world and the interior workings of the individual psyche.

This full philosophy is on display in one of Dalí's later and greatest paintings, *The Hallucinogenic Toreador*, which was painted between 1969 and 1970. (This painting was displayed in New York in a gallery as a work-in-progress during the period when Klarwein and Venosa were also both living in NYC.) On one hand, the stunningly psychedelic painting is a kind of visual autobiography, a retrospective of Dalí's career; while on the other hand, Dalí, by combining overt symbolism with optical illusions and disturbing and yet familiar motifs, manages to create his own visual language, and the result is one of the finest oil paintings of the twentieth century.

Considering Dalí's firm stance that he did not take drugs, his choice of title, and the psychedelic optical effects of the painting itself, painted at the height of the First Psychedelic Era, reiterates what Klarwein and Martin Sharp and other artists of that era have stated, that *psychedelic* wasn't a drug, but an aesthetic wave that was moving through the culture, something new awakening that was in the air. When Dalí said in an interview in America in 1970, "Take me I am the drug; take me I am hallucinogenic" he knew the influence that he had already had on psychedelic culture, for in many ways the surrealists had initiated it some forty years earlier on foreign shores. And while Dalí was notoriously unfriendly to other artists and reputedly difficult to deal with, he has appeared repeatedly throughout this visionary history, most uncharacteristically befriending and mentoring three of the greatest known psychedelic painters of the twentieth century—Ernst Fuchs, Abdul Mati Klarwein, and Robert Venosa—exactly because he recognized them as the great surrealists that they were.

Fuchs—who quietly admitted to trying peyote, is known to have taken mescaline and magic mushrooms, and who clearly traveled in psychedelic circles in the late 1960s and 1970s—preferred to avoid discussing psychedelics in relation to his art, undoubtedly mindful of his legacy in the history of European art. Klarwein, who said that "Fuchs is the most psychedelic painter of all, except Dalí and Bosch, of course"—and who was already perceived as an outsider by the New York art market—was similarly cagey about his own psychedelic use, despite his famous psychedelic friends. When writer David Jay Brown asked Klarwein in an interview not long before he died how psychedelics had influenced his art, Klarwein stated, echoing the sentiments of the British artist Martin Short:

They haven't. It was more the spirit of the times. I think it all goes together. I painted psychedelically before I took psychedelics. When Tim Leary first saw my work he said, "You don't need psychedelics." And that was before I took them. It's like what Dalí says, "I don't take drugs. I am drugs." (Brown, "A Thousand Windows")

Nevertheless, Klarwein's friendships with the likes of Jimi Hendrix and Timothy Leary, along with his legacy of legendary LP art covers for musical icons like Santana; Miles Davis; Earth, Wind and Fire; The Last Poets; and many others, make him the quintessential sixties psychedelic artist, despite his many proclamations to the opposite. And in the eyes of some of psychedelic art's most knowledgable historians—including the blotter-art collector and psychedelic art guru Mark McCloud, and Alex Grey, the most famous visionary artist of the twenty-first century—Klarwein *is* the Father of Psychedelic Art.

In McCloud's opinion:

Mati made the break from the symbolism of Fuchs, and the dreamscapes of Dalí, and was the first one to map the psychedelic dimension, to really begin to express the psychedelic experience in its fullness. All psychedelic painters since—Venosa and Alex Grey included—have walked in Mati's footsteps.

Echoing McCloud's sentiments, Alex Grey wrote:

Klarwein was able to capture the multi-colored iridescent visions and patterns of the inner worlds demonstrating what an experienced psychonaut and fanatically disciplined painter he was. I was thrilled to finally meet Mati in 1994, and glad to know that he appreciated my work and felt a fellowship with so many of the younger visionary artists whom he inspired.

He was an inspiration to so many artists because he expressed the freedom to imagine and paint anything. He visited and painted mystical dimensions of consciousness, and could coax us into spiritualized epiphanies one moment then plunge us into completely bizarre erotic frenzies.

By the time Wall Street and the 1980s had turned New York into a glittering shell of the great artists' metropolis it had once been, Klarwein had returned to his home in Deia on the island of Mallorca,

off Spain, where he turned his attention to painting landscapes, whose hallucinogenic aspect are created, as David Jay Brown observed, "by the dazzling amount of detail in the painting that normally wouldn't be visible from the distance depicted."

Abdul Mati Klarwein died surrounded by those who loved him in 2003, having declared himself to be "the most famous unknown painter in the world." Whether or not he will ever posthumously receive the fame that many would say he deserved, it is impossible to say. However, if psychedelics continue to be reintegrated into our mainstream society, I believe there will be a great reappraisal of psychedelic art, and a time when Klarwein's paintings are recognized as some of the finest art of the twentieth century. And it is probably fair to say that either way, the world will never see another artist like him.

21

MODERN ART
IN THE 1960s

Mark Rothko and Andy Warhol

Art to me is an anecdote of the Spirit, and the only means of making concrete the purpose of its varied quickness and stillness.

MARK ROTHKO

Everything is plastic, but I love plastic. I want to be plastic.

ANDY WARHOL

I would like at this point in this art history to consider the careers and fates of New York's two most famous artists circa 1969: the Colorfield or Abstract Expressionist painter Mark Rothko* (1903–1970), and the Pop Artist Andy Warhol (1928–1987).

One of the most famous of the postwar American painters, Mark Rothko was born in Russia to a well-educated Jewish family who emigrated to the United States in 1913. Rothko, who received both a secular and a religious upbringing after his father converted back to Orthodox Judaism, believed that art was a tool for emotional and

*Although Rothko never used either of those terms.

religious expression. Over the course of his career he would explore that theme to the point of mysticism arguably further (and certainly more famously) than any other artist in the twentieth century.

Initially tutored by a fellow Russian-American Jew, the Cubist painter Max Weber (1881–1961), Rothko was first influenced by mythology, and the works of Freud and Jung, and then later and most directly, by Friedrich Nietzsche. Considering himself "a myth-maker," Rothko wrote (in 1949), "without monsters and gods, art cannot enact a drama" and along with his peers Adolph Gottlieb and Barnett Newman, believed that by using mythic form as a catalyst, they could merge the two European styles of Surrealism and Abstraction.

While Rothko paintings of this early period are full of mythological imagery, inspired by the surrealists, he began to experiment with automatic painting—letting the brush meander without conscious control in an attempt to release the creative forces of the unconscious. As his technique loosened up, a new abstraction appeared. His gorgeous watercolors of the mid-1940s, which are luminous and transparent and without any recognizable form, marked a turning point in his career.

A 1942 manifesto written by Rothko declared, "We favor the simple expression of the complex thought. We are for the large shape because it has the impact of the unequivocal. We wish to reassert the picture plane. We are for flat forms because they destroy illusion and reveal truth," while a 1943 letter to the *New York Times* (written with Adolph Gottlieb and Barnett Newman) asserted, "It is a widely accepted notion among painters that it does not matter what one paints, as long as it is well painted. This is the essence of academicism. There is no such thing as a good painting about nothing. We assert that the subject is crucial and only that subject matter is valid which is tragic and timeless. That is why we profess a spiritual kinship with primitive and archaic art."

With his search for transcendental meaning in formlessness, and by describing his increasing abstraction as a search for "clarity," Rothko had begun walking the classical mystic's path. By the late 1940s Rothko's paintings were devoid of any symbolism, figuration, or association with the natural world, replaced by asymmetrically arranged patches of color

sometimes referred to as multi-forms. For Rothko, eschewing represen-tation permitted greater clarity, "the elimination of all obstacles between the painter and the idea and between the idea and the observer."

Convinced that naming his paintings interfered with the tran-scendental nature of the art, Rothko began numbering his canvases instead. His paintings of the 1950s are characterized by "expanding dimensions and an increasingly simplified use of form, brilliant hues, and broad, thin washes of color." Color—for which Rothko is perhaps most celebrated—achieves an "unprecedented luminosity'" in these very large-scale designs that were used in order to overwhelm the viewer, or in his own words, to make the viewer feel "enveloped within" the paint-ing. Rothko even went so far as to recommend that viewers position themselves as little as 18 inches away from the canvas so that they might experience "a sense of intimacy, as well as awe, a transcendence of the individual, and a sense of the unknown."

For some critics, the large size was an attempt to make up for a lack of substance. In retaliation, Rothko stated:

> I realize that historically the function of painting large pictures is painting something very grandiose and pompous. The reason I paint them, however is precisely because I want to be very intimate and human. To paint a small picture is to place yourself outside your experience, to look upon an experience as a stereopticon view or with a reducing glass. However you paint the larger picture, you are in it. It isn't something you command! (Ross, *Abstract Expressionism,* 172)

By 1950 Rothko had begun to find commercial success, but as his fame grew, he became more personally isolated, losing many friends from jealousy and accusations that he had sold out, which caused him increasingly to feel that he was misunderstood as an artist. His misgiv-ings and distrust of the New York art world increased, and he became highly protective of his work, often returning commissions on paintings after the work was completed, as well as turning down numerous sales and exhibitions, complaining:

A picture lives by companionship, expanding and quickening in the eyes of the sensitive observer. It dies by the same token. It is therefore a risky and unfeeling act to send it out into the world. How often it must be permanently impaired by the eyes of the vulgar and the cruelty of the impotent who would extend the affliction universally! (Hess, *Abstract Expressionism*)

Like many mystics before him, in recognizing the futility of words in describing this decidedly nonverbal aspect of his work, Rothko abandoned all attempts at responding to those who inquired after its meaning and purpose, stating finally that silence is "so accurate." Wishing to move past abstractionism as well as classical art, Rothko stated that in his paintings "surfaces are expansive and push outward in all directions, or their surfaces contract and rush inward in all directions. Between these two poles, you can find everything I want to say."

Insisting that labeling him as an abstractionist or as a great colorist was misleading, Rothko famously claimed his interest was:

only in expressing basic human emotions—tragedy, ecstasy, doom, and so on. And the fact that a lot of people break down and cry when confronted with my pictures shows that I can communicate those basic human emotions . . . The people who weep before my pictures are having the same religious experience I had when I painted them. And if you, as you say, are moved only by their color relationship, then you miss the point. (Rodman, *Conversations with Artists*)

As Rothko became increasingly convinced that people purchased his paintings simply out of fashion and that the true purpose of his work was not being grasped by collectors, critics, or audiences, the colors in his work began to grow darker and darker, his bright reds, yellows, and oranges subtly transformed into dark blues, greens, grays, and blacks. Then, in 1958, he was commissioned to paint a series of paintings by the Seagrams company for their flagship new Four Seasons restaurant

in New York, as one commentator later observed, placing his art "firmly in the belly of the beast." Rothko completed forty canvases in a three-month period before departing on a trip to Europe, where he would admit that his intention was to paint "something that will ruin the appetite of every son of a bitch who ever eats in that room." Later, upon seeing the completed restaurant, he refused to hand over the paintings and returned his commission, causing considerable controversy.

Despite bad publicity from this affair, Rothko was at the height of his fame in the early 1960s; he sat next to Joseph Kennedy at John F. Kennedy's inauguration ball. But by the end of 1962 the writing was already on the wall for the Abstract Expressionists, as Pop Art was rapidly becoming the new darling of the New York art world. Outraged, Rothko called the pop artists "charlatans and young opportunists," saying of Jasper Johns's flags when he saw them, "We worked for years to get rid of all that."

Depressed by the vapidity of Pop Art, Rothko increasingly advocated the spiritual dimension of his own art. In 1964 he accepted the commission for a chapel in Houston, Texas, symbolically far from the New York art world that he now despised. Rothko told friends he intended the Chapel to be a place of pilgrimage, and his single most important artistic statement. According to Wikipedia ("Mark Rothko"):

> The Chapel is the culmination of six years of Rothko's life and represents his gradually growing concern for the transcendent. For some, to witness these paintings is to submit one's self to a spiritual experience, which, through its transcendence of subject matter, approximates that of consciousness itself. It forces one to approach the limits of experience and awakens one to the awareness of one's own existence. For others, the Chapel houses fourteen large paintings whose dark, nearly impenetrable surfaces represent hermeticism and contemplation.

These paintings would be Rothko's final artistic statement to the world, although Rothko himself never saw the completed Chapel or

installed the paintings. (They were unveiled at the Chapel's opening in 1971.) In 1970, Rothko committed suicide by overdosing on depressants and slitting his own wrists in New York. He was sixty-six years old. Ironically, his Seagrams murals, which had been hidden in storage since 1968, arrived in England for installation in their own room at the Tate Gallery in London on the very same day.

While Rothko painted a remarkable 836 paintings during his life, his heirs were later bilked of the majority of his fortune by his financial advisor Bernard Reis and the Marlborough Gallery, whom they later sued in court, receiving a token $9.4 million of the vast value of Rothko's estate. In 2012, his 1961 painting *Orange, Red, Yellow* sold for $86.9 million, setting a new record for a postwar painting at a public auction. Three years later, his *Number 6* (*Violet, Green, and Red*) broke the record again when it sold for $186 million.

My inclusion of Mark Rothko in this essay about visionary art will undoubtedly confound and infuriate even some of my allies, for, close to fifty years after his death, Rothko's work remains as controversial and polarizing as when he was alive. Many commentators rank Rothko among the greatest of twentieth-century painters, while others dismiss him as a charlatan. In the end it is only a visceral reaction to the work itself that will enable the viewer to pass judgment. (Personally I am always astonished how much viewing a Rothko with my own eyes can affect me, and I am not alone in this neomystical experience. If you do not understand the allure of Rothko, I recommend spending twenty minutes quietly sitting in front of one of his paintings if possible.) But in the broader context of this essay as a search for the spiritual in art, within that definition, few would deny that Mark Rothko's unique journey deserves inclusion.

Andy Warhol however, the quintessential Pop Art artist who coined the phrase "fifteen minutes of fame," was in many ways Rothko's complete antithesis, and requires inclusion because of the deliberate lack of any spiritual component—or of any meaning at all—in his art.

Before his career as a fine artist, Warhol was a successful commercial illustrator throughout the 1950s, including a stint for RCA records

designing record covers. Along with Jasper Johns, Robert Rauschenberg, and Roy Lichenstein, Warhol became famous for painting iconic, often everyday images from American culture in the 1960s. In his first solo fine-art show in Los Angeles in 1962, Warhol exhibited thirty-two paintings of Campbell's Soup cans—one for each flavor, and later in December of the same year, New York City's Museum of Modern Art hosted a symposium that first named this new style Pop Art. During this symposium, the newly minted "pop artists" were attacked for capitulating to consumerism, and the critics especially scandalized by Warhol's open embrace of market culture.

However, Warhol and the other pop artists had captured the zeitgeist of the time, rebelling against the increasing abstraction and forced erudition of modern art. By painting everyday items like soup cans, they declared that nothing was great art and anything could be Great Art. Warhol's work, more than that of any other artist, would "explore the relationship between artistic expression, celebrity culture, and advertising that flourished by the 1960s," with Warhol the pop artist, and Warhol the pop icon becoming practically indistinguishable.

Warhol was one of the first openly gay celebrity artists in America (in the days before gay liberation), and his studio, The Factory, "was a well-known gathering place that brought together distinguished intellectuals, drag queens, playwrights, bohemian street people, Hollywood celebrities, and wealthy patrons" (Wikipedia, "The Factory"). The Factory really was a factory too: the ever-productive Warhol kept everyone busy screen-printing, making movies, painting, photographing, doing something. The consummate postwar artist, Warhol used many types of media, including hand drawing, painting, printmaking, photography, silk screening, sculpture, film, and music.

Warhol was also one of the first to realize that he could create celebrities, grooming bohemian characters that he called "superstars," as well as producing an album for one of the most influential rock groups of all time, the Velvet Underground. (Along with providing the cover art, Warhol paid for the studio time for the album *Nico and the Velvet Underground*.) Established as a fixture on the New York social scene,

Warhol spent the 1970s cultivating wealthy patrons, and despite being dismissed as merely a "business artist," later reinvigorated his career through collaborations with younger artists like Jean-Michel Basquiat and Julian Schnabel.

Warhol's unflinching superficiality and commercialism has been seen alternatively by his critics as "the most brilliant mirror of our times," or as "servile, facile, and spiritless," but after his death in 1987 Warhol got the last laugh. At the completion of his first solo show in 1962, Warhol sold the entire group of *Soup Can* paintings to the gallery owner Irving Blum for $1000. When the Museum of Modern Art acquired the set in 1996, they were valued at $15 million. Warhol's 1963 canvas *Silver Car Crash* (*Double Disaster*), which was "'painted" using silkscreens, sold at auction for $105 million in 2013, a mere forty years after its creation, and breaking the record for a postwar painter set by Rothko the previous year.*

Mark Rothko's friend, the poet Stanley Kunitz, saw Rothko as "a primitive, a shaman who finds the magic formula and leads people to it." (Describing Rothko as a shaman in the 1950s is quite remarkable, and one of the earliest nonanthropological uses of the word that I have seen.) Great poetry and painting, Kunitz believed, both had "roots in magic, incantation, and spell-casting" and were, at their core, ethical and spiritual. The luminosity of some of Rothko's finest work—and for me personally, the ability of a painting to transmit light is one of the surest signs of an artist's visionary or mystical connection—is without parallel, while in the somber darkness of the Rothko Chapel, he explored the ultimate mystical connection with the Void in a way

*An untitled painting of a skull painted by Jean Michael Basquiat in 1982 sold for $110.5 million in 2017. (Basquiat, who was originally a graffiti artist without a conventional art-school training, could have fallen under the original museum label for a Visionary Artist—which was for outsider, untrained artists.) Incredibly, the $110.5 million paid for Basquiat's painting is not the record for a post-war painter as the prices being paid for modern art continue to soar—Jackson Pollock's *#17A* sold for $200 million in 2015, besting the $186 million earlier paid for Mark Rothko's *Number 6* (*Violet, Green, and Red*).

that no artist had ever attempted, nor is likely to attempt again.

Warhol, on the other hand, openly embraced the superficial and the banal, and most of all, celebrity, saying, "I love Hollywood. They're so beautiful. Everything's plastic, but I love plastic. I want to be plastic." That one such artist could follow the other in the history of modern art reveals the great polarities that often arrive in both art and culture, like the switching of some internal magnetic poles when either society or fashion demands a change from one extreme to another.

But a social philosopher could equally put forward the case that the vast chasm between the intention behind the art of Mark Rothko and that of Andy Warhol is analogous to the schism in humanity created by two world wars and the arrival of the Atomic Age, along with the shifting of the planet's industrial and commercial centers to the United States—for although they were born only twenty-five years apart and ostensibly both Americans, the two artists came from very different worlds.

Rothko, whose family escaped Russia in 1913 so his brothers wouldn't be enrolled in the Russian imperial army, came of age during the Depression and the worldwide rise of fascism, and experienced first-hand the intense feeling of dislocation caused by the Holocaust through stories from Jewish émigrés who arrived in New York during World War II. After the war, the grim facts of Hitler's attempted genocide and Stalin's pogroms continued to emerge, while many of Rothko's generation suffered an existential crisis with the devastating threat of the arrival of the Nuclear Age. To my untrained eye, in their two-decade collapse toward darkness, Rothko's paintings express both this fall—the descent into chaos that could be the end of thousands years of history, structure, and form—and the classic mystic's search for meaning in the ultimate emptiness of the Void.

Rothko himself said, "The exhilarated tragic experience is for me the only source of art" (Porter, *Personal Statement*). After the outbreak of World War II, he believed that a new art form was needed with a new subject matter that would have the necessary social impact and yet would be able to transcend the confines of political symbols and values.

Always the mythologist, Rothko sought to relieve modern man's spiritual emptiness through his art, and the weight of that impossible burden ultimately killed him.

In this regard I put Rothko in the company of other iconoclastic Americans like Walt Whitman, Henry Thoreau, Henry Miller, and William S. Burroughs; lone voices in the wilderness warning us of the dangers of the arrival of the Industrial Age. Warhol, on the other hand, whose art was born out of a time of postwar American dominance and unprecedented prosperity, wholeheartedly celebrated the rise of American consumer culture, lifting everyday objects like soup cans up to the level of fetishes, and by immortalizing icons as American as Elvis, Marilyn Monroe, and car crashes, made himself an American icon along the way.

Any attempt to look for the spiritual in most of Andy Warhol's work would be futile, as is any attempt to link it to an earlier European lineage. Warhol himself, while privately a practicing Byzantine Catholic, deliberately avoided symbology and often refused to explain his work, suggested that all one needs to know about his work was "already there on the surface"; while the age-old solitary shamanic struggle of the artist in the sanctity of his cave-studio was now replaced by the assembly-line factory model of the second half of the twentieth century.

Pop Art firmly asserted the post–World War II American worldview in all its vapidity; twentieth-century life was becoming increasingly superficial. Any interest in the spiritual (or even the political) was antiquated and outdated, making art solely (and most importantly) a commodity. In the new, New York–driven art world from the late 1960s onward, art would be all about the almighty dollar, and little else. This pragmatic philosophy, of which Warhol was the undisputed king, would see the value of collectable art skyrocket exponentially from the 1980s.

In the mid- to late-1960s, when Rothko and Warhol dominated the art world, your choices as a "serious" New York artist were two: abstract expressionism or pop art. Psychedelic art, however, while a form of professional suicide for a trained artist, offered the same allure as psyche-

delic culture: it was subversive, and at its core it was transcendental, the latest link in an age-old chain back to primitive art. During the 1960s there were undoubtedly a number of other excellent psychedelic painters, sculptors, muralists, and other artists in New York, California, London, and other areas, as well as illustrators, comic-book makers, and even blotter-art artists; but for most of the sixties psychedelic art itself was little more than a buzz term, and a niche market at best after Leary was on the run.

Then by the early seventies, even the once-subversive allure of psychedelic art had become corrupted by advertising—most famously in the work of the New York artist Peter Max—and "psychedelic" soon became a recognizable commercial style. Such was the situation in 1971 when Robert Venosa, after overseeing the production of the Santana *Abraxas* cover (Venosa designed the Santana logo, one of the most famous in pop culture) quit his successful job at his own commercial art and advertising agency, and after giving up his prime New York apartment (reputedly along with some 2000 LPs, many of them still in their wrappings, and a number of expensive business suits still hanging in the wardrobe), put his Dodge van on a ship to Europe to chase his dream of being the first recognized American Fantastic Realism painter.

22

THE ARCHITECTS
OF CONTEMPORARY
VISIONARY ART

Robert Venosa and Alex Grey

*Bravo Venosa! Dalí is pleased to see spiritual madness painted
with such a fine technique.*

SALVADOR DALÍ

With the arrival of Robert Venosa in this narrative, we arrive at
a most important figure in the history of psychedelic art, since
during Venosa's lifetime perceptions about psychedelics had changed
enough that he would not mind being labeled as a psychedelic artist,
even if he did not fully embrace the term. But in his decision to leave
his successful advertising agency to go to Europe in 1970 to pursue
painting, Venosa showed where his real interest as an artist lay—in the
little-known (in America) genre of Fantastic Realism, or as it is some-
times known, Visionary Art.

Venosa had discovered Klarwein's and Fuchs's art in 1967 from a
book on Fantastic Art, and then fell under Klarwein's influence after
meeting him after a Timothy Leary lecture in New York in 1969.

While already a highly successful commercial artist, Venosa's artistic breakthrough came as a psychedelically inspired vision of a Jesus emerging from an atomic field that he attempted to paint and draw. When he showed Klarwein the result, Klarwein was impressed enough—reputedly saying "Why didn't I think of that!"—that he begrudgingly agreed to teach Venosa how to paint "properly." Klarwein subsequently taught Venosa his own modified version of Fuchs's *mischtechnik,* so when the time came for Venosa to leave New York, he traveled to Austria where he met Fuchs, and briefly studied under Fuchs's son Michael.

From Austria, Venosa drove his van to Cadaques, Spain, the home of Salvador Dalí. In typical New Yorker fashion, he looked Dalí up in the telephone book and called him up, and Dalí, in typical Dalí fashion, asked Venosa if he was beautiful. Venosa, after thinking about it for a moment, replied that he was, and Dalí invited him around to his nightly sunset cocktail gathering at his house. Dalí was suitably impressed both by the content of Venosa's psychedelically inspired work and by the skill with which it had been painted, and the two would become firm friends after Venosa settled in Cadaques for the rest of the 1970s.

By the mid-seventies, Venosa was an established member of the European Fantastic Realism family, exhibiting in major shows alongside Fuchs, Klarwein, Fuchs's main assistant De Es Schwertberger (1942–), and the Swiss artist H.R. Giger, who would later become world famous for his sets and monsters for the film *Alien.* Venosa's own art from this period often seems to pay homage to Dalí and Fuchs while maintaining a transcendental light and fluidness all of its own, best represented in his extraordinary painting *Astral Circus* (1976–78). Venosa was also approached in the 1970s by the community living at Damanhur in Italy to move there and guide the painting of the Temples to Humankind there. One can only imagine how even more dramatic the underground temples might have been had Venosa agreed to be involved!

Hans Rudolph (H. R.) Giger (1940–2014), with his close friendships with Leary, Venosa, Stanislav Grof, and Alex Grey, is another internationally renowned psychedelic artist who was uncomfortable admitting that psychedelics had an influence upon his art. Giger's

biomechanical nightmares apparently emerged from his LSD experiences, and his first paintings were from art therapy. Before Giger was employed by Hollywood to design the sets for *Alien,* he was involved in the proposed film adaption of the Frank Herbert cult sci-fi novel *Dune* by Alejandro Jodorowsky that was never made; Venosa also worked on the *Dune* project with Giger.

Both Giger and Venosa's work became more widely known through the lucrative sales of fine-art posters* of their work in the 1970s, and through LP covers. (Venosa designed over 50 LP and CD covers.) Venosa would also be responsible for introducing Giger to Dalí. After showing Dalí some of Giger's work, Dalí said he would like to meet him. Venosa called Giger that same night to tell him, and Giger was on the first plane to Spain at 6:30 the next morning!

By 1982, Venosa's fame back in the United States (much of it due to extended exposure from the quasi-psychedelic magazine *Omni*) had resulted in a number of commissions and commercial opportunities, and he began traveling with his partner, Martina Hoffmann, between Cadaques, New York, and Boulder, Colorado. This is how Venosa recorded that change:

> Enjoying the clear, clean mountain air and relatively sane consciousness of its populace, I settled on Boulder as my base in the States. Compared to the raucous, colorful activity of Cadaques, Boulder appeared somewhat anorexic. But the siren of success, along with the Muse of Mammon, wailed a seductive tune, irresistible in its promise but demanding in the changes deemed necessary if I were to sing along: The Merry Mediterranean mirage would have to give way to the Aggressive American Kindergarten for a season or two. There would be exhibits to arrange, press releases to disseminate, collec-

*Perennial dorm-room favorites, Van Gogh's and Salvador Dalí's paintings are some of the most reproduced images of all time thanks to fine-art posters. Many people have also been introduced to Giger, Venosa, and Alex Grey's work this way. (Carey Thompson told me he had a Venosa poster all through college and never realized it was a painting!)

tors to romance, critics to confuse, and an entirely new sense of art to cultivate. My idea of art, as previously understood, would require major surgery if I were to immerse myself in the American standards and expectations of what that word represented.

The admiration and aristocratic respect given the artist in Europe is stripped clean upon arrival in the U.S. as these architects of culture are transmogrified into novelty items and entertaining curiosities. The centuries-old tradition of dedication and perfection while working in the solitude of a tranquil studio at the limited speed allowed by brush and paint is left at the gates of the rapid-fire, non-stop, instant-sensual-gratification American sitcom culture. Trying to compete in the fast lane of the high-velocity illusions and banal delusions of movies and TV poses a problem for the painter and his two-dimensional immobile images. Nevertheless, the challenge, then as now, of affecting the consciousness with more eternal value cannot be denied, and so, combining the historical deep roots of European culture with the dynamic of America's youthful energy, an attempt is constantly made. ("Bio," www.venosa.com/bio.html)

Throughout most of the rest of his life, Venosa kept studios in Boulder and Cadaques. Along with painting, he and his partner Martina Hoffmann (who was originally a sculptor, and then switched to painting after meeting him in Cadaques) offered workshops in which he taught his own modified version of the *mischtechnik* that he had learned first from Klarwein, and then from Michael and Ernst Fuchs himself.

While the 1980s were the least psychedelic decade on record and Venosa himself had been away from psychedelic culture for some time, Boulder, despite its apparent sleepiness, was one of the few psychedelic holdovers left in America. Along with renewing his friendship with Timothy Leary, Venosa taught workshops at legendary psychedelic-friendly institutions like the Naropa Institute in Boulder and Esalen in Big Sur. In 1992, Venosa met a young mycologist called Terence McKenna after he attended one of McKenna's lectures in Boulder; the

two became firm friends and mutual admirers. McKenna would play his part in fully reintegrating Venosa back into what remained of psychedelic culture, including trips to the Amazonian rain forest. (Venosa's *Ayahuasca Dreams* from this period is one of my all-time favorite visionary paintings.)

In 1999, on their flight to Hawaii to participate in the AllChemical Arts Conference that was the culmination of Terence McKenna's dream to organize a conference on psychedelics and creativity, Venosa and Martina Hoffmann met a husband-and-wife artist pairing on their way to the same conference: Alex and Allyson Grey. (While they had corresponded, the two couples had never actually met.)

The fact that both Venosa and Alex Grey were invited by McKenna to participate in his AllChemical Arts Conference indicated the two men's stature in psychedelic art, but it is also important because this is the first time in this history that any major artist (in this case two) was willing to openly admit that taking psychedelics was a major influence upon his art. The physicist Niels Bohr once said that new theories never win people over: the old school just dies off, and at the dawn of the twenty-first century, it appeared that some thirty years after their prohibition, a new dialogue about psychedelics was once again emerging.

By openly declaring that psychedelics were a part of their artistic process, Robert Venosa and Alex Grey are undoubtedly the Fathers of twenty-first-century Visionary Art—the often confusing, though historically accurate, Blakean code name under which psychedelic art has now largely reappeared. With Venosa's participation in the AllChemical Arts Conference, and the term *visionary art* being used on the cover of Grey's book *Sacred Mirrors,* the technical differences between the (European) Fantastic Realists and (American) psychedelic art grew muddier, at least in the short attention span of the United States, where by the beginning of the twenty-first century, visionary art and psychedelic art had become essentially the same thing.

In 2000, Venosa would publish another retrospective of his work, *Illuminatus.* Tragically, Terence McKenna's foreword to this book would be his last words. On April 3, 2000, only months after the AllChemical

Convention, which had been the culmination of so many of his dreams, McKenna died of an aggressive brain cancer. He was fifty-three. Barely a few months into the twenty-first century, psychedelic culture—which had just begun to emerge in the 1990s after a decade in hiding, largely thanks to McKenna's inspired writings—had lost its most charismatic spokesperson since Timothy Leary. His death left an immediate vacuum, and although few people yet realized it, a new Psychedelic Era had just begun.

ALEX GREY (1953–): AMERICAN MYSTIC

Like the paths of shamans and mystical travelers, the arduous route [Alex] Grey took to spiritual transcendence, purification, and the liberating vision that became the Sacred Mirrors was not one of simple godlike purity, but a painful, errant, and circuitous journey through the poisonous swamps and jungles buried deep within the blackest, bleakest recesses of life, death, ritual, and perception. The pitfalls on this shadowy, earthy road were sinkholes into the abyss of madness and malevolence, but the light at the end of the tunnel was that of the Godhead itself.

CARLO MCCORMICK, "FROM DARKNESS TO LIGHT:
THE ART PATH OF ALEX GREY"

With the rise of the cult of the personality, the increasingly tortured mystic-artist has become something of a common theme in this examination of the history of visionary art, starting with Michelangelo, the first famous artist, and then with the tragic examples of Vincent van Gogh and Mark Rothko, two of the most celebrated painters in history of modern art. Much rarer, however, is the artist who begins his process tortured, only to find redemption—some might even say enlightenment—from their existential crisis through their art.

Although he has been deified by contemporary psychedelic culture, few people other than those closest to Alex Grey—who in the twenty-first century has become the most celebrated psychedelic artist in

history, the face of the worldwide visionary art movement, and perhaps the most popular American artist since Andy Warhol—seem to realize that he is exactly that unique kind of artist. For as in the classic tradition of shamanism, where a shaman is recognized by and nurtured from an initial "psychotic" break or incident, this may also be the source from which Alex Grey's often transcendental art originates.

Although he had learned to draw from an early age, Grey first rejected painting after leaving art school and began his career in 1973 as an avant-garde performance artist, wrestling with the idea that the conflict of opposites was the underlying principle in the cosmos, as well as with the obvious internal conflict within himself. In 1975, this obsession with polarity culminated in *Polar Wandering,* for which he made a pilgrimage to the North Magnetic Pole, and after stripping naked in the snow, ran in a circle. As the New York art critic Carlo McCormick put it, this was a "geophysical meditation on the rotational and electromagnetic forces of the earth, so powerful that it induced a primal out-of-body trance state during which the artist experienced the sensation of 'slowly dissolving into a pure energy source and becoming one with the planet's innate dynamic frequency'" (McCormick, "From Darkness to Light," 21).

Upon returning to the East Coast, the young Alex Grey became increasingly morbid, his meditations on the polarity between spirit and substance bordered on the taboo and the unethical, resulting in a number of highly controversial performances. To describe this period of Alex Grey's art as "dark" would be an understatement. During the late 1970s, when he worked as an embalmer and preparer at a morgue, as a performance artist he took such liberties as locking himself in a freezer full of corpses for five minutes (*Deep Freeze*), suspending himself upside down tacked to a crucifix with a dead man's hollowed-out body as a counterweight (*Life, Death, and God*), and shot a series of "hauntingly elegant and spiritually iconographic black and white photos of variously malformed fetuses, born dead and preserved in jars of formaldehyde" (*Monsters*) (McCormick, "From Darkness to Light," 21).

Then at some point something inside of Grey recognized that he

had strayed into the darkest and most forbidden of territories, and these transgressions resulted in series of nightmarish visions in which the young artist believed he encountered a truly evil and malevolent force, and that he was "on the edge, very near a point of no return," finally only banishing the apparition by repeatedly reciting "I know Divine Love is the strongest power." In another dream, Grey was in a court-room in front of an angry jury, while a woman accused him of trespass-ing on her body in his morgue work. When attempting to explain that it was in the name of art, he received no forgiveness, but instead was told by the judge that from then on he had to do more positive work, putting him on life probation never again to create such negative and taboo images.

As McCormick explains in his essay in *Sacred Mirrors:*

Dream, nightmare, vision, hallucination, premonition, or mystical intervention? The fact is, on some level outside of creative reasoning or creative ferment, these events took place for Alex Grey in a way that was, to him, indisputably real. In the shamanic tradition, impor-tant information from the realm of the dead or the spirits comes in visions or dreams. In recalling the visions today, Grey does not so much seek to answer the question of their origin as to articulate their form in the sphere of his own soul: [. . . saying] "The visions were a turning point for me. They helped me to realize that I could spend a lifetime in darkness and ignorance, and that it was time for me to move on." (McCormick, "From Darkness to Light," 22)

It was then, at the depths of this existential despair, that Alex Grey made a desperate move that has become engraved in psychedelic history. In his own words:

To develop a unique voice, an artist individuates from the social fabric, distilling their own touch, emotional flavor, and worldview, which generates and saturates their aesthetic artifact. My "polarity works," actions such as my half-shaved head, were initiatory rituals,

ordeals, trials. Fulfilling a dream vision, I shaved half my hair, externalizing the division between the rational and intuitive hemispheres of the brain. For half a year I maintained my half-shaved persona, performed various polar experiments, and pondered whether life was worth the living. Overwhelming anxiety and despair hung like leaden clouds over me. At twenty-one years old, suicide called to me in the shadow of a shallow, pointless existence. Desperate times called for desperate measures. So I prayed for a sign from the God that I didn't believe existed.

That same day, May 30, 1975, I took my first dose of LSD. After arriving at the party and sharing the drug [in a bottle of Kahlua] with the hostess, I sat on her couch and closed my eyes. Inside my head, I was spiraling through a pearlescent tunnel from utter darkness toward a brilliant light. My ignorance was the darkness, God was the light. The polar opposites blended together seamlessly and it was then that I decided to change my name to Grey [i.e., the blending of black and white]. My mission as an artist was now clear: to reveal and unite polarities, male with female, flesh with spirit. This propelled my search for the One love and light at the heart of all mystical tradition. (Grey, *Net of Being,* 31–32)

Alex and the hostess of the party consumed most of the LSD in the Kahlua bottle and spent the rest of the night glued to the couch. The next day, in an attempt to understand what had happened to him the night before, Alex rang her back and invited her out to lunch. On this, their first official date, Alex and Allyson discovered that they had shared the same vision on LSD. Allyson—who had been tripping steadily since 1969—then gave Alex his first rundown on psychedelics, and they have rarely been apart ever since.

This first shared vision of the soon-to-be husband and wife turned out to be one of many shared psychedelic visions, the most famous and influential of which occurred in 1976, when the two artists simultaneously experienced the same psychedelic vision of the "Universal Mind Lattice."

Our shared consciousness, no longer identified with or limited by our physical bodies, was moving at tremendous speed through an inner universe of fantastic chains of imagery, infinitely multiplying in parallel mirrors. At a superorgasmic pitch of speed and bliss, we became individual fountains and drains of Light, interlocked with an infinite omnidirectional network of fountains and drains composed of and circulating a brilliant iridescent love energy, We were the Light, and the Light was God. (Grey, *Sacred Mirrors,* 7)

After their shared mystical experience of their Universal Mind Lattice, the pair decided that "a vision of sacred interconnectedness was the most important subject of art." Inspired by their 1978 performance *Life Energy,* and by Allyson's subsequent inspiration that Alex should create detailed paintings that viewers identified with as mirrors of his cosmological view of the body, mind, and the spirit, by 1979 he had conceived of the *Sacred Mirrors* series. These paintings took a decade to come to fruition, including the elaborately carved frames, which Allyson played a major role in creating. The full series of twenty-one framed paintings was first exhibited at the New Museum in New York City in 1986. According to Carlo McCormick:

In their collected and assembled form the impact is like a crystalized hallucination. The works stretched for over 150 running feet and towered above the viewer at a height of ten and an half feet. The frames, elaborately carved and painted gold on black with stained-glass inserts, created a seemingly endless row of colored light. The thousands of hours of labor required to produce such a body of work recall a period in art history when devotional labor was at the core of art production. Yet a closer look at the overall symbols and the images on the frames calls up contemporary and future images and genres of art. The viewer's mind is overloaded with information and gropes for categories in which to place the work. Is it Realist? Surrealist? Minimalist? Maximalist? Post-Modern? Psychedelic? Abstract? Religious? Medical? Scientific? Or Visionary? Even if the

viewer is not familiar with all the subject matter presented, there is an overwhelming impression of encyclopedic scope, and a sense of the sacred intent which produced the art." (McCormick, "From Darkness to Light," 27)

When the *Sacred Mirrors* series was released as an art book in 1990, those who managed to look past the startling images and delved into the essays within were presented with a concise philosophy gained from more than two decades of meditation and reflection, while the artworks themselves seemed to transmit even more meaning than the words. Struggling for a comparison, Holland Cotter, art critic for the *New York Times,* wrote in 2002:

> Alex Grey's art, with its New Age symbolism and medical-illustration finesse, might be described as psychedelic realism, a kind of clinical approach to cosmic consciousness. In it, the human figure is rendered transparently with X-ray or CAT-scan eyes, the way Aldous Huxley saw a leaf when he was on mescaline. Every bone, organ and vein is detailed in refulgent color, objects and space are knitted together in dense, decorative linear webs.

This combination of precise, medical-style drawings and auras and energy fields arrived as a revelation in psychedelic art. The skill required was obvious to even the most ignorant observer, while many of the paintings possessed a mystical quality, evoking classical Tibetan thangka contemplation paintings, or even early Christian meditations. While erudite critics might sense some faint kinship with fantastic realism—*Praying* (1980), the now iconic painting on the cover of the *Sacred Mirrors* book, for example, invokes the same psychedelic spiritualism as Mati Klarwein's earlier *St. John* (1962)—there is no mention of Klarwein or Fuchs or any of the fantastic realists within *Sacred Mirrors,* nor does Grey himself feel any particular association to the Vienna School, because he is ultimately as interested in the history of mysticism as he is in the history of art. While Fuchs, Klarwein, and

Venosa painted fantastic and angelic beings into the visionary dimensions of their art, within the pages of the *Sacred Mirrors* Alex Grey confesses to conversing with such illustrious beings—he is perhaps the first well-known artist since William Blake who is clearly unafraid to do so. Unlike Robert Venosa, who looked to Europe and the fantastic realists for inspiration, Grey is a uniquely American artist, and one who, along with his wife and artistic partner, Allyson, have walked a psychedelic path largely all of their own.

While the decision to use *The Visionary Art of Alex Grey* as a subtitle for *Sacred Mirrors* was intended to place Grey's art within the same lineage as William Blake's, as previously mentioned, the new terminology also had a pragmatic side. For at that point in time in the early 1990s, the cultural attitude toward psychedelics was so negative that using a subtitle that proclaimed "The Psychedelic Art of Alex Grey" would have opened the art up to ridicule (and possible censure) almost immediately. Yet once the codified cover of that book is opened, the importance that Alex Grey attributes to the psychedelic experience is laid out in the preface from virtually the first page.

Which, in 1993, during the height of the media-intensive War on Drugs, was a brave and committed act for an unknown artist hoping for a sustainable career. But even though Alex wasn't aware of it at the time, other forces were at work that would soon make his art the stuff of psychedelic legend, and see him on his way to being anointed as the most important psychedelic artist of his time.

23

THE COLLECTORS

Mark McCloud and Jacaeber Kastor

Interviewer: So how did you come to start framing them? [the sheets of LSD].

McCloud: Well that's another question about my rebirth. See, I was a very difficult seventeen-year-old. Hendrix had just died, so I took 300 mics of Orange Sunshine, and basically the fabric I existed on changed. [McCloud fell out of a seventh-story window during this experience.] I vibrated myself out of this world and into a different thing, and that's when I really started collecting. At first I was keeping them in the freezer, which was a problem because I kept eating them, but then the Albert Hofmann acid came out, and then I thought, Fuck, I'm framing this. That's when I realized, Hey, if I try to swallow this I'll choke on the frame.

JULIAN MORGANS, "MARK MCCLOUD HAS
30,000 TABS OF LSD AT HIS HOUSE"

BLOTTER ART, POSTER ART, AND
THE PSYCHEDELIC SOLUTIONS GALLERY

Largely thanks to the escalation of the War on Drugs under President Ronald Reagan and the "Just Say No!" campaign led by his wife, Nancy, the greed-filled era of the 1980s was statistically the least psychedelic decade in U.S. history. Even in San Francisco, the heart of the LSD revolution, the respect given to psychedelic art was minimal (if any), while the psychedelic poster art of the 1960s was considered practically worthless by the majority of collectors. It would be the exception of two committed individuals who still believed in psychedelic art—one in San Francisco, and one in New York—who act as tastemakers for the almost unimaginable Second Psychedelic Revolution to come.

Mark McCloud is a San Francisco artist and former art professor who started collecting blotter art–printed tabs or sheets of paper LSD over forty years ago. Fascinated by this art form as it was born somewhere in the early 1970s,* McCloud began matting the sheets, framing them, and hanging them like fine art, eventually even getting close enough to the acid dealers themselves that they would supply him with "undipped" (and therefore legal) sheets of the art. By the mid-eighties McCloud was exhibiting his collection around the Bay Area; in 1987, he won a blue ribbon at the San Francisco County Fair for his "unusual and timely exhibition."

McCloud has his world-famous collection of over four hundred framed sheets of LSD in his Victorian house in San Francisco, alternatively known as the Institute of Illegal Images—the largest known collection of blotter art in the world—along with thousands of unframed sheets, hundreds of art books, rare psychedelic posters, giant photographs of Albert Hoffman, and original paintings by Alex Grey and other psychedelic artists whom McCloud has known and often

*In the 1960s, LSD was originally distributed on sugar cubes, and then as small pressed pills. The practice of laying the LSD on printed sheets of absorbent blotter paper printed with artwork (so as to advertise the "brand" of LSD) began in the 1970s.

helped. McCloud first saw Grey's work at the 1987 San Francisco Arts Commission Gallery show *Retrospectacle,* curated by Carlo McCormick (the same New York art critic who would later write one of the major essays in *Sacred Mirrors*), which celebrated the twentieth anniversary of the Summer of Love. The gallery hosted psychedelic art from artists old and new, including a painting called *Purple Jesus,* which Grey had painted for the show. Knowing great psychedelic art when he saw it, McCloud paid $1000 for the painting—more than the asking price— and gave it to his mother, who was living in Argentina's Patagonia region. (The original painting is still there.)

The following year (1988), McCloud curated a show of his blotter art called The Cure of Souls at the Psychedelic Solution Gallery in New York. Also on display in the gallery were original works by Alex Grey and Allyson Grey's *Secret Language* paintings.

A highly-skilled painter in her own right, for the last thirty years Allyson Grey's own psychedelic experiences have led her to explore as a painter an essentialized world view consisting of three root components: chaos, order, and secret writing. Her secret writing is comprised of twenty unpronounceable letters, corresponding to the nameless presence, existent in all sacred writing, the spirit embedded in communication that cannot be reduced to concepts. Stylistically, her highly geometric repetition of color and form is reminiscent of the best of the psychedelically inspired Optical Art of the 1960s, such as the work of Bridget Riley (1931–). Allyson also works with her husband Alex as a team on many of their projects—Allyson, for example, led the creation of the carved frames for the *Sacred Mirrors* series, and she is a tireless force in the (ongoing) construction of the Chapel of Sacred Mirrors. Always live-painting together, some of Alex and Allyson's most recent paintings are a collaboration between the two artists' styles.

When Jacaeber Kastor moved to New York from the Bay Area in 1981, psychedelic culture wasn't just dead there, it was actively ridiculed or despised—the doorman at the famous Studio 54 nightclub informed Kastor that with his long hair he was either a drug dealer or a hippie, and either way he had better cut his hair if he ever wanted in.

Despite that attitude, Kastor opened the Psychedelic Solutions Gallery in a rundown part of the East Village in 1986, another brave act in the Just Say No! era of Ronald Reagan. Kastor, who along with McCloud is regarded as one of the greatest authorities on psychedelic art in the world, was incensed that it was given no criticism or commentary, let alone being taken seriously. He intended his use of the word *psychedelic* in the name of the gallery to be galvanizing, and it was. While the remnants of New York's psychedelic community quickly gathered around it, numerous artists (including Alan Atwell) told him that they would not display their artwork there, because they were afraid that the New York art world would effectively blackball them if they did.

Outraged that *Art Forum* magazine never included any Psychedelic Art between its covers, Kastor wrote the magazine a scathing seven-page letter in protest. Shortly later an art reviewer from the magazine, Carlo McCormick, turned up on Kastor's door, and the two soon became firm friends. McCormick curated the 1987 *Retrospectacle* in San Francisco, which introduced Alex Grey to the West Coast and Mark McCloud, and McCloud's blotter-art collection to Jacaeber Kastor. McCormick was also a frequent doorman for Psychedelic Solutions events.

In the late eighties, the word *psychedelic* was the kiss of death to a serious art career, and most people studiously avoided being associated with it. Kastor persisted, however, opening the gallery on Halloween in 1986 with a successful Rick Griffin show. Later he put on a show that united all seven artists from *Zap Comix* for the first time in thirty years. (A special issue of *Zap* was created for the event.) Gallery openings at Psychedelic Solutions were often more like old-school acid happenings than conventional art shows, attracting virtually the entirety of the New York psychedelic scene and various psychedelic royalty—such as the Shulgins and Terence McKenna—who were passing through New York. Continuing to operate mostly as a psychedelic art gallery from 1986 to 1995, Psychedelic Solutions successfully introduced major psychedelic artists like the Greys and the psychedelic abstractionist Oliver Vernon to the world, and European painters such as H. R. Giger to the United States.

The successful *Zap Comix* show at Psychedelic Solutions led to solo shows in the late 1980s by the "lowbrow'" pop surrealist (and *Zap* contributor) Robert Williams. Inspired by the type of art that Kastor was exhibiting at Psychedelic Solutions, Williams founded *Juxtapoz* magazine in San Francisco in 1994 with "the mission of connecting modern genres like psychedelic and hot rod art, graffiti, street art, and illustration, to the context of broader more historically recognized genres of art" (Wikipedia, "Juxtapoz"). In 2000 the magazine expanded its vision even wider to include all kinds of underground art. Immediately popular, *Juxtapoz* has been incredibly influential in reopening the dialogue about psychedelic and other forms of outsider art. As of 2009, it was the most popular and widely distributed art magazine in America.

From 1996 till 2004, Kastor slowly shifted Psychedelic Solutions to being a rock poster gallery, with over 50,000 artifacts in its catalog. In 2004, in a sign showing that psychedelic culture was returning to the mainstream, and also revealing the potential of the evolving medium of the internet for artists, Wolfgang's Vault, an online poster-and-memorabilia auction site, purchased the Psychedelic Solutions archive for a sum rumored to be around $4 million—validating Kastor's long-held assertion that such posters were collectible art.

Meanwhile, back in San Francisco (and unbeknown to Alex Grey), Mark McCloud had turned the *Purple Jesus* painting into a print before shipping the original off to Argentina. The print was then reproduced on 7.5-inch-square blotter paper and perforated so the paper could be torn into 900 tabs. McCloud printed around 3000 sheets and distributed the perforated prints far and wide. In typical San Francisco fashion, an underground chemist then dipped a number of the sheets in LSD (the "alchemical presence" or the "Holy Ghost," according to McCloud's philosophy).

By this time McCloud himself had long been considered something of a psychedelic authority on the West Coast, where he is regarded as the Father of Blotter Art. His artistic credentials are impeccable; born in Argentina, he studied at L'École du Louvre in Paris before returning to finish his undergraduate degree and then getting an MFA at the

University of California at Davis. After graduation, he moved to the San Francisco Bay Area, worked as a curator and an artist, lecturing from time to time at Santa Clara University, and became immersed in the Bay Area art scene. A two-time recipient of grants from the National Endowment for the Arts, McCloud served on a number of boards and was already a noted art collector. On top of all that, he had first tripped when he was thirteen, personally knew Timothy Leary, and is one of the greatest practitioners of Beatnik Speak since Neal Cassady. So when the *Purple Jesus* acid first appeared in the early 1990s shortly after the publication of *Sacred Mirrors,* the psychedelic community in California was duly alerted to Alex Grey as a new psychedelic talent emerging from the opposite coast.

But there was more to the distribution of the *Purple Jesus* acid than just its artwork. According to an article written for the webzine BOOM:

> The Jesus acid was personal for McCloud, a way to display his own theology in the form of something that both was and was not religion properly defined. It reflected a lifestyle. Perhaps this is what happens with ordinary and extraordinary artifacts in California, religious or not, but treated as religious in some respects, ritualized in ways that enjoy varying degrees of success and sustainability, innovation, and meaning. The art didn't originate in California, but was reappropriated and reconstituted in California as something else. And California is where it popped, took on a life of its own, and then went out from here in a quasi-religious fashion inasmuch as acid has been taken in communities seeking to enjoy its religious benefits, inducing religious experience, and affirming religious sensibilities. (Sexton, "Jesus on LSD")

LSD as a source of genuine mystical experience—this was a dominant theme that both Alex Grey and Mark McCloud shared, and one that had mostly been lost and rejected by American culture during the anti-drug hysteria of the 1980s. Meanwhile, the timing of this particular

batch of LSD itself could not have been more synchronistic for psychedelic culture, for in the summer of 1994, this sheet of LSD was reputedly the last (and certainly the favorite) acid that was distributed throughout the Grateful Dead parking-lot scene before Jerry Garcia died in 1995 and the legendary band disbanded. In circles knowledgeable about blotter art, aficionados will tell you that the Purple Jesus acid (or just Jesus Acid) has become one of the most famous sheets of acid in history.

From the band's inception in 1965 till its disbandment in 1995, the Grateful Dead and LSD were virtually synonymous. Originally known as the Warlocks, they were the house band for Ken Kesey's and the Merry Pranksters' Acid Tests in the mid-sixties. That, and the fact that the Dead's biggest fan and early sponsor was also the world's most famous LSD chemist—Augustus "Bear" Owsley Stanley III— who designed both the Dead's dancing bear logo and the band's 1960s Wall of Sound touring system, cemented the band's reputation as LSD's leading advocates after the Merry Pranksters brief tenure ended. Over the following three decades, it would be the Grateful Dead who would develop the original Prankster model of lights, rock 'n' roll, and acid on tour into something uniquely their own, while creating the most enduring American psychedelic community in modern history along the way.

On a purely practical level, the sprawling, constantly touring, parking-lot scene of the Grateful Dead shows were the perfect vehicle for the Brotherhood of Love to distribute their intentionally low-priced LSD for decades. Throughout the 1980s and early 1990s, when the remnants of psychedelic culture were mostly being nursed in protected pockets underground, the Grateful Dead pretty much *were* psychedelics in mainstream America. If you wanted to score some LSD, you either went to the parking lot of a Dead show, or you found the local hippie house of Deadheads. (This was particularly true in virtually any college town, or any ski town.) The distribution of the Purple Jesus acid throughout the Dead parking-lot scene effectively spread Alex Grey's art across the United States and Canada, while the sudden death of Jerry Garcia and the ceasing of the Grateful Dead's legendary near constant

touring suddenly gave the Purple Jesus the historic status of being "the last sheet of Dead acid." More than one die-hard Deadhead has told me that for them—as it would be for much of psychedelic culture—Alex Grey's art appearing at this critical juncture in the mid-nineties was like a finger pointing in which direction to go.

24

NEW PSYCHEDELIC TRIBES

BOOM! and Burning Man

The Promised Land is any environment that has been metaphorically spiritualized. An elegant example of this universal experience is found in the mythology of the Navaho. Living in a desert, the Navaho have given every detail of that desert a mythological function and value, so that wherever people are in that environment, they are in meditation on the transcendental energy and glory that is the support of the world. The Promised Land is not a place to be conquered by armies and solidified by displacing other people. The Promised Land is a corner of the heart, or it is any environment that has been mythologically spiritualized.

JOSEPH CAMPBELL, *THOU ART THAT*

By the end of the 1990s, a significant and generally unforeseen factor had begun to emerge in psychedelic culture with the arrival of both the World Wide Web and the first digital art. The internet would have a huge influence in bringing psychedelics back into mainstream culture, because this new information web was virtually impossible to

censor. Silicon Valley meanwhile has a significant psychedelic history all of its own (as documented in John Markoff's *What the Dormouse Said: How the Sixties Counterculture Shaped the Personal Computer Industry*), and numerous psychedelic users were tech-savvy, including Timothy Leary, who had one of the first websites. Psychedelic information sites like Erowid.org arrived on the Net as early as 1995, while psychedelic art—often images taken from Robert Venosa or Alex Grey—soon appeared on countless websites.

Electronic music—which had initially been known as Acid-House music in England—also became an increasingly popular, if not pre-dominant, form of music in urban centers, with more and more of the music being made, produced, distributed, and played on computers. The seamless all-night dance parties that emerged with the music, originally known as raves, were generally fueled by MDMA (Ecstasy) and/or LSD, and after the mid-nineties the global electronic dance music (EDM) community had taken over from the singularly American Grateful Dead as the new torch bearers of psychedelic music, again often using images taken from Venosa or Alex Grey on their handbills and posters. Underground and subversive from their very beginnings, these openly psychedelic raves increasingly went on for days as they transitioned from inner-city warehouses to suitable deserts or other remote locations, far from any unfriendly authorities. So by the year 2001, with the deaths of Timothy Leary, Ken Kesey, and Jerry Garcia, the psychedelic sixties and seventies were mostly buried, and the known center of the psychedelic world had already begun to move away from the transient parking lots of the jam bands that did their best to follow in the footsteps of the Grateful Dead to two unique counterculture festivals held far from any urban centers—BOOM! in Portugal, and Burning Man in the United States.

First held in 1997, the now-biannual BOOM! festival is dedicated to psytrance (Psychedelic Trance, or Goa Trance, as it was originally known), a genre of electronic music that originated between Goa, India, and Europe in the late 1970s and 1980s. Although little known in the United States, over the past twenty years psytrance has become one of

the most popular forms of electronic music in Europe. According to this rather colorful Wikipedia entry:

> This freak mosaic was seasoned by expatriates and bohemians in exile from many countries, experienced in world cosmopolitan conurbations, with the seasonal DJ-led trance dance culture of Goa absorbing innovations in EDM productions, performance and aesthetics throughout the 1980s before the Goa sound and subsequent festival culture emerged in the mid-1990s. Rooted in an experimental freak community host to the conscious realization and ecstatic abandonment of the self, psyculture is heir to this diverse exile experience. (Wikipedia, "Psychedelic trance")

Perhaps the first universal and global psychedelic tribe, whose roots go back to the original international hippie trail of the 1960s, Europe's psychedelic-trance festivals are a multiethnic, multilingual, multicultural entity, united in their transcendental desire to dance. Favoring a style of electronic music with higher numbers of beats per minute than American festivals, psytrance music aims to elevate the listener through the chakra system by means of a repetitive speeding up of the beats (toward the end of an 8–12-minute track), which (again according to Wikipedia) was originally intended "to assist the dancers in experiencing a collective state of bodily transcendence, similar to that of ancient shamanic dancing rituals, through hypnotic, pulsing melodies and rhythms."

Goa, India, a tiny, tranquil, beach-lined state in India, has also been the home of a significant psychedelic culture since the mid-1960s, with more than one chemist-in-exile sheltering among its palms, or in not-so-far-away Pune with the Oshoites. (Including Nick Sand.) When psychedelic culture went into remission in much of the world in the 1980s, Goa was one of the few places that was little affected, and the now mostly electronic, turntable-and-computer created psytrance music actually evolved out of the all-night drum and guitar parties from the original sixties hippie trail population. Goa Gil, for example, the most

famous of the Goa Trance DJs and a practicing Shiva *sadhu* (renunciate), is originally a musician from San Francisco.

After psytrance found its way to Europe in the early to mid-1990s, BOOM!, which is now held biannually around the full moon in August on the shores of Lake Idanha-a-Nova in Portugal, was one of the first major European psytrance festivals in 1997. Then in 2001, the generally conservative Portuguese government did something extraordinary: they broke with the worldwide system of prohibition and incarceration, and legalized small amounts of any drug in their country.* BOOM! then synchronistically found itself in the position of being the only festival in the world that could openly advocate psychedelic culture.

In 2002, the BOOM! organizers made a partnership with the Canadian production company Invisible Productions to help turn BOOM! into an integrated psychedelic art, music, and culture festival. Invisible Productions then brought Alex Grey and Robert Venosa to give presentations, with their art being used by the main-stage VJs—video jockeys, or video artists, as they would prefer—in various permutations across multiple projection screens.

Grey's and Venosa's participation in 2002 helped launch BOOM!'s reputation as *the* visionary art festival in Europe—a reputation it has worked hard to build on in each incarnation by attracting the best psychedelic artists and speakers from all over the world. Along with its extraordinary Liminal Drop Gallery Speaker Zone, as well as introducing innovations like Cosmic Care (an area of trained professionals especially created to help people having difficult trips), and on-site drug-testing caravans that enable BOOMers to test whatever drugs they are buying, BOOM! has the highest concentration of jaw-dropping visionary art—including various stages, large-scale sculptures, and Visionary Art galleries—outside of Burning Man. Because of both its conscious intention and the large amount of visionary art, BOOM! has become the best-known European transformational festival, and you often hear

*A controversial move that has largely been a social success, with reduced crime, overdoses, and addictions reported.

it (erroneously) referred to as the European Burning Man. (Burning Man has been developing its own European regionals, such as in Spain).

Consciously rejecting sponsorship, BOOM! is run as a socialist-style collective, with most of the money that is made going back into BOOM! and outreach programs in the local communities. The organization is in the process of buying the land it is held on, where the collective has already made numerous improvements, such as the building of a water-treatment station for the festival grounds, and developing compost toilets that turn the festival's most obvious source of waste into organic fertilizer. (Water is free and readily available at BOOM!—and you might die without it.)

Less than twenty years since its conception, BOOM!, much like Burning Man, is challenged by its own success. The 33,000 tickets allotted for the 2016 edition sold out in a little over a month, leaving many people wishing that they could be there also. (The organizers made the undoubtedly difficult decision to reduce the size from 2014.) But this success also now translates to a considerable financial boon to the artists who participate in the official Visionary Art Gallery on site (now known as MOVA—the Museum of Visionary Art). BOOM! is one of the events where an aspiring visionary artist is most likely to sell an original painting, and there are significant sales of the participating artists' prints, stickers, and clothing, making it one of the most important dates on the visionary art calendar.

> *I don't think that art, if it's isolated and specialized, can really create culture. It needs a cult.*
>
> ERNST FUCHS

Burning Man's origins began in 1986 on the evening of the summer solstice at Baker Beach in San Francisco—still the recognized center of psychedelic culture—when an artist named Larry Harvey and his friend Jerry James built and burned an effigy of the figure of a man with a group of around a dozen friends. By 1988 Harvey had named the gathering "Burning Man," and then in 1990, with attendance reaching

eight hundred people, local police interrupted the event, preventing the actual burn. The effigy was then disassembled and later taken to Black Rock Desert in Nevada, where it was reassembled, and subsequently burned, at a different (already existing) event organized by Kevin Evans and John Law from San Francisco's Cacophony Society called Zone #4: A Bad Day at Black Rock, conceived "as a dadaist temporary autonomous zone with sculpture to be burned and situationist performance art" (Wikipedia, "Burning Man").

Another Cacophonist, Michael Mikel, realized that the newcomers would face significant challenges coming to the hostile desert conditions from the city for the first time; so he renamed himself Danger Ranger, and created the Black Rock Rangers.

The intersection of these two different groups in Black Rock Desert led to what can be considered the first era of Burning Man (1991–96). Although in 1991 the combined event required a legal permit from the Bureau of Land Management for the first time, this period is mostly remembered for its lawlessness—complete with guns, massive explosions, and an open unregulated playa. By 1996 participation in the event had grown to eight thousand people, and after a couple were run over sleeping in their tent that at the festival that year, John Law and a number of the Cacophony Society disavowed the event afterward, saying it had grown out of control.

Burning Man's second era then began in 1997, when Larry Harvey and company formed a limited-liability company to comply with permitting requirements, and a grid system of streets was first implemented, creating Black Rock City. For the first time, a seven-mile temporary plastic fence also surrounded the event, and speed limits and areas off-limits to vehicles were implemented. By 2000 (my own first Burn), 23,000 people were in attendance. Black Rock City was laid out in its familiar horseshoe pattern, the Man was raised and lit with neon tubes (although it did fall over three times and catch fire early on Burn night), and features like art cars and theme camps (which today help define Burning Man) were already implemented.

As a Burner I have independently contributed a great chunk

of the past seventeen years of my life toward Burning Man, from actively participating in the leadership of various-sized Burning Man theme camps and villages (from 35 to 500 people), to the writing of *Tryptamine Palace* (probably the only book ever written *for* Burning Man) and my subsequent decade of public speaking appearances on the playa, or my other major contribution as a Burning Man artist— the conception, construction, and captaining of a now iconic art car called the Lady Sassafras. These endeavors, which have cost me personally tens (if not hundreds) of thousands of dollars, and thousands upon thousands of precious hours, all to spend two weeks a year (one for build, one for the event) on the playa, and therefore I think I have as good a perspective on the subject as anyone to be able to say that the magical, unruly, unpredictable, constantly changing, and, I believe, truly uncontrollable beast that is Burning Man, is probably the most misunderstood, and most misrepresented, social phenomenon on the planet today.

To call Burning Man a festival totally misses the point, for Burning Man is first and foremost an art movement—the last major twentieth-century art movement, the first of the twenty-first, and the most vital in our current paradigm. Secondly, it has evolved into a tightly knit and closely interwoven community, many of whose members have known each other for over two decades, although that has been challenged by Burning Man's sudden explosion in popularity after becoming an LLC in 2011. Finally it is also—and this is what keeps you going back—a state-of-consciousness generator uniquely its own.

Originally an anarchistic expression of personal freedom, the Burning Man experiment has now sufficiently penetrated the American consciousness—and, in the past two decades, especially that of Silicon Valley—that it may yet achieve the cult status required to bring about true cultural change. Artistically, it is an evolution of the rebellion of twentieth-century art against rules and scholarly pretentiousness. Dadaist at the roots, the artists of Burning Man have combined the surrealist dreamscape of the desert with the "everything is art" ethos of pop art and taken the concept to its furthest conclusion: an avant-garde

performance community that creates art purely for itself to experience and enjoy interactively for a week, before watching that same art then be burned to the ground.

But unlike the cerebral attraction of pop art, which consciously worships the culture of consumerism, advertising, and corporate entitlement, deliberately making itself a commodity and utterly soulless—a kind of intellectual junk food—the art of Burning Man disavows twentieth-century commodification and commercialism: that is, until very recently, it has not been created to be marketed or sold or to be experienced anywhere other than on the playa. Burning Man art is conceived of and created at the level of the heart. As a part of that process, the creation of the art becomes a kind of an initiation rite, with the artist often playing out a mini-drama of considerable challenges before (hopefully) achieving the exuberant period of celebrating the creation's completion, and then, only a few days later, the quiet moment of reflection of watching it burn.*

Burning Man has evolved as a uniquely modern drama that unconsciously mimics those mystical performances of the original Eleuisinian Rites in Greece, generated by an artistic intention as well conceived as Chavín de Huantar in Peru, where artists with no steel tools hewed tunnels and gods in rock on the strength of their psychedelic vision. With the artist playing the role of the hero's journey, during the week of Burning Man all participants are pilgrims who have followed in the artists steps to honor and observe and ultimately connect with the art in a very personal and visceral manner. The final burning of the art then creates a mystical connection between the invisible creator and the enraptured audience, a psychic tension that then spontaneously creates a magical synchronicity in its immediate surroundings, a resonance caused by the fractal of pure creation energy rippling through the Akashic field. Accompanied by music and performance and fire and the widespread consumption of psychedelics,

*Not all Burning Man art is burned: the art cars and metal sculptures are not, for example.

art is lifted back up to the level of mystical ritual at Burning Man, dancing on the edge of religion.

The modern equivalent of a mystery school, these ritualized performances have generated a pervading sense of genuine community, a secret cult outside of everyday society.

The most spiritually significant of these performance burns—and generally the most spectacular apart from the elaborately choreographed burning of the Man itself—is the burning on the final (Sunday) night of a (generally) wooden edifice created annually each year since 2000 and often simply referred to as the Temple (see www.thetemplecrew.org). While the Man (which burns on the Saturday night) is still designed by Larry Harvey each year, and is constructed by (and is central to) the Burning Man organization, the Temple was not conceived of the same way. In many ways it simply evolved out of an apparent early need of an evolving Burning Man community.

In 2000, a San Francisco–based sculptor called David Best (1945–) was about to begin constructing an installation (with Jack Hayes) called the Temple of Mind at Burning Man when a crew member was killed in a motorcycle accident. Best and his crew had already constructed an installation called the Mausoleum the previous year, and now the death of one of their members transformed the Temple of Mind project into a sacred space in which to remember others. After this temple was constructed, people spontaneously began writing dedications to the dead on the walls, and later cathartically attaching photos, letters, even suicide notes—a symbiotic development that greatly added to the Temple's mystical importance and increased the sense of community ownership.

The Temple possesses the duality of being both a somber and a celebratory space. Dance parties (notably the Temple of Breaks in the early 2000s) are occasionally held there, and the Temple is used for weddings and other celebrations, along with its dual role as a memorial for the departed. In contrast to the Dionysian anarchy of the burning of the Man, the burning of the Temple (on the final Sunday night) is a silent and sacred affair which the vast majority of longtime Burners consider

to be "the soul of Burning Man." Since many of the weekend partiers leave Sunday morning after the Man burns to try and avoid the inevitable traffic gridlock and get back to the "real world" by Monday, the Temple Burn on Sunday night, where the memories of departed friends, family, and other loved ones are transmuted into flames and ash, is also generally the most poignant moment of actual community.

Between 2000 and 2004, David Best and Jack Hayes returned to Burning Man with their Temple crew to build ornate wooden temples in Best's signature style, using cutout pieces from a jigsaw puzzle company and other recycled items—the *Temple of Tears* (2001), *Temple of Joy* (2002), and the gorgeous *Temple of Stars* (2004)—and once in paper—the *Temple of Honor* (2003). (After 2001, Burning Man helped fund the construction of increasingly larger temples.) David Best has taken breaks since then, but in total he has created ten of the seventeen iconic Temples that have been built and subsequently burned— the Temples of *Forgiveness* (2007), *Flux* (2010), *Transition* (2011), *Juno* (2012), *Grace* (2014), and most recently, simply *The Temple* in 2016, which Best says is his last one.

Best has also built a number of art cars and buses, and was an early pioneer of the unique and substantial Burning Man art-car tradition. (Which is also another whole book in itself—the Burning Man historians are going to be a busy lot.) Few Burners would argue with the statement that along with Larry Harvey, David Best is the best known and most universally beloved of all Burning Man's artists.

While this is purely my own interpretation—my personal mythology culled from sixteen years of playa fires, if you like—for me, the Man (which has steadily been growing taller and grander throughout the years) represents our human technological ego, the bright and shiny hope that our consumer-industrial society is so infatuated with that we put it up on a pedestal, even though we know that this is the very same Pandoran technology that now threatens to kill all life on this planet. By contrast, the Temple represents our universal longing for a reconnection with a timeless Source—something older than *Homo sapiens* and our clever technology—and for a sincere and

believable spiritual element to human life. The Man was conceived of intellectually, even as an artistic expression of release and redemption, while the Temple evolved out of the spiritual needs of the Burner nation, out of the very playa dust itself. For me, that distinction is significant.

In 2008, an installation artist called Shrine On (Brent Allen Spears, 1964–; http://shrineon.com) continued the original Burner tradition of using recycled material to build Basura Sagrada Temple in collaboration with Tucker Teutsch. Shrine has created numerous other smaller temples and shrines (and an art car) in his unique recycled paint-and-bottle-cap style at Burning Man throughout the years, while his temples/installations (sometimes used as stages) have been a fixture at transformational festivals on numerous continents for the past decade, appearing at BOOM!, Lightning in a Bottle, Symbiosis, Coachella, and many others over his three-decade-long career. (Shrine is also the original artist who designed the interiors of the House of Blues on Sunset Strip and in New Orleans.) Shrine's temple-stage at the 2009 Angel Falls Symbiosis, and his installation the following year at the 2010 BOOM! festival—the Golden Shack Gamelatron, a musical temple with Taylor Kuffner—remain particularly memorable for that era.

Along with allowing for the creation of art cars, or mutant vehicles, as they are known—motorized vehicles "mutated" sufficiently to look like art—the unique, virtually completely flat canvas of Black Rock Desert has proven to be a boon for large-scale metal sculpture artists. Burning Man art installations differ from many in the world in that they are often designed to be interactive, with no boundaries between the art and the observer. People climbing around on the unique surrealist sculptures of Burning Man set in the alien environment of the pancake-flat gray desert is one of Burning Man's most defining features, and while there are far more examples than I have time to list here—yet another a full book could be written about more than twenty years of Burning Man sculpture—the following sculptors deserve special mention, both for the originality of their contributions and the length of time of their commitment.

Burning Man's Mutant Vehicles

One of Burning Man's most unique artistic contributions is its art cars, or mutant vehicles, as they are known. Originally appearing on the playa in the mid-1990s even before the innovation of the horseshoe design of the streets of Black Rock City in 1997, mutant vehicles are motorized vehicles—cars, trucks, buses, and larger—that have been converted to look like a piece of movable art. These art cars are the only motorized vehicles allowed on the playa—the desert surrounding Black Rock City—or on the streets of Black Rock City during the event. (Bicycles and walking are the main method of transportation.)

The first art car at Burning Man was a UFO, and in the two decades that have followed, memorable large-scale pirate ships (La Contessa), dragons (Draca, Abraxas), a giant whale, and even a giant mirror-balled rubber duck, along with numerous ingenious smaller craft, have transported thousands of people around the playa. Since my own major contribution as a Burning Man installation artist was the conception, construction, and captaining of one of these art cars between 2005 and 2014, I will quickly outline that mutant vehicle's history.

While I call New Orleans home, in 2005 I was fortunately at Burning Man the week when Hurricane Katrina hit. At that point I was already planning on building an art car based on a New Orleans trolley-car—to be called An ArtCar Named Desire—but then the massive devastation of New Orleans and the widespread talk that the city was finished, led to the idea of creating something more spectacular, and thus to the building of the Lady Sassafras, an art car that is based on a Mississippi riverboat.

Built over a period of two years in a warehouse in New Orleans, the Lady Sassafras is built around a 1988 Chevrolet school bus that had been used as a Hurricane Katrina supply vehicle. The bus was purchased on eBay, and approximately 60 percent of the steel used in the outer structure was salvaged from the streets of New Orleans after Katrina. (I returned to New Orleans from Burning Man almost

immediately. Most of the steel came from twisted industrial shelving that was thrown out of warehouses, although the two main beams in the main deck are from a historic local fish market.)

The original engineer on the project, Mick Vovers, was a former oil-rig engineer turned photographer-and-artist from Australia who had never been to Burning Man (and still never has) and who quit the project halfway through because of escalating costs and increasing arguments over the design. (Mick sensibly kept advocating for lighter weight, while I more knowingly kept insisting that everything had to be strong enough for people to climb on. Every Burn, when dozens of people have clambered onto the top, third-story deck of the Lady Sassafras, I remember our final argument about its construction!) My next welder, Victor Small, was (fortunately for me) a die-hard old-school DPW* kind of Burner who taught me the importance of recycling and not wasting anything if possible, and who fortunately understood the unique demands of operating a mutant vehicle on the playa and played a major part in helping me finish the project.

To get the Lady Sassafras to Burning Man for the first time in 2008, I then drove the bus from New Orleans to Reno—over 2500 miles— then flew back to New Orleans and made the same trip in a Toyota Tundra with a fully loaded tandem trailer, at the height of gas prices ($4 a gallon.) I'm pretty sure I am the only person who has ever driven from New Orleans to Burning Man twice in the same year. The Lady Sassafras had been built in sections (it was too tall to put it all together in the warehouse we were in), and there was considerable debate over whether or not the material I wanted to skin the bow and sides of the boat with—an aluminum roofing foil—would work or not (fortunately it did), so the final construction of the "boat" herself on the playa was a

*DPW—Department of Public Works—refers to the long-term volunteers that spend months on the playa before and after laying out the city in the desert and then cleaning it up again.

major undertaking, with more than thirty friends of mine from all over the world joining my small crew to help us put it together. (I am lucky I have some very talented friends.)

When it was finished, the Lady Sassafras did indeed closely resemble a three-deck Mississippi riverboat, complete with pilot's cabin, twin stacks that shoot flames, and a paddle-wheel. Capable of transporting over seventy people, it has a bar, a DJ cabin, and 10,000-watt sound system, and—its most popular feature—a life-sized mermaid on the bow who shoots tequila out of her nipples, created by the master New Orleans Mardi Gras float designer (and longtime Burning Man artist) Richard Valerdie (Royal Artists). During its eight years at Burning Man the Lady Sassafras ferried thousands of passengers—friends and strangers—across the playa, while in its years as FractalNation's art car, the majority of the world's visionary artists, including Alex and Allyson Grey and the organizers of BOOM! have watched the various major Burns from the vantage of its high decks.

In the first decade of Burning Man in Black Rock Desert, the Argentinian-born Bay Area sculptor, performance artist, and filmmaker Pepe Ozan (1939–2013) was perhaps its most important independent artist. Ozan had been creating innovative steel-and-mud chimney fire sculptures in Black Rock Desert since the late eighties, and in 1993 he created the first of these sculptures after the arrival of Burning Man. Impressed by the spontaneous performance that had occurred around the sculpture, Ozan then began planning increasingly elaborate ritual-art performances that became known as the Opera. His sculptures were designed as the stage and as integral components of the performance, and then were burned to the ground at its dramatic climax.

By 1996, these Operas involved up to two hundred participants and thirty musicians, and were considered the most significant event other than the burning of the Man. Ozan's operas and sculptures continued until 2002, making them very much a bridge between the lawless mid-nineties era of Burning Man and its more recognizable art-and-performance-rich form of the twenty-first century, while his

1998 sculpture/opera titled The *Temple of Rudra* was a precursor to David Best's later temples.

In recognition of Ozan's contribution to Burning Man, the Burning Man Art Foundation commissioned him in 2005 to create *The Dreamer* as part of its theme. Psyche—the resulting surrealistic half-submerged purple head—had an entry into the inside where neurons and biological matter dangled. With support from the Black Rock Arts Foundation and the James Irvine Foundation, *The Dreamer* was later exhibited from May to November 2007 in Golden Gate Park in San Francisco. Pepe Ozan's death in 2013 marked one of the first losses of a major Burning Man artist.

After the sublime example of David Best's exquisite Temples, Michael Christian (http://michaelchristian.com), a Texas-born metal sculptor who moved to the Bay Area in 1995, has consistently been my personal favorite Burning Man artist. For numerous years I have been astounded to discover some wild visionary sculpture after dawn, only to find out later it's a Michael Christian. This occurrence has been so frequent that I now almost immediately assume that the coolest mid-to-large-sized metal sculpture I see each year is one his creations. Like in any genre, after a number of years you begin to recognize an artist's style, but I would have to say that Michael Christian is notable in the diversity of his remarkable creativity.

Since he first attended Burning Man in 1997, Christian has created some of the playa's most iconic and memorable metal sculptures, including *Orbit* (1999), *Koilos* (2007), *Canelaphyte* (2011), *ePod* (2014), *Keynote* (2009), the much-loved light-filled rotating globe *Home* (2010), and the spectacular *Brainchild* (2015), a giant silver baby with an exploded head that you could sit inside. Christian's often kinetic sculptures are sometimes integrated with lights and video, while at other times they are designed for people to climb upon. Because they cannot be burned, these metal sculptures are often displayed at other more accessible festivals—the iconic *Keynote* made it as far as the 2010 BOOM! festival in Portugal—or find permanent homes and become public art. As a recognition of his importance as a Burning Man artist,

Christian's sculpture *Flock* (2001) was installed in Civic Center Plaza in front of San Francisco's City Hall by the Black Rock Arts Foundation in 2005.

Anything with fire is popular at Burning Man. The Flaming Lotus Girls started as a group of six women and two men in San Francisco in 2000, and over the past fifteen years have evolved into a collective of over a hundred artists of both genders creating large-scale kinetic fire art. Memorable pieces have included at least two of my personal all-time Burning Man favorites, the poignant *Angel of the Apocalypse* (2005) and the 168-foot-long *Serpent Mother* (2006), as well as the mesmerizing *Soma* (2009), a monumental representation of a neuron. These sculptures have also appeared at other festivals, like Electric Daisy Carnival, or have become public art.

Marco Cochrane (1962–; www.marcocochranesculpture.net), an American sculptor born in Italy, debuted *Bliss Dance* in 2010. The first of his trilogy of sculptures of singer and dancer Deja Solis, the elegant 40-foot-high statue of a naked woman striking a pose, replete with LED wires that illuminated the sculpture at night in changing colors, was an instant Burning Man classic. The 55-foot *Truth Is Beauty* followed in 2013, and *R-Evolution* in 2015. *Bliss Dance* later found a home on Treasure Island in San Francisco, before being moved to Las Vegas in 2016.

Art has also been the most powerful tool for building Burning Man community outside of Burning Man itself. In 2011, Burning Man introduced the CORE—Circle of Regional Effigies—project. Each Burning Man region in the United States and internationally was encouraged to create a unique sculpture to burn each year. The sculptures are arranged in a ring around the Man and were burned simultaneously on the Thursday night of the event. Giving participants in far-flung areas around the globe the opportunity to contribute to the building of a piece of art that would be later transported and burned at Burning Man considerably increased Burner community activities in numerous regions, with virtually every major American city having some kind a Burner community by now. The fact that Burning Man

now sells out the 70,000 tickets available each year has also resulted in an increase in importance in regional Burns, where effigies are created and burned along with other art, just the same as Burning Man. Some of these regionals are in fact now larger than Burning Man was for over the first decade.

25

PERFORMANCE ART AND PSYCHEDELIC CULTURE

[In] Reflections from Damaged Life, curator Lars Bang Larsen explores the connections between psychedelia and post-war art [. . . and] points out that one reason psychedelia has never been institutionally inscribed in art-historical terms may be that the artists themselves have resisted the "psychedelic," label feeling uncomfortable with the rapidity of which the term was commercialised. Yet the same artists, locating the site of creative production in the human nervous system, continued to investigate altered states while resisting reductive labels that they felt had sought to anaesthetise the manifest strangeness their work seeks to explore. In actuality, it appears psychedelia is a current that manifests across a variety of disciplines and aesthetics. Its visibility in the art world is as diverse, elusive and indefinable as the experience itself.

STUART HEANEY, "AVANT-GARDE HALLUCINOGENS: THE POETICS OF PSYCHEDELIC PERCEPTION IN MOVING IMAGE ART"

Burning Man and this new American psychedelic culture were of course not born out of nothing; its counterculture roots can be tracked back to the Beat Generation and all through the psychedelic

sixties, before they twist and turn through the mid-1970s and early 1980s, when New York, Southern California, New Orleans, Austin, Boulder, and especially San Francisco, were all homes to a significant, vibrant, underground culture that was often influenced as much by punk rock as it was by the sixties psychedelic culture. From the original Acid Tests onward, numerous groups and collectives emerged that would blur the line between music, performance, and art, as well as the line between the audience and the performer, setting the stage for the eventual arrival of Burning Man decades later.

Performance art has always played a prominent role in psychedelic culture. Performance and ritual played a large part in the revelations of the Greek Eleusinian Mysteries, while in more modern times, Aleister Crowley is known to have served peyote (and opium) in beverages to the audiences of his ritual performances as early as the 1920s. In the 1940s, the flamboyant performer Lord Buckley had a "club" called the Church of the Living Swing that held mescaline parties on yachts in San Francisco Bay. And during the formative years of the psychedelic sixties, Ken Kesey and his Merry Pranksters were a 24-hour-a-day-7-day-a-week piece of living performance art. Their central belief, propounded by Ken Kesey, was that they were all living in a movie (which they then attempted to), while their Acid Tests were an early attempt at erasing the boundary between the artist and the performer, and were the main precursor for the eventual evolution of Burning Man.

The political antics of dadaism and the radical performance philosophy of the Fluxus movement and the German artist and sculptor Joseph Beuys had a profound influence on experimental Haight-Ashbury communes like the Diggers, who used "street theater, anarcho-direct action, and art happenings in their social agenda of creating a Free City" (www.Diggers.org), and a decade later, on a young Alex Grey, who initially rejected painting after art school and started his career as a highly controversial performance artist. Alex and Allyson continue to conceive and direct performance-art pieces as a part of their lifelong artistic process. Works include *The Goddess* [1989], where the pair laid out 5500 apples in the shape of a goddess in the Lincoln Center Plaza in New

York, and Allyson sat in the center nursing their daughter Zena, while Alex performed one hundred prostrations at the goddess's feet. More recently, the Grey's "live-painting" on stage with electronic producers and bands can be seen as yet another evolution of their lifelong love of performance art.

The Cockettes' *Tricia's Wedding* (1971) and Willoughby Sharp's *Cough Up* (1975) are two early examples of cybernetics integrated with performance and psychedelics. Shown on a loop via CRT monitors with headphones, these were film and video works that captured performance as a process of transformation; both works reward patient viewing with cathartic payoffs.

The Cockettes were a drag theater troupe that used LSD as a vehicle to disrupt gender boundaries and to confound social conditioning. *Tricia's Wedding* is a wickedly accurate parody in drag that imitated a gossip-column television report of the actual whiter-than-white wedding of President Nixon's daughter to a high-flying Harvard lawyer. In the denouement, the proceedings are disrupted by an errant guest (a drag caricature of Eartha Kitt) who instigates an orgy by spiking the fruit punch with LSD.

The Cockettes used psychedelic substances as a catalyst in search of new forms of human agency by means of extrahuman states of perception. To ingest a hallucinogen is to open an orifice through which a multiplicity of otherness is allowed to penetrate. Neşe Devenot detected these parallels between psychedelic studies and queer theory in referring to the process of taking hallucinogenic substances as a "queering of consciousness" (Devenot, "A Declaration of Psychedelic Studies," 186). In other words, to trip is to deviate from the dominant norms. This strategy is intended to disrupt the normal continuity of performance and, by doing so, it not only affects the sensorium of the performer but also impacts the viewer.

Queering consciousness was also central to Willoughby Sharp's video performances, which collapsed the distance between events in his own nervous system and events in the performance space as mediated by the video platform. An early adopter of amateur video formats for artistic

purposes, Sharp used the potential of video to transmit images simultaneously into practice. He performed, usually on LSD, in front of a video camera in a separate part of the gallery while the audience watched his performance on a CRT monitor in an adjacent room. Like the Cockettes, Sharp used acid as a catalyst to collapse the boundaries between performance and spectatorship toward a spontaneous moment, during which a heightened sense of the real breaks through the artifice of performance and the act of performing *becomes* a shared reality for both viewer and performer (edited from Heaney, "Avant-Garde Hallucinogens").

After 1986, an experimental noise-postindustrial group heavy on percussion called Crash Worship or ADRV (Adoración de Rotura Violenta) started by Marcus Wolff and Simon Cheffins would take this concept of a spontaneous shared moment of reality on a wild twelve year tour. Originally a studio project, the band discovered that their live shows—featuring up to three drummers hammering out concussive polyrhythms to abstract mutated guitar, hobbit slayer, synthesizers, DIY effects, trombone, and dueling vocalists—were capable of bringing their audiences to the point of ecstatic chaos. According to Wikipedia:

> During performances, the band's members (or often provocateurs) would manipulate the crowd, involving them more deeply into the show, ultimately eliminating any boundaries between spectator and performer. The musicians would also mobilize their instruments on and off the stage into the middle of the audience (or outside), lighting explosives and hosing down the crowd with various liquids creating an atmosphere of celebratory abandon and mirth. Strobe lights, nudity, mysterious liquids, sex and smoke filled rooms (at next to zero visibility) were all a part of the average show. The chaos of these events often invited unwanted attention from police who would later forcibly shut down a large percentage of the band's performances. (Wikipedia, "Crash Worship")

During the early to mid-nineties, these heavily costumed and quasi-ritualistic Crash Worship shows had developed to the point of resem-

bling some kind of a primal Dionysian rite in which audience members were driven to the point of losing normal control—so much so that Crash Worship's provocateurs were often accused of spraying drugs on the crowd. (Which wasn't true—Crash Worship would never waste its drugs on the crowd.) A Crash Worship show was also an important node for the nascent early-nineties tribal culture, since when Crash Worship came to town, all the local underground culture made a point of coming out, with local fire and aerial performers and so on being encouraged to participate in the show. (Trevor Moontribe, one of the original American psytrance DJs, told me he opened for Crash Worship.) Before Burning Man introduced this techno-tribal culture to the greater world, a Crash Worship show was the first place where you ever experienced fire performers, half-naked aerialists, people with face and full-body tattoos, surgically implanted fangs and horns, and the emerging steampunk style—many of the things we today associate with urban tribal culture. (Crash Worship was categorized as "tribal-industrial" when Burning Man was still at Baker Beach, even though they thoroughly disliked the term.)

Here is how one Crash Worship spectator remembers these unique events:

> Oh, those live shows. A Crash Worship concert might begin with the band entering the venue from the street, pushing its way through the audience with mobile drum kits and fire dancers, then assaulting the spectators with strobe lights, fake (or possibly real) blood, wine, whipped cream, ice cubes, smoke, green Jello, small fireworks and god knows what else [. . .] rubbing various viscous substances on the half-naked bodies of any willing (or sometimes unwilling) participants. People got naked, people got dirty, people got injured. Mostly, the barriers between audience and performer broke down to the point where nearly everyone there felt like they were not so much at a show as participating in some kind of ancient ritual. "I reverted to a PRIMAL state," is how one witness described it. [. . .] a Crash Worship show was a totally unique experience. (The Weirdest Band

in the World, "Crash Worship," "https://weirdestbandintheworld
.com/2010/10/16)

Following two successful tours of Europe in the mid-nineties, Crash
Worship was at the height of their notoriety in America; they were
also—in the minds of management, record labels, and club owners—
unmanageable, and were eventually banned from playing in most major
club venues despite their popularity. This in turn only increased their
underground reputation; Crash Worship shows in this period often
took place in junkyards, abandoned warehouses, and memorably in the
Aztlan Theatre, the abandoned Los Angeles County Jail.

By the late nineties, internal conflict within the always tumultu-
ous band, along with the tremendous difficulty of organizing tours,
led to the final demise of what was perhaps America's most influential
"unknown" band; four shows were performed in San Francisco with
the legendary Master Musicians of Jajouka from Morocco before the
final Crash Worship show was held in their hometown of San Diego on
October 24, 1999.

Although many of the members of the band attended Burning Man
during the nineties, and elements of Pepe Ozan's Burning Man Operas
were greatly reminiscent of a Crash Worship show, Crash Worship itself
never performed at Burning Man, mostly because of the resistance of
one of the band's key leaders, the often hermetic JXL. Having been
on the road with the band during this period, and having had many
conversations with JXL—traveling with Crash Worship was how I first
heard about Burning Man—it is this author's belief that he was intent
on never confusing the two phenomena. Today, if you ask people who
attended both the early days of Burning Man and a Crash Worship
show, most will tell you that Crash Worship was the more primal
experience.

After the band's split, Crash Worship's cofounder Simon Cheffins
formed the popular Bay Area act The Extra Action Marching Band
in late 1999, who would be perennial anarchistic favorites at Burning
Man throughout the early 2000s, Cheffins was also the mastermind

behind the creation of La Contessa in 2001—a one-third-sized replica of a Spanish galleon that is Burning Man's most iconic art car. Almost as uncontrollable as Crash Worship, La Contessa only spent three years at Burning Man before it was banned, and later torched by an irate landowner.

In San Francisco, from the mid-1980s onward, a group known as Anon Salon—Joegh Bullock, Marci Crosby, and Mark Petrakis—were among the most active proponents of creating "artful community." They founded Climate Theater, a "boutique theatre-laboratory" in the heart of San Francisco that over the following thirty years would become arguably the most important small theater in the Bay Area. According to theater critic Rob Avila, "So much sprang from the Climate's operation in the 1980s and '90s that the outfit was soon labeled 'the biggest little theater in San Francisco.'" Anon Salon also organized the Glashaus Parties that would serve as "the Studio 54 for the first dotcom boom," and masterminded the Cobra Lounge vaudevilles. These circus- and burlesque-inspired vaudevilles would have a huge effect on the both the emerging steampunk style, and the early San Francisco Burning Man community of which Anon Salon was among the earliest proponents.

In 2001 the Anon Salon founders launched "The Sea of Dreams," an annual New Year's Eve party whose "founding spirit was consistently rooted in a triangulation of the visual, performative and musical arts and always with an eye to reaching out to other forward-thinking individuals and collectives." These Sea of Dreams events, which featured visionary art galleries and live painting, would be an important early venue for the new generation of emerging visionary artists.

Perry Farrell, the charismatic frontman for the cult prog-rock band Jane's Addiction, became one of the most influential counterculture figures of the 1990s by creating the Lollapalooza festival, which featured prog-rock, hip-hop, and electronic acts. A constant cultural innovator, Farrell also created the Enit Festival in 1995, which was billed as "an inter-planetary festival celebrating cosmic peace and sexuality," and was conceived as a traveling Lollapalooza afterparty. Designed to be

held outdoors, it consisted of multiple stages as well as several "rooms." According to Wikipedia, "Each room would explore different realms, such as a room each for sexuality, psychedelia, and art. In the room for sexuality, there would often be painted naked or half-naked women walking around or dancing under neon lights and heavy electronic music. As for the psychedelic and art rooms there would be paintings or still-models posing in a room reminiscent of an acid trip [. . .] At one point in the night, Farrell and a local conservationist group would hold a tree planting ceremony that everyone attending could join in giving back to the earth. Enit also provided a free vegetarian meal to all attendees." The same Wikipedia article also notes that the Enit Festival was an "unstable and unstructured event" that was poorly promoted and probably ahead of its time—Farrell dropped the concept after 1996 because of high production costs and a massive drop in attendance (Wikipedia, "Enit Festival").

By the early '90s, rave culture was becoming well-established in the United States. In Los Angeles, Pasquale Rotella was throwing the first events for what is now known as Insomniac Productions, the largest EDM-festival producer in the United States. In 1997, the first Electric Daisyland Carnival (EDC) was held in the Shrine Expo Hall in Los Angeles. Now held annually in Las Vegas, EDC is the largest EDM festival in the nation and one of the largest in the world: 400,000 people attended the three-day event in 2015. Although considered a mainstream festival, Electric Daisyland Carnival, which has one of the highest production budgets of any festival in the world, has increasingly drawn on the visionary art talent from the transformational festival circuit for stages, performance, and other psychedelic environments.

In 1993, a group who called themselves Moontribe began holding some of the first U.S. psytrance parties in the desert on every full moon—a tradition that, remarkably, still continues some twenty-three years later. Moontribe would be one of the groups first responsible for bringing large-scale sound systems to Burning Man. In the first era of Burning Man, there was considerable tension between the artists and the "ravers," as they were known—Sound Camp and the Burning Man

were originally several miles apart before the design for Black Rock City was first implemented in 1997. After a brief period in the late 1990s, when famous early EDM producers such as Goa-Trance originator Goa Gil and famous English EDM producers such as Sasha (ranked the world's number-one DJ in 2000) appeared on the playa, the Burning Man organization quietly discouraged the participation of such well-known foreign DJs, not wanting the festival to become known as a music event.

This resulted in a unique Burning Man musical culture that helped kickstart the careers of West Coast EDM producers such as David Starfire, Adam Ohana (now known as An-Ten-Nae), Random Rab, and most famously, Lorin Ashton, better known as Bassnectar. By favoring local (mostly West Coast) EDM producers, this ultimately created a unique, bass-heavy, Burner-specific genre when compared to the European psytrance festivals. Although psytrance was briefly popular in the American electronic music community, West Coast producers tended to favor music with fewer beats per minute than their European counterparts, which led to the creation of a number of alternative genres, including Dubstep.

Live performance has always been an integral part of Burning Man culture; along with the rise in popularity of local EDM producers came more opportunities for performers to appear on stage. By the end of the 1990s, there were art-performance collectives of all descriptions emerging up and down the West Coast, many inspired by the possibilities of an annual migration to Burning Man.

In 1996, a group of puppeteers and artists opened CELLspace, which would become one of San Francisco's major underground hubs until it closed in 2015. CELLspace was the home to the Yoga Tai Chi Collective and the Mystic Family Circus in the late nineties, and most recently to the Vau de Vire Society, who today continue the vaudeville-circus tradition with a big-top tent at Symbiosis Gathering, and at its annual Edwardian Ball.

El Circo, a group out of Ashland, Oregon, erected a large dome at Burning Man from the late nineties onward that hosted some of the

playa's best electronic music and performances, including its annual Burning Man designer fashion show, conceived by El Circo cofounder Tiffa Novoa, a clothing designer with strong ties to the Oregon Country Fair and a love of "fairy fashion." In their last year on the playa (2009), El Circo was co-produced by the Do Lab, founders of the Lightning in a Bottle festival.

Another early fire-dance-and-performance troupe that was heavily fashion orientated was Astara (led by Shawna Hoffman) from the Bay Area, which focused on different cultures from around the planet; as the tribal fashions from Burning Man also emerged into the outside world, the Burning Man inspired fashion shows became increasingly popular off playa.

Opulent Temple, which would go on to host some of the largest names in EDM at Burning Man, was founded in 2003. The creation of large art-sound-and-performance camps at Burning Man also led to the tradition of annual fundraising events first in San Francisco and Los Angeles, and then later as far off as New York, Miami, and Philadelphia. These off-playa fundraisers would often create a similar environment to their Burning Man camps—thus helping introduce Burning Man culture, with its associated fashion, music, and visionary art to the outside world, as well as attracting even more people to experience Burning Man itself.

26

THE BIRTH OF TRANSFORMATIONAL FESTIVALS AND VISIONARY CULTURE

Methods of mind expansion have been influencing art since the beginning of human time. The period studied by my book is unique as far as I know in that it is the first time ever that radically consciousness-altering drugs were available to and consumed by millions in an industrial society. Why did this happen? Because, I think, psychedelia was an answer to the spiritual yearnings of a population that could no longer find solace in established religions and science. Psychedelia and Divine Mind are live, Gnostic myths that continue to inspire seekers of all kinds, artists included.

INTERVIEW WITH KEN JORDAN,
AUTHOR OF *ARE YOU EXPERIENCED?*

B y the early 2000s this nascent Burning Man culture had become so popular it began to have an effect on the still relatively small North American festival circuit.

Between 2000 and 2003, a Los Angeles group of artists and

promoters held a private birthday party on Memorial Day weekend. In 2004, the event was opened to the public for the first time as an annual camping festival called Lightning in a Bottle (LIB) by the DoLab.

In 2005 and 2006 the DoLab brought a notable piece of mobile art to Burning Man. Created by Patrick Shearn and Abundant Sugar, it was a massive fiber-optic flower that went up and down on a cherry-picker and helped establish their artistic reputation. In 2009 the DoLab collaborated with the legendary El Circo on their final year at Burning Man, and in 2011, they contributed a major installation in front of the visionary art collective FractalNation.

In 2003, Emerg+N+See was first held in Oregon, and in 2005, the first Symbiosis Gathering was held in Northern California. All three of these U.S. festivals shared the same Burning Man–inspired meme of an ecofriendly, "leave no trace" ethos, electronic music, psychedelic art, and education festivals. In 2004, Shambala, a family-run electronic-music festival near Nelson, British Columbia, which had been operating since 1998, also introduced a psychedelic art gallery event for the first time. Like the Oregon Country Fair, Shambala is unusual in North America for actually owning the land that the festival operates on, and has been able to build permanent structures and add to its considerable infrastructure each year.

All four of these festivals have pushed the boundaries of psychedelic stage design in North America, and the development of these sculptured stages on which the (mostly) electronic acts perform has played a large part of the visual appeal of these transformational festivals. The stages have now become so complex that stage designers are increasingly being recognized as artists themselves, such as the eco-friendly designs of Gerad Minakawa and his team at Bamboo DNA, or the alien like designs of Adam Christophe and Jamie Valentine of Symbiotic Creations. Established artists such as Shrine On, Carey Thompson, Android Jones, Xavi, and Michael Divine are sometimes also commissioned to design stages at major festivals or at Burning Man.

This period produced an early golden age at the end of the first decade of the twenty-first century, which included the last LIB at the

lush Live Oak Fairground in Santa Barbara in 2008, and the 2009 Symbiosis Gathering at Angel Falls camp just outside of Yosemite. At this point, the still relatively unknown festivals themselves had grown to around 5000–8000 people, and the concept of visionary art was being embraced with little thought of the events actually being commercially successful. This youthful idealism led to some truly phenomenal stages at these events, built with a complexity whose like I doubt will ever be seen at such small festivals again, along with a full turnout by the mostly Californian psychedelic community.

This period is particularly memorable for me thanks to live performances by acts like the Oakland-based performance troupe The Yard Dogs Road Show, a burlesque-and-circus show whose backing band was headed by a pair of talented musicians, the guitar wizard Eenor and a prolific drummer called Tommy Cappel,*who were the cutting edge of the underground vaudeville-circus style† that evolved in San Francisco out of the Anon Salon era, or Portland's MarchFourth Marching Band, whose high-energy, horn-driven act included stilt walkers and circus performers.

At that time the Burning Man scene was still localized enough—the term *transformational festival* hadn't really caught on yet—that pretty much everybody still knew each other, or were connected by one or two degrees of separation at most. So when a Bay Area act as integral as The Yard Dogs played, the stage designers, costume designers, light crews, the performers, and even the audience were all intimately aware of each other—friends, lovers, family, fellow performers, designers, artists—and

*The incredibly talented drummer Tommy Cappel was also a drummer in the previously mentioned Extra Action Marching Band, and the last drummer for Crash Worship. He is one of the founders of the highly successful band Beats Antique (along with fellow former Yard Dog Zoey Jakes), a live electronic act that is the best-known proponent of this unique West Coast style.

†Leighton Kelly, the original frontman for The Yard Dogs Road Show, is also one of the cofounders of Five and Diamond clothing store in San Francisco's Mission district, one of the first stores dedicated to the emerging steampunk style. Five and Diamond remains one of the most important outlets for independent designers in San Francisco today.

of the acts that would be appearing on their stages. In a very real sense it was all one big underground psychedelic family, the likes of which had not been seen since the heydays of Californian counterculture in the mid-1960s, and now seemingly reborn with a significant increase in sophistication.

There was a moment while watching the Yard Dog show at Symbiosis in 2009 when I remember having the epiphany of realizing just how integrated everything really was—the performance, the music, the clothes, the stage and setting, the lights, and the crowd, who were dressed as if they should be on the stage—and how, unlike a famous rock act at a normal concert or festival, this was a performance of our tribe, by our tribe, nurtured and conceived and now seamlessly produced and presented all basically for the love of the tribe. Considering both Symbiosis's continuing success, and the reputation of this particular 2009 festival—generally regarded as the greatest transformational festival ever held, if you were lucky enough to have been at it—I suspect that for many of us that long weekend will be our Summer of Love moment.

Lightning in a Bottle, Emerg+N+See, and the Symbiosis Gathering were three of the first West Coast festivals that obviously followed the emerging Burning Man meme of psychedelic art (in all forms), electronic music, and community action. Headlined by the electronic music producers, DJs, and occasional band that were also emerging from the unique Burning Man culture, along with the new abundance of psychedelic art that Burning Man was generating, these festivals also featured sacred areas, yoga, and speaker series, often with psychedelic themes. However, unlike Burning Man, which is in many ways defined by its desert environment, these early festivals were initially held in lush, forested campgrounds. (Ironically, as these festivals have grown larger and larger, they have been driven back into the desert by the authorities—both Lightning in a Bottle and Symbiosis have been held on Indian reservations, historically some of the poorest parts of the United States.) Furthermore, since they were commercial events, they did not operate on a gift economy, but offered integrated (and highly popular) food,

clothing, and art vending areas. Much like the Oregon Country Fair, which preceded and inspired them, these multiday camping festivals become like mini-villages or towns in the forest for the duration of the event.

Despite their lofty intentions, the commercial aspect of these early spinoff festivals created a philosophical conundrum for their organizers. For although they were clearly inspired by the Burning Man meme, and followed many of Burning Man's Ten Principles (such as "Leave no trace"), these festivals were not affiliated or endorsed by the Burning Man organization in anyway, and Burning Man itself—mindful of its mission to develop out past Black Rock Desert and to develop regional and global events—has always been highly protective of its name against misappropriation. The promoters of these new West Coast festivals could not openly call themselves Burning Man festivals, nor could they advertise the art that they were presenting at these festivals as Burning Man art, even if the art had been at Burning Man; while advertising it as psychedelic art invited extra scrutiny from local politicians and law officials alike.

In honor of the tradition of classical Californian social activism that started with groups like the Diggers in the Haight-Ashbury in the mid-1960s, the term *transformational festivals* was created, expounding the idea that an informed and united community is capable of bringing about radical change, and that by attending these festivals you have an opportunity to become an active member of such a community, transforming both yourself and the world in the process. Active participation is encouraged, and there is a spirit of volunteerism that pervades these events, along with a general trust and friendliness associated with counterculture mainstays like Rainbow Gatherings, the Oregon Country Fair, or Burning Man. Meanwhile, taking the term from Alex Grey—with little knowledge or understanding of its convoluted history—the psychedelically inspired art, sculptures, and stages on display became collectively known as visionary art. Within a decade of the introduction of this term, contemporary psychedelic culture in its broadest form has become codified as visionary culture.

By the late 2000s, as attendances at these original festivals swelled rapidly and a number of other, similar festivals started to appear, this rather loose philosophy increasingly became a recognized terminology. At TEDxVancouver in 2010, filmmaker Jeet-Kei Leung presented a rambling TED talk about transformational festivals, discussing their similarities to pagan festivals. Other festivals around the world with similar social philosophies—such as BOOM! in Portugal, Rainbow Serpent (which began in 1997) in Australia, Envision in Costa Rica, and Ozora in Hungary—also began using the term. Transformational festivals are thus (unusually) based on their philosophy—a community-building ethic, and a value system that celebrates life, personal growth, social responsibility, healthy living, and creative expression—rather than on a particular electronic music genre (see Wikipedia, "Transformational festival").

By 2016, Lightning in a Bottle, now in its fifth location, had established itself as the largest of the American transformational festivals (other than Burning Man), with an attendance of over 35,000 people, while the DoLab has become an internationally recognized event-production company, producing spinoff festivals like the Woogie Weekend and the DirtyBird Campout, as well as providing stages and major installations for other festivals like BOOM! in Europe, and the giant American mainstream festival Coachella. The Symbiosis Gathering is now in its eleventh year, and offers a similar experience in Northern California, with a high reputation for its production and curating of both music and art, which exerts a considerable influence over Bay Area underground culture. In 2017, a special Eclipse Festival held in Oregon, a collaboration between Symbiosis Gathering and other international festival producers, attracted over 40,000 attendees. BOOM! and Ozora—Europe's two largest transformational festivals—similarly now draw over 30,000 festival participants. Festival culture has become a genuine twenty-first century social phenomenon. In 2000, there were less than fifty major music festivals in America; in 2015, there were over eight hundred. An estimated 32 million people attended at least one festival in 2014. Around half of these were millennials.

From the late nineties onward, there has been a distinct emergence of a twenty-first century "visionary" culture, complete with its own music, art, and fashion. These increasingly large festivals—Burning Man was attended by 80,000 people in 2016—require an enormous amount of visionary art and performance to create the expected ambience, including sculptured and heavily decorated stages replete with video-projection artists, installation-type sculptures and shrines, the requisite (and highly popular) visionary art galleries of paintings, prints, and smaller sculpture, along with the now-expected sight of artists live-painting on stage to the headlining EDM producer or DJ. The loose term *visionary* is now also applied to many things other than painting, including dance, photography, and theater, since for visionary/ transformational festival culture to expand, it was going to require an army of artists. Fortunately for this emerging culture, there was a significant wave of trained and emerging young artists waiting to arrive.

27

THE INTERDIMENSIONAL ART SHOW AND THE TRIBE 13 COLLECTIVE

You have to be prepared to do something for ten years before anyone will start taking you seriously.

ROBERT VENOSA

While Burning Man culture was rapidly becoming the cutting edge of the psychedelic underground in the Bay Area by the late '90s and early 2000's, in other parts of the country more traditional sixties psychedelic culture had continued on after the death of Jerry Garcia and the cessation of touring for the Grateful Dead.

First started in 1969, the Oregon Country Fair (OCF), outside of Eugene, is one of the remaining mainstays of sixties psychedelic culture. It has been long associated with Ken Kesey, whose family owns a nearby creamery, as well as the Grateful Dead, who played concerts there in 1972 and 1982 to aid in the purchasing of the land that the OCF is on. Over the past thirty-five-plus years the fairgrounds themselves have developed into a fairyland village in the Oregon forest: hundreds of vendors sell hippie arts and crafts, while various stages offer music and performances for this family-friendly event.

Around sunset the fair closes for those not fortunate enough to have a coveted wristband that allows you to stay inside, even though performances continue well into the night, endowing the more private night side of the event with a mythic nature of its own. Along with inviting musicians and performance troupes to participate, the OCF has a long history of commissioning local artists to make outsider installation–type artwork for the event, much of which is illuminated at night. Throughout the 1980s and well into the 1990s, before Burning Man emerged, the Oregon Country Fair and the nomadic annual Rainbow Gatherings were considered the main nodes of psychedelic culture.

More traditional forms and styles of psychedelic art are well represented among the vending booths of the Oregon Country Fair, including glass blowing, stained glass, sculpture, wood, stone, bone carving, and other crafts.

The Northern California artist Mark Henson received a studio art degree in California in 1973 and became a professional artist who works with paint, wood, metal, and computers. Henson's traveling gallery, Sacred Light Studio, is always popular at the Oregon Country Fair and other Renaissance fairs and hippie festivals in California, Oregon, and Washington. Henson's painting style is solidly out of the classic late sixties/early seventies California psychedelic style, occasionally reminiscent of underground comic or poster art while often expressing social themes or an earthy type of erotica, or sometimes both combined. Says Henson about his art:

> While I tend to be a down-to-earth person, when activating my creative energies I begin by looking deeply within myself, and seek to express what I may find waiting there. My sincere wish is to tap into the Divine Source of Being, to Consciousness, to Spirit, or whatever you may call it—that place where existence comes from, and to bring into visual reality images manifesting the knowledge revealed while in this presence. Strangely enough, I have discovered that the more intensely personal my vision is, the more widely it resonates when presented to the world.

I believe that art can have the ability to catalyze positive social and cultural changes. In addition to stimulating our visual cortex, Art has the amazing magical power to evoke profound emotional intensity as well as to provoke intellectual thinking. My aspiration as an artist is to create compelling images of beauty and power that serve to promote our Conscious Evolution as human beings, and to show us how to live in a peaceful world. To this end I like to present images exploring themes of Awakening Consciousness, Divine Sexuality, Political Realities and Living in Harmony with Nature.

In the early 1990s, a young artist called Roman Villagrana moved from California to study at the Art Institute of Seattle, where, along with the more traditional psychedelic culture, he also became heavily involved in the early days of the grunge music scene, creating psychedelic posters and handbills for the bands like Blind Melon and Soundgarden. Rock poster art—which had been mostly dormant since the early seventies— had a mini-resurgence in the mid-eighties to early nineties, ignited by the work of Frank Kozik, who started by creating posters for the punk rock scene in Austin in the early eighties. An entirely self-taught artist, Kozik eventually moved to silk-screening large colorful rock posters that made him internationally known, his poster art being the first recognizable style since the San Francisco artists in the 1970s.

While the grunge music immortalized by Kurt Cobain and Nirvana is generally associated with heroin and opiate use, psychedelics played a large part in the early years of grunge in the late eighties and early nineties, as well as being present in the music and philosophies of the Pixies, the Red Hot Chili Peppers, and Jane's Addiction, three of the largest alternative bands who broke out with hit albums in the 1990s. The alternative-metal band Tool, which formed in Los Angeles in 1990, would be instrumental in bringing Alex Grey to wider fame when they used his artwork on their album covers and in their groundbreaking stage show. The Flaming Lips, another important psychedelic band, famed for its innovative light and stage shows, formed in Oklahoma in 1982. However, arguably the most influential rock band to come out

of this era was the pre-grunge Texan band the Butthole Surfers, who formed in 1981. Famed for their legendarily unruly live shows, the band and their audiences were also legendary consumers of psychedelics, preferably LSD.

Psychedelic culture has never been a blanket affair nationwide. It has only ever been, at its best, a series of active pockets; cities and towns like Detroit, Ann Arbor, Eugene, Austin, Boulder, Telluride, Tucscon, Asheville, and New Orleans all have significant unwritten psychedelic histories, complete with regional music, psychedelic art, traditions, and annual happenings, all their own. Meanwhile, the kind of psychedelics and other drugs that a particular culture or area takes—or to be more accurate, the kind of psychedelic or drug they can get—tends to have an effect on that regional culture's art and mythology.

The most popular drug in the Northwest is cannabis: 1991 marked the first year of the Seattle Hempfest, a gathering dedicated to the decriminalization of cannabis that would grow over the next fifteen years into a three-day annual political rally, concert, and arts and crafts fair with attendance typically over 100,000. Roman Villagrana contributed early Hempfest posters. Art is political for Roman Villagrana just as much as it is spiritual, and in his view, the best kind of art is art for a purpose, such as the Conscious Alliance, a 2000 event with which Roman was involved and in which artists donated art to be sold to buy food for the needy.

Oregon and the Northwest is also major magic-mushroom country. Favored by many hippies for their natural origin and shorter duration, magic mushrooms also tend to provide a more visual high than LSD, and are capable of creating fields of psychedelic imagery behind closed eyes or in a darkened room. The head shops of the Pacific Northwest are to this day filled with this colorful shroomy imagery.

Wherever magic mushrooms were in the 1990s, Terence McKenna—either through his name, or a book, or in person—also appeared, and anywhere Terence was in the nineties, talk of the end of the Mayan Calendar in 2012 wasn't far behind. From the date of the publication of his magnum opus *Food of the Gods* in 1993, the

approaching 2012 end-of-time date increasingly occupied the imagination of psychedelic culture. With Terence's unexpected death in 2000, that trend only intensified. During the late 1990s Villagrana was creating posters for the cult band Tribe Sector Nine that mined all these contemporary psychedelic themes, and was an early innovator of painting live on stage with the band. Traveling in a biofueled vehicle with his young wife, Jennifer Ingram, Roman sold prints, T-shirts, and stickers of his "Intergalactic Art," preaching the need for a "conscious healing art movement along with ecological production methods."

By 2003, with two children to support, Roman realized that the nomadic art-selling life would no longer suffice. There was also a sense, a few short years after Terence McKenna's AllChemical Convention and then sudden death and with the 2012 date only drawing closer, that both psychedelics and psychedelic art were gaining momentum again. With help from some like-minded sponsors, Villagrana and Ingram opened their first gallery in Seattle in 2003. Having traveled the length and breadth of North America selling Villagrana's art, the pair had met other artists who were similarly psychedelically inclined, and invited them to participate in the opening of their new gallery, an event they were calling the First InterDimensional Art Group Show.

Although Villagrana and Ingram had no experience in running a gallery and had never held a group show, one of their sponsors put a full-page $5000 ad in *Juxtapoz* magazine, and on the opening night, 1800 people showed up, including Robert Venosa and Martina Hoffmann, who had never met any of the West Coast artists before, but whom Villagrana had urged to participate. Out of a combination of blind faith, chaos, and an unwavering belief in the power of psychedelic art, the collective of artists that would soon become known as Tribe 13 was born.

Along with Alex and Allyson Grey, the Tribe 13 collective of artists (which included Venosa and Hoffmann as mentors) would largely be responsible for creating a contemporary narrative that has convincingly separated visionary art from the psychedelic art of the 1960s.

The same year, 2003, also saw the dismantling of Kansas silo LSD laboratory, and the start of the major acid drought that followed.

Again, the inevitable result of prohibition is diversification, and once again Terence McKenna was the sage who had pointed the way; for while LSD was largely responsible for the psychedelic art of 1960s,* the visionary art of the twenty-first century has largely been influenced by DMT and its natural analogue, ayahuasca.

DMT has a reputation for being far more visual a drug than LSD; short-acting, the visions can actually overwhelm the voyager, especially in a darkened room. DMT is a truly visionary drug—the user can experience other dimensions, other planets, Hindu or Egyptian gods, or aliens as clichéd as little green men. With fantastic interdimensional beings, sacred geometry, and a fascination with the impending 2012 date, this new generation of psychedelic artists raised on Terence McKenna's words now began to paint the realms that he had so lovingly described.

Sharing Roman Villagrana's keen fascination with alien visitations and ancient civilizations, along with a deep resonance with the "Universal Feminine," the German-born painter and sculptor Martina Hoffmann (www.martinahoffmann.com), Robert Venosa's partner, is a very fine Fantastic-Realism painter in her own right, who helped teach Venosa's workshops on his modified *mischtechnik* (he replaced the tempera base, which is difficult to work with, with casein) for close to thirty years. Since the loss of Venosa in 2011, and her mother more recently, Hoffmann's work appears to have acquired a new weight and depth, as evident in the remarkable *Universal Mother* (2015). Hoffmann's mission statement offers "the visionary artist makes visible the more subtle and intuitive states of our existence and creates maps and symbols reflecting consciousness and the mystical experience. My work is an attempt to portray Source Energy as the one universal force beyond the confines of cultural and religious differences."

*Or was it? DMT was around in the 1960s, it was just less common and had a heavy reputation. However, much of the poster art could just as easily have been influenced by DMT—visual artists being the ones who would have been most attracted to it, and with their prominence in the San Francisco underground, undoubtedly would have had access to it.

While she and Venosa were the only Tribe 13 artists who had actually known Terence McKenna, it is Carey Thompson and Luke Brown who are arguably the two most influenced by his legacy.

Carey Thompson (www.galactivation.com) is originally from Virginia and North Carolina, and spent a number of years after college in Mexico and Central America exploring the art and cosmology of ancient Mesoamerican sites before returning to the United States. He first became noticed in 1998 when he was asked to create a poster for the Southern rock jam band Widespread Panic for their Atlanta New Year's Eve show, and later produced posters for Sound Tribe, Sector Nine, and the String Cheese Incident, amongst others.

From this New Year's Eve show in the late nineties, the concept of the "Galactivation" was born—a series of closed-door, psychedelically inspired art retreats that were later realized in California after Thompson himself moved to San Francisco. An avid Terence McKenna fan (his son is named McKenna), Carey was one of the first artists to begin weaving the impending 2012 date first into his paintings and Burning Man installations and, over the past decade, in his sculptural exploration of highly popular large-scale Portal forms that offer a gateway to transformation.

Five years later, on New Year's Eve in 2003, when Carey Thompson was painting at an early Sea of Dreams event, he met Luke Brown, a Canadian tattoo artist who was becoming well-known for his early use of digital art. Carey showed Luke a sketch of a drawing he was working on, to which Luke replied, somewhat surprised, that he had had exactly that vision just the weekend before on peyote and had intended to start drawing it, but since Carey already had, he now would not need to. And so two of the most influential visionary artists of their generation met and began an artistic brotherhood that has lasted well over a decade.

Synchronicity is very much a psychedelic phenomenon. Psychedelic environments such as BOOM! and Burning Man are noted for the amount of synchronicity that occurs within their boundaries. Stanislav Grof, one of the most respected scholars of psychedelics, devoted an entire chapter to synchronicity in his autobiography, *When the*

Impossible Happens, while in *Tryptamine Palace* I make numerous mentions of the notable increase in synchronicity after my first 5-MeO-DMT experience—I often like to say that synchronicity is the universe betraying its intention. Roman Villagrana also goes by Synchromystic. But when it comes to psychedelic synchronicities, few people can claim to have experienced them with the regularity of Luke Brown.

Born in Canada and now a resident of Bali, Luke Brown was a punk skateboarder kid when he took his first hit of acid. Somewhere in the middle of the trip, he took up a pen and paper and started drawing, and since that time he has never stopped making art. Initially a talented tattoo artist close to covered in tattoos himself, Brown uses his own body as his ultimate canvas. But he became tired of the strain on his body from tattooing around the same time he was becoming one of the earliest of the visionary artists to realize the potential in digital art—a copy of Photoshop was literally dropped in his lap as he sat wondering how he could possibly portray that first vision that he had just experienced on LSD. Luke was also an early proponent of the commercial possibilities of glicee, the archival-quality canvas-printing technique that has played a major part in the success of twenty-first century visionary art because of its durability and its low printing cost. (The majority of visionary art prints on display at festivals are glicees, and these are the high-end reproductions most artists sell.)

The unique quality to Luke's highly skilled work quickly gained him an international audience, and he was asked to exhibit in a group exhibition in Zürich in 2003, next to his heroes Alex Grey, Robert Venosa, and H. R. Giger. At the related party, commemorating the sixtieth birthday of Albert Hofmann's discovery of LSD, a stranger offered him a tab of LSD on which one of his own artworks was printed. More specifically, it was the drawing he had done that very first night tripping when he was a teenager. In Luke's own words:

So there I was, at this party, exactly ten years to the night that I had had that first awakening. Ten years to the night that I worked on a piece of artwork for the first time: and here it is being presented to

me in Switzerland, in the location where LSD was discovered! To me, that was like a huge cosmic revelation, I felt supported in everything that I was doing.

Along with designing and creating sculpture, jewelry, and clothing, Luke Brown is a true visionary artist in the sense that he very much paints the visions he sees, and possesses a tremendous memory for his incredible visionary experiences. (One day, when it is again legal to study psychedelics, this will be a fascinating question to attempt to answer: why do some people, like Luke Brown or Alex Grey, possess the ability to have tremendously visual psychedelic experiences, while other psychonauts, like me, tend to be much more cerebral, with Terence's "true hallucinations" generally only arriving on extremely large dosages?)

Another noteworthy synchronicity was involved with Luke Brown's painting *Alpha Centauri* (2011), which is considered by many of his peers as one of the twenty-first century's first visionary art masterpieces. At BOOM! in 2006, as part of the Tribe 13 European tour, Brown sat under one of the many trees scattered around the grounds while he was on magic mushrooms and smoked DMT. A vision of a strange, radiating, alien, almost godlike creature appeared to him— or in his own words, it started to *become* him—the various intricate plates of the being's body snapping around him as he sat there, before the vision eventually wore off and disappeared. Six months later, while in Australia, Luke had the same vision again while on ayahuasca, so he decided to take on the almost unimaginable task of trying to paint what he had seen. A year and a half later, he took the still unfinished oil painting to BOOM! to display it for the first time. Close to 5 feet tall and sewn into a cloth frame like a Tibetan thangka, *Alpha Centauri* is incredible in its detail, and it is hard to believe that anyone could remember so much, let alone have the skill and patience to attempt to paint it. Upon arriving back at BOOM!, Brown discovered that the Liminal Drop—BOOM!'s speaker zone and visionary art gallery—had been built exactly around the very same tree under which he had experienced the original interdimensional vision. There are hundreds if not

thousands of trees scattered around the BOOM! site, but Luke Brown got to hang his *Alpha Centauri* on the very same tree in the center of the gallery.

Another original Tribe 13 artist known for his visions of other dimensions and alien realms is the Ashland, Oregon-based artist Xavi Panneton. While Xavi had actually previously met Roman Villagrana, he was not initially included in the Tribe 13 roster; after seeing the advertisement for The Interdimensional Art Show in *Juxtapoz,* Xavi rang up Villagrana and demanded to be included. While also a painter and digital artist, Xavi is best known for his large-scale murals. A master of stencils and spray cans, Xavi can transform a wall or room in record time, a talent that had made him equally popular at festivals (Xavi designed the main stage dance temple at BOOM! in 2014), or for painting the eye-popping facade of a business. Feeling he has in many ways outgrown the festival scene, Xavi now concentrates on large-scale commercial commissions; in 2016 he was commissioned to paint a large mural on the thirteenth floor of Google's offices celebrating "the psychedelic sixties."

A true visionary, he explains:

The subject of patterns is vast, I will just jump in. I have a pretty severe case of synesthesia, meaning I see music and hear colors and shapes. So as a teenager, when I began to see the patterned light streams of music I was experiencing at raves, my art then reflected this. This came naturally and was not induced by taking any drugs. The deeper I went into the realms of Light and patterns, the more I came to appreciate the mastery in the works of the Creators. I like to follow in the deep lineage of beauty they have set before us. It is my intention to create patterns, colors and sensations that both stimulate joy and relax the mind [. . .] while the primary "meaning" of symbols for me is that they are vast sums of experience condensed into a single package that can be downloaded instantly into your mind and heart. The total contents of the package will then be instantaneously cognized at every level of your being. [. . .] Symbols are literally a visual mark of the experience contained within it. For example, you

get a package that contains the entire history of a particular culture. The "symbol" is the spiritual identities of every person who lived in that culture combined, as well as all their knowledge and experiences. All this is condensed into one shape that burns with meaning and a strange familiarity. (Sol Purpose, "The Art of Xavi Panneton," http://solpurpose.com/featured-artist-xavi-panneton)

Despite Tribe 13's role in redefining psychedelic art, nonpsychedelic origins for their visionary art, such as Xavi's, turn out to be a surprisingly common theme among a number of the Tribe 13 artists.

A. Andrew Gonzales (1963–; http://sublimatrix.com), from San Antonio, Texas, is another original Tribe 13 artist for whom the term *visionary art* is entirely somatically accurate; at the age of nineteen he had a number of "supernatural events of the soul" comprising out-of-body experiences and lucid dreams, "some of which involved brief encounters with mysterious adepts or messengers," Gonzales says on his website. "On three occasions during my lucid dream practice I awoke enveloped in a fiercely radiant golden light, moving rapidly toward its blazing white center. Upon opening my eyes, I felt what could only be described as a sense of being reborn. Everything around me looked new, and I felt this wonderful sense of peace and clarity that would last for months. Whether real or illusory, these experiences inspired in me an acute sense of the astonishing miraculousness of everything."

Equally visionary is Gonzalez's unique technique as a painter. Michelangelo, as has been noted previously, famously preferred sculpture to painting because sculpture allowed him to simply reveal the form already hidden within the stone. Thus sculpture can be seen as a subtractive process, whereas painting is typically an additive one, but Gonzalez turns this on its head. He achieves a sculptural look by airbrushing acrylics onto gesso panels, then lifting pigment with an abrasive eraser. This is followed by the application of transparent layers of paint. In darker sections, he may repeat these steps many times over, in an incredibly time-consuming process that creates a unique and spectacular form of visionary art.

Heavily influenced by William Blake's engraving *The Whirlwind of Lovers: Paolo and Francesca*, Gonzalez's work is akin to "a revival of classical Neoplatonic ideals centering on the figure as both temple and vessel, sublimed by transformative forces" (www.arthistoryarchive .com/arthistory/contemporary/A-Andrew-Gonzalez.html). Listing Dalí, Fuchs, Blake, Giger, and Alex Grey as influences, Gonzalez is internationally known as a fantastic realist, and cotaught the 2015 Mishtechnik Seminar in Austria with another American artist who was also an original Tribe 13 member, David Heskin (www.davidheskin.com).

Co-owner of Colorado's Luminous Flux Gallery with his wife and fellow-artist, Aloria Weaver, Heskin is "inspired by visions of shared creation," and cofounded Dreaming Co:Nexus, an Artist Co:laboratory, which combines different artists' visions through collaborative live painting events and "Art Vigils" that can last "anywhere from 18 to 48 hours—the artists coming and going to keep the candle of wakefulness lit, while passing back and forth the flame of creation." Heskin and his wife are also guest instructors at the Vienna Academy of Visionary Art, an institute created out of the growth in popularity in the annual Expanded Visions in the Mischtechnik seminar taught by Laurence Caruana and Amanda Sage.

While these artists are today on the verge of being well-known names, the common refrain from the artists themselves at this First Interdimensional Art Show was that they had not known there were other artists like themselves out there at all: in 2003 there were only two famous American visionary artists—Robert Venosa and Alex Grey. (Alex and Allyson Grey would also visit the Seattle Tribe 13 Gallery in 2003, but were not at the First Interdimensional Art Show.) Incredibly Robert Venosa and Martina Hoffmann were sitting with them now, and as the excited group of artists went out as a group for dinner the night after the success of the gallery opening, Venosa in his typical blunt New York manner laid down the law. Movements do not just happen overnight. You can't just put a $5000 ad in *Juxtapoz* magazine and create a significant genre. For anyone to take you seriously, you have to do something for at least ten years. And yet despite Venosa's gruff manner,

the other artists could tell he was impressed. It might still be a long road ahead, but there was no doubt that something had been started that night in Seattle.

Perhaps to prove to Venosa just how serious Tribe 13 was about advancing visionary art, one of their angel sponsors sent Roman Villagrana, Luke Brown, and Carey Thompson (along with Kris Davidson and J. Garcia) to Cadaques in Spain that summer for Venosa's and Martina Hoffmann's painting seminar—perhaps the most avid group of feral students that have ever descended upon a master. Along with this group was another American artist who deserves mention, since he is both an associated Tribe 13 member, and currently the most famous living American Fantastic Realism artist: the incredibly gifted Kris Kuksi (1973–; www.kuksi.com).

Growing up in an isolated rural area of Kansas virtually devoid of culture or stimulation, Kuksi created entire worlds inside his head. Today, his intricate fantastical sculptures have been described as "mind-blowing, macabre and beautifully grotesque art"—Kuksi "cuts and reshapes old objects, small toys, mechanical components and other parts and refashions them into works of art that bear little resemblance to the original appearance. A wide range of materials are utilized, including model parts, wood and metal. The artist describes these as 'mixed media' that are melded by 'a flowing composition and visual balance'"(Wikipedia, "Kris Kuksi").

Kuksi is also a highly skilled painter with a master of fine arts degree in studio painting. According to critics, Kuksi's paintings are "either so realistic they could be photos or psychedelic, almost esoteric." Having now been exhibited in more than one hundred exhibitions worldwide, and with his work collected by Hollywood film directors, rock stars, the late actor Robin Williams, and the current CEO of Nike, Kuksi is one of the rising stars of the "real" art world (his pieces have been auctioned at Sotheby's) and as was the case with Dalí, Fuchs, and Mati Klarwein before him, it does Kuksi little good to admit to his psychedelic inclinations or inspirations, irrespective of his obvious talent.

After the Cadaques trip to learn the Old Masters' techniques* from Venosa, Carey Thompson, Luke Brown, and Xavi all moved to San Francisco where they lived in an old Victorian known as the Funk Palace, which would become the youthful center of a major rebirth of psychedelic art in the Bay Area. The occupants of the Funk Palace house would be instrumental in organizing both the private Galactivation retreats, and the Synergenesis art show in San Francisco, which would be one of the focal points of early visionary art between 2005 and 2007.

The formation of Tribe 13 meanwhile coincided with the birth of the spinoff West Coast transformational festivals, and from 2003 onward, Tribe 13's movable galleries were an integral part of numerous festivals, including Earthdance, Harmony, Symbiosis, and Lightning in a Bottle, as well as countless smaller events. Jennifer Ingram and Tribe 13 were also responsible for creating one of the first major visionary galleries at Burning Man in 2006 (for Entheon Village), the Liminal Drop Gallery at BOOM! in 2010, and for curating the FractalNation Gallery at BM in 2011–13. The showpiece of Tribe 13's year, however, continued to be the annual Interdimensional Art Shows, which continued until 2010. In 2009 the show was held in Seattle, San Francisco, and Eugene, Oregon, and unlike the festival galleries that (generally) featured reproductions of the Tribe 13 artists' works, at the Interdimensional Art Show the original paintings were actually on display—in 2009, Tribe 13 sold fifteen out of twenty-five originals on offer.

The origins of the name Tribe 13 itself came from the Old Testament story of the twelve tribes of Israelites. Borrowing the concept of the Lost Tribe from the Rastafarians, Roman Villagrana reasoned that it been forty years since the first psychedelic wave had swept through the West Coast of the United States, and now after forty years of wandering in the desert, it was time for the tribe to return home to the Promised Land.

*Or at least Venosa's version of it, after he had learned first Mati Klarwein's version, and later from Fuchs himself; one of the common threads among Fantastic Realism painters seems to be inventing (less difficult) variations on Fuch's original *Mischtechnik*.

"We are all going to come together," Villagrana predicted, "attracting many people and spiraling out into the world. Through positivity, music, art, and culture, we are going change it all for the better" (quoted in Ingram, "Tribe 13"). The clarity of his and Jennifer Ingram's stated mission was as startling as it was obvious: visionary art could be the seed that saves the world, or at least be a part of that necessary shift.

Of course Tribe 13 was not alone in that mission; after Alex and Allyson Grey visited the Seattle Gallery after its opening in 2003, the Tribe 13 artists pilgrimaged en masse to New York in 2004 in a show of support for the opening of the first Chapel of Sacred Mirrors (CoSM) in Chelsea. First the support and encouragement of Robert Venosa and Martina Hoffmann, and then of Alex and Allyson Grey—for the young Tribe 13 artists who only a couple of years earlier hadn't even known that one another existed, suddenly it really did feel like they were coming home.

28

THE CHAPEL
OF SACRED MIRRORS

*Art could be the new Religion; with psychedelics once again
recognized as sacraments.*

ALEX GREY

In 1996, Alex and Allyson Grey acted upon a shared vision (experienced on MDMA) they had in 1984 of creating a temple for visionary art in which to house the *Sacred Mirrors* series by forming a nonprofit for the eventual construction of the Chapel of Sacred Mirrors; board members included Deepak Chopra and Ken Wilber. Their stated mission—to build "a sanctuary for spiritual renewal through contemplation of transformative art."

In 1997, the Greys were invited to address an annual conference on psychedelics in California called "MindStates," and Mark McCloud loaned the organizer a couple of his Alex Grey originals for the show. For the New York artists, this trip to California came as something of a revelation, since for the first time they addressed an audience actually interested in the psychedelic inspiration in their work rather than inevitably having to defend themselves at some point in the questions that follow their talk. The Greys had discovered the West Coast psychedelic community and vice versa. Psychedelic culture in America

(and before long the world) would soon never be the same again.

In 1998, Grey published *The Mission of Art*, which traced the evolution of human consciousness through art history, exploring the role of the artist's intention and conscience, and reflecting on the creative process as a spiritual path. By 1999, when he was invited to participate in Terence McKenna's AllChemical Conference on art and creativity alongside Robert Venosa, Grey's stature as one of the world's top psychedelic artists was becoming well established, while with the publication of *The Mission of Art,* he also became increasingly recognized as an emerging psychedelic philosopher.

Feeling the absence caused by Terence McKenna's death in 2000, and realizing that psychedelic culture needed a rational discourse to grow as well as suitable environments in which to gather, Alex and Allyson Grey decided to increase their efforts to endorse and encourage psychedelic culture through their slide-show presentation on psychedelics and art, while at the same time raising funds for the creation of the Chapel of Sacred Mirrors.

In 2001, Grey's exposure received a huge boost when the prog-rock band Tool used his artwork on their album *Lateralus,* While the Beastie Boys had used his work on one of their albums as early as 1994, it was Grey's association with Tool that would bring him to a worldwide audience when he executed the stage design for the associated tour, which included massive reproductions of the album art. (Alex also later provided the artwork for the 2006 Tool album *10.000 Days* and the computer-generated graphics for the video of the single "Vicarious." Tool also used a few of his paintings on their 2007 tour of Europe, Asia, and North America.)

In 2002, Alex took up Terence's mantle when he was invited to give a presentation at BOOM!, as it was wanting to become more involved with psychedelic art and culture. In 2003, after being advised by shaman Alex Stark that the building of a sacred space would require a community, Alex and Allyson also began holding full-moon prayer ceremonies in their Brooklyn home. Noise complaints by neighbors meant that the Greys' home quickly became too small to house the event's rap-

idly widening popularity, but thanks to an outpouring of support from the nascent community that was forming around these gatherings, the first Chapel of Sacred Mirrors opened in a donated space in Chelsea in the heart of New York City's gallery and nightclub district on the autumnal equinox of 2004.

Along with the *Sacred Mirrors* series, the original chapel also displayed a number of Grey's major works (many of which had been repurchased from collectors by the CoSM Foundation), including *Theologue, Net of Being, Cosmic Christ,* and *Journey of the Wounded Healer,* as well as Allyson Grey's *Secret Language* paintings. The Greys continued to hold full-moon gatherings at the new chapel, as well as painting seminars and talks from visiting speakers of note. The Chelsea CoSM quickly became a hub of the New York New Age community.

In 2005, CoSM hosted an event called Avatar, which featured a bicoastal visionary arts panel that included Roman Villagrana, Carey Thompson, Luke Brown, Xavi, and David Heskin. Also in 2005, to honor the occasion of Albert Hofmann's hundredth birthday the following year, Jody Polishchuk, a Canadian visionary-art collector and major supporter of Tribe 13 (who later opened the Meta Gallery in Toronto) commissioned both Venosa and Alex Grey to paint portraits of Dr. Hoffman. After Grey finished his portrait, *St. Albert and the LSD Revelation Revolution,* he realized the work should be part of the permanent collection at the soon-to-be-opened Chapel of Sacred Mirrors, and respectfully returned Polishchuk his commission. After Grey presented the painting to Albert Hofmann for his signing at the World Psychedelic Forum—the conference held in Basel, Switzerland, for his hundredth birthday—the portrait returned to New York, where it has become one of the artist's most reproduced images. After Hofmann's death in 2007, his family presented the Greys with a pair of his spectacles as an official "relic" for the newly created chapel. (CoSM also has a lock of Dr. Hofmann's hair.)

In 2005, Tribe 13 artist Carey Thompson acted upon a vision he had of creating a Meso-American-style frame for his painting *Singularity* by building an installation at Burning Man called the DiMethyl Temple

(with Rob Newell), which was filled with crystals and visionary-art reproductions from Thompson, the Greys, Tribe 13 artists (including Venosa and Hoffman), and Victor Olenev (1957–2006), a transplanted Californian multimedia artist originally from Russia.

Born into an artist's family in Moscow, Olenev moved to New York in 1976, where he studied art at the Pratt Institute. After moving to California with his family in 1990, Olenev became fascinated with early digital art. In the early 2000s he was introduced to the California psytrance scene through his daughter Nastassia, and soon after began exhibiting and selling his digital prints at festivals. After Olenev's first Burning Man in 2004, Carey Thompson invited him to participate in the DiMethyl Temple in 2005. Olenev's brilliant totemic portraits and dark Gigeresque collages have exerted a considerable influence on the other younger visionary artists, while his less-known oil paintings (some replete with magic mushrooms) exhibit a playful mythical genius reminiscent of Klarwein's canvases. (Olenev died in 2006, one of the first major deaths in the still small visionary art community.)

Later in 2005, Larry Harvey and other key Burning Man staff came to New York and visited the Chapel of Sacred Mirrors. After this visit, Alex Grey was invited to participate in Burning Man in 2006, where large-scale reproductions of his art—including a massive set of carved wooden wings from CoSM itself—were displayed inside the base of the Man. It was the first time that an artist had been so honored, and it effectively anointed Grey as the most important psychedelic artist of the new century.

In conjunction with this occasion, MAPS cosponsored a large camp at Burning Man, which Grey named Entheon Village. Along with the Burning Man MAPS Speaker Series (which included the Greys, Alexander and Ann Shulgin, and Nick Sand, who had only recently been released from jail), Entheon Village had a dome with Alex and Allyson Grey live-painting to DJs inside and—in another first for the playa—a major Visionary Art Gallery (curated and organized by Jennifer Ingram) of mostly Tribe 13 artists. The following year (2007), Entheon Village hosted Robert Venosa and Martina Hoffmann.

In the fall of 2008, the Tribe 13 artists were invited to hold a group show at CoSM, the first outside visionary artists to do so. Shortly afterward, on January 1, 2009, the original NYC Chelsea CoSM closed, as Alex and Allyson shifted focus onto the eventual construction of the permanent Chapel of Sacred Mirrors on 40 acres of land that the CoSM Foundation had purchased in Wappingers Falls in upstate New York in 2008.

This signaled the beginning of an arduous eight years of fund-raising and travel for the Greys as they have appeared at festivals and conferences around the world promoting visionary art and the construction of the Chapel of Sacred Mirrors. This period was nearly dramatically cut short almost before it began, when in the winter of 2009–10 the couple was involved in a horrendous car crash, and both were lucky to survive.

Frail and in back braces, they made their first public appearance after the accident at the first major MAPS conference in San Jose, California, in April 2010. MAPS had commissioned Alex to paint a portrait of Alexander and Ann Shulgin in the same spirit as his Albert Hofmann portrait, and at the MAPS conference the Greys presented the painting, which had been thrown out of the vehicle they were in when it crashed, and was later returned to them by a stranger. (A limited edition of prints of the painting were sold to raise money for both MAPS and CoSM.) The sight of a packed hotel ballroom witnessing Alex and Allyson in their back braces viewing the painting with the clearly aging Shulgins hammered home just how important the Greys had become to psychedelic culture.

The day after the MAPS weekend, on April 19, 2010, CoSM and the Greys held a fund-raiser at a San Francisco nightclub called Temple to celebrate Bicycle Day, the day that Albert Hoffman first dosed himself on LSD in 1943 and had to ride his bicycle home as a result of wartime rationing. On this night, along with Alex and Allyson live-painting on stage to an array of San Francisco's top EDM producers, Tribe 13 created a gallery for the event, with the Tribe 13 artists spread out painting around the dance floor, while Jonathan Singer, a live video

artist who is Alex Grey's VJ, projected deconstructed waves of the various artists' own art in morphogenic waves across the giant screens on the walls.

A twenty-first visionary art alliance had clearly been made and was now a part of creating a new kind of inspired psychedelic environment of a sort that had never been seen before. On this night in San Francisco, there was a clear sense that the Burning Man–inspired transformational festival culture was on the verge of being a movement, and that psychedelic culture was undeniably once again on the rise. After the deaths of Terence McKenna, Ken Kesey, and Timothy Leary, contemporary psychedelic culture needed new heroes, and Alex and Allyson Grey, with their singular belief that visionary art could be the next religion, were clearly just what the universe had ordered.

NEW PERSPECTIVES

—◈—

MOKSHA, Alchemeyez, and The Temple of Visions

After 2010, it became increasingly clear that a new renaissance in psychedelic art and culture had arrived. Fueling the rapid growth of transformational festivals at the end of the first decade of the twenty-first century, Burning Man experienced a sudden surge in popularity as it made the uneasy transition from a cult underground event to a global cultural bucket-list topper. Along with the Silicon Valley billionaires and their celebrity friends, the rest of the global elite increasingly discovered the event thanks to worldwide exposure encouraged by the board of the newly formed Burning Man LLC after 2011, when Larry Harvey and the other three original founders gave up control of the event.

While more conventional Californian art and music festivals like Earthdance and Harmony Festival had already been displaying visionary art and inviting artists to participate for several years, the Lightning in a Bottle and Symbiosis Gathering festivals represented a new emerging vision for the festival experience. From the beginning these particular events were remarkable for the design of their stages and for the amount of visionary art on display, as well as the number of artists who variously participated, including all the Tribe 13 artists and Alex and Allyson Grey.

This new vision saw these festivals as a blank canvas for intentional

transformation, with art galleries in the woods, large metal sculptures, flower and crystal mandalas, shrines, while the stages themselves were reimagined as intricately crafted and painted works of art, virtual temples to music and dance. In 2006, the DoLaB Foundation started Lightning in a Paintcan, which is (according to LIB) the largest live-painting event in the world, with up to thirty visionary artists live painting at the festival at any time. Symbiosis has similar numbers of artists participating, and both festivals offer extensive galleries of visionary art and sculpture. During this early period there was little thought of profit and loss, with many artists simply wanting an opportunity to participate.

As transformational festivals have grown more popular, they have also increasingly spread farther from their origins; in the United States, the Sonic Bloom festival began in Colorado in 2005, the Tribe 13 artists visited farther east to Electric Forest in Rothbury, Michigan, in 2008, while a popular Burning Man camp called the Philadelphia Experience began their own PEX festival on the East Coast in 2010. (After 2010, Burning Man regional events also became increasingly popular and important in states like Tennessee, Texas, Utah, and Georgia.) Internationally, in Canada, Australia, South Africa, New Zealand, all over Western and Eastern Europe, and in even more remote locations like Central America, Brazil, and Turkey, similarly themed festivals have proliferated. With the increasing commingling of the West Coast transformational festivals and the European and Australian psytrance scene, with the live-painters, the artists who design the stages and various environments, the workers who build them and tear them down again, the lightning, sound, and video technicians and engineers, as well as the DJs, performers, stage managers, and vendors who travel internationally from festival to festival, over the past decade a reasonable-sized global community has now formed around this increasingly global tribal culture.

Nevertheless, in December 2009, when virtually the entire American visionary art community met in Miami during Art Basel (the largest art show in America) at the debut edition of the (much smaller) Moksha

Art Fair, they were still all able to fit in one large room. Two panels were presented over the course of the three-day event, one by the elders of the visionary art world—Venosa and Hoffmann, Alex and Allyson Grey, and Mark Henson—while the other was of the up-and-coming artists—Luke Brown, Amanda Sage, Carey Thompson, Android Jones, Adam Scott Miller, and Autumn Skye.

Another classically trained painter with a master of fine arts degree, Adam Scott Miller (www.adamscottmiller.com) is an early member of the American visionary arts community who had strong Tribe 13 ties before moving to Australia in 2010, where he paints, teaches, and remains a leading influence in the international visionary arts movement. Another visionary painter in the tradition of Blake, Miller combines a keen scientific curiosity and understanding from his own unique visionary perspective. As he explains:

When I was fifteen years old, I suffered an impact to my head resulting in a concussion and damage to my optic nerves. Obvious to me afterwards, my memory and vision was affected. Mysteriously, I began seeing subtle forms throughout all space, within my immediate vicinity. [. . .] This experiential proof has catalyzed my gnostic faculty to recognize occult dimensions of presence that are normally hidden from view by the perceptual mechanisms, biological and psychic. This "shamanic wound" marked my life as a formative causal factor in how and what I see. It was the way in which I healed also, that opened this latent gift.

As an artist, I've had this sense of being an explorer—sailing into unknown territory to bring back maps to share of lands we are not yet in, or aware of. We are literally swimming in a sea of vibratory information and our conscious minds only dimly begin to apprehend less than a percent of a percent [. . .] and that tiny window we have is only made sense of by, the significance of symbol. [. . .] Esoteric, archetypal, alchemical, and geometric symbols are in my visions as they speak from a place of universality, a shared space that is transcendent yet implicit to the nature of

reality [. . .] The momentum of visionary art evokes transpersonal, integral, cosmic consciousness. The movement of human evolution is from the egobound to the transpersonal form, that transcends and includes all states and stages it has held before. (http://solpurpose .com/featured-visionary-adam-scott-miller)

The Canadian artist Autumn Skye Morrison is a very talented painter whose work can often be seen in festival galleries and is associated with Tribe 13; her multimedia painting *Shelter for Opening* was one of my personal favorites at the 2009 Moksha art show—one of the largest displays of original visionary artworks that I have been fortunate enough to witness. As with Adam Scott Miller, and her fellow Canadian artist Chris Dyer (who lives in Montreal), geography has somewhat limited Autumn Skye's exposure to West Coast audiences, a disadvantage lessened by the worldwide reach of the internet. (Another Canadian, for example, Luke Brown, is one of the better known next-generation visionary artists, and lives in Bali.)

This first Moksha Art Fair was full of memorable moments, including a bus ride for the artists around Miami in a Burning Man bus complete with DJ and external sound system, seeing Jonathan Singers visuals for the first time, and Android Jones proposing to his then-girlfriend Phaedra at the end of a spectacular dance and projection performance they were developing called *Phadroid*. But it was the high concentration of both original artworks and their artists at a single event that was notable, and while there were DJs and the usual trappings of an electronic music show, this event (co-curated by Tribe 13) was clearly about presenting the art in a gallery setting. And unlike the high-ego and often unfriendly major shows during Art Basel (such as SCOPE and PULSE), Moksha always felt like a family affair, with both Venosa and Grey notably spending the majority of their time encouraging the numerous younger artists in attendance. Kris Kuksi was exhibiting at SCOPE—the most cutting-edge contemporary art show in America and my personal favorite at Art Basel—and came over to Moksha one evening to visit with his visionary-artist friends. He expressed how com-

pletely different the attitude between the artists was at the two shows, saying that at SCOPE none of the other artists would talk to each other at all.

The excitement about the rapid emergence of a viable visionary art community at Moksha after the blissful success of the Symbiosis Gathering in Angel Falls just two months earlier in which virtually all the artists had participated was obvious. The combination of visionary art and the emerging festival culture offered a potential meme from which to help change the world, and few things could be more exciting than that. It was also obvious from this show that this current group was capable of making some remarkable art. While art historians with far greater credentials than mine will undoubtedly scoff at the comparison, I would say this excitement must have undoubtedly been comparable to the early shows of the Impressionists in Paris in the late nineteenth century, or the gatherings of the original surrealists in the early twentieth century, or of the fantastic realists after World War II— the excitement of the collective sense that as a group they were exponentially more powerful than as individuals. As the key year of 2009 drew to a close, it was clear that visionary art in America was on its way to becoming a movement all of its own.

Terence McKenna's original AllChemical Convention would be one of the inspirations for the Alchemeyez Visionary Arts Congress, organized by the artist Rio Gordon, and was first held in the spring of 2010 on the Big Island of Hawaii. Both the Greys, along with Venosa and Hoffmann, were in attendance, along with an army of younger aspiring visionary artists showcasing their original art. In 2011, the second Alchemeyez, held at the Hilton Waikoloa Village, featured over two dozen artists including Romio Shrestha, the seventeenth reincarnation of the master Tibetan Thangka painter Arniko; a speaker series that included Dennis McKenna and myself; and over forty musical acts and numerous live performances, all carefully curated to showcase the cream of visionary culture. The fact that this was in a Hilton, originally built by Japanese investors, which at one time had been the most expensive hotel in the world, its grounds littered with priceless centuries-old

Buddhas and Hindu statutes, while dolphins swam inside the hotel in their own pool, only added to the mythic and often unreal atmosphere of that unique event.

Chris Dyer (1979–), the previously mentioned Canadian artist who lives in Montreal, was another of the Tribe 13 artists on display at Alchemeyez. Dyer was born in Ottawa, but his family moved to Lima, Peru, when he was six. Here he discovered skateboarding and surfing, but when he became involved with one of the violent local soccer gangs, his family sent him back to Ottawa to study at the age of seventeen. In 2000, now living in Montreal, Dyer began painting on the decks of old skateboards that he had ridden or broken, a medium that made him stand out in the local art scene. Through exposure in skateboard magazines, his recycled skate paintings landed him his dream job of doing graphics for Creation Skateboards in San Francisco; in 2011 he was promoted to art director and brand manager. Dyer expresses his authentic Peruvian background and heritage in his colorful art (some of which looks positively Chavinian), making him something of a bridge between the North American visionary artist and the Amazonian aya-husca school of painters led by Pablo Amaringo, even though Dyer says he painted this way long before he tried ayahuasca.

In downtown Los Angeles, the Temple of Visions—a gallery and sacred space—also opened in 2010, and quickly became a hub for the emerging southern Californian visionary art community.

Of all the current contemporary American psychedelic artists, Amanda Sage (1978–; www.amandaSage.com) undoubtedly has the strongest classical visionary-art pedigree. Sage spent her formative years in the progressive environment of Boulder, Colorado, and her high-school art teacher was the fantastic/visionary painter Haiku Hirata-Miyakawa, who introduced her to the work of Ernst Fuchs. After graduating in 1996, she moved to Vienna to study under Michael Fuchs, and later became Ernst Fuchs's painting assistant for a decade, spending five summers working on Fuchs's lifetime project in the Apocalypse Chapel in Klagenfurt, Austria.

After 2006, Sage began spending more time back in the United

States. While she had not been aware of them while at high school in Boulder, she was introduced to Venosa and Hoffmann in Vienna in 2001 through Fuchs. In 2007, when she went to Burning Man for the first time, the only people she knew were Venosa and Hoffmann and the Tribe 13 artist Android Jones, to whom she had been introduced in Boulder in 2001 through a mutual friend and whom she briefly dated. Martina Hoffmann then connected her with the Tribe 13 gallery at Entheon Village.

The high technical standard of Sage's painting after her years assisting Ernst Fuchs is obvious to both experts and amateurs alike, and she could have remained full time in Europe pursuing a career as a noted Fantastic Realism painter. However she soon joined the Tribe 13 collective as one of its most active members, and moved into a studio loft above the HIVE Gallery and Temple of Visions in Los Angeles in 2009. Amanda Sage also maintains a studio at WUK, a self-governed culture house in Vienna that is one of the largest of its kind in Europe (and has served on its board of directors), and teaches workshops on Fuch's *mischtechnik* at the newly formed Visionary Art Institute and around the world.

Remarkably professional and organized, Sage is as passionate an activist as she is a painter and a fervent believer in the power of art to create change, stating on her website:

> My aspiration is to paint messages, visions and narratives that communicate with an "older & wiser us," awakening ancient memory; as well as the "present us," so that we may grow up and accept the responsibilities towards ourselves, each other, and the rest of existence on this planet . . . now.

During a vision quest to Bali, Indonesia, one of the first paintings that Sage started there was an abstract work, which turned into a self-portrait of her sleeping and a rainbow snake coming out of the sky with an egg in its mouth. Describing the egg form as "a perfect form to feel safe and explore anything within," Sage says. "I'll never forget

the moment when I realized I would be painting eggs for the rest of my life." (Interestingly, the egg form was also a subject of Hildegard of Bingen in the twelfth century)

Today Sage continues to explore a variety of neomythical and shamanic themes from within the timeless artistic womb of her translucent egg forms; but it is her politically charged self-portrait *Ana Suromai* (The lifting of the skirt) that will most likely be singled out as an early masterpiece of twenty-first-century visionary art. Fittingly for one of the leading psychedelic painters of her generation, Sage's birthday is on April 19—Bicycle Day.

30

A FRACTALNATION

Your cargo is splendid, your generosity boundless, and your motives are beyond our understanding **You Have Made Magic.** *. . . . You are the winner because through your magic you have made hope. People you will never meet walked up to your creation and were made happy. . . . You join a rare group of artists who are making something new . . . A Richer, Funnier, Tastier, Future.*

<div align="right">

From the certificate of excellence presented to
FractalNation by the Burning Man organization
at the conclusion of Cargo Cult 2013*

</div>

In 2006, Carey Thompson, Luke Brown, Xavi, Shrine On, and Jennifer Ingram and the Tribe 13 gallery went on a European tour with Thompson's DiMethyl Temple that included BOOM! and The Glade in England. Impressed by the potential they saw at BOOM!, the Tribe 13 artists returned in 2008, and in 2010, Carey Thompson was named BOOM!'s art director—perhaps the most prestigious job in the world of transformational festivals—while Jennifer Ingram was invited to curate the BOOM! visionary art gallery.

One of the last artists to join Tribe 13, the accomplished digital

*No one had ever heard of a camp being so recognized before at Burning Man.

artist Android Jones, was also invited to design and create BOOM!'s psytrance mainstage, The Dance Temple. With Android Jones and Jonathan Singer mixing the projections on the main stage, Carey Thompson building one of his signature starportals, Shrine On building his Temple/Gamealatron, the DoLaB building a major stage, and the iconic Michael Christian Burning Man sculpture *Key Note* on display on the shores of Lake Idanha-a-Novaplaya, along with live-painting by Luke Brown, Amanda Sage, Adam Scott Miller, Xavi, and Ka, and performances by Lucent Dossier and other Burner-inspired dance companies, BOOM! in 2010 signaled the full-blown invasion of West Coast U.S. visionary art into the European psytrance festival consciousness.

In 2011, Android Jones and Carey Thompson thought it would be interesting to reverse the experiment and create a camp at Burning Man that included the organizers of BOOM!, who had never been to Burning Man before. This idea would lead to the involvement of key members of BOOM!, Symbiosis, the DoLaB, Envision Festival (from Costa Rica), Source Festival (from Maui), and MAPS. With a major gallery with the full participation of Tribe 13 artist and a main stage designed and executed by Gerald Minakawa and the Bamboo DNA crew, along with the massive Abraxas dragon and Lady Sassafras riverboat art cars and their respective crews, FractalNation—the resulting Burning Man art-music-performance village—was a unique experiment that drew on the cream of the talent of the transformational festival world. (On what was supposed to be their holiday!)

Andrew "Android" Jones, while one of the last members to join the Tribe 13 collective, is now its best-known living artist, and it was his personal vision and desire to create a Burning Man camp that showcased the emerging visionary culture that played a large role in enticing the various groups to participate.

While a classically trained art-school graduate in drawing, painting, and animation, Android Jones has emerged as a pioneering early twenty-first century digital artist. Realizing in art school that digital art was the first new medium to arrive in art in literally hundreds of years, Jones from that time on devoted himself to learning about the new and rap-

idly evolving technology. After art school he interned at George Lucas's Industrial Light and Magic, as well as creating his own LA-based art development company, Massive Black. Burdened with a heavy student debt load after leaving art school, Jones went to work for the video gaming industry—a period he describes as his "dark night of the soul."

Already something of an introvert and a brooding personality, Jones sank into a deep depression. At a typically candid talk at BOOM! in 2010, he showed a series of the dark art that he produced at night at home alone and sent out into the nascent internet video-art community, where it connected with a generation of similarly alienated youth. Desperate for a change, Jones tried ayahuasca for the first time in 2005. Something remarkable happened during that experience, a transformation symbolized by a white angelic being who visited him and that he recreated in his first piece of art afterward. (This white angel now acts as his logo.) The contrast between the before-and-after art is remarkable, and Android Jones after hitting rock bottom—in a story similar to Alex Grey's—would tell you that he was effectively saved by psychedelics.

Quitting his job, Jones moved to San Francisco, discovered the Burning Man community, and began the life of an independent artist. One of his early friends on the West Coast was the EDM producer Lorin Ashton, also known as Bassnectar, who invited Jones to go on tour with him. Not the sort of person just to sit around backstage, Jones devised a way he could "live-paint" on a tablet that he hung off his hip like a guitar, producing an entire digital painting on screens behind Lorin as he performed. Thus he accidentally created himself an alternate career as a much-in-demand live-video artist, well known for his many-layered psychedelic works and live performances using a custom-built digital setup.

Describing his work as "Electro-mineralism," Jones attributes his ability to create to the wonders of technology, crediting the planet's resources for advancements in art production. Describing himself as a digital alchemist, he states that his aim is to alter the viewer's perception by pushing the boundaries of the imagination through the use of innovative media forms:

The older I get I realize that I don't make art just for myself anymore, I want to make art that serves people, serves the community that I am part of, the species I am part of. Art is an incredibly powerful tool, it creates a lot of reactions, brings about change and inspires people. I often try to think what are the needs of people, what's the most important kind of art right now, what kind of art I can make that can uplift humanity, what kind of art that I can make that can glorify God and creation, what kind of art I can make that can catalyze [the] consciousness of different people and a lot of time I really think the power of art is not so much in the piece itself but its [*sic*] in making things that help stimulate ideas, stimulate questions, or conversations. (Bhavika, "An Interview with Android Jones")

The San Francisco–based company Obscura Digital soon recognized Android Jones's unique talents. A cutting-edge company that creates immersive experiences by projection onto large buildings and monuments (famously creating the holograph of Tupac Shakur at Coachella), Obscura Digital was responsible for having Android Jones live-paint his images on the Sydney Opera House, and most recently in 2015, on the Empire State Building in New York. Here his use of the image of Kali, the Hindu goddess of destruction, as the final projection promoting *Racing Extinction,* a movie highlighting the impending ecological crisis, caused considerable controversy among American Christian fundamentalists, who thought it was proof of devil worship.

Jones's tremendous speed and productivity have resulted in a huge body of work—he once created a self-portrait every day for a thousand days. His arrival in California around 2006 coincided with the early genesis of transformational festivals, and he soon became one of festival culture's most admired and prolific artists; along with founding the influential FractalNation art and performance camp at Burning Man, he and his team now often curate galleries of visionary artists' work at festivals (such as BOOM!'s new MOVA gallery in 2016). Alongside his more visionary interests, Jones is invited to teach digital-art seminars all over the world thanks to his significant presence on the internet. (Corel

digital software uses Android Jones artwork on the box for its Painter software.)

Of all the contemporary visionary artists—Alex Grey included—Android Jones may be the artist with the greatest chance of achieving art superstardom because of his early embracing of the digital media and the opportunities they bring. Remarkably innovative and constantly exploring the cutting edge of technology, Android's evolutionary art fits perfectly with the new Silicon Valley Digital Burner mentality* and is attracting many well-funded backers. By breaking free of the centuries-old mold of what an artist consists of, Jones is also free to pursue multiple areas of new technology to create art. In 2016 he brought a remarkable 360-degree planetarium-style projection system, which allows the viewers to become fully immersed into a dreamlike moving display of his art (complete with sound tracks provided by famous EDM producers), to the highly inhospitable environments of BOOM! and Burning Man, a feat that few contemporary artists could dream of managing. As this kind of technology exponentially advances—especially virtual-reality (VR) technology—and with Android's reputation established as one of the first important digital artists as well as one of its most innovative, his fame as a uniquely twenty-first-century artist can only grow.

Android Jones's and Carey Thompson's key participation in so many different festivals and events all around the globe, including BOOM!, made them uniquely qualified to germinate a major visionary statement like FractalNation. As one of the other cofounders of FractalNation—and the person who had the honor of naming it—I can say with authority that virtually all the artists and activists involved believed in one form or another that Fractal was an effort to help to deprogram the myths about psychedelics that have been created by nearly fifty years of prohibition, and a demonstration of what could happen if visionary culture was simply

*Entrepreneur Elon Musk recently said, "If you haven't been to Burning Man you can't understand Silicon Valley. Burning Man *is* Silicon Valley." (Bowles, "At HBO's 'Silicon Valley' Premiere")

allowed to flower into the world. The end result was both more difficult and more breathtaking than anyone could have anticipated, a true community effort that created for three straight idealistic years—2011–2013—the collective pinnacle of psychedelic culture in the world.

On August 9, 2011, only a few weeks before Burning Man and the inauguration of FractalNation, Robert Venosa died at sixty-five after fighting a long battle with cancer, which he had revealed to very few people. Venosa was universally revered among younger artists because of both the greatness of his art and the generosity of his time and spirit, and his death immediately left a giant void that no one could ever hope to fill. His passing, after the nearly fatal car accident of Alex and Allyson Grey the previous year, also underscored the fact that there will always be a changing of the guard. Venosa's absence was as authoritative as his presence, and FractalNation in 2011 was very much dedicated to his inspiration and his memory.

With its visionary art gallery, projections, performance, stellar musical line-up, and the added attractions of a giant Perspex foam tub/party (complete with DJs) provided by the grandson of Dr. Bronner, and a towering illuminated beacon-like installation out in front of the camp created by the DoLaB, FractalNation was immediately a major Burning Man success. The Beats Antique show at FractalNation in 2011 drew one of the largest crowds ever on the playa when approximately a third of Burning Man showed up. FractalNation also played host to the MAPS "Zendo Project," a harm-reduction program that created a space for people to recover from heavy psychedelic experiences without being arrested or heavily medicated, or both. The involvement of MAPS contributed a more serious and scholarly aspect to the collective's visionary hedonism.

This first year's success resulted in a return the following year, in conjunction with Area 51 from Atlanta, who were responsible for the Alex and Allyson Greys' participation. At the 2012 edition of FractalNation, along with the requisite artful DJ area and dance floor, the Greys occupied one large dome (with a speaker series curated by Daniel Pinchbeck), while the Tribe 13 artists occupied another large

dome with a full gallery, along with the added innovation of the MAPS speaker series. For the final evening of talks by Alex and Allyson Grey and myself, there were over five hundred people in attendance.

The year 2012—which he had long been awaiting because of his keen interest in Meso-American art and culture—also represented a major milestone for Fractal cofounder Carey Thompson. Along with his job as art director of BOOM!, Burning Man invited him to create one of his signature LED-enhanced Star Portal archways for the entrance of the Center Camp, the most heavy trafficked location. Then not long after Burning Man ended, his son, McKenna, was born.

By 2013, internal egos had seen Fractal grown to global aspirations; with participation by festival groups from Costa Rica (Envision), Portugal (BOOM!), South Africa (AfrikaBurn), Canada (Shambhala), Australia (Serpent Rainbow and Maitreya), and New Zealand (Luminate), FractalNation now became a Fractal Planet as the village population topped 500 for the first time, and even included a pair of visiting Shivite sadhus from India. Essentially a microcosm of the rapidly expanding world of transformational festivals, Fractal Planet was a huge project, which featured a giant visionary art gallery dome replete with exterior projections, a separate MAPS speakers' dome, the Zendo, and a huge, shaded dance floor that accommodated thousands beneath a dramatic mainstage designed and created by one of the leading California-based visionary artists, Michael Divine.

Michael Divine (1976–) is originally from Connecticut. After two years studying writing and comparative religion at Syracuse University, Divine excused himself to pursue his alternate studies as a painter more seriously. An original and unusually skilled self-taught artist, Divine was inspired early on by the power of transcendence in music, and then eventually in art in general. Divine offers in his personal mission statement on his website (www.tenthousandvisions.com):

> I decided that's what I wanted out of my artwork—to tap upon that is-ness—to dance and play with it—to love and cry and learn and fly. That is the heart at the core of my work—touching that

which cannot be touched, naming that which cannot be named, and expressing the vast ineffable inexpressible is-ness.

At times, it might seem hard to catch that which cannot be caught—to find it—dance with it—as soon as you reach, it is gone. Look and it has vanished. My work is about that, too. It's about that dance. The parts that seem ugly or chafe against me or rub me the wrong way—the parts where there is longing, a desire for a connection, the illusion of shells, of skins, of perceptions. It's about all of it.

Divine's painting *The Glass Onion* is another well-known and highly regarded work of early twenty-first-century visionary art. In 2014, he published a book of his artwork, titled *The Sublime Dance,* through crowd-funding; the book features an introduction by Alex Grey and a foreword by Martina Hoffmann. Divine and his wife, Violet, were also responsible for the highly visible mural *Convergence* on the outside of the old church in Venice Beach, California, that is home to the Full Circle spiritual community center founded by former child TV star Andrew Keegan, and was famously raided by the LAPD vice squad for serving the fermented beverage kombucha at its meetings!

Michael Divine's elaborate stage and surrounding environment was the largest of the three Fractal productions, and was home to five days of almost seamless music and integrated performance, notably including (on the Saturday night of the 2013 Burn) two of visionary culture's premier acts, both with original music supplied by Tipper, Burning Man's most beloved EDM producer; the Lucent Dossier Experience, an avant-garde circus and performance troupe from Los Angeles; and *Phadroid,* a digital-dance collaboration between Android Jones, and his then-wife Phaedra.

Whether one has had a healing experience or a beautiful vision, a mystical insight or a sense of spiritual transcendence, some rapturous sensory enhancement or a revelation that reveals hidden dimensions in the mind and nature, the creative spirit seeks to express these profound and powerful experiences through

the medium that it finds most effective. As our species continues to evolve, as we grow smarter and more aware, our artistic ability to express these extraordinary states of consciousness will surely grow and develop into realms that we can now hardly conceive of.

DAVID JAY BROWN, MAPS BULLETIN VOLUME 22

As outlined in a previous chapter, from its earliest murky beginnings, performance art has played an important role in the development of visionary culture, and from Alex and Allyson Greys' performances in the late seventies and early eighties and Pepe Ozan's original Burning Man operas onward, there has been a significant body of what can be considered as visionary performance.

Founded by Lightning in a Bottle cofounder Dream Rockwell from an inspiration by the installation artist Shrine On, the Lucent Dossier Experience is regarded as the top performance troupe in transformational festival culture, and it is now evolving well into its second decade.

Lucent Dossier's first performance was for the 2004 Sea of Dreams event at the Park Plaza Hotel in Los Angeles and featured twenty-one performers, all dressed in white, with tribal body paint, bones, feathers and Victorian lace. Since this time Lucent Dossier has evolved into a highly sophisticated music, dance, and performance troupe, integrating live musicians with original electronica and cutting-edge dance, fire, and aerial performances, into a kind of psychedelic tribal version of Cirque du Soleil. Wikipedia notes:

All the performers dress in fantastical costumes and makeup unique to Lucent Dossier, the costuming consisting of recycled and found objects that might include the bones, wings, teeth and feathers of animals found dead either on the side of the road or in the forest. They are known for their custom body airbrush tattoo makeup, a look they originated in 2005. This tribal body art gives them their signature otherworldly, haute couture look. (Wikipedia, "Lucent Dossier Experience)

The Lucent Dossier Experience has now performed all around the world, and has been a mainstay at both Coachella and Lightning in a Bottle since 2005. With a host of performers and acts involving fire performers and high-flying aerials, a Lucent Dossier performance is no small feat, and the Michael Divine stage at Fractal Planet had to be specially designed for their elaborate show, which was the first time they had performed at Burning Man.

After Lucent Dossier's performance on Fractal's final (Saturday) Burn night in 2013, FractalNation founder Android Jones and his wife, Phaedra, enacted their own visionary performance, the remarkable dance-and-projection performance *Phadroid*.

Born in Hungary and classically trained in ballet, modern dance, and theater, Phaedra performed dressed in white, her solo dance performance a stark contrast to the mayhem of the Lucent Dossier Experience. Every eye in the massive audience was glued to her movements as she possessed the stage as if dancing in a deep sustained trance, while with his portable digital rig hanging from his hip, Android Jones live-painted fractaling digital images of molecules, butterflies, and exploding nebulae that were individually projected upon her, each floating image seeming to know telepathically where she would next appear.

A stunning visual feast that at its sublimest heights touched on magic, by the time that Saturday night at Burning Man was over, the appreciative audience at Fractal Planet knew that although very different in style, they had just been witness to two of the most cutting-edge visionary performances ever conceived. As the Fractal Collective's final act, it was a suitably psychedelic way to go out.

31

BEYOND 2012

Creating the Visionary Age

The main thing to understand is that we are imprisoned in some kind of art.

TERENCE MCKENNA

In his book *The Tribes of Burning Man: How an Experimental City in the Desert Is Shaping the New American Counterculture*, Steven Jones, city editor for the *San Francisco Bay Guardian*, defines Burning Man's renaissance period as taking place between 2004 (when Larry Harvey conceived of the Ten Principles and the gift economy, and when Jones first went to Burning Man) and 2010. (His book came out in 2011.) Personally I would begin the period either in 2000, with David Best's first major temple, or in 2002, with the Floating World theme memorable for the arrival of the La Contessa art car on the playa. (And ironically the year the airport went in.) In the following year, 2003, theme camps broke 500 for the first time, and the amount of placed art on the playa doubled from 120 installations to over 260.

I would also end this period around 2013—FractalNation's final year at Burning Man—although an argument could easily be made that it should be 2011, the first year that the event completely sold out, signaling the beginning of a ticketing crisis that effectively ended the

stability of the original Burning Man community. (Attendance grew from 25,000 to nearly 70,000 in this period, while worldwide demand far exceeds supply.) Or it could equally easily be said that this first period ended with the arrival of the much-anticipated 2012 Mayan calendar date that José Argüelles, Terence McKenna, Daniel Pinchbeck, and Nassim Haramein had greatly popularized, and the subsequent disappointment after this date came and went and, despite some claims to the contrary, nothing of note actually happened.

In October 2012, The DoLaB and Symbiosis combined forces to hold an Eclipse Festival in Australia with local promoters, and then, for the actual Mayan Long Count date in December, the DoLaB elected to hold a festival at the Great Pyramid in Egypt, while that country was in the middle of civil unrest that bordered on civil war. In the Yucatán in Mexico, two different festivals were held around December 21, 2012 that were reported to be organizational and environmental disasters by independent observers. After the excitement and purpose of the buildup (irrational as it might have been) for visionary culture heading into the 2012 date, the cold reality afterward was that the world still had a long way to go before any significant change would be made.

Fractal Planet in 2013 was in many ways a microcosm of transformational festival culture at that time. We grew too big, too fast, and in the end, we burned out under the weight of our own lofty intentions. These days the Burning Man organization—with Larry Harvey as the mouthpiece—is trying to justify the influx of Silicon Valley millionaires by claiming that it is this group—the 1 percent, as Harvey calls them—that have backed many of the art projects and artists on the playa for many years. While this may be true in some cases, these sources rarely seem to back artist collectives or performance camps, and while FractalNation had some angel donors, it never received any major largesse from Larry's 1 percent. The majority of funds were raised by events in San Francisco and Los Angeles, crowdsourcing, camp dues, and off-playa sales of art. In the end the Fractal Collective ended up more than $60,000 in debt after our three years on the playa, one of the main reasons FractalNation has never returned.

While $60,000 is a significant debt for a collective of artists who worked for free (or at varying degrees of their own expense) for months to create a remarkable collective vision, this sum is insignificant compared to the money that is being spent at Burning Man each year now that it has attracted the attention of the global elite. For Burning Man itself—the godfather of all transformational festivals—is also at a crisis point of sorts, a losing battle between the counterculture artists who have created the first twenty years of visionary community there, and the influx of the global mega-wealthy who are successfully turning Burning Man into their own private psychedelic playground. Making it, as one longtime and highly respected playa billionaire remarked, echoing my own sentiments exactly, "the new Ibiza."

Community—which has always been the byproduct of the Burning Man experiment—has become irrevocably commodified with the sale of the Burning Man board in 2011 to Silicon Valley interests with their own ideas and agendas. (Board members include a "Rock 'n' Roll" hotelier, and a TV mass marketing executive.) Today the 75,000+ tickets available for Burning Man are gone in fifteen minutes, and going to the playa has become the counterculture equivalent of winning the Golden Ticket to Willy Wonka's Chocolate Factory. Larry Harvey, the "founder" of Burning Man and, despite all the politics, still its most public face, seems to sincerely believe that much like Eleusis (where you could only go once), a single trip to Burning Man is enough to change you for life, and he is apparently intent on pumping as many people through the experience as he can. Harvey himself clearly enjoys his fame and his relationship with Silicon Valley and big money in general, and to long-time Burners who have watched as this drama has unfolded over the past twenty years, he increasingly resembles a bloated and decadent Medici Pope, extending his hand to the celebrities and high-rollers that roll in straight from the airport on art cars to kiss his golden ring.

With this increasing pampering to Billionaires Row (thanks to the enlarging of Black Rock Airport in order to allow their private jets to land), and the death of the DIY ethos thanks to the invasion of plug and play hotel camps that circumvent the ticket lottery by charging up

to $20,000 per person for the week, either violating or making a mockery of virtually all of the Ten Principles,* increasingly only pockets of the original Burning Man community remain. As the average cost of a week at Burning Man steadily increases, a smug and self-congratulatory transient population guarantees that the managed spectacle of Burning Man will only continue to grow, but the original community is unlikely to ever return to the close-knit and idealistic nature of those renaissance years of the first decade of the twenty-first century, just as it will never return to those lawless days of John Law's pre-1996 Burning Man. If there is one thing the first twenty years of Burning Man seems to have taught us, it is that evolution cannot be denied, or even necessarily influenced.

However, if community is the byproduct of the Burning Man experiment, then providing a venue for visionary art must be its central purpose. And although the community is challenged by the enormous influx of money and the high volume of new arrivals onto the playa in recent years, the art has only grown grander. Burning Man is first and foremost the crucible of the visionary art movement, and with this influx of wealthy international patrons, the art has gotten larger and more ambitious, creating exponentially more fame and opportunities for visionary artists of all varieties.

With its unique large-scale, often interactive or kinetic sculptures, and now numerous visionary art galleries and speakers' series, Burning Man performs the same vital function for visionary art that the Salon des Refusés did for the Impressionists: it provides a popular venue for art outside the mainstream to prove its enduring appeal. Each year, as millions more dollars are spent on creating art specifically for Burning Man, the argument for regarding visionary art as a real genre steadily grows. In 2015, grants for art at Burning Man broke a million dollars for the first time, with 326 placed pieces of art. This number repre-

*Larry Harvey's ten Principles are as follows: Radical Inclusion, Gifting, Decommodification, Radical Self-Reliance, Radical Self-Expression, Communal Effort, Civic Responsibility, Leave No Trace, Participation, and Immediacy.

sents only a fraction of the money spent annually on art at the festival. Mutant vehicles and theme camps, for example, are not included in these.

Meanwhile, over these same five years, the number of transformational festivals (piggybacking somewhat on Burning Man's success) has exploded all over the United States and the world, with crowds that are increasing exponentially in size. The transformational festival meme is rapidly on its way to becoming a youth fashion, with more mainstream events like Coachella, Electric Daisy Carnival (in Las Vegas), and Voodoo Fest (in New Orleans) utilizing more and more of the artists and performers that have evolved out of the last decade of visionary culture, while the tribal and steampunk fashion styles are also increasingly penetrating mainstream culture. The same is occurring with festivals in Europe as they witness the success of festivals like BOOM! and Ozora. (One commentator in the national press in 2016, who had only been going to Lightning in a Bottle for the past five years, remarked on how much noticeably younger the majority of festival-goers had become since he had started attending.)

As these festivals have grown and become more successful, many are becoming increasingly conservative as well, as a style and pattern for transformational festivals has been established and organizers strive more for commercial success. On both major continents, the same hundred or so musical acts—DJs and EDM producers mostly—seem to travel the festivals in an increasingly predictable circuits (most sharing the same management), as do the same small army of visionary artists, festival workers, and vendors. Concerned that they may be prosecuted under the Crack House law,* transformational festival promoters in the United States are increasingly wary of having speakers talk about psychedelics—once the mainstay of any transformational festival speaker series. They prefer less controversial (though equally worthy) topics, like alternative currencies or permaculture, or more fantastic ones, such as the alien channeling

*As was "Disco Donnie" (now one of the most successful EDM promoters in the world) for a rave in New Orleans in 2001.

of Bashar, or the embarrassing Flat Earth Panel at LIB. This tendency toward New Age fantasies in turn unfortunately discredits the practical psychedelic information being presented to the mainstream world.

While the increasing success of these ever-larger festivals also leads to greatly increased opportunity for all the various electronic music producers and visionary artists involved, it also leads to an increasing environmental impact, invariably causing many longtime attendees to ask if transformational festival culture has now become more of a fashion that somehow lost sight of its original serious intention.

The increase in popularity of visionary art, and the need for installations and visionary galleries at the expanding number of festivals and cultural events has also led to the increasing inclusion of numerous new artists who currently lack the years of training and dedication shown by Robert Venosa and Martina Hoffmann, Alex and Allyson Grey, and the Tribe 13 artists. While I would argue that visionary art is like Surrealism in that it is more of a philosophy than a necessarily recognizable style, with the increase in less skilled artists (and the relative ease of creating rudimentary digital art), there is now a dangerous dilution of the genre that is resulting in a recognizable visionary template—a corny quasi–Alex Grey/Android Jones imitation, often replete with sacred geometry and basic fractaling images. Thanks to the broad reach of the internet, visionary art has also influenced street art and graffiti in the past decade, and is even influencing local tourist art in places like Bali, India, and Latin America. As its popularity increases from this global digital exposure, and with few shows of original paintings to convince a more knowledgeable public, visionary art risks becoming a cliché. Barely twenty-five years since the publication of *Sacred Mirrors,* both visionary art and visionary culture are already standing at some kind of a crossroad.

Ironically, however, just as contemporary visionary culture looks as if it may stumble into mere fashion in its quest to educate the rest of the world about the value of entheogens, suddenly in this second decade of the twenty-first century it appears that mainstream society has begun to reappraise psychedelics on its own.

In the decade since the first MAPS conference in 2006, research on psychedelics has begun to return to the universities in a number of forms, most promisingly for their potential as cures for depression and post-traumatic stress disorder, and for helping end-of-life patients in their final months. The progress of these experiments has been reported on positively in the mainstream press, notably in the *New York Times,* the *Washington Post,* and the *New Yorker.* Twenty-eight hundred people from forty countries attended the MAPS Psychedelic Sciences 2017 conference in Oakland, with a considerable amount of international media attention. This was the largest conference on psychedelics ever.

Conversation about LSD as a source of inspiration and creativity also unexpectedly returned to mainstream conversation with the publication of the authorized biography of the late founder of Apple Computers, Steve Jobs (titled *Steve Jobs*), which was released nineteen days after Jobs's death in 2011. One of the many things that were revealed in the biography, and much commented on after Jobs's subsequent canonization as a genius, was his positive relationship with LSD, ostensibly while he was at college. According to Jobs:

> Taking LSD was a profound experience, one of the most important things in my life. LSD shows you that there's another side to the coin, and you can't remember it when it wears off, but you know it. It reinforced my sense of what was important—creating great things instead of making money, putting things back into the stream of history and of human consciousness as much as I could.

Jobs's biography also revealed that he was less likely to hire you if you *hadn't* taken LSD—by his estimation, LSD made a person more likely to "think out of the box," which was the kind of designer and executive that Jobs wanted at Apple.

While the connections between psychedelic culture and Silicon Valley have been well-documented in John Markoff's fascinating book *What the Dormouse Said: How the Sixties Counterculture Shaped the*

Personal Computer Industry), Jobs's enthusiastic endorsement of LSD turned a lot of mainstream heads, and especially among the heads of industry themselves. Was LSD in fact not a worthless hippie drug after all, but rather a closely guarded Silicon Valley secret, the source of Jobs's creativity? The revelation in 2014 that Eric Schmidt's final test before being announced as the CEO of Google back in 2001 was going to Burning Man with Sergey Brin and Larry Paige only reinforced that perception, along with the well-publicized takeover of Burning Man by the Silicon Valley tech elites in recent years, and the founding of their own Burning Man–inspired event: Further Future, held outside of Las Vegas. A desert festival featuring a full spa, virtual-reality booths, and pep talks from tech startup billionaires, this may be the new model for networking in the twenty-first century.

Following the publication of *The Psychedelic Explorers Guide* in 2011 by James Fadiman, a Bay Area psychologist and underground psychedelic therapist with long ties to Silicon Valley (and to a lesser extent my own article "Psychedelics and Extreme Sports," see chapter 10), the mainstream media become increasingly fascinated with the concept of *microdosing:* the idea of taking tiny, nonpsychedelic amounts of LSD to promote clarity and creativity.

Currently microdosing is the hottest topic in psychedelics, with the therapeutic properties of MDMA, psilocybin, ketamine, and LSD (for curing depression and PTSD, and for end-of-life patients) a close second, followed by a growing interest in the transpersonal properties of 5-MeO-DMT—another compound that many underground therapists believe would be of immeasurable value to end-of-life patients. As federal legalization of marijuana grows closer—the American Medical Association has finally admitted that cannabis is an effective medicine for numerous conditions—the days of regarding psychedelics as dangerous compounds with no positive benefits may slowly be coming to an end. The possibility for a new era for visionary culture in the mainstream hovers tantalizingly on the distant horizon.

32

AKSHARDHAM

The Visionary Wonder of the World

BAPS Swaminarayan Akshardham in New Delhi, India, is the world's largest comprehensive Hindu temple. It measures 356 ft (109 m) long, 316 ft (96 m) wide and 141 ft (43 m) high, covering an area of 86,342 sq ft (8,021.4 m². The grand, ancient-style, ornately hand-carved stone temple has been built without structural steel within five years by 11,000 artisans and volunteers. [. . .] Akshardham showcases the essence of India's ageless art, borderless culture and timeless values.

CERTIFICATE PRESENTED BY
GUINNESS BOOK OF WORLD RECORDS

Other remarkable examples of contemporary visionary art exist outside of the narrow corridor of the Western visionary tradition that I have mostly focused on thus far. In India, long famous for its dizzying array of temples, shrines, mosques, and churches—Hindu, Jain, Buddhist, Muslim, Christian, Zoroastrian—this vibrant, visionary tradition continues today, notably with the construction of the remarkable Swaminarayan Akshardham in New Delhi in 2005, a Hindu mandir that is quite possibly the most impressive example of visionary art ever created. (In Sanskrit, *mandir* means a place where the mind becomes

still and experiences inner peace. Often, as here, it refers to a temple.)

Akshardham is a spiritual and cultural campus in India's capital city. The temple sits near the banks of the Yamuna River and draws an estimated 70 percent of New Delhi's visitors. According to Swaminarayan Hinduism, the word *akshardham* means "the abode of God" and is believed by followers to denote a temporal home of God on earth. The inspiration had come to build the temple in 1968 from Yogiji Maharaj, then spiritual head of BAPS Swaminarayan Sanstha, who had a vision of a grand temple built on the banks of the Yamuna. Attempts were made to start the project, but little progress was made, and in 1971 Yogiji Maharaj died. Then in 1982, Pramukh Swami Maharaj, Yogiji Maharaj's successor as the spiritual head of BAPS, resolved to continue fulfilling the dream of his guru, and prompted devotees to look into the possibility of building a temple in Delhi. Pramukh Swami Maharaj stood firm in following the wishes of Yogiji Maharaj to build a temple on the Yamuna, and in April 2000, after eighteen years of negotiations, 90 acres of land were provided by the Delhi Development Authority and the Uttar Pradesh Government.

Upon receiving the land, Pramukh Swami Maharaj performed *puja* (an act of worship) on the site for success in the project. Construction on the temple began on November 8, 2000, and on July 2, 2001, the first sculpted stone was laid. Design of the temple was entrusted in a team of eight sadhus consisting of scholars in the field of the *Pancharata Shastra,* a Hindu scripture on architecture and deity carving. The sadhus watched over the stonework as well as carrying out the research on carvings on Indian craftsmanship from between the eighth and twelfth centuries.

An extraordinary artistic accomplishment that celebrates India's long spiritual and cultural history,* Akshardham is constructed entirely without steel or concrete, from architectural techniques mostly unused

*Along with the main mandir (temple) itself, the complex includes a Disney-style boat ride through the history of India, and an iMAX theater screening a Bollywood-made movie (with a cast of forty thousand) about the swami's seven-year journey around India as a legendary thirteen-year-old yogi, Nilkanth Varni.

in eight centuries, with seven thousand carvers and three thousand volunteers put to work during the construction, who provided 12 million hours of skilled work and 300 million hours of volunteer labor. (Among the carvers were local farmers and fifteen hundred tribal women who had suffered from a drought and received economic gain from this work.) With over six thousand tons of pink sandstone coming from Rajastan, workshop sites were set up around different sites within the state, as each night over one hundred trucks were sent to Akshardham, where four thousand workers and volunteers worked on the construction daily.

The initial stonecutting was done by machine, while the detailed carvings were done by hand. The mandir features the Gajendra Pith around its base, a plinth paying tribute to the elephant for its importance in Hindu culture and India's history, which contains 148 life-sized carved elephants, weighing a total of 3000 tons, while the temple itself contains 234 ornately carved pillars, and is intricately carved with flora, fauna, dancers, musicians, and deities, including twenty thousand *murtis** of sadhus, devotees, and *acharyas* (learned men). Nine massive domed ceilings carved from Italian marble complete the interior. Sublime beyond belief, these resemble more than anything that intense symmetrical fractaling of reality that you experience after blowing out a big DMT hit.

Inspired by an inner vision, the mandir is recognized as the largest Hindi temple in existence and is unquestionably one of the most beautiful. One of the most psychedelic sights you could ever hope to see, Akshardham is, as Luke Brown first described it to me, *the* Tryptamine Palace, and arguably the single greatest artistic achievement of the twenty-first century so far.

Akshardham was consecrated on November 6, 2005—incredibly, only five years after work had begun—by Pramukh Swami Maharaj and was ceremoniously dedicated to the nation by the president of India,

*A murti is a physical embodiment of the Divine, where the carving and the deity become one.

Dr. A. P. J. Abdul Kalam, in the presence of twenty-five thousand invited guests. After touring the central monument, President Kalam then gave a speech on where Akshardham fits within Indian society, and finished by saying;

> Pramukh Swamiji Maharaj has inspired thousands of people across the country and abroad and brought together the best of the minds for creating a beautiful cultural complex. It has become a place of education, experience, and enlightenment. It creatively blends the traditional stone art and architecture, Indian culture and civilisation, ancient values and wisdom and the best of modern media and technology. Multiple layers of this complex expresses the strength of the mind, willpower of the human being, indomitable spirit, flowering kindness, fusion of scientific and medical talent, myriad colors of varied cultures, and ultimately the power of knowledge. In essence, it is a dynamic complex with lively images. [. . .] Akshardham has happened at the dawn of twenty-first century with the commitment and dedication of one million volunteers. What has happened today at Akshardham inspires me and gives me the confidence that we can do it. The realisation of developed India is certainly possible before 2020 with the millions of ignited minds like you.

33

DREAMING OF THE LIGHT

The Promise of Visionary Art and Culture

*Visionary art is subversive in its message to the world, [. . .]
in the sense that the common mind cannot entirely escape
the subliminal force planted in the creation that will affect,
superconsciously, whomever confronts the art. The form, color,
imagery, energy and spirit in the work, contain the seeds of an
awakening and, unbeknownst to the observer, the first stages of
allowing experience to follow suit. And from experience comes
knowledge, followed ultimately by wisdom.*

ROBERT VENOSA, INTERVIEWED
BY MARTINA HOFFMANN, MAPS BULLETIN VOLUME 22

In 2015, the remaining members of the Grateful Dead sent a wave
through the psychedelic community when they banded together for
one "final" mini-tour. As a sign of both their enduring popularity and
of how much times have changed, tickets for their "final" performance
in Chicago reputedly exchanged hands for as much as $13,000, with
an average price of around $600. At the Dead shows in Santa Clara,
California, the bosom of Silicon Valley itself, tie-dyed gray-haired hip-
pies and leather-and-feather Burners alike danced to the timeless psy-
chedelic tunes, while the two best-known digital visionary artists and

VJs—Android Jones and Jonathan Singer—projected their unique psychedelic visuals onto giant screens across the stage and around the stadium. Android Jones also created a Dead poster for the show in the tradition of psychedelic poster art, while Jonathan Singer—who is also Alex Grey's VJ—went on to create the visuals for the Chicago show, and is now on semipermanent tour with the various remaining band members.

The tradition of psychedelic lights and projections at Grateful Dead shows, an art form that they largely pioneered, originates with Ken Kesey and the Merry Pranksters and their original Acid Tests. Psychedelic sacred ground, Augustus Owsley Stanley's ashes were in the sound booth for these final Dead shows, and the decision to include Android Jones and Jonathan Singer on visuals would not have been made lightly. The fact that they were chosen to add their contemporary vision to the Dead's more than fifty years of psychedelic history that began at those first Acid Tests was both a recognition of Jones and Singer's reputations as the most innovative artists in their field, and a symbolic passing of the torch—a moment where classical psychedelic and contemporary visionary culture merged effortlessly as One, to the delight of the multigenerational, chemically united audience.

Psychedelic culture that night in Santa Clara, nearly fifty years after its prohibition in California first began, appears to be alive and well. Visionary art meanwhile, as one of the main catalysts of this latest psychedelic resurgence, has become the active face of this cultural wave, much like rock music was in the 1960s. Reflecting on why that might be for a moment, why artists have replaced musicians as the torchbearers of psychedelic culture, it appears that even in these days of high technology—where the skill of the live musician has been replaced by the EDM producer and his computers—people are still mesmerized by the skill and dedication to make great art.

While visionary art is often projected upon screens, and then deconstructed and rearranged for psychedelic effect, or created in front of your eyes with a live Android Jones digital painting, the fascination with the centuries-old technology of the paint brush remains. That

same ancient awe that shamanic initiates must have felt when they entered those painted Paleolithic caves can also root an entire section of a psychedelically inclined dance floor motionless as they stand and watch Alex and Allyson Grey paint, seemingly absorbing in each and every slow and careful stroke. The concentration of the viewers in a visionary art gallery at a festival is also notable. You can watch people entirely enter the art in a way that you rarely witness, the viewers—often aided by psychedelics—seemingly connecting at some deep level with the artist's intent, or losing themselves in the world that the artist creates, touched at some level by the ancient mystical process.

Meanwhile, outside in the "real" art world, the influence of psychedelics may be just as pronounced as in visionary art, only not as loudly advertised. A walk through the SCOPE art show at Art Basel in Miami—regarded as the most cutting-edge annual art show in America—reveals many paintings that could easily be psychedelically inspired, some more overtly than others. (One painting I saw at SCOPE in 2010 had a figure with a tiny shopping list hanging out of one pocket that said, "Milk, Bread, LSD . . . ")

Fred Tomaselli (1956–) is a well-known contemporary American artist whose works have been represented in numerous museum solo shows and international biennials. They are in the public collections of institutions such as the Museum of Modern Art; the Whitney Museum of American Art; the Brooklyn Museum; the Albright-Knox Art Gallery; and the Museum of Contemporary Art, Los Angeles. Tomaselli readily admits to the influence of LSD and other psychedelics in his art, and even goes as far as embedding Ecstasy pills, LSD tabs, and psychotropic plants into his resin collages.

In describing Tomaselli's work, curator James Rondeau wrote (in 2003):

> Over the course of the last ten years, Fred Tomaselli has established an international reputation for his meticulously crafted, richly detailed, deliriously beautiful works of both abstract and figurative art. His signature pieces are compelling, hybrid objects: *ersatz,* or

maybe surrogate paintings, or tapestries, or quilts or mosaics. Their various components—both over-the-counter and controlled pharmaceuticals, street drugs, natural psychotropic substances and other organic matter, collaged elements from printed sources, and handpainted ornament—are all suspended in gleaming layers of clear, polished, hard resin. Forms implode, explode, oscillate, buzz, loop, swirl, and spiral. Actual objects, photographic representations, and painted surfaces co-exist without hierarchy on and in a single picture plane. The combined effect, neither determinably real nor fully illusionistic, is at once electrifying and destabilizing.

Or alternately, according to Tomaselli's own straightforward artistic philosophy;

These chemical cocktails [embedded in the paintings] can no longer reach the brain through the bloodstream and must take a different route to altering perception. In my work, they travel to the brain through the eyes.

Of all today's contemporary artists, it is the Taiwanese-American James Jean (1979–) who is most universally admired by today's tribe of younger visionary artists, and the one they would most love to claim as one of their own.

Jean, virtually straight from art school in 2001, started an extraordinary early career as an illustrator, finding early fame for his *Fables* covers for DC comics. Other clients included *Time* magazine, the *New York Times, Rolling Stone, SPIN* magazine, ESPN, Target, and Atlantic Records, among others. In 2006 Jean also won the prize for Best Artist at the World Fantasy Awards.

Making the jump to the commercial art world, Jean then hit gold with the clothing giant Prada in 2007, creating a mural for their Epicenter stores in New York and Los Angeles, and a backdrop for the spring-summer Prada show in Milan. Aspects of the Epicenter mural and the Milan wallpaper were transformed into clothing, handbags,

shoes, and packaging. Prada undertook a global campaign that featured Jean's work in advertising environments, animation, and special events, and in 2008, Jean again collaborated with Prada, developing an animated short based on the wallpapers, clothing, and accessories produced in 2007. He wrote, storyboarded, and did the visual development for the animation, which would be eventually titled "Trembled Blossoms," taken from the poem "Ode to Psyche" by John Keats.

Then, later in 2008, Jean shocked the world by announcing that he was retiring from illustration and commercial art to concentrate on painting. (His first solo show was at the Jonathan Levine Gallery in New York in 2009, which has also had shows by Kris Kuksi, Oliver Vernon, and Mars-1.) A skilled life-drawing artist who is constantly sketching, Jean's large paintings feature mythical, almost hallucinatory, cosmological landscapes, in lush, bright, and often contrasting colors, often replete with whimsical or erotic imagery, and even the occasional mushroom. Jean is a dedicated jazz trumpeter, and there is a lyrical and allegorical quality to Jean's canvases that reminds me of the best of Luke Brown's or Android Jones's work. Like those leading visionary artists, Jean is just as comfortable with Photoshop as he is with a pencil or paint brush, saying, "There are circles where Photoshop is anathema, but not in any that I travel" (quoted in Ryan, "In the Jeans: An Interview with James Jean"). He also says that everything he does has its root in paper drawings, be they oils or Photoshop. In the winter of 2015, Jean was chosen by Apple to help launch the iPad Pro and Apple Pencil.

With highly successful solo shows in New York and Los Angeles, and commissions for large-scale murals from museums, James Jean is regarded as one of the most important and exciting contemporary artists in the world today. The leading example of the collapse between commercial art and fine art, highbrow and lowbrow, Jean observes, "That's assuming there are these two static worlds that never mingle, when it seems that culture and money, in particular, is making that membrane more porous." As a sure sign of his cultural uber-coolness, for Chinese New Year, 2016, Jean collaborated with Beats by Dre electronics in creating exclusive art for a limited-edition pair of headphones.

As with many great artists, Jean draws his influences from an extremely broad range of sources—including old Chinese scroll paintings, Japanese woodblocks, anatomical lithographs, mezzotints, the Japanese artist Hokusai, Shanghai advertising posters, Russian constructivist artists, and Dürer's etchings—while his work itself manages to look both strikingly modern and subconsciously familiar at the same time, with (some of) his large-scale work resembling a sophisticated melange of the best of contemporary visionary art, the psychedelic poster art of the sixties, and Latin American street murals, all filtered through Jean's own unique and highly skilled lens. Or as Jean himself said, "I think the best paintings of mine are born from the deepest recesses of the mind, from dark and surprising places."

There is also a slow but inevitable reappraisal going on of both the role of psychedelics in art and of classic psychedelic art itself.

In 2005, the Tate Liverpool Gallery in England curated an exhibition, "The Summer of Love: Art of the Psychedelic Era," which it marketed as "a ground-breaking exhibition which reveals the unprecedented exchanges between contemporary art, popular culture, civil unrest and the moral upheaval during the 1960s and early 70s." This popular show exhibited paintings, posters, sculpture, light shows, and films from the sixties Psychedelic Era, including work by Isaac Abrams, Richard Avedon, Lynda Benglis, Harold Cohen, and Richard Hamilton, as well as Jimi Hendrix's only known painting. Special emphasis was also placed on environments, and film, video, and multimedia installations, including a liquid crystal projection by Gustav Metzger, and a room with multiple projections of the Boyle Family's films, first used in light shows for the psychedelic band The Soft Machine.

The show was successful enough that it toured in Europe and later made its way to the Whitney in New York in 2007. I read a number of reviews of the Tate and Whitney shows, and generally the critics concentrated on the lowbrow aspect of the art, bemoaning a lack of skilled artists. Thus it wasn't until I interviewed Jacaeber Kastor

that I realized to some surprise that Mati Klarwein's *Aleph Sanctuary* (1963–1971) had been recreated and was on display at these shows.* (Kastor said they had to kick him out of there each day at the Whitney.) The fact that these critical reviews failed to mention one of the greatest single contributions to psychedelic art in the twentieth century, created by a highly skilled classical painter, seems to me to reveal some prejudice against psychedelic art that remains as strong as many of society's prejudices against psychedelics (and psychedelic users) themselves.

In 2011, a *New York Times* art critic called Ken Johnson released a book called *Are You Experienced? How Psychedelic Consciousness Transformed Modern Art,* in which, rather than focusing on the works of known psychedelic artists, he examines contemporary art since the 1960s. He notes that "boundaries between conventional media such as paintings and sculpture stretched and dissolved. Hierarchical distinctions between high and low culture became irrelevant. Weird new forms proliferated." Then he asks, "Would art have developed as it did in the past fifty years, and would it be the way it is now, if psychedelics and psychedelic culture had not been so popular?"

In an interview with David Jay Brown, Johnson says:

Painting and sculpture got more psychedelic in all kinds of ways—and not necessarily along the lines of conventional "psychedelic art." Painters and sculptors have explored possibilities from hallucinatory illusion-making to the unvarnished display of found objects and raw materials. The idea that there must be one dominant style like Cubism or Abstract Expressionism went out of style, at least in part, I believe, because psychedelic consciousness, excited by all things great and small, is inherently nonhierarchical. (Brown, "How Psychedelic Consciousness Transformed Modern Art")

*Much of the *Aleph Sanctuary* was recreated with reproductions, since many of Klarwein's originals have apparently disappeared, while the rest reside with a collector in Spain. It seems that Klarwein had a somewhat disposable attitude toward his work.

When asked if he thought there was a taboo about discussing the role of psychedelics and art, Johnson offered the following analysis:

> I'm not sure that the topic is taboo so much as that it has not been regarded as worth investigating. For most observers, psychedelia has been a minor blip on the sociological radar and has had little effect on art. There is a risk of embarrassment if you do take psychedelic culture seriously.

As we have seen, however, at this point early in the twenty-first century societal perceptions of psychedelics are beginning to change again. As a result, the value attributed toward psychedelic art is rising, with some of the art—an original Alex Grey or Robert Venosa, for example, already being in the six-figure range.

Personally, I am somewhat surprised that this new Silicon Valley Burner tech elite hasn't caught on more to the potential value of psychedelic art. If I were in their financially elevated position, I would want an original Mati Klarwein, or a Robert Venosa for my home, while younger artists like Oliver Vernon, Android Jones, and Amanda Sage could be filling my corporate boardroom walls. Apparently Silicon Valley and the Burner Billionaires aren't there yet, and are so far only willing to pay lip service to psychedelic culture. But as attitudes shift and the dealers in the traditional art world sense a potential market, this may quickly change also.

Six figures for a piece of art is, however, a trifling amount in the career of the neo-Pop artist Jeff Koons (1955–), the most commercially successful contemporary artist over the past thirty years. With a career that is in many ways modeled after Andy Warhol's, Koons revered Salvador Dalí so much as a teenager that he made a pilgrimage to see him at his hotel in New York. But Koons himself is the true heir of Andy Warhol's love of banality, and has taken Warhol's Factory production model to a new extreme. His current 16,000-square-foot factory in New York's Chelsea district has ninety to a hundred and twenty assistants in "art fabrication," where Koons uses a color by

numbers system to produce the art, generally in series of five.

Koons, who may be the greatest self-promoting artist of all time (he employs a team of PR and image consultants to help shape his image), first rose to prominence in the media-saturated art world of the 1980s, and then hit it big with his *Banality* series. This included a porcelain-and-gold-plated statue, *Michael Jackson and Bubbles the Chimp,* which sold for $5.8 million three years after its creation. Unlike the rest of his inflated peers of the eighties, however, Koons managed a remarkable second act in the following decade with his *Celebration* series—which, true to the form of "great art," nearly broke him with its cost and complexity, but that culminated in a 2014 retrospective at the Whitney that one reviewer called "as digestible as a pack of M&M's."

The commodities broker-turned-artist's *Balloon Dog (Orange)* sculpture from the *Celebration* series sold for $58.4 million in the same year (2013) as Warhol's *Silver Car Crash (Double Disaster)*—the highest price ever paid for a work of art by a living artist. (Jasper Johns holds the record for a painting by a living painter—$28.6 million for *Flag,* painted in 1966. Koons's own paintings have sold for over $8 million.) While Koons himself says there is no meaning to his work, and thus it is beyond critique, the renowned critic Robert Hughes wrote that Koons is:

> An extreme and self-satisfied manifestation of the sanctimony that attaches to big bucks. Koons really does think he's Michelangelo and is not shy to say so. The significant thing is that there are collectors, especially in America, who believe it. He has the slimy assurance, the gross patter about transcendence through art, of a blow-dried Baptist selling swamp acres in Florida. And the result is that you can't imagine America's singularly depraved culture without him. (Hughes, "Showbiz and the Art World")

Some of Koons's earliest art—his vacuum cleaners—were exhibited in the New York Museum of New Art in 1980. In 1986, just as Koons began his meteoric rise to the top of the art world, Alex Grey exhibited

The Sacred Mirrors at the same museum. Since that time the two New York artists have charted almost polar opposite courses, as Koons, the successor of Warhol's rejection of meaning and substance, has become the notoriously demanding darling of the modern art world, while Grey, with his peculiar mysticism, has achieved a sage-like status within twenty-first century visionary art.

Alex Grey's major contribution to art history is his willingness to publicly acknowledge the source of his own creativity as the Universal Source of all creation—the first Western artist since William Blake to so openly do so—along with the fact that he is the first modern artist to promote psychedelics as religious sacraments. This realignment of psychedelics and classical mysticism—territory mostly abandoned since Aldous Huxley, Alan Watts, and the early days of the Harvard experiment—makes me wonder if more lies behind the arrival of psychedelics and visionary art at this crucial juncture of the modern consciousness than just an evolution in art and social culture.

Synchronicity is one of the lodestones of psychedelic culture. Wherever it occurs, it appears like an affirmation of some deep truth, a flash of gnostic revelation that suggests a hidden order behind the world. Synchronicity is, as I have said, the universe betraying its intention. Therefore it was with a considerable shock of recognition that while researching this visionary art history, I noticed the following terrifying synchronicity: In 1976, Alex Grey had a psychedelic vision of Christ crucified to an atomic mushroom cloud towering over a burning city. Agonizing over the vision for four years, he finally painted *Nuclear Crucifixion,* a 114-by-124–inch representation of that vision, which he later interpreted as signifying that "Christ stood for what is good in us, and that same brutality and ignorance that murdered Jesus could someday be responsible for a nuclear war." This was his *first* psychedelically inspired painting.

Earlier, in 1969, Robert Venosa had a similar psychedelically inspired vision, which he did his best to represent in a sketch. When he showed it to Mati Klarwein, Klarwein was so impressed that he begrudgingly agreed to teach Venosa how to "paint properly," thus starting the most

important apprenticeship of one psychedelic master to another in the twentieth century. The subject of that painting? Jesus appearing in an atomic field—Venosa's *Atomus Spiritus Christi*.

The synchronicity in the fact that both Robert Venosa and Alex Grey were inspired to start their careers as visionary artists because of psychedelic visions of a nuclear Jesus strikes me as further evidence that psychedelics have arrived as an antidote to humanity's potential widespread destruction at its own hands, and that visionary art may yet be the vehicle for our redemption.

This thought then keeps circling back around in my mind to the dark, prescient message in the Rothko Chapel, and the sad death of Mark Rothko, the world's most famous artist of his time, dying by his own hand. And then I think of Abdul Mati Klarwein—the world's most famous unknown artist, by his own cheerful admission, as well as this critic's pick for the greatest psychedelic artist of all time—who, shortly before he died, surrounded by those who loved him, said: "Once I used to dream about sex, and then I dreamed about drugs, but soon I will be dreaming only of the Light again."

As an example of how the spirit of contemporary visionary art fundamentally differs from that of mainstream art, I can't think of anything more obvious than that. Visionary art—psychedelically inspired or otherwise—is the art of the spirit and the soul, the manifestation of the mystery of the light of Source into a clear vision channeled through the artist's brush, chisel, pen, or digital tablet. It is a process through which the artist in deep meditation sometimes contacts the truth that they are merely a conduit for some far greater Power. This is an art that seeks to fully celebrate all the magic and wonder possible in life, both by enlightening the artist and through creating community with the sensibility it co-creates. As an art lover, I look forward to the day when I can see with my own eyes an exhibition of all the greatest original paintings of visionary art—the best of Ernst Fuchs, Mati Klarwein, H. R. Giger, Robert Venosa and Martina Hoffmann, Alex and Allyson Grey, and of Luke Brown and Amanda Sage and Android Jones, and of Kris Kuksi,

and James Jean, and of course, with Dalí's *Hallucinogenic Toreador*—so that I can be able to fully marvel at their skill and creativity.

To really see the light in the paintings and the beauty in the vision, to be touched up close by that same mystical shamanic power, just as I am by a Monet, Van Gogh, or Rothko. Visionary art's importance (if any) in the days to come is yet to be realized, but it seems clear that today's visionary artists are the latest participants in a timeless mystical process, for they truly believe that life is art, and that creating visionary art is as good for the soul as any religion. Together they form a collective vision that is in itself a mode of prayer, a gnostic evocation of our ever-evolving relationship with the Creator-Artist—or the Divine Mind, as the New York art critic Ken Johnson calls it—that represents the brightest hopes and aspirations of all humanity. Certainly far more so, one would hope, than a giant polished stainless-steel sculpture of a balloon dog.

34

THE FURTHERRR COLLECTIVE AND OTHER IMPORTANT CONTEMPORARY VISIONARY ARTISTS

Nearly every generation produces a visionary artist; and nearly every artist produces at least one visionary painting.

MARTINA HOFFMANN

Since this is a personal and far from complete history of visionary art, there will be many fine painters and important events that I will have left out, either because of the direction of the narrative or because of ignorance of my own. In an effort to remedy this, I would like to mention the following important contemporary visionary artists.

Laurence Caruana (1962–), is a Maltese painter, writer, and lecturer who apprenticed under Ernst Fuchs for a year in 2000, and who now teaches visionary art seminars; his work is popular at the galleries of the European psytrance festivals. Caruana is also responsible for the webzine *The Visionary Revue,* which has documented the evolution of the

contemporary visionary art movement, and he is the author of the *First Manifesto of Visionary Art.*

According to Caruana's definition:

> Where Surrealists tried to elevate the dream-state into a higher reality (and opposed the use of narcotics) the Visionary artist uses all means at his disposal—even at great risk to himself—to access different states of consciousness and expose the resulting vision. Art of the Visionary attempts to show what lies beyond the boundary of our sight. Through dream, trance, or other altered states, the artist attempts to *see the unseen*—attaining a visionary state that transcends our regular modes of perception. The task awaiting him, thereafter, is to communicate his vision in a form recognizable to "everyday sight." (http://visionaryrevue.com/webtext/manifesto1.html)

Maura Holden (1967–) is a highly skilled self-taught painter from Philadelphia whose work has evolved entirely independently of the Tribe 13 collective, and yet who is emerging as one of America's greatest visionary talents. Holden says that she spent most of her youth in a "multidimensional daydream," and her work has always featured inner landscapes populated by spirits and supernatural beings. Initially influenced by the surrealists, Holden knew that she had found her spiritual lineage as a painter when she was introduced to the works of Ernst Fuchs at the age of twenty-four. After her first solo show in 2002, she participated in two year-long group shows at the American Visionary Art Museum.

In 2003, Holden "embarked in an experiment in consciousness" when she retired to a hermit's cabin in rural Vermont and began a new shamanic nature-oriented phase. For three years, she remained in the cabin, without running water, electricity, or the media. Secluded in the forest, she experienced a suspension of time and ordinary perception, and rediscovered, through astral journeys, what she came to think of as the archaic human mindset, brimming with myth, magic, and archetypes (www.vagallery.com/maura-holden.html).

Describing this experience as "a death and rebirth," Holden emerged from her seclusion with a new body of work. In 2006 she created her own website, and before long the publisher Jon Beinart discovered it and included her work in *Metamorphosis: 50 Contemporary Surreal, Fantastic and Visionary Artists*. Around 2007 she became pen pals with Laurence Caruana, eventually leading to her direct participation in the Visionary Art community. In 2011 she joined Caruana, Amanda Sage, and A. Andrew Gonzales in teaching the "Visions in the *Mischtechnik*" seminar, in Tori Superiore, Italy, where she led a drawing intensive.

"Psychedelics are very important to me," Holden says:

I'll go so far as to call them my sacraments. To me, they are absolutely sacred allies [. . .] Mind you, I don't recommend psychedelics to others. People have different experiential capacities. Some people can be psychically injured, or swept into harmful delusions, or they may just never break through into the profound . . . That said, I'll maintain that under their influence I have traveled through the most sublime and terrifying realms, and beyond all realms—into the Great Unity. The images for all of my major pictures have come to me under the influence of psychedelics. (https://transpersonalspirit. wordpress.com/2012/08/24/visionary-art-maura-holden)

Oleg A. Korolev (1968–) is an exceptional Russian visionary artist who is a founding member of the Society for Art of Imagination, and who studied under Ernst Fuchs in 2004. According to Korolev's philosophy:

(a) Transcendental part of human nature always looks for its own Eternal source and inevitably has doubt regarding visible reality. The conditionally perceived illusionary surroundings require examination and overcoming, [. . .] Surrealism, through its inner absurdity and paradoxes, destroys trust in reality. It is an aesthetic game of the human imagination with a nostalgia for everlasting spiritual liberty.

But visionary art has a different field of the play, the Contemplative artist is a participant of the action himself, he doesn't play with the help of mind by the symbols and their mechanical constructions anymore, but operates with energies, forces which bear the images, intuitive way [. . . .] A Visionary artist can not be Atheist, he always serves a certain Power and represents it by own creative activity and life. I would describe my art as a Contemplative one, which embodies a certain cognitive model of Mystic Reality and actually devoted to a Contemplation of a beauty of invisible Divine things. (www .visionaryrevue.com/webtext0/korolev.html)

Carrie Ann Baade (1974–; carrieannbaade.com) is another very skilled and talented American visionary painter whose work initially evolved independently of psychedelic culture. Living in Tallahassee, Florida, she is an associate professor in the fine arts department at Florida State University. Her oil paintings blend "dense, imaginative contemporary and classic symbology with luminescent color, often featuring themes of mortality, sexuality, personal transformation, and the darker side of human nature," according to Wikipedia ("Carrie Ann Baade"). Increasingly well-known as a rising pop surrealist, Baade has had numerous solo shows and has exhibited in group shows alongside fantastic realists including Fuchs, Giger, and Kuksi, and lowbrow artists like Robin Williams and Mark Ryden. In 2011, Baade curated "Cute and Creepy," a large group exhibit at the Museum of Fine Art at Florida State University that included many of the biggest names in the contemporary pop surrealism movement. This represented a major cultural shift since it was the first time works of this genre had ever been presented in a major show in an academic museum setting.

Emma Watkinson (1973–; emanations.co.uk) is a talented English painter with a keen interest in Druidry and the Kabbalah. Her sprawling mythological paintings remind me of Mati Klarwein's at times, and she was a painting assistant for Ernst Fuchs in 2012.

A recent favorite of mine, Naoto Hattori (1975–), is a Japanese-born artist who received a BFA in illustration from the School of

Visual Arts in New York in 2000, and is now considered a rising pop surrealist star. While his work is clearly psychedelic, Hattori says about his art:

> My vision is like a dream, whether it's a sweet dream, a nightmare, or just a trippy dream. I try to see what's really going on in my mind, and that's a practice to increase my awareness in stream-of-consciousness creativity. I try not to label or think about what is supposed to be, just take it in as it is and paint whatever I see in my mind with no compromise. That way, I create my own vision. (www .wwwcomcom.com/artist.html)

Kathryn June "Ka" Amorastreya (www.serpentfeather.com) is a Texas-born painter and performer who now lives in California. Best known for her festival performances in her self-made feathered costumes, Ka has been painting since 2002, and often shows with the Tribe 13 artists. She is also a founding director of the Visionary Art Foundation.

Bali is the home to a significant population of visionary artists, attracted to both the island's artistic heritage and its low cost of living. Mark Lee (www.somnio8.com), originally from South Wales, is another remarkably talented visionary artist. Graduating with a degree in 2D animation, Lee entered the video gaming industry, spending four years developing concept games in augmented reality for the London studio of Sony Computer Entertainment. In 2005 he resigned after the London bombings and began a spiritual pilgrimage that brought him to Bali, where he lives today and concentrates on his masterful oil paintings of mythical figures and landscapes. A guest instructor at the Vienna Academy of Visionary Art, Lee is capable of rendering ideas and designs in quick pencil sketches, then translating those designs via computer rendering into more elaborate creations through scanning, refining, reprinting, and redrawing. These, in turn, may be virtually augmented and realized into 3D models for printing or sculpting—allowing Lee to explore whole new vistas of vision and creation.

In the United States, Lee is represented by an Oakland-based art collective, the Phaneros Family, that also includes Jonathan Solter, Bernard Duaine, Hannah Yata, Jack Sure, and other San Francisco Bay artists. These Phaneros Family artists have painted a number of large collaborations at West Coast festivals in recent years.

Originally from San Francisco, Jake Kobrin (jkobrinart.bigcartel.com) is a painter versed in acrylic, oil, and digital paintings; like many contemporary visionary artists, he also designs tapestries, wall hangings, clothes, and jewelry.

Jessica Perlstein (www.dreamstreamart.com) is another up-and-coming Bay Area visionary artist. She graduated with a BFA in 2006 and subsequently spent time in the jungles of Peru on her personal spiritual quest. Upon returning to the thriving music scene of the Bay Area, she found she could combine her two passions of art and music as a live painter. In 2011 she apprenticed with Android Jones and participated in his "Seeing Is Believing" tour, which brought interactive live digital painting to festivals along the West Coast. Jessica remains a popular and enthusiastic presence on the transformational festival scene and is now invited to travel internationally to paint along with a number of other talented American artists, such as Colorado's Randal Roberts, Morgan Mandala, and other skilled painters.

THE AMAZONIAN SCHOOL OF AYAHUASCA PAINTERS

South American visionary painters, for whom the painting of visions respects hundreds, if not thousands, of years of shamanic tradition, deserve a special mention. Classically untrained and far outside the classifications of world art history, these South American painters have produced some of the finest visionary classics.

Pablo Cesar Amaringo (1938–2009) was an acclaimed Peruvian painter who for many years was a *vegetalista,* a shaman in the mestizo tradition of healing, but who abandoned that practice for art, help-

ing run the Usko-Ayar School of Amazonian Painting in Pucallpa, Peru. Amaringo's work came to the attention of the world's psychedelic community when Dennis McKenna and Luis Eduardo Luna discovered him living in poverty and selling the occasional painting to tourists. Luna suggested that Amaringo paint a series of his ayahuasca visions, which became the basis for the book *Ayahuasca Visions: The Religious Iconography of a Peruvian Shaman* (1999). After the release of the book (coauthored by Luna) and the rise in interest in ayahuasca, Amaringo became increasingly well-known internationally, and his exotic and colorful visionary paintings have since become some of the most valuable psychedelic art of the twentieth century. After a protracted battle with illness, Amaringo died in 2009.

Andy Debernardi (1968–), one of Pablo Amaringo's students from the Usko-Ayar school, now continues on Amaringo's tradition of painting ayahuasca visions, and is gaining an international reputation of his own, with frequent tours of Europe and the United States. Luis Tamani Amasifuen is another very fine Peruvian painter from Pucallpa, whose work is now seen in Europe and the USA.

Brazil, with its Santo Daime and UDV churches, now has a number of artists who attempt to convey their visions on *housca,* the Brazilian version of ayahuasca. Alexandre Segrégio of São Paulo, Brazil, and Paulo Jales (PauloJales.wordpress.com) are two of those.

From Bogotá, Colombia, Alex Sastoque (www.alexsastoque.com) is a painter, sculptor, photographer, and filmmaker who is gaining international acclaim. His work has been exhibited in group shows alongside those of Fuchs, Venosa, Grey, Hoffmann, and others. (Sastoque was the invited artist to Moksha in Miami in 2011.) His artistic work first materialized in painting, video art, and installation views obtained in entheogenic rituals with ayahuasca and peyote. Additionally, his work seeks to portray and transmit knowledge, teachings, and spiritual experiences that have been received through contact with shamans from different indigenous communities in Colombia.

THE FURTHERRR COLLECTIVE:
THE PSYCHEDELIC ABSTRACTIONISTS

*Objects and their functions no longer had any significance. All
I perceived was perception itself, the hell of forms and figures
devoid of human emotion and detached from the reality of my
unreal environment. I was an instrument in a virtual world
that constantly renewed its own meaningless image in a living
world that was itself perceived outside of nature. And since the
appearance of things was no longer definitive but limitless, this
paradisiacal awareness freed me from the reality external to
myself. The fire and the rose, as it were, became one.*

FEDERICO FELLINI,
DESCRIBING HIS EXPERIENCE ON LSD

The final group of psychedelic artists I would like to mention here is
also perhaps the most difficult to categorize, as well as the group who
most begrudgingly use the term *visionary art*—the psychedelic abstrac-
tionists, best represented in the United States by the innovative San
Francisco–based Furtherrr Collective.

The Furtherrr Collective is the brain child of Brian Chambers, a
Northern Californian psychedelic art dealer and collector. Originally
a blotter-art and psychedelic poster collector, Chambers is something
of a protégé of both Jacaeber Kastor (who is a huge fan of psychedelic
abstractionism and op art and spends his time looking for unknown
psychedelic abstractionists from the late 1950s and early 1960s) and
Mark McCloud, and has developed a particular passion for engineering
collaborations between different painters.

For that purpose, in 2009, at the now-legendary Symbiosis festi-
val outside of Yosemite, California, Chambers brought together sev-
eral artists he admired, and the Furtherrr Collective was born out of
the collaborative spirit of that event. Repeating the experiment at the
2010 "Metropolis" Burning Man, five of the original Furtherrr artists—
Mars-1, Damon Soule, NoMe Edonna, David Choong Lee, and Oliver

Vernon—collaborated on a mural-sized canvas housed inside a 40-foot dome, and the Furtherrr Collective artists have been active participants at major psychedelic events like Symbiosis and the CoSM Bicycle Day parties (where Mars-1 has painted collaborations with Alex Grey) ever since. Highly respected by the Tribe 13 artists, the pioneering visionary artist Luke Brown, speaking on a group panel about visionary art at BOOM! in 2016, described the Furtherrr artists' collaborations as "one of the most exciting developments in contemporary visionary art."

Today the Bay Area–based collective boasts ten members.

Oliver Vernon (1972–) is a New York artist now living in Northern California, and is a rare psychedelic artist who has maintained a foot in the "real" art world. The Furtherrr website offers the following description of Oliver's mind-bending work:

> Visually, California based artist Oliver Vernon's paintings draw upon an incredibly varied pool of influences, from abstract expressionism, to post pop Surrealism and the polished finish of figurative realism. Formally, his work is about the deconstruction, and hence the necessary reconstruction of visual space. From this central dichotomy stems many others: logic/illogic, physical/metaphysical, imprisonment/liberation. His paintings come to us, perhaps, as detailed snapshots of the few primordial milliseconds when the blueprint of the universe was being sculpted from the final throes of chaos. In this sense, anything goes. Each painting has its own set of rules, or rather the rules are being bent, broken and ultimately formed within each painting. Color, form, energy, architecture, good, evil, flesh and machine are lurking, never as physical entities, but as transient archetypes searching out their final places within the framework of the cosmos. (www.furtherrr.com/oliver-vernon)

Graduating with a BFA from Parsons School of Design in 1995, Vernon had as early influences abstract painters like Kandinsky and Klee, or abstract expressionists like Rothko and Jackson Pollock, rather than Surrealism. At that time, he had little or no knowledge of Ernst

Fuchs or the fantastic realists at all. Living in Brooklyn, Vernon worked for a painting restoration company after he graduated, where he learned the easel skills of using tiny brushes and applying traditional color wheel theory to match colors. In New York Vernon also became heavily involved in underground electronic music culture, during which time he began live-painting at the NYC Giant Step parties, and met Alex Grey, who took a keen interest in his work. An intense period of discovering the tenets of Buddhism followed, during which Vernon spent a couple of years simply painting mandalas. Jacaeber Kastor was another early supporter, and after Brian Chambers saw Vernon's work, he brought him out to Symbiosis in 2009, an event that later led to a shift to California and full-time membership in the Furtherrr Collective.

Explaining to me that one of the interesting things about being in the Furtherrr Collective was that all the artists have learned one anothers' techniques from painting together, Oliver said he started realizing whole new ways to paint. And then, when he saw some recent work of the newest generation of young abstract painters, something inside of him clicked back again—this was the kind of art he had always loved and was inspired to create.

The result is breathtaking to witness—an exploration in color, form, and perspective. Vernon paints psychedelic mindscapes that suggest the existence of some primordial collective unconsciousness, occupying an infinitely riotous void. Vernon states:

> Portrayals of chaos and order in painting are nothing new. Mark Tobey is one of the early examples from the early twentieth [century], whose dense all-over abstractions sought to explore the representation of the spiritual in art. Jackson Pollock is the most famous example. At the core I identify with these artists in their vision, however I feel the need to implement a multitude of varied techniques, methods, approaches, and to fuse them together into unified wholes. The world, and life itself, seems often like chaos . . . a staggering myriad of opposing forces moving in visible and invisible cycles, all coexisting in a simultaneous, interdependent system. What medita-

tion has given me was the ability to sit quietly with this great chaos and to feel the perfection in its balance. It's like witnessing from the eye of the hurricane . . . there is serenity within the madness of it all. (https://artasylumboston.wordpress.com/oliver-vernon)

Vernon now lives and paints in Northern California, while his paintings are in numerous collections, including New York's Metropolitan Museum of Art. A large-scale painting was commissioned and is prominently on display in the foyer of the new Grand Hyatt Regency hotel in Los Angeles.

Mars-1 (Mario Martinez, 1977–) began his career as a graffiti artist in his home town of Fresno at the age of thirteen, before he attended the Academy of Art University in San Francisco. The Furtherrr website states:

His unique imagery explores possibilities of otherworldly existence through highly developed, multi-layered landscapes. Often employing a fuzzy-logic aesthetic, Martinez's artwork has a sentient appearance, like a tulpa—which in mysticism, is the concept of a materialized thought that manifests into physical form. His unique style has been described as urban-Gothic, sci-fi abstracted, quasi-organic form. Early inspirations include: graffiti, animation, comic book characters, UFOlogy, extraterrestrials, unexplored life, mysteries of the universe, alternate realities and the abstract quality of existence. The true meaning of Martinez's imagery is ultimately left open to interpretation. (www.furtherrr.com/new-gallery-3)

Currently the most successful of the Furtherrr artists, with paintings selling for as high as $60,000 at his last show in New York, Mars-1 has begun producing bronzes of his sculptures, some of which are nine feet tall (and appeared on the playa at Burning Man in 2015).

Neither Oliver Vernon, whose main influences are modern art's abstractionists, nor Mars-1, who came out of the Latin American tradition of graffiti art, claims any kind of kinship to the Vienna School

of Fantastic Realism, or Ernst Fuchs, though if there is one thing they have in common with the fantastic realists, it is the high technical standard of their painting. (A commitment to life drawing and painting technique has been judged as steadily less important in contemporary art since the advent of Warhol and pop art, but the high technical standard of fantastic realism and visionary painters is one of their main characteristics. Ernst Fuchs himself was one of the technically greatest painters of the twentieth century.)

Brian Chambers, the mastermind behind the Furtherrr Collective, became interested in psychedelic art from collecting blotter art and 1960s rock posters. From Chambers's perspective, the correct terminology for the Furtherrr Collective would be "psychedelic artists," not visionary ones. (Neither Jacaeber Kastor or Mark McCloud is a particular fan of the term either.) But with their close ties to Alex and Allyson Grey (the Furtherrr artists have taught painting seminars at CoSM, and regularly appear at the CoSM Bicycle Day events in San Francisco, with Mars-1 and Alex Grey having collaborated on a painting) and their desire to be included in the conversation of contemporary twenty-first-century psychedelic art, even they concur that these days the distinction means little; the Furtherrr website thus describes their particular form of psychedelic art as a "contemporary visionary genre."

PART FOUR

◈

Accidental Ingestions, Amazonian Overdoses, and Other Reports from the Front Lines

35

A PILGRIMAGE TO THE DANCE TEMPLE

◈

My Journey to BOOM!

People say that what we're all seeking is a meaning for life. I don't think that's what we're really seeking. I think that what we're seeking is an experience of being alive, so that our life experiences on the purely physical plane will have resonances with our own innermost being and reality, so that we actually feel the rapture of being alive.

JOSEPH CAMPBELL, *THE POWER OF MYTH*

As I stood smoking a joint among a thick cloud of small flying insects on the edge of the busy Spanish freeway, watching the sun setting over a barren Spanish countryside that cruelly resembled some imagined scene from *Don Quixote,* I realized that like any true pilgrimage, my journey to the BOOM! in Portugal was apparently not supposed to be an easy one. The fact that I had been invited to be a guest speaker at what was billed as the world's largest psychedelic music, art, and visionary culture festival, clearly meant nothing to the cars that ignored my attempts to hitchhike as they sped by. Nor had it impressed the woman at the rental car desk in Madrid who had refused to give me

my reserved car because my license was not in order, or influenced the ticket agents at either the bus or the train station in Salamanca, who earlier that afternoon had told me that all transport to Portugal was sold out for at least five days. A fact that meant that there was a genuine possibility that after coming all the way to Europe, I might not now even make it to BOOM! at all.

Never one to shirk a challenge, and like any psychedelic author worth his salt (no pun intended), I had resolved that where there was a will, there was a way, and that if I made an assertive move, then that Way would surely open up for me. So I jumped into a taxi and asked the driver in my poor Spanish to take me to the first gas station out on the freeway to Portugal, where, I reasoned, I should be able to hitch a ride. But after he had driven past two such stations without stopping and seemed hell-bent on driving me all the way to the border, a shouting match ensued that resulted in me being dumped off at an overnight rest area full of surly Portuguese truck drivers who regarded me like a contagious plague, with no gas station in sight. This untenable situation had then forced me out onto the Spanish highway to attempt to hitchhike as the cars sped by at 100 miles per hour in the rapidly fading light.

"Brilliant, Roc," I said to myself as I finished a joint. (Like any functional schizophrenic, I often talk to myself in these types of situations.) "You just paid a cab driver 25 euros to drop yourself out in the Spanish countryside in the dark, and now you are going to probably either get run over or arrested, or at the very least, will have to sleep in a field. Nice work, *hombre*."

Somewhat despondent after this review of my own poor decision making, and genuinely fearful that I might get run over if I stayed out on the highway, I dragged my heavy bags back up the on-ramp and onto the overpass in search of somewhere to spend the night. (Believing that I had a rental car, I had brought a full selection of camera gear as well as too much clothing and costumery. My camera bag alone weighed 20 kilos.) Walking to the top of the overpass, I could see the faint glow of green lights off in the gathering darkness, looking as if they were only a mile or two away. Having nothing better to do, I slowly walked

toward their glow, dragging my suitcase behind me while praying to all my gods that it would be a gas station. Which it was, one of those giant Euro stations with a bar, restaurant, hotel, discothèque, a large parking lot full of commercial trucks, and, most fortunately for me, a group of French psytrance hippies in a pair of converted house-trucks on their way to BOOM!

After hearing of my predicament, they fed me, encouraged me to drink their alcohol and smoke their hashish, readily agreed to let me ride with them to BOOM!, and later refused to accept even the offer of a tank of (very expensive) gas for their kindness. Thanks to their generosity, that next day, as I witnessed the slow-moving migration of house-trucks and overloaded vehicles making their way down the narrow cobbled Portuguese back roads, I was glad that I was arriving in this way and not in a rental car or on the undoubtedly more comfortable artists' shuttle. In this disorganized pilgrimage I recognized another limb of the global psychedelic tribe that I consider my true family.

This international nomadic tribe comes together as a physical community at a loose-knit network of festivals with fantastic names like Shambala, Rainbow Serpent, Lightning in a Bottle, and of course Burning Man. This was clearly the same tribe—albeit speaking over forty different languages—that was gathering twenty-five thousand strong on the transformed shores of Lake Idahna-a-Nova in Portugal to openly celebrate all aspects of the psychedelic. Happy just to be making it to BOOM!, I already felt right at home.

Held biannually around the full moon in August since 1997, BOOM!'s roots are as a psytrance festival. Psychedelic Trance (or Goa trance) is a DJ/producer-driven, thumpingly hypnotic genre of electronic music that originated in Goa, India, and has become one of the most popular forms of electronic music in Europe, and the main stage at BOOM!—called The Dance Temple—is dedicated virtually exclusively to psytrance's various subgenres. While this particular form of electronic music is obviously unabashed in its drugs of choice, what makes BOOM! unique when compared to any other festival like it

around the world is the fact that in 2001, the normally conservative Portuguese government introduced some of the most liberal drug laws on the planet, decriminalizing the possession of small personal amounts of virtually anything.

Because of this freedom, BOOM! is the only festival in the world that is able to be openly and unabashedly dedicated to modern psychedelic culture. It is unique in that it is able to create an environment where psychedelics can be openly used without fear or paranoia. Recognizing the opportunity, in 2002 the BOOM! organizers made a partnership with the Canadian production company Invisible Productions, who were responsible for inviting the visionary artists Robert Venosa and Alex Grey to give talks and display their art. These were the first steps that would evolve BOOM! away from being a straight psytrance DJ festival, and into being an integrated psychedelic art, music, and culture event uniquely its own. This collaboration would help BOOM! to become the main European venue for the visionary art movement that is most commonly associated with Burning Man and other similarly inspired West Coast festivals: each successive edition has attracted a steadily increasing number of visionary artists of all types from all around the world.

From BOOM!'s beginnings, its international organizers made a conscious decision to reject corporate sponsorship and concentrate on building a viable community around the event. The festival promotes all aspects of the emerging visionary culture, dedicated not only to EDM producers and DJs and live music, but also to the work of contemporary visionary artists. Along with the nonstop music, BOOM! boasts an art gallery, large-scale art installations, and performance art, as well as informative workshops and lecture series designed to promote the kind of balanced ecological worldview to which many psychedelic users subscribe. This dedication to openly promoting all the various aspects of today's psychedelic culture, along with the obvious freedom that one has to consume pot, hash, or psychedelics while at the event, has given BOOM! the rightful reputation of being the most psychedelic festival in the world.

Or as the official BOOM! website (www.boomfestival.org/boom2016/home) puts it: "The idea behind BOOM! is to create a space in this time continuum where people from all over the world can live in an alternative reality. [. . .] and in together allowing the Culture, the Love, the Sacred Earth and the Art to melt and mingle and eventually . . . BOOM! We all take one big step together."

Personally I did not think I was much of a fan of Psychedelic Trance music, but as a long time Burner who has becoming increasingly distressed by witnessing the draconian police harassment (mostly of pot smokers) that is now common at Burning Man, I was curious to see what a truly free psychedelic environment would be like. And inevitably my first mistake was to compare BOOM! too much to Burning Man, which is an unfair comparison. Black Rock desert, where Burning Man is held, is a unique canvas upon which to create an event, and the community that has evolved there is very different; I personally consider Burning Man to be as much an art movement as it is a festival. In truth, with its set stages, fixed musical schedule, restaurant area, and shopping zone, BOOM! seemed to me to be more like a typical festival (albeit one with a lot of good art) than it did Burning Man. There are no art cars, for example, which are a unique part of the character of Burning Man, no concept of gifting, and very little participation on the part of the BOOM!-goers themselves—no random theme camps, games, costuming, very little fire spinning or tribal wear. Unlike Burning Man, where Radical Participation is understood to be the best way to experience the event, the majority of the young Europeans that come to BOOM! clearly expect to be entertained and seem to do little to entertain themselves.

So my initial impression of BOOM! was perhaps a little disappointing, and I wondered if I had expected too much. But my attitude began to change when I visited the Liminal Zone, an area that contained the Theatroom (an outdoor stage for dance and performances), the massive speakers' area, and The Drop, an incredible visionary arts gallery designed and built by Gerald Minakawa and the Bamboo DNA crew, that featured the works of attending visionary artists like Luke Brown,

Amanda Sage, Adam Scott Miller, Autumn Skye, Xavi, and their European counterparts.

The Liminal Drop was a truly impressive structure, a blend of art and function created with ecosustainable materials. Its deliberate positioning in center of the festival sent a message to all its participants: we are here for more than a party, so you might as well stop by and learn something. The central theme of BOOM! in 2010 was Water, its importance to life and its precious scarcity, while the lecture series at the Liminal Zone was titled "Frontiers" and featured an incredible variety of cutting-edge speakers. With some of the largest crowds that I have seen at an event of this type, it was in these crowds of rapt listeners that I recognized the same desire for community that I have seen at Entheon Village at Burning Man, at the Symbiosis Gathering in their giant saddle-span tent, and at the incredibly beautiful speakers' temple-stage* at Lightning in a Bottle in Southern California.

One of the most powerful arguments for the legalization of psychedelics is the fact that these compounds could be such powerful catalysts toward the creation of a stable and sustainable relationship with each other and with our planet. Psychedelics have been proven to bring about change—which is undoubtedly part of the reason they are so feared. It was this common desire for real community that I increasingly witnessed as BOOM! progressed, readily apparent in the friendly way in which you could strike up a conversation with just about anyone (as long as they spoke your language). This process was undoubtedly made easier by the fact that you could sit in the small tea houses (or anywhere) and roll a joint and pass it around with no concern at all. At a festival renowned for its psychedelics, a joint or a chillum is as common as a water bottle, and most of the Europeans smoked a mixture of hashish and tobacco, with the hashish reportedly being of surprisingly mixed quality. (The Europeans smoke a crazy amount of cigarettes.) Some mid- to high-grade cannabis (presumably from Spain, which has

*Ironically largely created by Derrick Ions, the central figure behind the tragic Ghost Ship commune in Oakland.

a decent medical grow scene) was also sporadically available and was in high demand with the non-European community.

The fact that I had to make a presentation midway through the festival limited my investigation into anything other than cannabis and hashish over those first few days, but once that obligation was over, I resolved to fully investigate exactly what BOOM! had to offer. So I went over to the Kosmic Care Center, where I knew that Rick Doblin and MAPS were involved in a care program for the unfortunate cases where people have bad trips and need either professional help or just a place with friendly people to chill out. From the informed staff there, I discovered that there was an astonishing array of different compounds available at BOOM!, including those more commonly known, such as Czech LSD or an apparently popular bright purple MDMA crystal, to rarer compounds such as the extremely potent DOC, which is rarely seen in the United States.

But since my primary field of enquiry these days is the organic tryptamines, the thing that I was looking for was called *changa*—a blend of MAO-inhibiting herbs soaked with DMT (originally invented in Australia) that is kind of a smokable ayahuasca blend. I had heard that there had been booths openly selling the mix at BOOM! in 2008. Although these changa booths had now apparently disappeared, I was told that there was plenty of it around. I just hadn't been able to find any.

The days were brutally hot, with temperatures reaching as high as 110 degrees, while the ground was hard and rocky like that of Southern California and there was not an abundance of shade. Swimming in the lake was a constant respite, and as the daytime heat rose over the festival, the beach bar/dance spot called Tripical Beach became increasingly popular. When you were not in the water you had little choice but to get out of the sun, which is why I was hiding in the tent booths of the vendors' area when I bumped into my notorious Israeli friend Yaron, whose adventures in search of 5-MeO-DMT toads and traveling to Burning Man I recount in *Tryptamine Palace*.

I hadn't seen Yaron in nearly three years after he had disappeared from the United States, leaving a trail of rumor and mayhem behind

him, so he filled me in on his side of the various popular tales. Then, he claimed, he had returned to Israel, where he was the world's largest legal marijuana grower, with a company called Canna-Pharmaceuticals. Despite this fact, Yaron didn't have any weed on him, so he immediately tried to hit me up for mine. Then he said I must have some DMT on me (when you write a book about DMT everyone thinks you carry it around like candy). As it happened, someone had given me a rock of what they said was DMT after my lecture, and I was carrying it around in a piece of foil in my pocket, waiting for the right opportunity. So we went down to the lake to my favorite spot out on a point and rolled a joint as we waited for the sun to go down.

"We can smoke this DMT," I told Yaron, "but what I really want to try is some changa."

"What is that?" Yaron asked me, and I gave him the breakdown of what I knew. Yaron then reached into his pocket and pulled out a small plastic bag containing some black-looking herbs.

"This is some apparently really good changa that I got given this afternoon," he told me. "I didn't know what it was until you told me."

Sweet psychedelic synchronicity. We stuffed a bowl full of the changa and spread the crystalline orange DMT out on top and then passed the pipe back and forth as we watched the sun set into the lake. When the DMT visions reached their peak, I closed my eyes and lay back on the shore, enthralled by the universe beneath my eyelids, until I felt Yaron tap me on the knee. Sitting up, I opened my eye to the swirling whorls of a world transformed into a Van Gogh painting, and was astonished to discover that there was an ancient dwarflike creature, dressed in some kind of a leather tunic that went down to his stubby knees standing in front of me.

"This is my friend Albert Dwarfmann from Estonia," I heard Yaron say in a thick, garbled accent that seemed to emanate from a rock somewhere behind me. "He wants to know if we want to do some original Sandoz LSD. He says it was buried for fifty years behind the Iron Curtain and now deserves to be free, so he brought it to BOOM! to give to people."

I blinked nervously as I looked at Yaron's face and realized that one eye and eyebrow were a good two inches higher than those on the opposite side of his face, and that everything suddenly had a weird flat two-dimensional look, like a cubist painting.

"Albert Dwarfmann?" I thought to myself. "Iron Curtain acid? Did I really just hear all that?" But then I gave up any attempt at rationalization, nodded my head, and stuck out my tongue. The Estonian Johnny Acidseed dipped a short glass rod into a small bottle and then dropped two drops of liquid into my mouth, and I closed my eyes again and lay back down on the shore. When I opened my eyes again after an unknown period, the sun was virtually gone, and Yaron and I were alone.

"Albert Dwarfmann split?" I asked Yaron. "What a wild cat. Where did you meet him?"

"What are you talking about?" Yaron said, his familiar thick Israeli accent now returned.

"Your Estonian buddy with the acid. The dwarf in the leathers."

Yaron looked at me as if I were mad. "That was obviously some bomb-ass DMT we just smoked," he answered.

Right at that moment, Jonathan Human, a poet from San Francisco, walked up to where we were sitting, and the conversation turned. Jonathan asked us if we had been over to the Sacred Fire Healing Area, where there was reputedly a lush faeryland village in the forest, and since neither Yaron or I had made it that far yet, we readily agreed to go check it out. As we went to skirt around the enormous Dance Temple, Jonathan remembered he had to go backstage to find someone, so I decided to go see what was going on in the raised, spaceship-looking VJ booth. As luck would have it, both Android Jones and Jonathan Singer (who is Alex Grey's VJ) were manning the visuals that night. Knowing that this pair of artists were two of the top psychedelic VJs in the world, we stopped to smoke a joint with AJ and Singer and watch the show.

One thing that made the Android Jones Dance Temple so unique was the fact that it had several different zones with hexagonal screens that could be moved around each day to form different shapes. (The

screens were the shape of a water molecule—and of a DMT molecule.) Two VJs would work from the main video booth, while another worked behind the main stage in concert with a light engineer. The result was a hallucinatory blur of very different forms of psychedelic imagery. For example, Jonathan Singer was both deconstructing and reconstructing a number of the younger visionary artists' paintings into a flowing visual river of hypnotic imagery on the main screens that was uncannily similar to an ayahuasca vision, while Android Jones was creating a surrealistic live painting from a digital drawing pad on another set of screens, as the entire massive tent structure pulsated with ever-changing colored led lights (run by a separate engineer), and a cacophony of sound raged from what was reputedly the largest Function One sound system ever created.

Up to this point I had spent most of my time at night at the DoLaB's Groovy Beach stage, which featured more the type of dub, dancehall, or breaks that I personally like, while the psytrance had always driven me out of the Dance Temple after a short time. But on this occasion the music seemed more dynamic and funky, and as I peered past the seething lights and visuals and out over the massive crowd, I realized that instead of just a DJ, there was actually some kind of band on the stage. Yaron had climbed up into the VJ booth with me, and I could see that he was as transfixed by the scene as I was, and then suspecting that Albert Dwarfmann's magic was at play, I checked on Jonathan Singer as he worked his laptops, and saw that he was clearly grooving along to the music as well.

"These guys are great," Singer said, as if reading my mind. "This is the best thing I have seen in here all week."

"Who are these cats?" I asked, and Singer checked his schedule.

"The Green Nuns of the Revolution." He replied and I realized incredibly that I actually knew something about them. Over breakfast that morning, my good friend and pioneering American psytrance DJ and producer Trevor Moontribe had been telling me the acts I should try to see, and he had specifically mentioned this one.

"Classic nineties Goa Trance." Trevor had told me. "These guys are

more musicians and producers than DJs, and they will blow your shit up. You will lose your mind. Trust me."

Expert advice that I had forgotten shortly after the morning joint had been burned, since I had thought it unlikely that I would be spending any great period of time listening to psytrance in the Dance Temple, impressive a structure as it might be. But here I was, losing my mind just as Trevor had predicted, and one thing for sure was that I wasn't the only one, as the Green Nuns of the Revolution (who, I found out are original BOOM! favorites, having appeared there since the first festival in 1997) blew the roof off the mother sucker to an ecstatic and adoring crowd.

As the throb of the music seemed to integrate its way into the minds and souls of the sweat-drenched mob inside the Dance Temple, to my eyes they began to think and move like one giant mycelium—a Bose-Einstein condensate of coherent music and dance—while the visionary web of lights and visuals all around us seemed to arbitrarily open portals to universes and dimensions previously unknown. I realized that Singer and Jones were being just as swept up and elevated as the rest of us and that the result was coming out in their living, breathing, real-time digital art, the swirl of hallucinatory images seeming to anticipate and accentuate the music like some oracular fourth-dimensional fog above our heads, while far away on the stage, the giant decahedron behind the Green Nuns pulsed a different vibratory color with each drop of the bass, and strange sounds erupted with the volume of aeroplanes, funky alien noises emanating from subliminal frequencies previously unknown to man. The quivering chakras and portals of my tryptamine-charged mind opened notch by notch with each aural assault until I found my inner self cocooned in an elevating whirlwind of strangely meditative sound, and I realized that the core of my being was being picked up and plain blown away by this . . . psychedelic Goa Trance!

BOOM! Just like that, my initiation was complete! Like all the other good pilgrims there, I had received my ineffable transmission of sound, vision, and satori from the Temple of Psytrance, and for a moment seemingly outside of time, I felt Joseph Campbell's rapture at

being alive. An experience, like a lightning bolt to your core, that mere words can never really describe, but that I can still feel inside of me as I sit here and try. BOOM! Maybe that's it after all. Maybe that's as close as you can get. But of course if you don't make the pilgrimage, you will never have a chance to know.

36

AN ACCIDENTAL VISIONARY EXPERIENCE

I was at Burning Man for two weeks in 2008, working on an art-car project (The Lady Sassafras) that had taken nearly two years to complete, and then spent two more weeks in northern California cleaning and detuning. I was supposed to go up to Humboldt and go to Earthdance at the Hogg Farm, but I was too burned out for any more festivals or partying, so I decided to head back to my home base in the Deep South via the central Rockies. Stopping for a night in Salt Lake City, I checked my emails the next morning and discovered that I needed to get back home more quickly than I had realized, so I jumped up, grabbed my dog, and took off again in my heavily laden truck.

It was mid-afternoon as I approached Moab, Utah, after a few hours of driving, and I decided that I wanted to go for one last dirt bike ride before my summer was over. I had my 450 KTM Enduro bike on the back of the truck, and I know the Moab area pretty well, having mountain-biked there numerous times over the last twenty years. I had been planning to stop at the Gemini Bridges area on the north side of town, but as I approached that trailhead I spontaneously decided that I would go and ride the famous Slickrock trail instead.

I had ridden Slickrock perhaps a dozen times on mountain bikes, but never on a dirt bike, and since I was alone, and I knew that the pop-

ular Slickrock trail is marked with a painted white dotted line on the red rock, my reasoning was that I wouldn't get lost; if by bad luck I got hurt, someone would find me. But since I'm a pretty competent dirt-biker (my father was a national champion in dirt bikes in New Zealand, and so I was lucky to grow up on one), I wasn't too concerned about the severity of the trail or getting lost.

At this point let me mention an interesting anomaly in my own psy-chonautical career—virtually all the greatest entheogenic experiences in my life have come by accident. My original epiphany on 5-MeO-DMT (as described in *Tryptamine Palace*) can be included in this category, since I barely knew what it was when I first tried it, and I had no idea that I would fall through the Looking Glass. I was not looking for God that night, nor really have I ever been. The ceremonies and other inten-tional settings I have tried have never been as effective for me as my accidental crossings into other dimensions. I don't seem to be able to seek the visionary experience, these visions always seem to have to sneak up and surprise me.

So it would be on this day. As I prepared my camelback for the ride, I noticed a small bottle of saline tucked in an outside pocket. Since the hot desert air was already drying out my contact lenses, I put a drop in each eye, and subconsciously noted that the drops had a slight sting. Without thinking much harder, I placed another couple of drops on the back of my hand and tasted the solution, but my taste buds were so fried from my two weeks on the playa I wasn't sure I could taste anything at all. A few more drops directly on my tongue finally revealed a slight metallic taste just as my alarm bells began to go off and I realized maybe this bottle wasn't saline at all. Then my phone suddenly rang—even though previously there had been no service. It was my English mate, Will, who lives in LA, and is another Burner and dirt-bike enthusiast.

"What are you up to?" he asks me, and I told him that I was about to go ride Slickrock on the bike, but thought I may have just unwittingly dosed myself with liquid LSD that someone had left in my camelback at Burning Man.

"Well, be bloody careful," he tells me, and I agree to give him a call

when I get out so he knows I'm all right. Firing up the bike, I waved my dog good-bye as he lay tied up in the shade of a tree, and took off into the convoluted ocean of red rock that is erroneously known as Slickrock. (If you are not a mountain biker or motorcyclist, and you have never heard of Slickrock, let me explain that this is probably the most famous bike trail in the world. And riding powerful dirt bikes on LSD is not recommended, so don't try this at home.)

A ten-mile loop, mostly on solid sandstone, the unique geology most resembles the petrified red rock of Mars. A psychedelic place at the best of times, within about an hour there was no doubt that I was tripping on something extra. The barren desert around me now a swirling sea emerging out of some red dimension, while the ubiquitous white-dotted painted trail had become my sole lifeline to reality. I felt like I was riding like an enduro god, loving the insane traction of the red sandstone, totally balanced and in tune with my machine, yet also aware that the intensity of my experience was steadily rising, my grip on my consciousness feeling like a cork resisting the gases inside a slow-filling bottle ready to explode. There are several spectacular viewpoints along the trail with mighty views of the Colorado River that I had intended to stop at, but I wasn't sure how quickly the ride was progressing (I did get lost repeatedly having too much fun) and when I stopped moving, I really knew how high I was getting, so I soon realized that even these ritual stoppages were out of the question—best I kept riding!

I rode almost the entire twelve miles with no real sense of speed or time, just a solid constant flow, almost like trials riding, with no hill or obstacle offering me any great challenge. But then as I was riding the steep trailhead back out (the trail really was quite "expert" for a motorcycle as well as for a mountain bike, I had discovered) I encountered a 3-foot-high rock face that as good as I was riding suddenly seemed completely unconquerable. I looked for another way up or around it, but this seemed to be the trail, and this time when I stopped, everything rippled in waves of red and blue and I lost all sense of three-dimensionality—not good when you have to ride up a steep rock face on a heavy 450 dirt bike!

Knowing I had no choice, I backed the bike up and had a go. As I hit the ledge and popped the front wheel up, I was forced to jump off the bike for the first time that day, and then had to rev the motor intensely as I struggled to muscle the rest of the heavy machine up and over the ledge. Mercifully over the obstacle, both the bike and I exploded from the tremendous effort, the bitter clouds of hot steam from the radiator pouring into my helmet to add to my sudden physical distress. Completely exhausted, I was forced to park the bike, and collapsed in the shade of a rock wall and a solitary tree, realizing that I had been riding for nearly two hours virtually without stopping or remembering to drink water. My heart and head were pounding, and I was soaked in sweat from the physical exercise, so I took a bunch of my body armor off and sat in the shade for an unknown period of time, trying to compose myself as I kept getting higher and higher while watching the sun steadily dropping lower in the sky.

Eventually I managed to get all my riding gear buckled back on, and then thankfully the bike fired back up, and I turned out to be only five minutes or so away from the truck once I arrived at the top of the hill. Back in the parking area, I was totally twisted, and trying to load up the bike, all the straps on my truck seeming completely alien to me. A group of dirt bikers from Oregon pulled up and offered me a cold beer, and as I tried to talk to them, all I could see were shifting transparent sheets of color that floated between us like a clear film in the air and I felt as if my brain was about to explode out of my ears. I was in no condition to talk to anyone, but luckily the riders from Oregon helped me load the bike up, and then spent most of the time playing with the dog while I stuffed all my gear in the back of the truck.

Finally I managed to stammer a good-bye and drove off. As I dropped down off the red sandstone plateau of Slickrock into the Moab canyon, it suddenly became dark since the sun could no longer reach down into the canyon's depths, and the bright lights of the town and the other vehicles blinded me to the point that it made it very difficult to drive, something that was unusual for me. Then, as I was driving down the main street of Moab, I had a bicycle tied onto the back with

the motorcycle that somehow managed to come loose and fall off as dozens of people were shouting at me to stop. I pulled over and retied the bike with the damned straps that I could have sworn I had never seen before, acutely aware of just how high and filthy I was, and the fact that I was in Utah, one of the least tolerant states in the Union. I had stopped right across from a motel and considered going in and booking a room for the night, but I couldn't stand the idea of the brightness of the motel office. I was feeling blinded by the artificial town lights and just wanted to get away from them all.

"Fuck it," I thought, "I will drive until I get out of Utah at least."

Back in the truck, I started driving south, but once again every light that came the other direction threatened to run me off the road, blinding me in the gloomy shadows of the canyon that were slowly growing deeper in the dying light of the day. I called Will in LA to tell him I was all right, and that it had been a mad ride, and it was easy for him to tell how very twisted I still clearly was.

"It's all right to pull over in situations like these, you know," Will advised me wisely, and I told him that I knew that, but I was in Utah for fuck's sake, time to go. But then after only another ten or so miles down the highway, I realized that for the first time in my life, I truly couldn't drive. When I then saw a pull-off on the side of the road, I instinctively pulled in and parked.

Getting out of the truck, I looked up to the horizon high above me and saw one of the numerous red rock arches that the Moab area is so famous for illuminated by the still-setting sun, a blue haze high above the canyon walls. In a sudden moment of orientation, I realized that I actually knew where I was: this was Wilson's Arch, I would often stop here when I drove to Moab from the south, since the arch itself was not too far a climb from the road and I had hiked up to it many times.

Clearly this was where I was supposed to go, so I set off up the dark slope clutching a Tupperware container full of weed, some water, and a pipe, and was halfway up the steep, loose slope before I realized that my swamp-raised Catahoula hound had not followed me. Cursing his inattentiveness, I came back down the slope, and broke a strap on my

sandals in the process. Finding Turk (my dog) confused at the bottom, I threw my broken sandals aside, and now with him tucked in behind me, climbed back up the steep rocky slope in bare feet, still feeling fully demented by the LSD. (I was later told that it was some ancient Prankster acid that had been dug up in Oregon and somehow was left on my art car. One of my crew had put it in my camelback, thinking it was my contact-lens solution. But who really knows?)

When I reached the top and stood under the arch, I saw a sight that made me gasp. To the east of me the full moon was rising up through the gap in the massive arch, while to the west the sun was setting above and behind the canyons, and I could just see the last glimpse of its full size and shape, virtually equal to the size of the moon as it was rising. In an instant I realized with a start that I was witnessing a very rare and special occurrence, of which I had just recently become aware through the writings of Joseph Campbell—the rising full moon of the autumnal equinox, a rare and potent moment of both balance and change.

During the weeks leading up to Burning Man, while I had been working on the final edit of my manuscript for my book on 5-MeO-DMT (*Tryptamine Palace*), I had found a remarkable passage from one of the great mythologist's books (*The Outer Reaches of Inner Space*) that explained that this particular day has served as a significant spiritual metaphor since at least the Bronze Age. Since much of what will follow will make little sense without this passage, I am including it here:

> Among the most widely known and (formerly) commonly under-stood symbolic signs inherited from the Bronze Age times by the high civilizations of both the Occident and the Orient were the sun and the moon: the latter, the moon, which sheds its shadow to be born again, connoting the power of life, as here engaged in the field of time, to throw off death—which is to say, the power of life, as here embodied in each of us, to know itself as transcendent of car-nality; with the sun, the light which is unshadowed, recognized as the light and energy of consciousness disengaged from this field of time, transcendent and eternal.

In the context of these symbolic assignments, the cycle of a single lunar month has been compared, by analogy, to the term of a human lifetime, with the fifteenth night, which is of the moon becoming full, equated with the human adult's thirty-fifth year (in the reckoning of threescore years and ten as the human norm). On that very special evening there is a moment when the rising moon, having just emerged on the horizon, is directly faced across the world, from the opposite horizon, by the setting sun. Certain months of the year and the two, at this perfectly balanced moment, are of equal light and the same size. By analogy, the confrontation has been likened to that in the mid-moment of a lifetime when the light of consciousness reflected in the mind may be recognized, either suddenly or gradually, as identical with that typified metaphorically as of the sun. Whereupon, if the witness is prepared, there ensues a transfer of self-identification from the temporal, reflecting body to the sunlike eviternal source, and one then knows oneself as consubstantial with what is of no time or place but universal and beyond death, yet incarnate in all beings everywhere and forever: so that as we again may read in the Upanisad: *tat tvam asi,* "thou art that."

As universal and powerful this Bronze Age metaphor, I was unaware of it when—in the last days of my thirty-fifth year—the light of consciousness exploded in my mind after I first smoked 5-MeO-DMT greater than any atomic bomb, and I came to recognize the timeless, eternal nature of its source, and my own nature, in a light brighter than any sun. So you can imagine the jolt of recognition that went through me like a lightning bolt when I read this transcendental passage from our master mythologist.

I had given this passage considerable thought over the previous weeks, and had even shown it to a close friend in California just days before, trying to convey the spiritual and intellectual excitement that Campbell's words aroused in me. Now, less than a week later, here I was, physically witnessing the exact day of the year that this metaphor arose from—with the sun setting equal in the west to the moon as it

rose in the east. A wave of synchronicity flowed over me, followed by something deeper and more mysterious, and for the first time I began to wonder if something very special was going on—surely such an occurrence must be more than a mere drug-crazed coincidence? Or was I searching too closely for meaning in what was in truth a random event?

Whatever was going on, I now felt the safest I had felt since arriving back in the Slickrock parking lot. I was away from all curious eyes, far above the highway, with a glorious view of the canyons and jumbled rock forms to the west, while the arch itself curved above my head like a giant eye. This ocular effect was magnified by the fact that the arch was bisected horizontally at the point it reached the ground on one end by a rock wall that ran away from me to the east, while the moon rose up from behind this horizontal line like the pupil in the center of the eye. I settled down and watched the last vestiges of the sunset and the fullness of the moonrise, feeling the magic in this place all around me. Then, as the moon continued to climb, I noticed that the rising moon light seemed to be illuminating a library of markings and petroglyphs along the base of the arch.

Filled with curiosity, I crawled around on my hands and knees and examined them closely, afraid that they would reveal that John loved Mary or some message equally inane, but there seemed no doubt that these were indeed ancient markings, all of which clearly pointed in the direction of the rising moon. Symbols of antiquity left by other men in other times, I realized that I had stumbled upon a site of shamanic value, and somehow knew that through the ages other men had traveled hundreds of miles across these vast rock wastelands to sit at this arch, to watch this same moon rise. The ghosts of ancient knowledge roared around me like an invisible wind, and I was so amazed that I got to my feet and felt my bare feet pressing into the rock, believing that I could even make out the impressions of the footprints of other men who had come to this place before me, standing at this exact same spot, looking out over century upon century of moonrises.

My feet had taken a beating at Burning Man, the alkali dust of the playa eating them alive with deep cracks and fissures that occasionally

weeped blood, and it had been madness for me to walk up the deep rocky slope in bare feet. But now the smooth rock felt better than any ground that I had ever felt before, and for one of the few times in my life, I regarded my feet with complete love and pride, for they had carried me to so many amazing places around the world, and now had brought me here, to this very special place. It felt as if pure *mana*—the energy reward of a life well-lived—was flowing up through the earth and recharging me, filling me with boundless power. Turning again to the west, where the sun was almost completely gone but a trace of the red desert remained, the far rim of the canyon lit by a mixture of the last of the daylight and the pale rising moon, I started thinking about the term *shaman,* and exactly what it meant to me.

Since I have written my book *Tryptamine Palace* (and even before), numerous people have tried to lay the mantle of the shaman upon me, and I have always protested, calling myself a modern mystic, and explaining that I do not deserve to be called a shaman, because I have no power to heal that I am aware of. In truth, I would have little interest in this power if it were available to me, since this has never been where my interest lies; as a mystic, I am only interested in my own very personal contemplation of the nature of God. But as I looked out over the canyon, I realized that my work *was* intended to heal—not the physical body of any single person, but the mental body of our people and our sick culture. I also realized that the insights that I was daily learning about myself could be used to reflect some kind of healing light back upon the world. With a start I realized that this was exactly what a shaman is: a shaman is the man on the outside, the man who goes up into the mountains, who watches the moon, and who then comes back down to lead his tribe with the double-edged sword of his own realizations.

To be a shaman, a leader of men, is not a reward, as many people may think; it is a destiny, a duty, what in India they call *dharma*. That is why shamans are chosen, not made, and I resolved that I would no longer fight that word, but be true to my own destiny, my dharma on earth. (For the record, I still do not consider myself a shaman, nor do I ever call myself one, but this experience undoubtedly gave me a sense

of deep brotherhood with all the centuries of seekers who have come before.)

"Visions of grandeur." I spoke the words out loud and laughed. But still the deeper truth in my thoughts challenged my shallow ego-mind back, and I could not deny the obvious power of this unplanned place where I now found myself, or the sense that I was being true to my destiny. I was also starting to feel much more grounded, the ebb and flow of the LSD apparently subsiding. Sitting back down under the arch, I thought that it would be a good time to smoke some weed, so I pulled out my pipe, and packed the bowl with some good organic Californian green from the tupperware container. The ritual of the firing of the pipe and the pull and puff of the smoke made me feel even more grounded and calm.

Lying back down on the earth, I stared up at the arch that bisected the now-starry night sky above me, and then I remember having the distinct feeling that I was sinking down into the rock, down into the bowels of the earth. After an unknowable amount of time, I suddenly sat bolt upright and looked around my surroundings with sudden fear, since I did not know who I was, where I was, or where I had come from. Time had just stopped, and I felt as if I was returning from some deep source of immeasurable power and knowledge, but I was afraid because I had no idea of a beginning or an end, or how I had arrived at this place.

After a couple of minutes, I regained my rationality and recognized with a chill exactly what had just happened to me. Smoking the weed had somehow reinvigorated the Prankster LSD, and I had spontaneously gone into that same deep resonance state with the universe that had previously only been available to me on 5-MeO-DMT. Only normally this event occurred out there in the noösphere, behind closed or unseeing eyes, somewhere inside of my mind, and then I would reoccupy my body, but on this occasion, it had actually occurred physically, and I had reoccupied my body and my surroundings still devoid of my ego or my identity, something that has never happened so completely to me before.

Now I was really spooked. I fearfully put down the half-smoked pipe of cannabis that was somehow still sitting in my lap before getting to my feet and shakily moving around, still somewhat in between two worlds. Something was definitely going on here, I was sure of that now, but I still didn't know what. I was both amazed and terrified that I had just had a transpersonal experience while lying on a rock edge, just inches away from a steep drop into oblivion. Standing up again in the center of the eye of the arc, I swung my arms in yoga sun salutations, and felt the energy roaring around within me. With each rotation of my arms I felt as if I was growing in knowledge and power, my fingertips tingling as I realized that this night was turning into some kind of an initiation for me.

Looking up through the arch, I marveled at the perfect trajectory of the rising moon, and at how, if you stood in exactly the center I was, it seemed to split the middle of the arch exactly. Remembering Joseph Campbell's passage again, I somehow knew that I was physically witnessing the mid-passage of my own life, that my destiny had brought me barefooted to the opposite side of the world from that of my birth to this sacred place at this sacred time, for a very specific reason; and that if I could just wait until the moon crossed the arch itself, something very special was going to happen, and maybe not just tonight, but for the rest of my life. Don't ask me how I knew, or what made me think this was so. It just *was*—a realization hanging in the air, just as bright as the gibbous moon and as grand as the infinite starry skies above.

The only problem with this soul-felt realization came from the fact that it would still be hours before the moon would cross above the rock arch, and I still had thirty hours of driving ahead of me. Plus I was getting cold, and the acid seemed to be fading, and with it, my resolve.

"You are going to get very cold tonight," I told myself. "That will be part of the challenge. You know you will be all right, you have spent nights out in the snow and ice and survived, you're not going to freeze to death here. And you need to wait . . . to be patient. You are infected with the lack of patience of modern living; you would have driven right past this place and not even been aware that it was the full-moon

equinox, but now you are here, and you must wait. This is a test, and if you drive away, you will forever wonder what might have happened if you had stayed."

Right at that moment, as if to test me, a pickup truck with loud music blaring pulled in off the highway, right beside my own truck down below in the otherwise empty parking lot, and I became afraid that my vehicle might be broken into. It stayed there for quite a while, and I considered climbing back down to the carpark to check on things, but I knew that if I went back down I would not come back up, and finally it took off again with a screech of tires.

An eighteen-wheeler came roaring through the canyon, its noisy diesel engine reverberating off the rock walls like some crazy wounded animal, jolting me out of my reverie. For a moment I wished that I was far out in the desert, away from the noise of the road, and as I look back to the west, where you could still make out the twisted red rock canyon walls from the power of the moonlight, I wondered, what was the chance of there being a truly sacred shamanic site so close to the road? But then I realized that a path is a path, and roads run along trails that first carried feet, and later hooves, rails, and tires. Anybody traveling through this canyon would be able to see this arch from below and wonder at its perfect placement and symmetry. Just because the highway was there defiling the canyon now didn't necessarily mean that this site was any less sacred. This then struck me as one of the many complexities that face a modern mystic/shaman: we are often forced to search for the trail of the sacred from among the debris of the profane.

The unknown quantity of LSD that I had accidentally ingested definitely felt like it was wearing off by now, and my rational ego-mind was getting a little bored. Two hours had probably passed since I had declared that I would stay under the arch and watch the moon pass over it, and a part of me kept telling myself that I was being foolish, that I clearly could drive by now and I had a long way to go, so I should come down off this mountain and get on with it. Telling myself that I had had plenty of fine philosophical realizations for one night, and what did I really think would happen once the moon hit

the arch? Was I actually becoming a fuzzy New Age thinker now, attached to such romantic notions? My experience with 5-MeO-DMT had undoubtedly changed me, and I began to wonder to what extreme degree, but at the same time, another, deeper part of my mind fought back. *What's your hurry? It's beautiful up here; look at those stars. You can always drive tomorrow. Soon you will be back in the city, and it will be months before you can be back in the desert again. Relax. Enjoy it. Drink in God's creation, in one of the most spectacular natural environments in the world. If it hadn't been for an accidental overdose, you would have driven right past this place, not even realized it was the autumnal equinox, not even seen this unbelievable moonrise. So chill the fuck out . . .*

Back and forth this inner battle went on as I distracted myself with some stretching and sun (moon!) salutations, and by spending some quality time with my dog Turk, who had been sitting, silent and Buddha-like, staring out into the wilderness. I wondered what this desert seemed like to an animal born in the Louisiana swamps and who had spent too much of his life locked up in the confines of our yard. (Dogs can teach us so much. I know exactly what Basho meant when he wrote, "Buddha is a dog.")

It was then that what would be the final major realization for the night came to me. Shamans, I realized, would not be able to stare completely at the sun, because this would blind them. A shaman could, however, look fully into the moon, which is the reflection of that same solar light, just as our temporary lives (and consciousness) are a reflection of the eternal Source of light and consciousness from which All Things come.

Now I may have read this somewhere before, and I'm quite sure that this realization is no news to those who actively seek shamanic experiences, but it seemed like a revelation to me at the time, so I immediately decided to try it, more out of intellectual curiosity and to defeat my growing restlessness than anything. I sat myself cross-legged and dead-center on the arch, my feet inches from the precipice in front, and focused my entire attention upon the moon, which was about halfway

up to the arch by now. To my amazement, the visions began almost immediately, and quickly overwhelmed me.

First the moon became a shining jewel, reds, greens, blues, and took on a very octagonal shape (or more—I didn't count the number of sides) that seemed to blaze and rotate in patterns of color in the sky, reminding me of the cut of one of those massive Indian gemstones from centuries ago that used to adorn the statues of their gods. The light from this jewel seemed to enter in through my forehead (third eye), causing the entire sky to burst into a light show all around me; I could hear myself saying "WOW"* over and over again, even though the words themselves seemed completely inadequate. (During this phase I could also make out what looked like runes around the edge of the moon, reminding me of Allyson Grey's secret-language paintings that I had never really appreciated until now.) The brightness of the lights in the sky was unbelievable, and there were explosions of light from behind me, but I did not turn around to look, I was determined to keep my attention on the moon. Meanwhile the visual phenomena in front of me were more than enough; to say that this light show was incredible, unbelievable, mind-blowing, just does not give it justice. I remember clearly thinking that I had just been at Burning Man and seen the best fireworks and light shows that technology has to offer, and this was way beyond that . . . a cosmic vision truly indescribable with mere words.

I have never had visions easily. The handful of times that I have actually "seen" things on anything other than smokable tryptamines have occurred as a result of (other) accidental consumption of truly massive amounts of psychedelics. But in this case I was a good five hours into my experience, and had been feeling for some time that I was coming "down." There was also a peculiar rationality to this whole night compared to other experiences, my mind very clear and totally astounded by what I was seeing. I watched as the moon then became completely white, like a blank screen with a bright golden ring around it, while the clouds became like a vortex spinning around it, the light

*"WOW!" was Steve Jobs's last word.

pulling everything in. This is when the "true" visions started in an unbroken wave that went on for forty-five minutes to an hour at least (I think—my grasp on time was limited). There are far too many details for me to describe here, but initially I watched the earth around me change from being red rock into a verdant garden, followed by vision after vision after vision of incomparable beauty, an unfolding of events flowing like falling snowflakes or a slow-moving river, flowering like a dream in a non-linear manner that I have always thought an ayahuasca experience would be like.*

I was completely physically overwhelmed by the experience, my body shaking as I cried genuine tears at the beauty and wonder of what I was seeing. After more than twenty years of entheogenic exploration I had never experienced anything even remotely like this, and I kept laughing and asking myself, "Are you glad that you stayed?" I thought of William Blake and was sure that I was now drinking out of the same cup that was his inspiration, but somehow I knew that this was all right, that men could see such wonders and not go insane; and that this was my reward for the work I had been given, for my writing, for my tribe building, and for all the hard work that is still to come. This night was both my reward and my reassurance, my proof (if I needed it) that I have been walking the right path, toward a mystery older than mankind itself, toward the deepest Mystery buried at the heart of all existence. For whatever unsought epiphany I had suspected might occur to me under this moon and this arch, I certainly hadn't expected anything remotely like this, and I knew it was a gift that might not ever come again.

Another vehicle pulled into the carpark below while I was in the midst of these visions, and while I knew it was there, I did not care. They could rob me of all they want, I told myself, because cameras, motorcycles, and computers are all replaceable, while visions like this

*So far my two traditional experiences with ayahusasca in Ecuador and Peru have produced little results other than vomiting, and, as the great botanist Richard Evans Schultes describes in his own experiences, colors and a few squiggly lines.

might not ever come in a lifetime. Nothing was going to make me come down from under this arch until this experience was over. (All of this was the paranoid ego-mind at work, trying to distract me—my truck was fine.)

The cold came somewhere early in the visions, I can't remember exactly when, only I know it wasn't right at the beginning, and that I lost all sense of time while the visions poured over me. The whole sky in front of me was lit up like a giant movie screen, framed by the rock confines of the arch, with the light of the moon rising up through its center. From the moment I had started to concentrate on the moon, I could not make out any of its craters or features—only its round shape and its blinding light. My body shook like a leaf, and my teeth chattered like those of a man possessed, and I was afraid I might bite my tongue and do myself some real injury, but I refused to stop looking at the blazing screen of the moon, my head tilting farther and farther back as it continued to rise. Remembering a cold night alone years before, when I was still an active mountaineer and I had taken shelter in a crevasse on top of a great mountain in a raging storm, I told myself that that night had been much colder, and even surrounded by deep walls of ice, I had survived it. I was in the desert in summer now, and it couldn't be that cold; I just had to endure it and let it go. Gradually the intense cold ebbed away as if it had never existed.

The whole sky was now a source of visions, incredible vistas wherever I looked, with bizarre tentacles of eyeballs that reached out and stretched around me like an octopus, and I realized that the landscapes I was seeing in the night sky resembled some of Alex Grey's paintings to a remarkable degree. I then became alternatively somewhat annoyed by this fact wondering if his art—especially these eyeballs!—had somehow primed my visions, and then I was glad of this resemblance, as I realized that he was actually painting very real vistas, just as a painter would paint a mountain, an ocean, or a forest of trees, offering proof that others had seen the wonders that I was now seeing. Impressed by this idea, I resolved that if Alex Grey could see and paint these worlds, then it would be my responsibility to try and paint them with words.

The moon had risen so high now that my neck was physically straining, until finally I had to break my concentration upon it. My legs were completely dead beneath me—I had had little awareness of my own body for hours—and I actually had to drag myself along the rock to untangle my unresponsive legs below me so I could get the blood flowing and get back to my feet. The intensity of the visions broke as soon as I stopped concentrating fully on the moon, though there were still faint remnants of the otherworldly vistas in the sky, and the peacock-feather colored eyeballs were still floating around me, googling down at my every move. "Very weird," I told myself, and my memory tried to dredge up something I had read about these eyeballs. Did the Tibetan masters see them also? Were they some kind of a membrane between the dimensions? I could not remember but I was sure they meant something.* An eighteen-wheeler then pulled into the parking lot far below me, and I instinctively turned toward the loud noise, thinking it might be a tow truck towing my vehicle away. (The only excuse I have for my extreme paranoia was a healthy fear of the Utah police.) Slowly pacing backward and forward, I swung my arms to get the blood moving again. Looking at my watch, I figured out that I had been sitting cross-legged for well over an hour of uninterrupted visions. I also realized that my dog was nowhere to be seen; I called out to him for a few minutes, afraid of where he may have wandered off to. Eventually he returned from his undoubtedly satisfying nocturnal doggy adventure. (If dogs can communicate, I wonder how he could start to tell the dogs in our neighborhood of the wonders he had seen.)

Turning my attention back to the moon, I saw that it was now

*I had only met Alex Grey once briefly when I wrote this piece, at the original CoSM in New York when I had visited there, nor did I know that Alex would provide the foreword for the final published version of *Tryptamine Palace*. Thanks to that synchronicity, Alex has become a friend and mentor to me over the years that have followed, and I have had the opportunity to discuss this experience with Alex. He told me that the Tibetan Oracle gave a talk at CoSM and identified the floating "peacock eyes," as I like to call them, and that Alex likes to paint (and that we have both seen numerous times) as guardians or walls between the *bardo* states.

blank apart from four eyeballs staring out of it and an intense gold ring around its circumference, while the rest of the sky was filled only with brilliant stars and the occasional string of wispy eyeballs staring back at me. I noticed what I thought must be the Pleiades twinkling in the distance, but they seemed too colorful to be stars, and then, to my continued amazement, I saw a cluster of colorful lights moving through the sky, completely unlike any aircraft I have ever seen. Watching as they moved from north to south, and then finally crossed over the arch, I lost them in the darkness, only to see them reappear and heading west. My already credibility-strained mind simply gave up on these, and I turned back to the moon. This night had already been crazy enough without having to deal with UFOs.

The moon still had a little distance to go before it hit the arch. The visions were now completely gone, other than the four eyeballs in the moon, which kept staring back at me. My mind was very clear and rational by now: all the effects of the LSD had now appeared to have worn off, other than a lack of tiredness—and this peculiar rationality heightened the sense of amazement at all that I was seeing. The close resemblance of many of my night's visions to Alex Grey's paintings kept my mind churning for some time, since I have always been a fan of Alex Grey's art, but no more than other contemporary visionary artists like Luke Brown, or Robert Venosa, and I had always assumed a fair amount of artistic license for all of their work. On one other occasion, I had a vision on toad venom, which both myself and my smoking partner realized the next day we had both had, that was identical to one of Alex Grey's works (*Bardo*). Still, I had never realized exactly how truly visionary the work of these artists really was, while now what I had just seen was so reminiscent of Alex's Grey's sprawling psychedelic vistas that I could only assume that his work was not the work of the imagination, but is in fact far closer to documentary! And indeed people frequently come to Alex and tell him that they have seen *exactly* the things he paints, while Alex himself likes to compare his work to the nineteenth-century American landscape painters who would travel to paint the wonders seen out west (Half Dome, Mount Shasta, southern Utah),

only to be accused of being fantasists by the East Coast art world, who didn't believe that such landscapes could ever exist.

The moon took about another hour to reach above the arch and disappear from view, and for the rest of this period I saw nothing but the four eyeballs inside the moon staring back at me, my contact with the rest of the visionary realm apparently broken. But the night would still throw one more surprise at me. Even though this all will sound clichéd to many of you, I assure you this is all completely true.

Once the moon disappeared behind the arch, a coyote started howling from across the canyon, the only one I heard all night, and it howled its heart out in a demented fashion like I have never heard a coyote howl before. (I have heard plenty of coyotes howl.) As the moon hit the arch, I looked at my watch, and it was three minutes to midnight. Another startling coincidence? Or is the full moon always directly overhead at midnight? (It is.) I then waited a half-hour more, more out of practicality then anything, because I knew that if I waited for the moon to traverse the roof of the arch, then its light would light up the steep path back down the canyon, which it did, bright as day. (I would have had a hard time getting back down in the dark, since I had neglected to bring a headlamp.) Then on the way back down, I suddenly heard a giant cat cough and growl in the darkness, a deep sound that literally seemed to shake the ground, and I froze in terror, as it seemed that a giant cougar must be close by.

My next thought was for Turk, my city dog who I could imagine being dumb enough to take on a mountain lion, but he seemed to hear nothing, just looking back at me as if to say, "Why have you stopped?" and then he kept heading down to the truck below. Standing there for a moment I gave thanks to the gods of the canyon and their protector spirits, told them that I wished them full respect since I understood that I had trodden on sacred ground at a sacred time, and then, as quickly and quietly as I could, I got the hell down off of there and into the waiting seclusion of my truck below.

By now the moon looked like any normal moon again, I could see its craters and seas clearly, and it no longer had the bright gold ring

around it, nor were there any celestial eyeballs to be seen. It was close to one in the morning—I had been under the arch for somewhere between five and six hours—and I fired up the truck and the stereo and drove till dawn. In Gallup, New Mexico, I checked into a motel, took a long bath, and then fell into a deep restful sleep till noon and then got back on the road again. Whether this event means that my mind has become more open to visionary experiences, I cannot tell you. All I know is that it had been a night of wonder like no other, quite possibly a night that will never be recreated, and I felt as if I had received some great blessing from the universe, my mission and my destiny seemingly clearer than ever, giving me all the inspiration I will ever need to continue to try and convince people of the magic inherent in the world.

37

THE PSY-FI CHRONICLES

A Harsh Encounter with Rapé

Apsychedelic trance festival in Holland—Psy-Fi—was the final stop on my month-long 2015 European speaking tour. Things started off a little screwy when its organizers sent a tiny car to the airport with no trunk or luggage space for three people, and it was clear that there was no room for me with my paraglider, climbing gear, and so on, even though I had previously warned them what I was traveling with. (A word to all festival organizers: never send an economy car for James Oroc.) For once I jumped happily at the opportunity to wait for four more hours for a van to come for me, so I threw my bags into the luggage storage at the airport, and then caught the handy train into Amsterdam to pick up a few smokable necessities from my old favorite, The Grey Area.

When I finally did catch my ride from the airport to Leeuwarden—the small town two-and-a-half hours north of Amsterdam that is the site of the festival—we managed to roll in (no pun intended) just at the tail end of a storm that had come in off the North Sea and in two hours had completely trashed the place. Large tents had collapsed, the fabrics on the main stage were shredded, one dome was half full of water—as I sat in one of the organizers' trailers upon arrival, the damage report continued to climb. The storm (waterspout?) was so powerful that a cow was reportedly lifted off the ground. I kid you not. Definitely a ripper. My feelings went out for the festival crew, who now had a major

job getting things back to ready, as the 17,500 people who had bought tickets kept steadily arriving to set up their campsites (in the pouring rain) before the opening ceremony scheduled for the next day.

Luckily, for the first time on my tour, the organizers had put me in a hotel. This was both a blessing for the first two days when it poured down rain, and a bit of a curse compared to the other festivals I had attended, since I wasn't really meeting anyone but the people staying at my hotel—DJs, organizers, and so on. Kind of a double-edged sword, and one made sharper by the fact that it was Build Week at Burning Man—the first I had missed in over a decade. And on top of that, the coming weekend would also be the tenth anniversary since Hurricane Katrina, and I had been at Burning Man when Katrina hit my home-town of New Orleans—hence the inevitable mythical co-mingling of the two.

A potentially emotional weekend for me, and one in which I felt myself keenly missing my tribe. However, I was excited to have the chance to address and connect with the European psytrance tribe, which is much more varied and multiethnic than at Burning Man, a fact that I had been greatly enjoying. But being stuck in the rain was not exactly what the doctor had ordered for my first serious case of playa itch, so I made the most of the hotel room in those first two days by writing a new (and final) short story for my long-threatened fiction collection *Who's Got the Bomb?*

On Friday night I delivered probably the best presentation of my tour (a two-hour epic romp through the pages of *Tryptamine Palace* and well beyond) to a full circus-style speakers tent, which found me con-stantly on my feet and in a deeply philosophical mood. The next day the sun came out, and that night I had the rare treat of seeing OTT (my favorite electronic music producer) deliver a stellar and unexpected "Hallucinogen in Dub" set in the very psychedelic setting of the radical Chill Dome. Exactly the medicine I needed, this was probably my favor-ite electronic set of all time: it was mostly a true Dub set (something I rarely get to see), the heavily psychedelic Jamaican/English music that I grew up listening to in New Zealand done in OTT's inimitable style.

For those familiar with English Dub, OTT actually cut his teeth working with the famed British producer Adrian Sherwood on his mythical On U sound label, working with bands like the Dub Syndicate and African HeadCharge—my favorite band ever—so I was in my own personal sonic heaven for two hours. Needless to say, I didn't make it back to the hotel until pretty late that night.

On Sunday morning I managed to stumble out of bed to go back to the festival for a longstanding date with my friends Eve and Yaegon to see Carbon Based Lifeforms, a DJ duo that Eve had been raving about since the early summer. Like many things this weekend, Carbon Based Lifeforms had been moved, from the main stage to the Chill Dome, after a noise ordinance got the main stage closed down on Sunday morning. (This was actually a blessing, since they already had the main-stage volume turned down so far that it was quieter than a club.)

The sun was shining, my work was done, and I was still cruising on the double-drop of happiness that OTT's set had demanded from the night before. So as CBLF came on with a long ambient intro and I relaxed in the very rear of the Chill Tent, things were feeling close to perfect. I should have known enough not to mess with a state of such bliss, but unfortunately that's not the way I am built.

It was my insatiable curiosity that was once again my downfall. Looking around aimlessly at my immediate surroundings with my usual hyper observant writer-photographer's eye, I immediately noticed that the two strangers closest to me were blowing some kind of snuff up their own noses with a very professional-looking apparatus that resembled the flexible hose of a hookah.

"Is that rapé?" I leaned over and asked with professional interest. Rapé (pronounced raap-hay), I had learned from Graham St. John, a fellow psychedelic author who had organized a number of the talks at both Ozora and Psy-Fi, is a (legal) shamanic medicine snuff from the Amazon in Brazil and Peru. Judging by the number of times I have been running into it, it clearly has a fast-growing reputation. Obviously a big fan of the stuff, Graham had been snuffing away quite frequently at Ozora and had offered it to me on numerous occasions, all of which

I had declined. The Dutch fellow of whom I had innocently asked the question now grinned back at me with a big grin and said that it was indeed rapé, and then asked if I would like to try some.

Although I had turned down Graham repeatedly in his offers to try rapé—mostly because of timing—its effect had been described to me as "mild, uplifting, and providing a general sense of clarity." Now, impressed as I was by the professional way in which these Dutch lads were hammering down their snuff, I suddenly thought that it might be just the ticket for the warm ambient beats that Carbon Based Lifeforms were putting out and the chilled-out vibe of the late summer afternoon.

"Just put a nice light twinkle on the day," I remember thinking to myself. Asking for a small dose, my new Dutch friend (who, it turned out, had seen my lecture and thus was more than happy to oblige) poured out a pile in my hand and instructed me on how to fill the pipe. Then he showed me how to loop it around and insert the stainless-steel nipple on one end in my nose, and the other end in my mouth. I dutifully blew the snuff up my nose as instructed—and virtually immediately found myself physically gagging as I reeled from the foul intensity of the blast.

"Fuck!" I thought to myself. "That's not at all what I expected!"

Struggling to keep my composure, I found nothing mild or uplifting about the experience at all. It felt more as if I had just poisoned myself, as my body immediately broke out in a sudden and dramatic case of the sweats and I felt nauseous.

In a flash, out of nowhere, Yaegon was on me with a serious look on his face.

"You've got to do the another nostril now. Balance it out."

"I don't know that I can," I pleaded, the distress clear on my face.

"No, go on," he insisted. "You've got to balance it out."

"Fuck, it tastes horrible."

"You don't want to swallow it. Here I will help you out and blow the other nostril. You just do what I tell you."

Preparing the rest of the snuff, Yaegon expertly took over the pipe.

"All right, you need to fill up your lungs and hold them at the top

of your breath." he said in his liquid Aussie accent. "Keep holding your breath."

And then, clearly relishing the role of bush doctor, he forcefully blew the snuff up my remaining virgin nostril.

While holding my breath definitely helped and I didn't swallow any of the bitter snuff down my throat this time, the blast still nearly blew my head off, the effect both disorienting and highly uncomfortable after the physical jolt rolled through my body. Once this first wave passed, I just sat there wobbling, feeling a kind of a strange mental clarity, but a debilitating, highly distressed one as I struggled again to retain my composure. It was then that I finally recognized the taste that had been just eluding me the whole time.

"Is there tobacco in the rapé?" I heard myself ask, a bright light suddenly going on in my reeling mind as I watched my Dutch supplier light up a huge tobacco joint, and he happily nodded his head to the affirmative.

"Fuck," I thought to myself. "That explains it."

If I had known that tobacco was involved in any way, shape, or form, I would have never touched the stuff, let alone taken the second blast. I have never smoked tobacco, and while I have snuffed tobacco juice in Peru in purification ceremonies and pulled chillums with various sadhus in India, tobacco most certainly has never been my ally, and I seem to have a virtual zero-tolerance for nicotine—I actually think I am allergic to it. On this tour (and, unfortunately, increasingly on the West Coast of the United States) I had to constantly ask people if there was tobacco in the joints they offered me (in Europe there virtually always is), because I have learned from experience that if I accidentally smoke tobacco, the effect can be dramatic.

"Yeah, I've got four different kinds of rapé back home, and the best one for me is the one without tobacco," Yaegon now chose to inform me. "The first time I did it was on a dance floor in Brazil when this old Brazilian medicine woman came up and offered it to me. I told her to give me just a little dose and she gave me about a quarter of what she would do, and of course it totally paralyzed me.

For a long time I couldn't even move, I just lay there in the middle of it all, until I finally managed to crawl off the dance floor. Luckily Eve found me right then and managed to get me out of there, since I just started purging out of each end. I felt amazing afterward though, it's powerful medicine."

Purging out of each end? I found myself groggily hanging on these words. "No one had told me that was a possibility," I thought, but as soon as Yaegon said it, I knew that that reality was where I was heading. Within about three minutes I threw up (slightly) for the first time on the very edge of the Chill Tent, and with the flushed realization that a lot more was coming, I managed to make it to the bushes situated about thirty feet behind the tent before the first wave of vomiting really set in. Here I was besieged by round after round of horrific convulsions so intense that I had no choice but to collapse in a shivering heap between each new wave, so completely paralyzed that I could barely roll over or move my head.

Yaegon came out to check up on me.

"Yeah, that's it, mate, just purge it all out. It's all good for you. That was kind of irresponsible that guy not telling you that there was tobacco in it, though."

"I guess I should have asked more questions," I managed to gasp in between heaves, the thick and chunky volume of my earlier (vegan) vomiting now beginning to turn into painful string of bile. "Was that a big dose?"

"Oh yeah," my Australian bush doctor answered with clear authority. "Each nostril was about four times what I normally do, I reckon."

Just what I needed to hear. Another wave of powerful vomiting rolled through me like an internal tsunami seeking air, each convulsion now feeling like it was threatening to break a rib.

"It's good medicine," Yaegon informed me again. "What needs to come out, comes out. It's good for you. And at least you have a nice sound track to listen to."

With that Yaegon headed in back to the Chill Tent, and I noticed from my prone position face-first on the ground that his toes

were painted with black glitter—the last moment of amusement or distraction that I would have for at least the next hour.

As a child I always became sick on fairground rides, while as a para-glider pilot, I have a long history of suffering from air sickness so severe that at times it has made me consider giving up the sport I love the most. (After the first couple of weeks of spring flying, it mostly goes away, and if I fly a lot it goes away almost completely.) Vomiting is thus indisputably one of the things I enjoy the least, vomiting in public even less so. This fact makes me wary of ayahuasca (I have tried it twice) and also makes me scrupulously avoid any synthetic compounds that might make vomiting or excessive trips to the bathroom even a remote possibility. Hence the next forty-five minutes of being paralyzed and barely able to roll over to vomit in the bushes—all the while situated in clear view of the back edge of the Chill Tent, with numerous strangers walking by—was to say the least an extremely humbling, humiliating, and highly unpleasant experience. Certainly a lot less glamorous than captaining the Lady Sassafras* around the playa on a Saturday after-noon (which is what I had done on this same weekend for most of the previous decade), and it was made all the more frustrating by the fact it was totally unexpected.

My Dutch benefactor came out and took a look at me, declaring with a sincere smile the same "Ja, ja, it's good, get rid of everything that must go" spiel that Yaegon had laid on me. All I could say in reply was that I generally like to choose the time and place for my purges as I vomited again slightly at his feet, and I thought for a moment that if I could have gotten to my own feet that I would have probably decked him. Another wave of intense purging hammered its way through me, violent physical aftershocks that felt as if they were crushing my insides with a vice. This time I managed to crawl and stick my head in a bush as I began heaving and groaning, as my Dutch benefactor headed back into the Chill Tent with a slightly worried look on his face.

*My Burning Man art car—a Hurricane Katrina supply bus converted to look like a Mississippi paddle-steamer.

The convulsions had me lashed me to the ground, helpless, so unable to move that I was finally reduced to being able only to roll over each time to vomit in a growing pile of bile beside my head from which I couldn't drag myself away, only capable of flopping over on my back and lying there like dead in between the gut-wrenching contractions. I have thrown up plenty in my life, but I couldn't ever remember anything like this. It was far worse than any air sickness or college hangover that I had ever experienced, even worse than the vomiting that accompanied the migraines I had suffered as a kid, my personal benchmark for misery, I realized, till now.

"Please let it stop," I begged audibly as I lay sobbing face-first into the ground, my tears lying atop the damp black soil, but the convulsions wouldn't let up. Wave after wave pulled everything out of me and left me lying paralyzed in the sun, too exhausted to move at all. Finally, with a monumental effort, I managed to crawl to a small patch of shade behind a video screen a few feet away, knowing that the now surprisingly hot sun would fry me where I lay.

Once I made it to the shade, I realized that I was completely drenched in sweat, my body's exterior glands working as if I had just climbed a mountain or run a marathon. I began to shiver violently, not sure if I was hot or cold anymore, my body temperature apparently erratic and unstable. The rapé had seriously fucked up, I told myself, and I wondered if I had genuinely been poisoned. Medicine? On what fucking planet could this be considered medicine? I would need to be able to fly without a paraglider after this shit wore off for it to be anything close to being worthwhile. Medicine? The crazy shit hippies were willing to believe astonished me.

This bitter realization brought on another wave of vomiting. Of course I had long since emptied all the remotely solid items from my stomach, and now even the bile was beginning to run out. Instead of really vomiting, I was now basically experiencing severe, full body-wracking convulsions, which managed to only drive a thin drool of spittle dribbling from the corner of my my mouth. Every now and then I would surprise myself with another puddle of internal juices, my

stomach purging everything that it owned, while my body shook, convulsed and cramped as it curled up in a fetal position on the ground. Seeking refuge in happier times and other lands, I felt a moment of relief that this wasn't happening at Burning Man, where I undoubtedly could have made the same poor choice of not asking enough questions before accepting an Amazonian snuff on the dance floor, and then thinking for a moment how dramatic a MOOP* incident that might have led to.

Yaegon reappeared.

"You feeling any better?"

"Not really."

"Ah, well, it will pass. It's all good medicine, you know."

Dressed in his purple smock with one of those feminine gold headpieces he likes to wear, Yaegon looked for all the part like some Egyptian deity standing above me in the sun, his form outlined with a bright, painful aura.

"Here, I brought you some water."

Like Moses out of the desert.

"That's probably a good idea," I said, but then, as I tried to get to a sitting position, another wave of convulsions rolled through like a winter swell in Waimea Bay, and I collapsed prone again.

"Do me a favor," I manged to ask. "I left a barely smoked joint of pure weed on the table beside Eve. Could you grab that for me?"

"Oh yeah, the old ganja," Yaegon said with a wise smile. "Stick to what you know. That's probably a good idea. I'll go get it for you."

While he was gone, I considered the great fear that had been possessing me for some time. Yaegon had mentioned "purging out each end" (and worse), and I had no doubt that the second part of this prediction was soon about to hit. Thus I found myself sincerely hoping that unlike this first wave, the secondary effect would not be in public. Problem was, as physically dehabilitated as I was, I genuinely could not

*MOOP = Matter out of Place: a Burning Man acronym for trash or any alien matter on the playa. One of the Ten Principles of Burning Man is "Leave no trace," though that has been increasingly ignored over the past few years.

move, the two nostrils' worth of Amazonian "medicine" snuff having utterly devastated me. I considered asking Yaegon to help me get to the portaloos, but the toilets were a decent distance away, and with his slender form, like that of most DJs, I doubted that he would be of much help to me anyway. He and Eve together might have had a chance, but they had been waiting for this particular set at the Chill Tent for so long—a rare event for a couple who practically live at festivals since Yaegon is a producer—that I could not bring myself to ask them for help and thus drag them away their fun because of my own stupidity. The irony of the fact that with virtually any other DJ set in the past month of festivals that we had all attended, Yaegon and Eve would have been ready to move on in less than five minutes was not lost on me, and I resolved that I would have to just tough this one out alone. Hopefully a little bit of water and a couple of puffs on the joint would settle me down enough that I could get to my feet again, I thought.

Yaegon delivered the joint and lighter as promised, and after I told him that I was all right, he headed back into the Chill Tent. After taking a couple of sips of water by holding myself up with one arm, another attempt at sitting upright resulted in yet another set of violent convulsions that managed to raise the heads of a couple of middle-aged women who had rather unobservantly sat down near me to eat their lunch. I now began to wonder if the rapé had not in fact affected my inner ear, for any movements I made seem to bring on another wave of vomiting and convulsions, with each wave seemingly worse than the previous series. (Ketamine has a similar effect upon me: it affects the balance mechanism in the inner ear.) As much as I had pinned my hopes that a couple of puffs on the joint might help— for I have always found cannabis to be an excellent (if not the best) natural medicine for cramps and vomiting—I could not actually bear the thought of putting anything else into my body right now: all my body wanted was for the convulsions and the sickness to stop so that it could rest, and a quiet dark hole that it could crawl up in. But I knew that I had to get to the portaloos first, or suffer the greatest humiliation of my adult life—the imminent possibility that I might

trump my current state of public vomiting by actually soiling myself lying here on the muddy Dutch ground.

Pretty strong motivation to get me up on my feet, you would think, but, try as I might, I could not, each attempt foiled by another wave of cataclysmic purging that left me weaker than the last. "High-altitude sickness had nothing on this," I cursed to myself. "At least at 20,000 feet in the Andes I could still stagger around. I must be really fucked up."

"O Lord, please help me now." I beseeched the heavens, calling upon my Quantum God. "I'm here trying to do good work—do I really deserve this?" But as the old Jewish proverb says, "Man thinks, God laughs" and I knew that the God I believed in had no problem with what I was going through, this being just another ripple of experience informing the infinite holographic zero-point field. Still, it seemed unnecessary, and by now I was feeling that I had undeniably learned my lesson, any sense of psychedelic rock-star status I had was long since gone. But still the purging went on and on, until eventually, with a Herculean effort in a pause between convulsions, I manged to sit up, and then a few minutes later, actually get to my feet.

I had also managed to pick the joint and lighter up off the ground from where Yaegon had placed them by my head, but I still felt too weak to actually inhale anything other than air. Heading off toward the staff portaloos which, while a little further away than the public ones, I reasoned would have less chance of a line, I staggered down the narrow pathway like the proverbial village drunk, my reflexes and coordination majorly impaired. Ludicrously I felt a moment of sudden paranoia, wondering if people were looking at me, and then I reminded myself that I had just been vomiting in the middle of the festival for close to an hour and no one had seemed to care. Who gave a fuck what people thought about me right now anyway? I told myself, this was pure self-survival. At least I was on my feet and moving, and I registered the fact that while I had been laid out vomiting and clearly in distress, not a single stranger had stopped to ask me if I needed help. "One of the little differences about Europe," I mumbled to myself, and actually managed a

strained chuckle at this line stolen from *Pulp Fiction*. Somehow I didn't think this would have happened at any West Coast festival. Some concerned faery would have undoubtedly stopped and asked me if I was all right. (God bless all you little faeries everywhere.)

Finally I made it to the Promised Land—the staff portaloos, which were mercifully empty. I won't bore you all with the details of what went on in there. I will only say that, fortunately, it was far less dramatic than the vomiting but similarly effective. I sat in that portaloo for a long time, finally managing the first couple of weak therapeutic puffs on the joint that I had been holding on to so long.

Things were getting better, but when I eventually got off the plastic throne, I found I was still far too weak to walk back to the Chill Tent; the effort to get to the portaloo had taken all I had. So I sat on a bench outside the nearby staff canteen for a while, until the shade caused me a series of chills, the day clearly growing colder. Spying a patch of sun and grass among the tents set up beside the kitchen, I moved over and lay down in the sun and closed my eyes, as exhausted as after any mountain I have ever climbed, or after any marathon multiday debauchery session. The rapé had done a royal job on me, and I couldn't help but respect the thoroughness with which it had cleansed me out. But where was this marvelous afterglow, this clarity that had been advertised? Struggle as I might to find some silver lining in this dubious cloud, I could find nothing but an extreme sense of physical debasement, the kind of feeling that one has after slowly recovering from a long illness or an unfortunate accident. While rapé obviously worked for some, it clearly didn't work for me. I chided myself again for trying an unknown substance in public, and without asking enough questions. I had gotten that lesson out of the afternoon, I told myself, and not much else.

A shadow passed over me, and as it stopped and hovered there, I opened my eyes. A woman was standing beside my head, a Psy-Fi volunteer I had met briefly a couple of nights earlier while waiting for a shuttle outside of the staff office.

"Oh hey there!" she said enthusiastically, clearly recognizing me. "How's it going?"

"Not so good, unfortunately." I managed to answer. "I have been a bit sick."

"Is there anything I can do to help?"

"No, I'm OK thanks," I said. "I just need to lie here for a while."

Embarrassingly, the effort of answering the woman now caused a minor wave of vomiting to roll through me again, the first in some time, and there was nothing I could do but puke where I lay at the feet of this stranger.

"Do you mind if I sit with you?" the woman asked, apparently not put off by the puddle of bile at her feet. All I could do was nod my head in weak consent, thinking perhaps a little company would be good for me.

I have found in my life that people like talking to me. I'm one of those people my community likes to come to with its hopes and fears, and I have had many a stranger tell me the damnedest things within hours of meeting me. I guess my ego believes that it's my considerable experience and occasional flashes of wisdom that produces that effect, but it could be equally likely that it's simply my physical appearance, my solid, rocklike nature, that allows others to moor in the calm waters of my shores. Whatever the reason—and on this occasion I can offer neither explanation from my intellect or my aura, since both were virtually entirely absent—this would be one of those times, as over the next forty-five minutes this woman, whom I had only talked to for approximately five minutes some two nights before, proceeded to tell me virtually her entire, occasionally tragic, life story.

It was a potent storm of words and tears to which I was a literal prisoner, still so physically exhausted that I could not move to escape this verbal purge if I had wanted to, with even my occasional bouts of mostly empty vomiting having no effect on slowing her story. This fact caused me a moment of real panic some five or ten minutes into her history, until I realized with a flash of clarity that by being there I was performing some essential function for this stranger, even though I could barely move my head to occasionally nod, let alone offer any analysis or advice. (This is also one of the main trainings of hospice

volunteers: to simply sit quietly with people and listen.) This realization allowed me to rest and let the waves of powerful emotions wash over me, like waves onto an unyielding shore, my participation in the conversation clearly far less important than my simply being there. Still I managed the occasional nod or shake of the head, while the woman herself squeezed my thigh from time to time, perhaps checking that I was still actually awake and listening, since most of the time all I could do was lie there like dead in the sun with my eyes closed. Psy-Fi was only the second festival this woman had attended. I learned there had been a controversy with her campmates. A friend had recently died, which had something to do with both why she was here and the situation at her camp. . . Her story came out of her just as the rapé had just purged the bile out of me, a verbal cleansing that she clearly required. As she happily continued on and on, I lay there, managing the occasional puff on my joint, happy that I was at least performing some useful function despite my extremely debilitated condition. Somewhere toward the end, the woman mentioned that she was bipolar, and having known a disproportionate number of bipolar people in my life and finding conditions like it and Aspergers fascinating, I clinically stored that fact away into my own mental archives.

As her story came to its natural end, I suddenly felt much better, and for the first time in hours I sat up without difficulty, somewhat surprised at how much of my strength had suddenly returned.

"Thanks for listening," the woman said, clearly having appreciated having someone to talk to, and I told her in all honesty that it was my pleasure, and that I was now feeling well enough to go and try and find my friends again. Getting to our feet, we exchanged heartfelt hugs, two random strangers connecting in a meaningful exchange almost impossible outside of a festival, and I tottered off toward the Chill Tent feeling glad to be alive.

Carbon Based Lifeforms had long since finished their set, and Eve and Yaegon were nowhere to be seen. I realized that I had no real idea of how much time had passed since I had made the poor decision to try the rapé, but figured it was at least three hours. The music around me

sounded shrill and painful on my ears, and I realized how weakened I was from the arduous experience, still with none of the advertised after-glow apparent. Realizing that a festival was probably the last place I needed to be right now, I made my way back to the staff office, and recognizing my distressed state, one of the drivers volunteered to take me back to the hotel straightaway. Rarely have I been so happy to see a hotel room alone. After taking a shower and drinking as much water as I could, I was soon asleep, completely exhausted at five-thirty in the afternoon, after one of the harshest public experiences of my life.

I had put in a request for a ride to Amsterdam the following day, but when I checked my computer back at the hotel room, I discovered that my ride had been scheduled for 6:15 a.m., and one look at the state of my room told me I wouldn't be making that. Arising around 11 a.m., I figured that Psy-Fi had done plenty for me by this point and that I could organize my own transport to Amsterdam (via train) easily enough. However, as I was waiting at the hotel, I finally met Rob Psy-Fi, the genial dreadlocked main organizer who was responsible for both the festival and for my own appearance at it. I had been trying to find him all week to thank him for inviting me there to speak, and thus was very glad to spontaneously run into him. As we talked, he asked me how I was getting back to Amsterdam and then offered to take me back to the festival, where he could easily organize a ride for me. Luck was clearly going my way, so I gratefully accepted the offer, and soon after we got there they found a car and driver to take me to the airport—far more than I had expected.

My psychedelic rock-star status now restored, we exited the festival, at which point my driver—a bespectacled German—asked me if I wanted to do a tour of the town of Leeuwarden first.

"I'm just a volunteer," he explained, "so if you're not in a hurry we can do what we like. Perhaps you would like to visit a coffee shop before we go?"

Leeuwarden, I had been told, was a town of around 90,000 people that had a staggering thirty-eight coffee shops—the highest number per head of any town in Holland. A "coffee shop"—for any of you who may

be confused—is a Dutch euphemism for a licensed establishment that sells (along with tea and coffee) hashish and marijuana in a variety of different forms. Since my own supply of weed had just run out, and I had never had the chance to visit a coffee shop outside of Amsterdam (which tends to cater more for tourists), I readily accepted this opportunity to both check out a local's coffee shop and see a bit of the town.

The center of Leeuwarden was pleasantly Dutch—a mix of attractive old buildings and picturesque canals replete with floating houseboats. My driver drove us around somewhat haphazardly, declaring that he thought he knew how to find his favorite coffee shop out of the plethora available. Parking the car on the edge of a canal, we then started wandering the cobbled alleyways of the old town, while my driver asked various random strangers for directions, finally arriving at our goal in a somewhat random zig-zag manner. The coffee shop itself was cozy, though rather plain—an old two-storied building with none of the art or thematic style that distinguishes many Amsterdam coffee shops—but its selection of wares was considerable, and its prices half that of what I had paid at the Grey Area in Amsterdam. Suddenly as excited as a kid in a candy store by both the choices and the novelty, I ended up purchasing several different items, and then after ordering a mint tea, moved into the rear of the establishment and sat down at a long shared table to roll myself a pure joint.

Marked by the wristbands that we all still wore, I noticed that a number of the patrons had also been at the festival, but the vibe in the coffee shop was quiet and very chill, most people clearly having had enough partying for the weekend. My driver had a call come in on his phone but apparently didn't have the credits to reply, so he got up and went outside, telling me that he would be back soon.

By the time my joint of Pearl Haze was finished, he had returned and then, after borrowing some large papers from a stranger who was sitting beside us, he proceeded to roll an enormous joint of his own.

"You want to smoke?" he asked me, and I explained that I didn't smoke tobacco.

"It's pure," he said. "I don't mix with tobacco either."

A German who smoked pure joints! I was astonished, and readily accepted his joint even though I was already well stoned.

The stranger who had given my driver his papers and a light now joined in our conversation. Another German, he had also been at Psy-Fi, and noticing the different color of my wristband, he made a comment.

"You are a VIP?" he remarked with a slight sneer. "Are you a DJ?"

A psychedelic author, I explained, fortunate enough to have been invited to speak about my book. This explanation seemed to satisfy the stranger, who seemed to have a distinctly socialistic bent, and we soon dropped into a rather dark, conspiracy-theory-laden conversation about the state of the modern world, while my driver and I smoked away on his giant gorilla finger of a joint.

In an effort to change the direction of the conversation, I remarked that I had met few locals at the festival, and my driver informed me that the vast majority of people there were from outside of the area; even though Leeuwarden was a college town, few locals had actually attended, since psytrance music was comparatively unknown in Holland. My tour of the European psytrance scene had made me realize that most of the festival goers moved from one festival to the other all summer, a tightly knit and very international tribe. I had also noticed that the vast majority of the volunteers I had met at Psy-Fi were either German, Belgian, or from some other European country, and I wondered how Psy-Fi had been so successful in conscripting so many foreigners.

"This was only my second festival I have been to," my German driver explained. "I am bipolar and was depressed for a long time, and then I went to a psytrance festival in Germany and realized these gatherings are good for me. That's why I volunteered at this one."

Another bipolar festival neophyte! What was going on here? My driver was now the third volunteer who told me that Psy-Fi was only the second festival they had ever attended. The first had been a large, seemingly socially awkward German girl who had driven me around earlier in the week. (I never asked if she was bipolar.) I found this fact somewhat astonishing, and I realized again that this festival (and all festivals) was providing some essential social function apparently miss-

ing in these slightly dysfunctional people's "normal" world. None of the three had any real interest in the music, and it was clearly the sense of community and connection that they were gravitating toward, something that was missing from their own world—the feeling that they could belong to something greater than themselves. After more than ten years of participating in the transformational festival scene in the United States, this now came as a very satisfying confirmation to me— the fact that we have all been working toward building something more than the monster parties that most mainstream festivals are.

The use of psychedelics at these events clearly plays a major part in breaking down the social barriers that inhibit many people in this modern, often frightening age, and promotes a sense of connection and community that so many people are apparently missing in their lives, along with an empathy and tolerance that is sadly lacking in the so-called real world. The attraction of both the European psytrance scene and the American transformational festival circuit is obvious, because the more of these festivals you attend, the more you become a part of this glorious international rainbow family that Allyson Grey fittingly calls "The Love Tribe."

Once the monster joint was finished, the driver and I exited the coffee shop, at which point I became aware of how completely ripped I was, since we had probably just smoked close to 3 grams of potent Dutch weed between us, and my usual tolerances had become greatly reduced over the past mostly smoke-free month. Attempting to retrace our steps, we soon became disorientated, and I quickly realized that my driver didn't have a clue where we were and that we were now like stoned rats lost in an antiquated maze.

"What a classic bonehead move," I thought to myself wryly, as I realized that I hadn't really paid any attention to where we had parked, nor had I noted the name of the street, as I usually would. I had no recollection of either the color or the make of the car, and all I could remember was that we had parked on a canal and close to a small bridge, since I had uncharacteristically put my faith entirely in the hands of my driver, only to realize that he was a slightly odd character, extremely

stoned, and as much of a stranger to the area as I was. Luckily I was in no hurry to get to Amsterdam. I wasn't catching a flight until a couple of days later, and the people I was staying with wouldn't be home until the evening anyway, so I followed the driver for a while until I was sure he was completely lost, and then the trained mountaineer in me took back over.

"We are going the wrong way," I told him. "I noticed that big church steeple as we walked to the coffee shop, and it was on our right, and now we are past it and heading away from it. We need to head back in that direction, so I figure if we turn right on this street we will skirt the other side of the church and arrive back at the car."

My driver looked dubious, undoubtedly embarrassed by his inability to find the loaned vehicle, but he finally agreed to follow my directions. Sure enough, as we came around the opposite side of the large church that I had subconsciously registered on my walk, we were back on the canal, and our car could be seen just a few hundred feet away. (Fortunately the driver remembered the color and make of the car—my own recollection was impaired.)

Still as stoned as could be, we jumped in the car and took off, trying to find our way out to the highway to Amsterdam. After half an hour of driving around the town to find the outer ring, we then found ourselves back at Psy-Fi, a fact that caused me a great deal of amusement but at least orientated us sufficiently that we could do a U-turn and follow the signs out of town. I had no phone—it was stolen in Hungary and I had survived a merciful month without it—while my driver's antiquated phone apparently had no maps function. How did we all survive back in those days before GPS and smartphones? I am proud to be able to say that I traveled the world for nearly two decades with paper maps and guidebooks and rarely got lost, and there is no doubt that our reliance on modern technology has atrophied our ancient skills.

We finally found the highway back to Amsterdam, and the rest of the journey progressed smoothly, with the driver suggesting various stops along the way that I soon realized were required for his own self-medication. At one point we stopped on the giant levee that the Dutch

built to reclaim hundreds of square miles of land that had previously been under water. I stood atop it, looking out at the tumultuous North Sea in one direction and the kite surfers enjoying the flat water of the lake on the other side, sobered by the fact that the Dutch were capable of such an incredible feat of engineering while my own hometown of New Orleans had been devastated because of the shoddy work of the Army Corps of Engineers.*

Eventually we arrived at Amsterdam's Schipol airport. I thanked my driver and bade him farewell before jumping on a train back into the city, where I went to meet some Dutch Burners whom I had never met before, but who had offered me a free place to stay through my worldwide Burner tribe. Over a fabulous dinner of Indonesian food in their stylish apartment that night—my host turned out to be a Dutch banker with a wry sense of humor and a lovely French wife with excellent taste in wine—our conversation jumped back and forward between the playa and the European psytrance scene. In the end we all agreed that it was all about both the transcendental power of art and music, and the deep human longing for the feeling of community, a family whose tremendous hospitality I was enjoying right there and then.

In such tenuous times, what could be a more beautiful thing?

*While Hurricane Katrina has largely been blamed for the massive destruction of large portions of New Orleans, the fact is that the storm barely hit New Orleans at all, and the failure was due to faulty engineering of canals built in the 1970s by the Army Corps of Engineers.

38

A DEATH
ON THE PLAYA

Profound. People keep asking me how my Burning Man was this year, and that's the only word I can really find to describe it. This was my twelfth Burning Man, so I guess I should have figured out by now that the playa can deliver virtually any experience, but the two Burning Mans so far that have been marked by the greatest evolution for me are those that have been marked by great tragedy—in 2005, when Hurricane Katrina hit our home town of New Orleans while we were on the playa, and now in 2014, when my greatest fear as both a camp organizer and as an art car captain happened, and one of our campmates lost her life from a terrible playa accident.

Her name was Alicia, she lived in Jackson Hole, Wyoming, worked in an art gallery, was on her way to New Zealand, and was a bright and vibrant soul. She arrived at Burning Man Wednesday night, but I never saw her on the playa. She was with a friend of mine (also a first-time Burner) who arrived at camp while the Lady Sassafras was taking a little down time and our crew was eating, and the pair took off out onto the playa without waiting for us to regroup. As far as we know, Alicia climbed onto the trailer of a moving art car, then either jumped off or fell, and subsequently fell back under the heavy tandem trailer, which ran over her over and killed her. Alicia had been on the playa less than three hours and probably spent more time waiting in line, before, literally and figuratively, she slipped through the cracks and the playa ate her up.

I found out about it the next morning (Thursday) as I was about to walk to the Temple for the first time after the Lady Sassafras pulled up beside the Abraxas dragon for the White Parade, usually my favorite morning of the week. I had not in fact even known that Alicia was coming to Burning Man, so after a short process of figuring it all out, and then realizing who it was, I became totally numb. I have lived in the great mountains of the world for many years and have a long history of paragliding, back-country skiing, and mountaineering, so I have lost an inordinate number of friends—including the Preacher, a fellow paraglider pilot who died in an accident only a month or so before, and whose name I was literally off to inscribe on the Temple Wall before I was told about Alicia. While few deaths come with a warning, this one seemed utterly surreal. Not really knowing what to do—my friend, who had been traveling with Alicia, had already been interviewed by the police and had left Burning Man again—I walked out into the beautiful crowd of friends in front of the glowing Golden Dragon and then saw the woman I really needed to see, standing with another lovely female friend of mine. As I told the pair of them what happened, and this other friend then started to cry, and I realized that by some bizarre synchronicity, she had been a passenger on the last art car that had had a passenger die by jumping out and being run over by the trailer, some seven years before. (I knew the story well, and the safety of the large trailer on the Lady Sassafras has been a matter of constant internal debate.)

Desert Dwellers are one of my favorite Burning Man acts, but I could not hear the music, nor did I have anything to say to anyone, so we packed up the Sassafras and headed back to camp, where I passed out in a muted exhaustion. At this point Brother Dance—one of my right-hand men at camp, and someone with whom I have made camps with for years at Burning Man—did an exceptional thing, and wrote the art car crew that had been involved in the accident a note of love and condolence. (Initially the rangers who came to our camp wouldn't tell him which one the other art car was.)

Running the Lady Sassafras is always a team effort, and at this

point I would just like to say a word of appreciation for all of those people who have worked with me on the playa, year in and year out, to make that dream a reality. I am humbled by the quality of people I am fortunate enough to have around me; my friends always make me proud, and most certainly did so in this incident. Later that day we met with the crew of the other art car when they came over to our camp, and you could see the astonishment on their faces when they realized that we too were an established crew that run a bus and large trailer similar to theirs (there aren't actually that many rigs of that size on the playa), and that of all the hundreds of camps at Burning Man, we were one of the few who could truly understand.

It was a unique meeting between two obviously dedicated art car captains and their crews, and there were other equally bizarre and powerful coincidences that I won't go into here. I hope that meeting gave that crew some comfort and healing, and I can categorically say that I believe they hold no blame. People climbing on the trailers of our art cars is close to unstoppable, and it is every large art car captain's worst nightmare. I personally have stopped the Lady Sassafras countless times to get people down off of our trailer. If anything can be taken from this tragedy, it is a reminder that Burning Man can be a dangerous place, and that we all need to look after each other and not take that for granted. I am constantly amazed by the stupid things that I witness people doing on the playa, and not in a good way. I also feel the burden of guilt that, despite all the efforts of both crews to create systems of support and safety for both our tribes and the friends and strangers that we constantly interact with, Alicia never had an opportunity to be guided or trained, and had she arrived at our camp a little earlier, or stayed a little longer, she would be alive right now. A sad and haunting thought.

The death of a campmate whom hardly any of us even saw and yet who was one of us all the same created a strange resonance within the camp, and a great deal of reflection and inner thought. We took the colorful flags down off the Lady Sassafras for the night and considered not going out at all, but that's not really the Louisiana way, so we rolled

around playing mostly brass-band and sacred music with most of our camp on board. (We also took the trailer off and repositioned the generators and speakers.) Apparently I said that we were going across the playa for a short cruise, and that ended up being all night (the Lady Sassafras saw eight dawns in 2014, a record), but we ended up with a prime spot for the Embrace Burn that dawn, which has become one of the most iconic burns in Burning Man history.

Friday afternoon is our annual Albert Hofmann Appreciation Cruise, which I was greatly looking forward to, and this year we had a great lineup, with David Starfire and Trevor Moontribe. I was having a fabulous Neal Cassady moment behind the wheel of a fully loaded Lady Sassafras until we got pinned down by the only major dust storm of the week on the Esplanade, and then after an hour or so of huddling in the bus, most folks bailed, leaving only a handful of close tribe onboard. At this point I decided to take the Lady Sassafras back to camp and regroup for the evening—the plan being to see if we could perhaps meet with the other art car crew for dinner. The idea of our two crews getting together seemed both appropriate and healing, and I found it timely and seemingly righteous that the elements were effectively shutting down our prescheduled partying.

The dust was still rising in thick angry clouds as we made our way very slowly down the Esplanade, only to run into a Hindu wedding parade coming (as it turned out) from our neighbors at Faux Mirage. The synchronicity of our arrival upon this beautifully attired group was perfect, and they excitedly asked us if we would ferry them to the Temple for their wedding, to which of course I willingly agreed. Able to take back over my DJ booth now that my famous DJ friends had departed, I played a mix of *bhangra* dance tunes and Hindi ragas to the delight of my audience, while our driver, Storyville Bob, took us fearlessly into the raging storm and somehow arrived unerringly at the Temple, which miraculously was sitting directly in the eye of the storm itself.

This was my first time at the Temple (my first attempt having been halted by the news of Alicia's death), and I was overcome by its intricacy

and beauty, the attention to detail was a welcome alternative to the massive temples of the past few years, the Temple reminding me of the great mosques of Persia, or of a Fabergé egg. As I wandered in something like a clarified daze, the tears finally started, and I cried for some time, I cried for Alicia, I cried for Preacher, and I cried about how beautiful and precious a thing life really is, just like this jewel of a temple I now found myself in, and that we would burn to the ground in two days. I got on my knees for a while and had a talk to my God about how confusing and frustrating some of her decisions could be. (My God's a woman, I'm pretty sure, or at least that's how she likes to appear to me, so I will go with that.) Then I wandered back out into the DJ booth of the Lady Sass and started quietly playing some of my favorite sacred music as I watched the storm rage around us and the sun begin to set behind the other side of the Temple. (Nice parking job, Bob.)

A very beautiful album by an British-Indian musician, Susheela Ramen called *Salt Rain* was playing from our sound system, and for a moment, just as the sun began to set through the Temple walls and the orange lights around the exterior began to flicker on at the very edge of darkness with the storm still raging all around us, the whole vision of a Temple began shimmering in and out of view as if it were a transmission from some other dimension of reality, and I thought to myself that I had seen a lot of things in a lot of places, but at that moment I didn't think I had ever witnessed a more incredible sight. As I stood there, rooted in awe, I began subconsciously reviewing my own existence, thoughts about life and death and tribe, about love lost and love found, about leadership and friendship, respect and honor, and my own successes and shortcomings, both of which are plentiful, I realized, once again, that life just IS . . . it makes no sense, follows no rules, and never lasts for anything more than this holy instant. It was then, as my eyes were feasting on the sublime beauty of the Temple illuminated by the setting sun, I suddenly felt everything swell up and fill me, I felt the very ISNESS of all things, both animate and inanimate, the singular electricity of the infinite moment, that blinding moment that Alicia was undoubtedly chasing as she made the unfortunate decision to jump from a moving art car.

Right at that moment a beautiful song called "A Song to the Siren" (originally by Tim Buckley) came on, and although I had heard the song many times, I realized for the first time that the song was actually about death—that death was the Siren who is always singing to us, the sweet voice on the far shore to which we must all inevitably swim, while life is this foolish boat we all sail in, crew and passengers on the Great Journey of Discovery. Watching the most amazing sunset I could ever remember seeing, at the most beautiful Temple that our tribe has yet raised to our Gods, while listening to a sublime voice singing this almost mythical song, my heart and soul swelled again as I celebrated Alicia's journey and thanked the world for my own, and a great peace and contentment unexpectedly entered my heart—the great power of music to heal—and I found myself weeping again, but this time not in sorrow, but in a deep appreciation for the miracle of life itself.

> *I'm as puzzled as a newborn child*
> *I'm as troubled as the tide*
> *Should I stand amid the breakers?*
> *Or should I lie, with death my bride?*
> *Hear me sing, swim to me,*
> *Swim to me*
> *Let me enfold you*
>
> TIM BUCKLEY,
> "A SONG TO THE SIREN"

Burning Man is a crucible for the human experience: sometimes the greatest party on the planet, at other times a genuine opportunity to evolve—a choice there is generally nothing you can do about. I don't know what happened out there this year, other than that a bright light was extinguished, and from the great sorrow of that moment, rare flowers formed. I feel as if I had learned as much about the important things in life at this Burning Man, as much as I had perhaps in the previous

decade, and while time will tell if this tragedy will in the end help me evolve, I am hopeful.

In a typical display of playa synchronicity, I met David Best by chance at the Temple a couple of days later on the morning of its burning, and got to show him the Lady Sassafras and express my deep appreciation for his work (he is truly one of my favorite artists; I was a little star-struck). During our conversation he told me that this was his favorite of all the Temples that he has built.

I told him I thought it was the most beautiful temple of all time.

ACKNOWLEDGMENTS

I would like to thank the following; Jon Hanna for his always excellent editing and support; Ken Jordan, and Reality Sandwich; Alex and Allyson Grey; Rick Doblin, Brad Burge, and the rest of MAPS; Fire and Earth Erowid; David Jay Brown; Martina Hoffmann; Jennifer Ingram; Mark McCloud; Jacaeber Kastor; Eli Morgan; Brian Chambers; Jon Graham and Jennie Marx, my poor editor at Inner Traditions; and Ann Shulgin for her legendary hospitality. I would also like to remember again and recognize Alexander Shulgin and Nick Sand, and my friend, the brilliant and sorely missed, Andrew Sewell.

BIBLIOGRAPHY

Ackroyd, Peter. *Blake*. London: Vintage, 1995.

Amaringo, Pablo, and Luis Eduardo Luna. *Ayahuasca Visions: The Religious Iconography of a Peruvian Shaman*. Berkeley, Calif.: North Atlantic Books, 1999.

Anonymous. "The Legendary Mati Klarwein." *Juxtapoz*, August 31, 2014; www .juxtapoz.com/news/erotica/thelegendarymatiklarwein.

Artaud, Antonin. *Voyage to the Land of the Tarahumara*. N.p., 1937.

Barker, Stephen, Jimo Borjigan, Izabela Lomnicka, and Rick Strassman. "LC/ MS/MS Analysis of the Endogenous Dimethyltryptamine Hallucinogens, Their Precursors, and Major Metabolites in Rat Pineal Gland Microdialysate." *Biomedical Chromatography* 2013 (May 23, 2013). www .researchgate.net/publication/251569256_LCMSMS_analysis_of_the _endogenous_dimethyltryptamine_hallucinogens_their_precursors_and _major_metabolites_in_rat_pineal_gland_microdialysate.

Beringer, Kurt. *Der Meskalinrausch*. New York: Springer, 1970 [1927].

Bhavika. "An Interview with Android Jones, the Digital Alchemist." Artwork, accessed June 26, 2017; https://fractalenlightenment.com/35635/artwork /an-interview-with-android-jones-the-digital-alchemist.

Blake, William. *The Marriage of Heaven and Hell,* 1790; accessed June 28, 2017; www.blakearchive.org/work/mhh.

Bohm, David. *Wholeness and the Implicate Order*. London: Routledge & Kegan Paul, 1980.

Boon, Marcus. *The Road of Excess: A History of Writers on Drugs*. Cambridge: Harvard University Press, 2002.

Bowles, Nellie. "At HBO's 'Silicon Valley' Premier, Elon Musk Has Some Notes." *Recode,* April 3, 2014. www.recode.net/2014/4/3/11625260/at-hbos -silicon-valley-premiere-elon-musk-is-pissed.

Brown, David Jay. "How Psychedelic Consciousness Transformed Modern Art: An Interview with Ken Johnson." *MAPS Bulletin* 22, no. 1 (2012); accessed June 28, 2017; www.maps.org/news/bulletin/articles/3048-special-edition -psychedelics-and-the-popular-arts.

———. Editorial. *MAPS Bulletin* 20:1; accessed June 28, 2017; www.maps.org /news/bulletin/articles/1226-special-edition-psychedelics-death-and-dying.

———. "A Thousand Windows: An Interview with Mati Klarwein." www .mavericksofthemind.com/mati.htm

Brown, David Jay, and Rebecca McClen Novick, eds. *Mavericks of the Mind.* 2nd ed. N.p.: MAPS.org, 2010.

Burroughs, William S. "William's Welcome: What Are You Here For?" From the album *Dead City Radio,* 1990.

Burroughs, William S., and Allen Ginsberg. *The Yage Letters.* New impression ed. San Francisco, Calif.: City Lights Publishers, 2001.

Cairns, George F. "A Theology of Human Liberation and Entheogens: Reflections of a Contemplative Activist." In *Psychoactive Sacramentals: Essays on Entheogens and Religion,* edited by Thomas Roberts. N.p.: Council on Spiritual Practices, 2001.

Campbell, Joseph. *The Inner Reaches of Outer Space: Metaphor as Myth and as Religion.* Novato, Calif.: New World Library, 2002.

———. *Thou Art That.* Novato, Calif.: New World Library, 1992.

———. *The Power of Myth.* New York: Anchor, 1991.

Capra, Fritjof. *The Tao of Physics: An Exploration of the Parallels between Modern Physics and Eastern Mysticism.* Boulder, Colo.: Shambhala, 2010 [1975].

Cotter, Holland. "Art in Review: Alex Grey." *The New York Times,* October 4, 2002; http://www.nytimes.com/2002/10/04/arts/art-in-review-alex-grey .html.

Cotton, Dale. "On the Road to Tarascon: Francis Bacon Meets Van Gogh," *Wild River Review.* www.wildriverreview.com/airmail/letters-from-around -the-world/on-the-road-to-tarascon-francis-bacon-meets-vincent-van-gogh (accessed August 11, 2017).

Council on Spiritual Practices. *Entheogens and the Future of Religion.* www.csp.org.

———. *Psychoactive Sacramentals.* www.csp.org.

Dalai Lama XIV. *The Art of Happiness: A Handbook for Living.* New York: Riverhead, 2009 [1999].

Davies, Paul. *The Mind of God: The Scientific Basis for a Rational World.* New York: Simon & Schuster, 1992.

Dawkins, Richard. *The God Delusion*. London: Bantam, 2006.

Devenot, Neşe. "A Declaration of Psychedelic Studies." *Reality Sandwich,* 2013; accessed June 28, 2017; http://realitysandwich.com/121888/declaration _psychedelic_studies.

Eliade, Mircea. *Shamanism: Archaic Techniques of Ecstasy*. Translated by Willard R. Trask. Princeton, N.J.: Princeton/Bollingen, 1964 [1951].

Fadiman, James. *The Psychedelic Explorer's Guide: Safe, Therapeutic, and Sacred Journeys*. Rochester, Vt.: Park Street Press, 2011.

Faggen, Robert. "Ken Kesey: The Art of Fiction 136." *The Paris Review* 130 (spring 1994); accessed June 28, 2017; https://www.theparisreview.org /interviews/1830/ken-kesey-the-art-of-fiction-no-136-ken-kesey.

Flemming, Robin, ed. *Metamorphosis: Fifty Contemporary Surreal, Fantastic and Visionary Artists*. Brunswick, Australia: Beinart, 2007.

Fuchs, Ernst. *Ernst Fuchs: Das graphische Werk, 1967–1980*. R. P. Hartmann, ed. Munich, Germany: Hartmann, 1980.

Gautier, Théophile. "Le Club des Hachichins." *Le Revue des Deux Mondes,* February 1846.

Gibson, Walter. *Hieronymous Bosch*. World of Art series. London: Thames and Hudson, 1985.

Goswami, Amit. *The Self-Aware Universe: How Consciousness Creates the Material World*. New York: Jeremy P. Tarcher/Putman, 1993.

Grey, Alex. *The Mission of Art*. Boston: Shambhala, 1998.

———. *Net of Being*. Rochester, Vt.: Inner Traditions, 2012.

———. *Sacred Mirrors: The Visionary Art of Alex Grey*. Rochester, Vt.: Inner Traditions, 1990.

Grof, Stanislav. *The Cosmic Game: Explorations of the Frontiers of Human Consciousness*. Albany: State University of New York Press, 1998.

———. *When the Impossible Happens: Adventures in Non-Ordinary Realities*. Boulder, Colo.: Sounds True, 2006.

Haisch, Bernard. *The God Theory: Universes, Zero-Point Fields, and What's Behind It All*. York Beach, Maine: Red Wheel/Weiser, 2006.

Hameroff, Stuart. "Quantum Computations in Brain Microtubules? The PenroseHameroff 'Orch OR' Model of Consciousness." *Philosophical Transactions of the Royal Society A: Mathematical, Physical, and Engineering Sciences* 356, no. 1743 (1998); www.quantumconsciousness.org/sites /default/files/1998%20Hameroff%20Quantum%20Computation%20 in%20Brain%20Microtubules%20The%20Penrose%20Hameroff%20

Orch%20OR%20model%20of%20consciousness%20-%20Royal%20 Society_0.pdf.

Hathaway, Norman, and Dan Nadel. *Electric Banana: Master of Psychedelic Art.* Bologna, Italy: Damiana, 2011.

Heaney, Stewart. "Avant-Garde Hallucinogens: The Poetics of Psychedelic Perception in Moving Image Art." *Closeup,* 2014. (No longer available.)

Helene, Zoe. "Interview: Publisher Ken Jordan." *Nailed,* September 13, 2014, https://nailedmagazine.com/interview/interview-publisher-ken-jordan.

Hess, Barbara. *Abstract Expressionism.* Cologne, Germany: Taschen, 2005.

Himwich, Harold E., Seymour Kety, and John R. Smythies, eds. *Amines and Schizophrenia.* Amsterdam, Netherlands: Elsevier, 1967.

Hofmann, Albert. "The Discovery of LSD and the Subsequent Investigations of Naturally Occurring Hallucinogens." In *Discoveries in Biological Psychiatry,* edited by Frank J. Ayd and Barry Blackwell, chapter 7. Philadelphia: J. B. Lippincott Company, 1970. www.psychedelic-library.org/hofmann.htm

———. *LSD: My Problem Child—Reflections on Sacred Drugs, Mysticism, and Science.* 4th ed. N.p.: MAPS org, 2009 [1979].

Hughes, Robert. *Nothing If Not Critical.* New York: Penguin, 1990.

———. *The Portable Van Gogh.* New York: Universe, 2002.

———. "That's Showbusiness." *The Guardian,* June 30, 2004; www .theguardian.com/artanddesign/2004/jun/30/art1.

Huxley, Aldous. *The Doors of Perception.* New York: Harper, 1954.

———. *Huxley and God: Essays on the Religious Experience.* New York: HarperCollins, 1992.

———. *Island.* London: Chatto & Windus, 1962.

———. *The Perennial Philosophy.* New York: Harper, 1945.

———. *Texts and Pretexts: An Anthology with Commentaries.* Reprint ed. Westport, Conn.: Greenwood, 1976.

Ingram, Jennifer Herbanmama. "Tribe 13." *CoSM Journal.* Accessed June 26, 2017: http://cosm.org/journal/28056.

Isaacson, Walter. *Steve Jobs.* New York: Simon & Schuster, 2011.

Jaynes, Julian. *The Origin of Consciousness in the Breakdown of the Bicameral Mind.* New York: Houghton-Mifflin, 2000 [1976].

Jeans, James. *The Mysterious Universe.* N.p.: Kessinger Publishing, LLC, 2010 [1930].

Johnson, Ken. *Are You Experienced? How Psychedelic Consciousness Transformed Modern Art.* New York: Prestel, 2011.

Jones, Steven T. *The Tribes of Burning Man: How an Experimental City in the Desert Is Shaping the New American Counterculture.* San Francisco: CCC Publishing, 2011.

Jung, Carl. "The Spiritual Problem of Modern Man." In *Modern Man in Search of a Soul.* London: Kegan Paul, Trench, Trubner, 1933.

Kloft, Hans. *Mysterienkulte der Antike: Götter, Menschen, Rituale.* Munich, Germany: C. H. Beck, 2010.

Kolbert, Elizabeth. *The Sixth Extinction: An Unnatural History.* 1st ed. New York: Henry Holt and Co., 2014.

Krippner, Stanley. "The Psychedelic State, the Hypnotic Trance, and the Creative Act." In *Altered States of Consciousness,* edited by Charles T. Tart. New York: John Wiley, 1969.

Lanza, Robert. *Biocentrism: How Life and Consciousness Are the Keys to Understanding the True Nature of the Universe.* Dallas, Tex.: BenBella Books, 2010.

Larrissy, Edward. *Blake and Modern Literature.* New York: Palgrave Macmillan, 2006.

Laszlo, Ervin. *The Connectivity Hypothesis: Foundations of an Integral Science of Quantum, Cosmos, Life, and Consciousness.* Albany: State University of New York Press, 2003.

———. *Third Millennium: The Challenge and the Vision.* London: Gaia, 1997.

Leary, Timothy, Ralph Metzner, and Richard Alpert. *The Psychedelic Experience: A Manual Based on the Tibetan Book of the Dead.* New York: Citadel, 2000 [1964].

Lee, Bernard J., and Michael A. Cowan. *Dangerous Memories: House Churches and Our American Story.* New York: Sheed & Ward, 1986.

Lewis-Williams, James David. "Three-Dimensional Puzzles: Southern African and Upper Palaeolithic Rock Art." *Ethnos* 67, no. 2 (2002): 245–264; www.tandfonline.com/doi/abs/10.1080/00141840220136846

Lipsey, Roger. *An Art of Our Own.* Boston: Shambhala, 1988.

Markoff, John. *What the Dormouse Said: How the Sixties Counterculture Shaped the Personal Computer Industry.* New York: Viking, 2005.

Masters, R. E. L., and Jean Houston. *The Varieties of the Psychedelic Experience.* New York: Holt, Rinehart, Winston, 1966.

McCormick, Carlo. "From Darkness to Light: The Art Path of Alex Grey." In Grey, *Sacred Mirrors.* Rochester, Vt.: Park Street Press, 1990.

McKenna, Dennis [O.T. Oss], and Terence McKenna [Oeric]. *Psilocybin: Magic*

Mushroom Grower's Guide. 2nd ed. N.p.: Quick American Archives, 1993 [1976].

McKenna, Terence. *The Archaic Revival: Speculations on Psychedelic Mushrooms, the Amazon, Vitural Reality, UFOs, Evolution, Shamanism, the Rebirth of the Goddess, and the End of History.* San Francisco: Harper San Francisco, 1991.

———. *Food of the Gods: The Search for the Original Tree of Knowledge—A Radical History of Plants, Drugs, and Human Evolution.* New York: Bantam, 1992.

Michaux, Henri. *Miserable Miracle.* New York: New York Review Books Classics, 2002 [1956].

Moreau, Jacques-Joseph. *Hashish and Mental Illness.* New York: Raven Press, 1973. Originally published in French in 1845.

Morgans, Julian. "Mark McCloud Has 30,000 Tabs of LSD at His House." Vice.com, April 2, 2014; www.vice.com/en_us/article/markmccloudcollects acidasartwork.

Morozov, Evgeny. "Moral Panic over Fake News Hides the Real Enemy—the Digital Giants." *The Guardian,* Jan. 7, 2017; https://www.theguardian .com/commentisfree/2017/jan/08/blaming-fake-news-not-the-answer -democracy-crisis.

Muschik, Johann. *Die Wiener Schule des Phantastischen Realismus.* Germany: Bertelsmann, 1974.

Narby, Jeremy. *The Cosmic Serpent: DNA and the Origins of Knowledge.* New York: Jeremy P. Tarcher/Putnam, 1998.

Nichol, Lee, ed. *The Essential David Bohm.* New York: Routledge, 2003.

Nilsson, Martin P. *Greek Popular Religion.* New York: Columbia University Press, 1947.

Nutt, David, Leslie King, and Lawrence D. Phillips. "Drug Harms in the UK: A Multicriteria Decision Analysis." *The Lancet* 376, no. 9752 (2010): 1558–1565.

Oroc, James. *Tryptamine Palace: 5-MeO-DMT and the Sonoran Desert Toad.* Rochester, Vt.: Park Street Press, 2009.

———. "Psychedelics and Extreme Sports." *MAPS Bulletin* 21, no. 1: 25–29. www.maps.org/news-letters/v21n1/v21n1-25to29.pdf.

Panhke, Walter. "Drugs and Mysticism." *The International Journal of Parapsychology* 8, no. 2 (1966): 295–313.

———. *Drugs and Mysticism: An Analysis of the Relationship Between Psychedelic*

Drugs and Mystical Consciousness. Unpublished thesis. Harvard University, 1963.

Porter, David. *Personal Statement, Painting Prophecy.* New York: Gallery Press, 1950

Postman, Neil. *Amusing Ourselves to Death: Public Discourse in the Age of Show Business.* New York: Viking, 1985.

Rapp, Otto. "The Vienna School of Fantastic Realism." Visionary Hall of Fame website, 2010; www.vagallery.com/page66.html.

Rodman, Selden. *Conversations with Artists.* Oakville, ON: Capricorn Books, 1961.

Rondeau, James. [Description of Fred Tomaselli's *Cyclopticon*]. *Parkett Art* 67 (2003); www.parkettart.com/editions/67editiontomaselli.html.

Ronsenthal, Sandy. "Recent Ruling Shows True Tragedy of Katrina Was Federal Government's Creation of the Disaster Itself." Huffington Post, July 5, 2010; www.huffingtonpost.com/sandyrosenthal /recentrulingshowstrue_b_391229.html.

Rosner, Helen. "Anthony Bourdain: The Post-Election Interview." eater .com, December 21, 2016, www.eater.com/2016/12/21/14038332 /anthony-bourdain-election-trump-interview.

Ross, Clifford, ed. *Abstract Expressionism Creators and Critics.* New York: Abrams Publishers, 1990.

Rubin, David S. "Stimuli for a New Millennium." In David S. Rubin, ed., *Psychedelic: Optical and Visionary Art since the 1960s.* Cambridge: MIT Press, 2010.

Russell, Peter. *From Science to God: A Physicist's Journey into the Mystery of Consciousness.* Novato, Calif.: New World Library, 2003.

Ryan, Theresa. "In the Jeans: An Interview with James Jean." Theresa Ryan's blog, March 30, 2010; https://theresaryan.wordpress.com/2010/03/30 /in-the-jeans-an-interview-with-james-jean.

Schmidt, K. "Zuerst kam der Tempel, dann die Stadt." Vorläufiger Bericht zu den Grabungen am Göbekli Tepe und am Gürcütepe 1995–1999. *Istanbuler Mitteilungen* 50 (2000): 5–41.

Schou, Nicholas. *Orange Sunshine: The Brotherhood of Eternal Love and Its Quest to Spread Peace, Love, and Acid to the World.* Reprint ed. New York: St. Martin's Griffin, 2011.

Schumacher, E.F. *Small Is Beautiful: Economics as if People Mattered.* New York: Harper, 1973.

Sexton, Jason. "Jesus on LSD: When California Blotter Acid Got Religion." BOOM 5, no. 4 (winter 2015); https://boomcalifornia.com/2015/12/29/jesus-on-lsd.

Shulgin, Alexander, and Ann Shulgin. *PIHKAL: A Chemical Love Story.* Berkeley, Calif.: Transform Press, 1991.

———. *TIHKAL: The Continuation.* Berkeley, Calif.: Transform Press, 1997.

Strassman, Rick. *DMT: The Spirit Molecule: A Doctor's Revolutionary Research into the Biology of NearDeath and Mystical Experiences.* Rochester, Vt.: Park Street Press, 2001.

Stuart, R. "Modern Psychedelic Art's Origins as a Product of Clinical Experimentation." *The Entheogen Review* 13, no. 1 (2004): 12–22; www.erowid.org/culture/art/art_article2.shtml

Tayler, John. "Today Is the 47th Anniversary of Dock Ellis' Acid-Fueled No-Hitter." *Sports Illustrated* online, June 12, 2017, www.si.com/mlb/2017/06/12/dock-ellis-acid-no-hitter-pittsburgh-pirates-anniversary.

Tolle, Eckhart. *A New Earth: Awakening to Your Life's Purpose.* New York: Dutton, 2005.

Vickers, Ilse. "The Descent into the Cave: The Relationship Between Paleolithic Cave Art and Depth Psychology." Bradshaw Foundation website; accessed June 28, 2017; www.bradshawfoundation.com/cave_art_an_intuition_of_eternity/decent_into_the_cave/index.php.

Wasson, R. Gordon, Albert Hofmann, and Carl P. Ruck. *The Road to Eleusis: Unveiling the Secrets of the Mysteries.* 30th ann. ed. Berkeley: North Atlantic Books, 2008. First published 1978.

Whitehead, Alfred North. *Process and Reality.* New York: Free Press, 1979.

Wilber, Ken. "In the Eye of the Artist: Art and the Perennial Philosophy." Foreword to Alex Grey, *Sacred Mirrors.* Rochester, Vt.: Inner Traditions, 1990.

Witkiewicz, Stanislaw Ignacy (Witkacy). *Insatiability.* Translated by Louis Iribarne. Evanston, Ill.: Northwestern University Press, 2012. First published in Polish in 1930.

Zohar, Danah. *The Quantum Self: Human Nature and Consciousness Defined by the New Physics.* New York: Quill/William Morrow, 1990.

INDEX

452

BOOKS OF RELATED INTEREST

Tryptamine Palace
5-MeO-DMT and the Sonoran Desert Toad
by James Oroc

The Psychedelic Explorer's Guide
Safe, Therapeutic, and Sacred Journeys
by James Fadiman, Ph.D.

DMT: The Spirit Molecule
A Doctor's Revolutionary Research into the Biology
of Near-Death and Mystical Experiences
by Rick Strassman, M.D.

Inner Paths to Outer Space
Journeys to Alien Worlds through Psychedelics
and Other Spiritual Technologies
*by Rick Strassman, M.D., Slawek Wojtowicz, M.D.,
Luis Eduardo Luna, Ph.D., and Ede Frecska, M.D.*

Into the Mystic
The Visionary and Ecstatic Roots of 1960s Rock and Roll
by Christopher Hill

Plants of the Gods
Their Sacred, Healing, and Hallucinogenic Powers
by Richard Evans Schultes, Albert Hofmann, and Christian Rätsch

Psychedelic Medicine
The Healing Powers of LSD, MDMA, Psilocybin, and Ayahuasca
by Dr. Richard Louis Miller

DMT Dialogues
Encounters with the Divine Molecule
Edited by David Luke and Rory Spowers

INNER TRADITIONS • BEAR & COMPANY
P.O. Box 388
Rochester, VT 05767
1-800-246-8648
www.InnerTraditions.com

Or contact your local bookseller